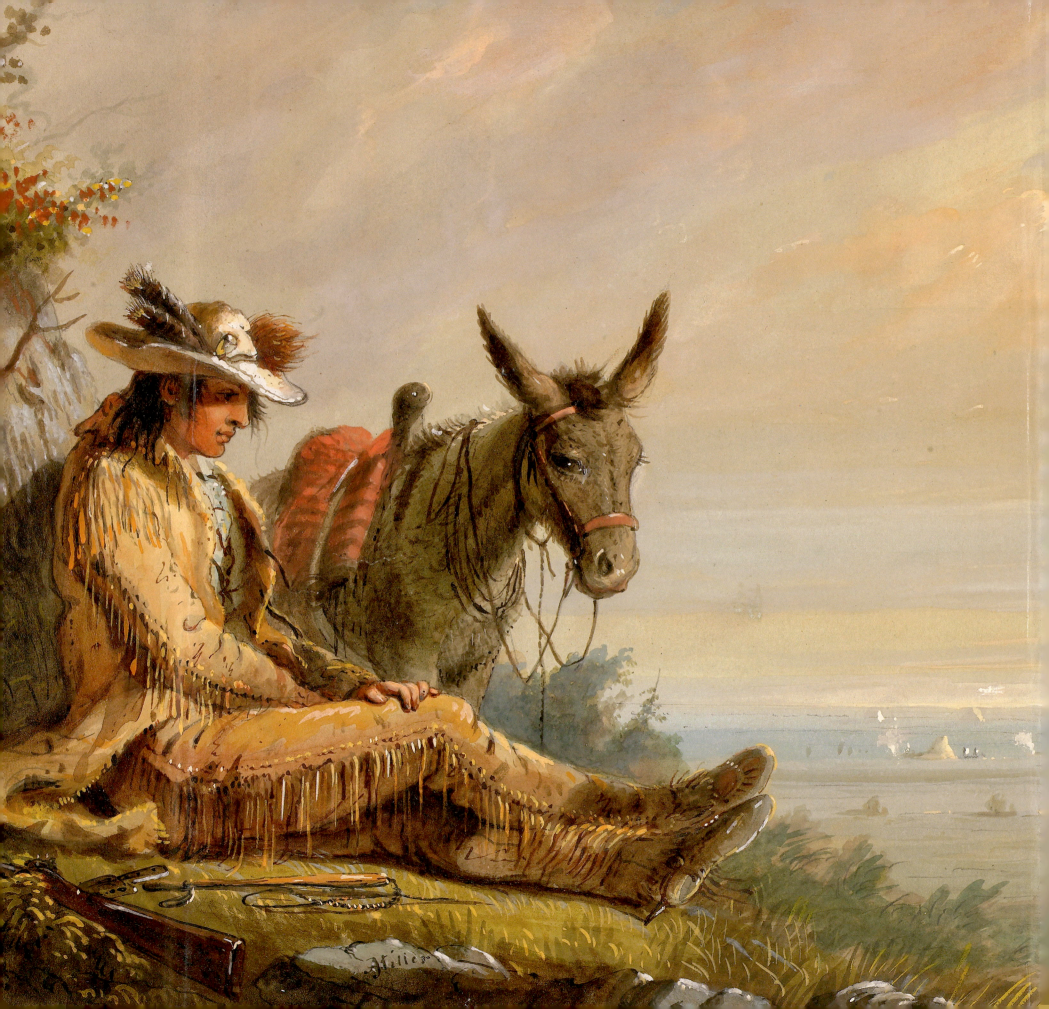

LISA STRONG

Sentimental Journey

THE ART OF ALFRED JACOB MILLER

AMON CARTER MUSEUM
FORT WORTH, TEXAS

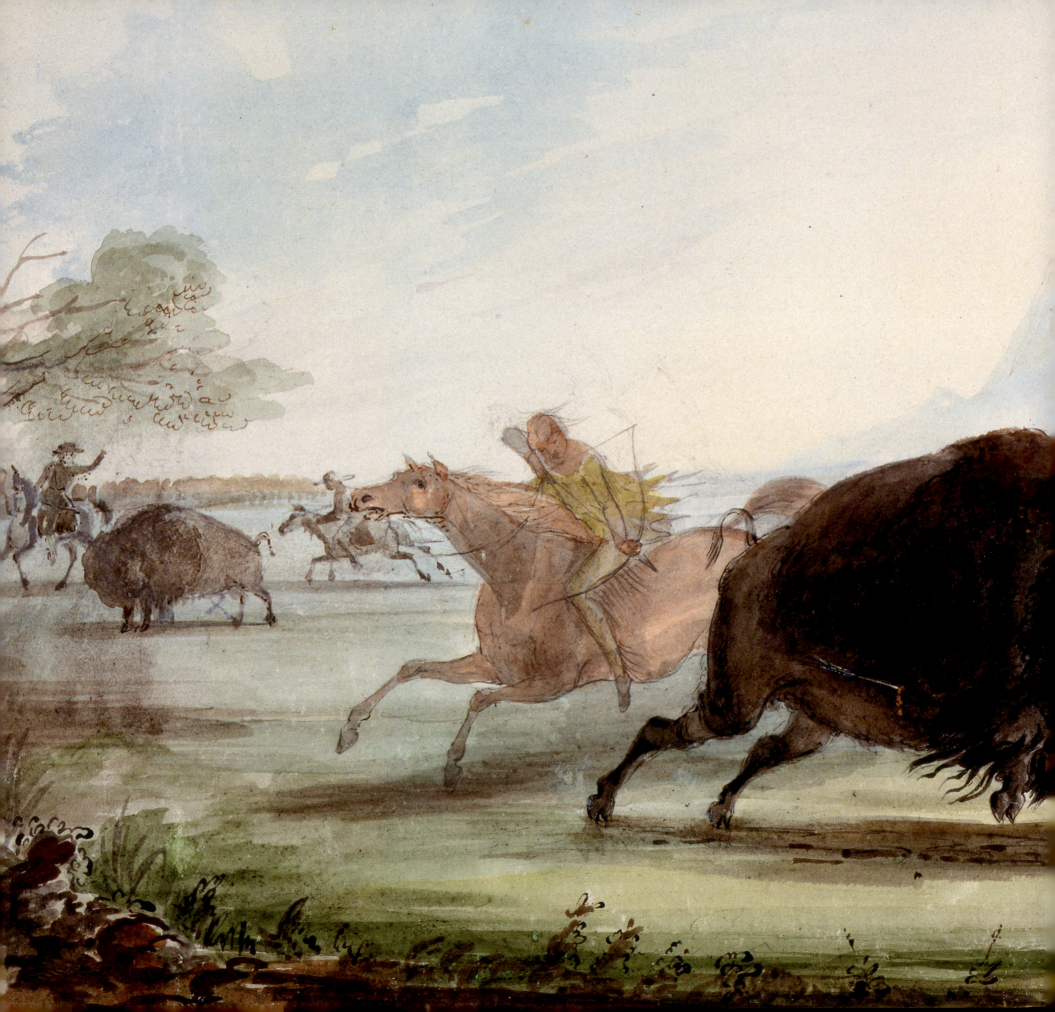

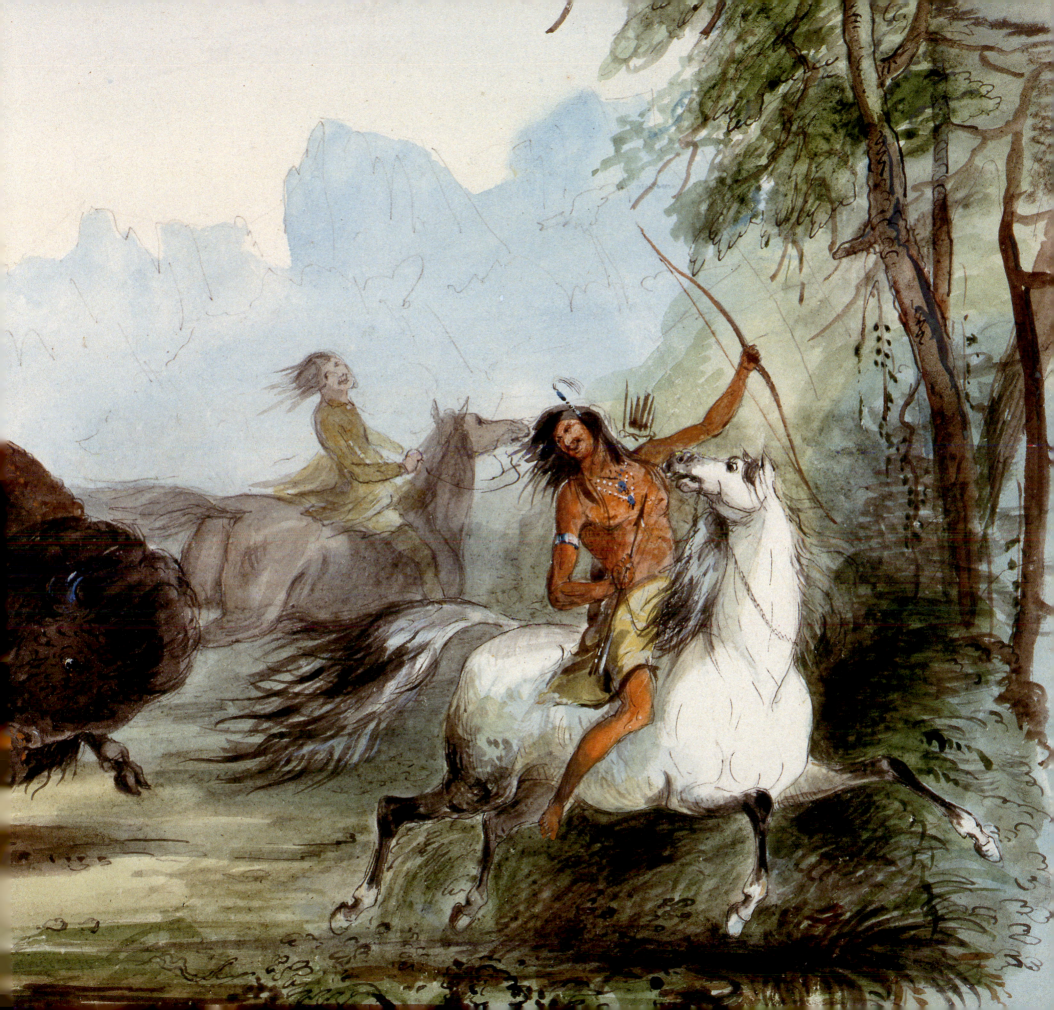

FOR SAM, ELI, AND EVELYN . . .

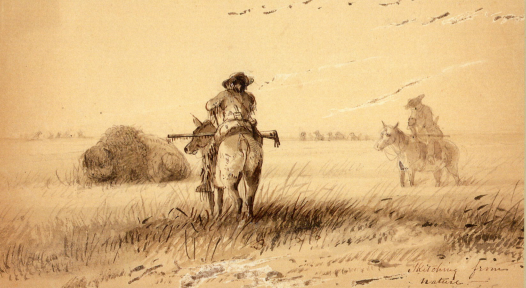

CONTENTS

ACKNOWLEDGMENTS

THIS PROJECT WOULD HAVE BEEN IMPOSSIBLE to complete without the generous support of the Amon Carter Museum. I am grateful to Rick Stewart, senior curator of western painting and sculpture, who encouraged me to develop my dissertation on Alfred Jacob Miller into a book and then an exhibition. He has been an enthusiastic and tireless supporter of the project almost from its inception. Ron Tyler, director at the Carter and dean of Miller studies, happily shared with me from his vast knowledge of the artist and readily facilitated the project. This book and exhibition would not have been possible without his excellent research to build upon.

The publication benefited immeasurably from the expert editing and production management of Will Gillham, director of publications, and his team, including Mary Jane Crook, Miriam Hermann, and the indefatigable and meticulous Jonathan Frembling. Steven Watson, photographic services manager at the museum, expertly prepared all the image files for reproduction, sometimes working from woefully inferior source imagery, and Jeff Wincapaw of Marquand Books gave the publication its elegant design. I cannot thank them enough for the careful attention they gave to this book.

Wendy Haynes, director of exhibitions and collection services at the Carter, coordinated all facets of the exhibition with great skill and patience. I was fortunate to have her guidance through each step in the planning and execution of the exhibition. I also thank Patti Junker, Jane Myers, Trang Nguyen, Nora Christie Puckett, Melissa Thompson, and Jodie Utter for their help at various stages of this project.

The exhibition would not have happened without the many individuals and institutions who graciously loaned their works of art: Garnett Family Library, Special Collections, University of Virginia, Charlottesville, Virginia; Everett D. Graff Family Collection, American Heritage Center, University of Wyoming; Museum of the American West Collection, Autry National Center, Los Angeles; Buffalo Bill Historical Center, Cody, Wyoming; Denver Public Library, Denver, Colorado; Eiteljorg Museum

of American Indians and Western Art, Indianapolis, Indiana; Gilcrease Museum, Tulsa, Oklahoma; High Desert Museum, Bend, Oregon; Johns Hopkins University, Baltimore, Maryland; The Eugene B. Adkins Collection at the Fred Jones Jr. Museum of Art, the University of Oklahoma, Norman, Oklahoma and the Philbrook Museum of Art, Tulsa, Oklahoma; Joslyn Art Museum, Omaha, Nebraska; Library and Archives Canada, Ottawa, Ontario; Maryland Historical Society, Baltimore, Maryland; Decatur H. and L. Vernon Miller Collection, Baltimore, Maryland; National Museum of Wildlife Art, Jackson, Wyoming; Oklahoma Museum of History, Oklahoma Historical Society, Oklahoma City, Oklahoma; Stonehollow Collection, Jackson Hole, Wyoming; Petrie Institute of Western American Art, Denver Art Museum, Denver, Colorado; Philbrook Museum of Art, Tulsa, Oklahoma; Private Collection, Texas; William J. Reese, New Haven, Connecticut; Sheldon Memrial Art Gallery and Sculpture Garden, University of Nebraska-Lincoln; Mr. James Sowell; Stark Museum of Art, Orange, Texas; Walters Art Museum, Baltimore, Maryland; Widener Library of the Harvard College Library, Cambridge, Massachusetts; Gerald Wunderlich and Company, New York, New York; and the Yale Collection of Western Americana, Beinecke Rare Book and Manuscript Library, New Haven, Connecticut.

A project of this scope also depends on the generous support of a number of institutions. Funding for the exhibition was provided in part by the National Endowment for the Arts, the Katrine Menzing Deakins Charitable Trust, the Crystelle Waggoner Charitable Trust, and U.S. Trust. I am also grateful for the assistance I received in research and writing from Columbia University, New York, New York; The Fitz-Randolph Foundation, Mt. Holyoke College, South Hadley, Massachusetts; The Luce Foundation, New York, New York; the Maryland Historical Society, Baltimore, Maryland; the Winterthur Library, Winterthur Delaware; and the Smithsonian Institution in Washington.

The following individuals were all extraordinarily generous with their time and resources at the institutions I visited: Sarah Boehme, formerly of the Buffalo Bill Historical Center and now at the Stark Museum of Art; Suzan Campbell, Eiteljorg Museum of American Indians and Western Art; Darlene Dueck, Anschutz Collection; William R. Johnston, Walters Art Museum; Larry Mensching, Joslyn Art Museum; George Miles, Beinecke Rare Book and Manuscript Library, Yale University; Anne Morand, formerly of the Gilcrease Museum of Art and now at the Charles M. Russell Museum; James Nottage, formerly of the Autry National Center and now at the Eiteljorg Museum of American Indians and Western Art; Ellen Simak, Hunter Museum of American Art; and Joan Troccoli, formerly of the Gilcrease Museum and now at the Denver Art Museum.

Gerald Peters and Deborah White of the Alfred Jacob Miller Catalogue Raisonné project were also extremely generous in sharing information with me about Miller's work. Decatur H. Miller and Donald Steuart Fothringham, Miller's and Stewart's descendants respectively, were also gracious hosts and enthusiastic supporters of my research. Kenneth Price, University of Nebraska-Lincoln, helped me with questions about Walt Whitman and shared portions of his manuscript with me. Finally, the outstanding research librarians at Columbia University; Yale University; Winterthur

Library; and the Maryland Room, University of Maryland, College Park showed great patience and resourcefulness in the face of my constant requests. In particular, Pat Lynagh and Cecelia Chin at the Smithsonian American Art Museum, along with Elisabeth Proffen and Francis O'Neill at the Maryland Historical Society, put their extraordinary research skills to work in helping me track down Miller's patrons and exhibitions. Some of the most important discoveries articulated in this book came as a result of their efforts.

I owe a great intellectual debt to so many people that it seems best to start at the beginning. Professor Barbara Novak used to lament that she had yet to have a student work in the art of the American West; she championed my interest in the field. At Yale, Professor Jules Prown graciously oversaw my first Miller project on watercolors at the Beinecke Rare Book and Manuscript Library. The methods of close observation and analysis I learned from him have informed everything that has followed. Professor Howard Lamar showed me the West was big enough for art historians from Columbia and encouraged me to go there. Kenneth Haltman was never officially my teacher, yet every bit a mentor. He read everything I wrote on Miller, from my independent study paper to the final chapters of the manuscript, offering insightful critiques and inspiring observations along the way. Peter Hassrick has encouraged me in the field of western art with a commitment and generosity that is impossible for me to sufficiently recognize here. His fine example of excellent scholarship and his enthusiasm for western art have inspired me to persist in the field. Alex Nemerov read the final manuscript, and his comments, criticisms, and kind words offered motivation at a crucial stage in the process. Finally, I cannot imagine undertaking this project without the support of Bill Truettner. He read my earliest drafts and pushed me to refine my arguments and support them with close formal analysis ever since. His high standards and exemplary scholarship have all been invaluable to me. This project would be a shadow of its humble self without his presence.

Many other friends and colleagues have helped me along the way, reading pieces of the manuscript or offering moral support. I wish to thank Petra Anselm, Samantha Baskind, Sarah Cash, Lisa Cutler, Anna Dempsey, Pamela Fletcher, Jonathan Gilmore, Bridget Goodbody, Anne Goodyear, Jennifer Graham, Ellen Grayson, Laura Katzman, Eileen Kelly, Elizabeth Roca, Heidi Russell, Maria Ruvoldt, Emily Shapiro, Kimberly Sienkiewicz, Lisa Sullivan, Katherine Tuttle, and Erin Valentino. In particular, I thank Renée Ater, Frank Goodyear, and Nancy Davis for their thoughtful reading of the manuscript. Finally, I thank Kimberly Rhodes, who I met on the first day of graduate school and who has been my friend and colleague from that day forward. In our lives and careers, we have often faced similar challenges. Kim's friendship, advice, and empathy have meant I have not faced these challenges alone.

Most of all, I thank my family. Lara Strong, Jane Strong, and Zsombor Jékely read portions of the manuscript for me and lent me critical moral support through the project's ups and downs. My mother always reminded me that no one had heard of Alfred Jacob Miller yet. Throughout my career,

my father, Dr. John A. Strong, has been my most valued colleague and the model of what the best in academia can be.

My husband, Sam, has never known me when I wasn't working on Alfred Jacob Miller and has tolerated the presence of this other, insistent, and time-consuming man in our lives for too long. He had the courage to enter my life during the last stages of writing my dissertation and has championed me as I struggled to keep the project going through demanding jobs, a terrible loss, and the birth of our two children. It was his unwavering faith that gave me the courage to keep going when I thought I had reached the limits of what I could do. The promise of his continued patience and humor provided the incentive I needed. Finally, I must offer an extra special thank you to my beloved son Eli, whose very long naps allowed this project to reach fruition.

Lisa Strong
Silver Spring, Maryland
May 2008

Is it not curious, that so vast a being as the whale should see the world through so small an eye, and hear the thunder through an ear which is smaller than a hare's? But if his eyes were broad as the lens of Herschel's great telescope; and his ears capacious as the porches of cathedrals; would that make him any longer of sight, or sharper of hearing? Not at all. Why then do you try to "enlarge" your mind? Subtilize it.

—Herman Melville, *Moby Dick, or the Whale*

INTRODUCTION "SCENES THAT DO HIM MUCH HONOR"

ALFRED JACOB MILLER (1810–1874) is famous today for his images of the American West, specifically of the Rocky Mountain fur trade and its participants. Yet the period of time Miller actually spent in the West (approximately six months) and the number of works he produced while there (probably about one hundred) are each relatively small. For most of his career, he lived and worked in Baltimore, and he found success there producing and reproducing nearly one thousand works of western genre between his return from the Rocky Mountains in 1837 and his retirement in 1872. The category of "western artist" encompasses figures like Miller and his contemporaries Karl Bodmer (1809–1893) and George Catlin (1796–1872), both of whom visited the West only briefly, as well as artists like Seth Eastman (1808–1875) and Charles Deas (1818–1867), who lived there for extended periods of time. Their categorization is simply a function of their subject matter. Although Miller's work ostensibly concerns western topics like the fur trade; Shoshone, Lakota, and Nez Percé peoples; and western landscapes, images of these subjects should be understood primarily as metaphors for key social changes taking place in the artist's own milieu of Baltimore and, for a brief period of time, Highland Scotland. In both locales, political upheaval, commercial modernization, and the increasing fragmentation of the upper classes transformed the traditional culture of the elite. Miller's gift as an artist was to recognize the profundity of such changes and to deftly use western subject matter, married with romance and sentiment, to address the transitions. Miller's subtle strategies of representation are difficult to discern at first glance; his images seem to be straightforward, self-contained scenes of western genre. Their meanings become visible, however, when his works are viewed within the context of the artist himself, his patrons, and the society they inhabited. Consequently, this study will offer discussions not only of life on the Great Plains and in the Rocky Mountains but also of life for a distinct stratum of society in the Scottish Highlands and Baltimore.

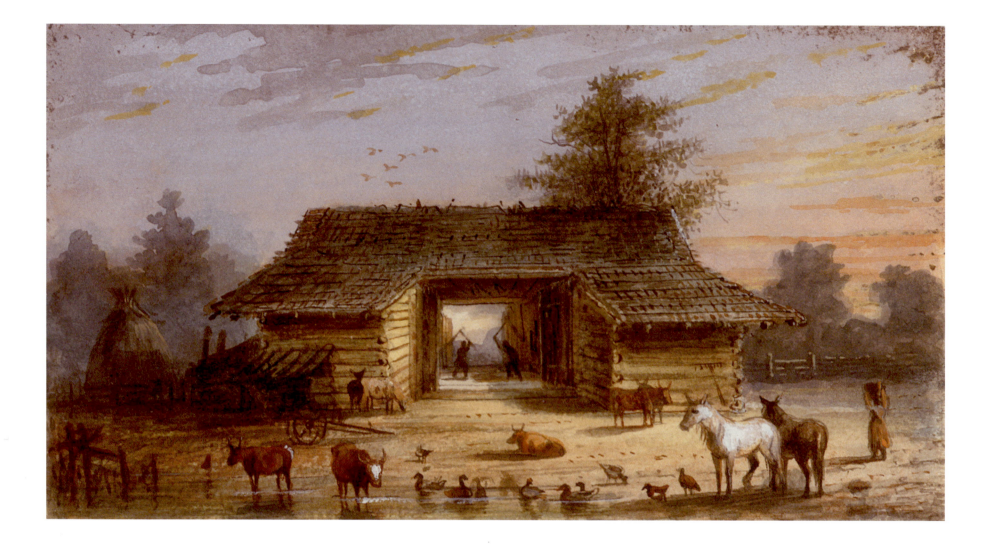

Alfred Jacob Miller in Baltimore

Miller was born and raised in Baltimore, and his personal and familial ties to the city were instrumental to the progress of his career. His father, George Washington Miller (1777–1836), successfully plied a number of trades—tailor, innkeeper, and sugar refiner—and accrued a substantial estate, including a home, warehouse, and sugarhouse in Baltimore, and a farm at Hawkins Point, Maryland (plate 1). Perhaps the most significant of his business ventures, from his son's standpoint, was a grocery store and tavern he operated from roughly 1804 to 1835. It was prominently located at the corner of Market Square near Baltimore Street, the city's main commercial thoroughfare, and formed a backdrop for many of his early sketches (plates 2–3).[1] George Miller's clients included two of his son's early supporters and patrons, eminent art collector Robert Gilmor (1774–1848), and merchant-philanthropist Johns Hopkins (1795–1873) (plate 4). Gilmor reportedly first saw the artist's sketches displayed in the window of George Miller's grocery store. Jacob Heald, a tobacco merchant, also ran a tab at George Miller's tavern. He not only commissioned portraits from Miller, but he also took on his younger brother Decatur as a clerk in his business. Decatur rose quickly through the ranks, becoming the owner of Heald Tobacco Commissions Merchants. It may well have been through Heald and Decatur that Miller gained the patronage of several prominent wholesale tobacco merchants over the course of his career.[2] Miller's father also had sufficient wealth and ambition to send Miller to one of the city's best private schools, the John D. Craig Academy, when he was fifteen. There he studied with the children of some of "the first families of Baltimore at the time—the Baltzells, Gills, Welshs, Carrs, Lows, McBlairs etc.," some of whom became patrons either of Miller's portraits or of his western work.[3]

By his own account, Miller showed an early interest in art. He occupied his time during Craig's long lectures drawing amusing caricatures of his classmates, which his teacher promptly discovered and destroyed.[4] Although some of Miller's friends recalled him as having been entirely self-taught, John Early, a student and later a patron of Miller's, records that Miller studied with portraitist Thomas Sully (1783–1872) in 1831–32.[5] The highly finished surfaces and stiff pose of Miller's *Henry Mankin and Daughters* (plate 5) has been compared to Sully's work. Other portraits, however, such as *Portrait of Mrs. Decatur Howard Miller (Eliza Credilla Hare)* (plate 6), display the tightly contoured, almost wooden-looking limbs and local coloring that are characteristic of the work of Sarah Miriam Peale (1800–1885), also active in Baltimore during Miller's youth.[6] Miller's earliest recorded works, a self-portrait (plate 7), a life-sized painting of *The Murder of Jane Macrea,* ca. 1828 (unlocated), and a monumental history painting, *Bombardment of Fort McHenry* (plate 8), were done while he was still in his teens.[7]

With the support of his family, who strongly encouraged his interest in art, and with financial backing of wealthy Baltimoreans, including Gilmor, Miller embarked on a tour of France and Italy in 1832–34. His first stop was Paris, where he was admitted as an auditor into a life class at the *École des Beaux-Arts.* There, he copied Old Master paintings at the Louvre as well as works by Eugène

PLATE 1 Barn Yard, Hawkins Point, n.d.
Watercolor wash on paper, 3¹¹⁄₁₆ × 6⁹⁄₁₆ inches
Decatur H. Miller Collection, Baltimore, Maryland

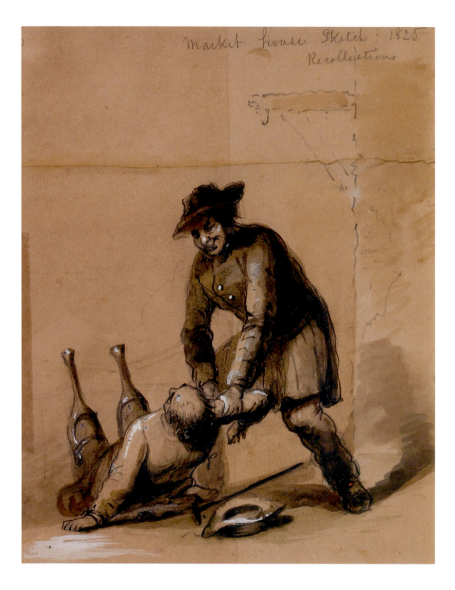

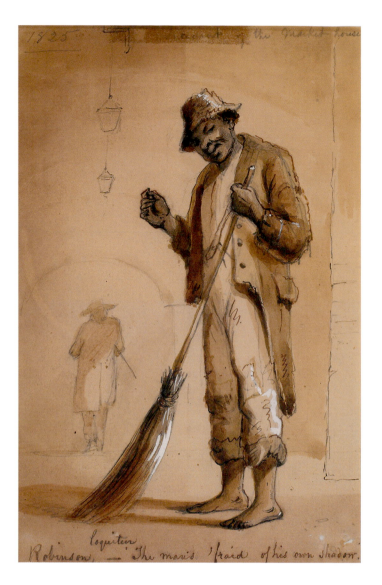

PLATE 2 Market House Sketch, 1825
Recollections conquered by "wrestling
with the Captain," n.d.
Pen and wash on paper, 7½ × 5¾ inches
The Walters Art Museum, Baltimore, Maryland

PLATE 3 Incident of the market house,
Robinson [loquitur] "The Man's 'fraid of his
own shadow" (The Market master has just
given R. a lecture about his idleness), n.d.
Pen and wash on paper, 16⅛ × 12¹¹⁄₁₆ inches
The Walters Art Museum, Baltimore, Maryland

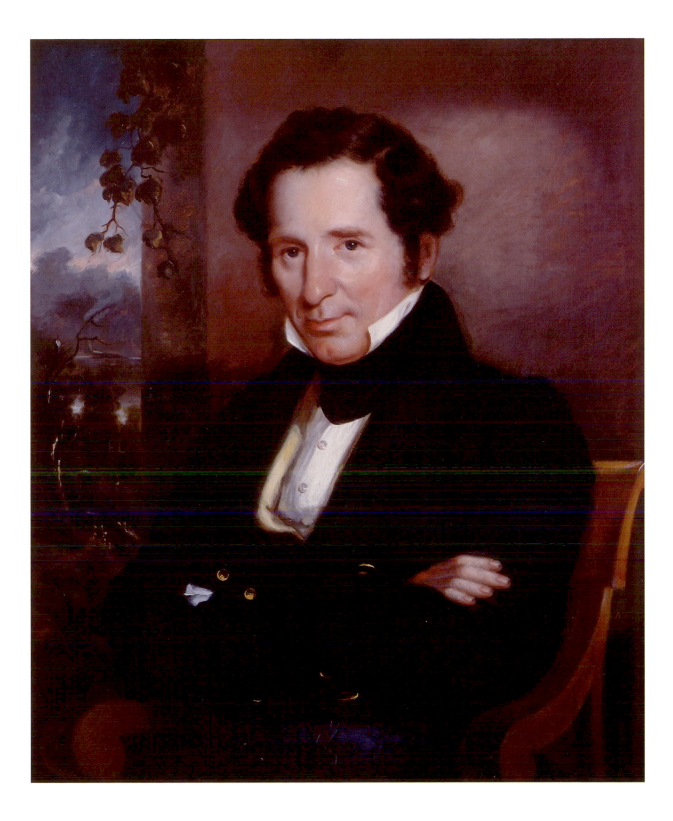

PLATE 4 Johns Hopkins, 1832
Oil on canvas, 30 x 25 inches
University Collections, The Johns Hopkins
University, Baltimore, Maryland

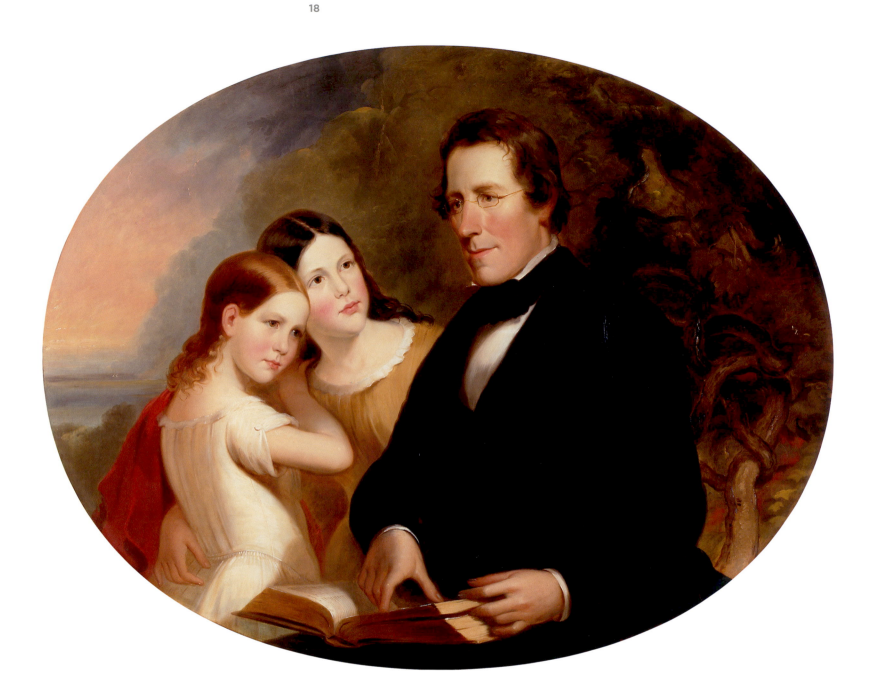

PLATE 5 Henry Mankin and Daughters, 1848–49

Oil on canvas (oval), 36⅞ × 48⅛ inches

The Baltimore Museum of Art: Gift of the Misses Mankin

PLATE 6 Portrait of Mrs. Decatur Howard Miller (Eliza Credilla Hare), ca. 1850

Oil on canvas (oval), 47¾ × 36¼ inches

The Walters Art Museum, Baltimore, Maryland

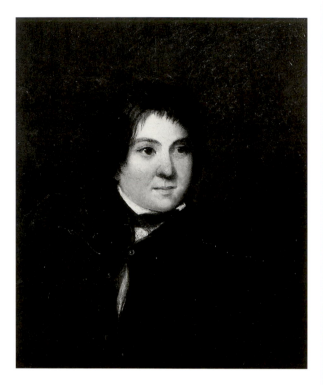

PLATE 7 Self Portrait, ca. 1827
Oil on composition board, 11⅝ × 10¼ inches
The Maryland Historical Society, Baltimore, Maryland

PLATE 8 Bombardment of Fort McHenry, ca. 1828
Oil on canvas, 42 × 96 inches
The Maryland Historical Society, Baltimore, Maryland

Delacroix (1798–1863). In 1833 Miller traveled to Italy, visiting Florence, Venice, and Bologna and settling in Rome, where he was admitted to the English Life School. He studied works in the Borghese Gallery and visited the Vatican, where he copied Raphael's (1483–1520) frescoes in the *Stanze della Segnatura*.[8] In his journal, a series of impressionistic recollections probably written late in life, he described spending time in the Café Greco with other young artists and meeting sculptors Bertel Thorwaldsen (1770–1844) and the head of the French Academy, Horace Vernet (1789–1863).[9]

His graphic work was clearly influenced by French romanticism, particularly the work of Delacroix, whose *Barque of Dante* (1822) he sketched at the Musée Royal de Luxembourg.[10] Certain of Miller's works on paper resemble Delacroix's, both in style and in the selection of potentially sensual and exotic subject matter. Art historians have noted, for instance, that Miller's *Waiting for the Caravan* (plate 9), shows similarities to Delacroix's *Women of Algiers in Their Apartment* (plate 10).[11] In each painting, attractive and youthful dark-skinned women lounge in shaded comfort, awaiting the arrival of men. Miller's watercolor shows several young women resting in the foreground under the shade of a tree while the fur trade caravan approaches in the distance. One lies in the graceful pose of an odalisque, arm resting on the lap of a second seated woman who is wrapped in a rich red robe. The contours of their slouching, twisted bodies, echoed in the rounded forms and long, curving lines of the composition as a whole, find complements in Delacroix's famous oil.

Miller returned to Baltimore in 1834 and took a studio over a music store, advertising himself as a portraitist and copyist of European Old Masters.[12] His career was dealt a setback in 1836, however, when his father died heavily in debt.[13] By Robert Gilmor's account, Miller's income from painting was insufficient to support him without the financial assistance his father had offered.[14] Miller also may have faced difficulties because many of his potential patrons could also have been his father's creditors or debtors. As coexecutor of his father's will, Miller was partially responsible for settling his father's estate. One biographer has noted that he did not begin keeping a record of his painting sales until 1846, the year after his father's estate was settled, suggesting either that Miller had been forced to trade his early work as compensation for his father's debt, or that he wished to hide any income that could be called in to pay it.[15] Perhaps for these reasons, Miller moved to New Orleans in 1837. By his own account, he arrived in the city with only thirty dollars in his pocket, securing rooms and entrée into New Orleans society by successfully painting a portrait of his landlord and the landlord's wife.[16]

In the spring of 1837, Miller received an auspicious invitation from Captain William Drummond Stewart (1795–1871) to accompany him on a journey to the Rocky Mountains. Stewart was a Scotsman who had spent the past five years on an extended hunting expedition in America. Second in line to the baronetcy of Murthly Castle, Stewart had recently received word that his older brother was ill. Anticipating that the 1837 jaunt would be his last, he sought to find an artist to record the exploits of his journey. Miller described how Stewart visited his studio one day unannounced and carefully examined the works he had on view. Looking over Miller's shoulder at a landscape on his easel, he

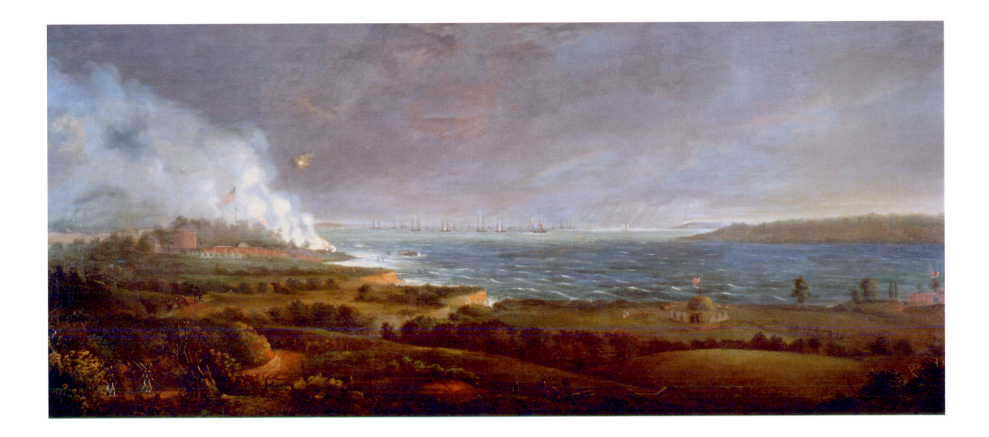

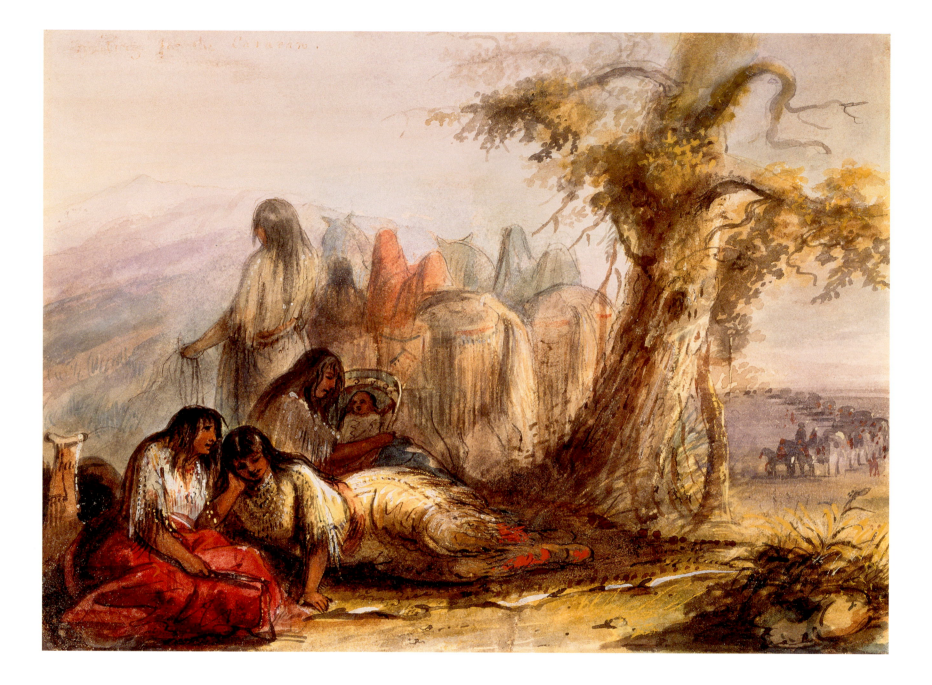

said, "I like the management of that picture and the view." He returned the following day to offer the commission.[17] Miller's narrative of their meeting stresses Stewart's interest in his artwork and includes a detailed, three-page description of the process of "dry scumbling" that he was experimenting with the day of Stewart's visit.[18] His professional competence was surely a factor in Stewart's decision to offer him the commission, but it may not have been the only one. In presenting himself to Miller, Stewart offered as a reference John Crawford, who was both his business partner in a cotton-exporting venture and the British Consul to New Orleans. Crawford, who served as British Consul to Baltimore from at least 1829 to 1833, likely knew of Miller already and might have recommended the artist to Stewart.[19] Consequently, Miller's first substantial commission possibly had its origins in Baltimore as well. After discussing Stewart's offer with Crawford, Miller eagerly accepted the commission.

Their destination that summer was the fur traders' rendezvous, an annual meeting between Rocky Mountain trappers and Saint Louis traders. The participants gathered at a prearranged spot along the Green River to exchange valuable pelts for a year's worth of supplies. Although the rendezvous played a pivotal role in the commercial enterprise of the fur trade, it also served an important social function, providing its participants an opportunity to relax and enjoy themselves after a season of isolation and hard work.[20] That July, the rendezvous was held at Horse Creek, a tributary of the Green River, near the present-day border of Colorado and Wyoming.[21] Miller, Stewart, and the rest of his party—including Antoine Clement, Stewart's Métis (mixed French and Cree) hunting guide—departed from Independence, Missouri, in mid-May 1837. They traveled to the rendezvous with a large caravan that included free trappers and employees of the American Fur Company, arriving about two months later. They spent only a week or so at the rendezvous, then headed into the Wind River Mountains to the source of the Green River. There they spent their time hunting moose and elk before returning to Saint Louis in early October.[22]

Miller reached New Orleans in the fall of 1837 and began work immediately on a set of watercolor sketches of scenes from their journey. By the following summer, he was back in Baltimore exhibiting some oil paintings to favorable reviews: "Mr. M. has not only enjoyed the advantages of foreign study, with the works of the great Italian and other European masters for his models," wrote one critic, "but at a later period, and with the benefit of a matured judgment, he has traveled through remote sections of the 'Far West,' where he has succeeded in giving views of the Rocky Mountains and other scenery that do him much honor."[23] By May of 1839, Miller had completed eighteen oil-on-canvas works that were exhibited at the Apollo Gallery (which would later become the Art-Union) in New York City to positive reviews.[24] The exhibition was well attended; Augustus Greele, the chairman of the exhibition committee, noted that the receipts of the exhibition had "more than doubled the amount of any former week since the formation of the [Apollo] Association" and that "the attraction continues to increase."[25]

PLATE 9 Waiting for the Caravan, n.d.
Watercolor, gouache, glazes, pen and ink, and graphite on paper, 7⅝ × 10⁵⁄₁₆ inches
Gilcrease Museum, Tulsa, Oklahoma

In the summer of 1840, Miller traveled to Scotland to complete the Stewart commission at Murthly Castle. His correspondence from Murthly describes with relish his painting studio on the first floor overlooking the garden and adjoining the library. There he set to work producing oil-on-canvas versions of some of his patron's favorite watercolor sketches. He also completed two of his most important oils, *An Attack by Crows on the Whites on the Big Horn River East of the Rocky Mountains* [*Crows Trying to Provoke the Whites to an Act of Hostility*] (see chapter 1, plate 9) and *The Trapper's Bride* (unlocated). Upon completion of Stewart's western works, Miller traveled to London, where he took a studio and began work for his patron on at least one religious painting, *Mary Magdalene Anointing the Feet of Our Saviour* (ca. 1842).[26] George Catlin, who was in the city to promote his Indian Gallery, visited him there. The two must have had a great deal to talk about, but Miller's correspondence offers little more than the tantalizing barb that "there is in truth however a great deal of humbug about Mr. Catlin."[27] After postponing a commission to produce lithographed illustrations for a novel Stewart was writing about their trek, Miller set sail for Baltimore in the spring of 1842.

Almost immediately upon arriving in Baltimore, Miller purchased a small farm, "Lorraine," five miles outside town (plate 11) and opened a studio downtown in one of the Law Buildings. Suitable studio space was difficult to come by in antebellum Baltimore, but Miller's particular choice of location may reflect his understanding of the different imperatives in obtaining patronage in Scotland and in Baltimore.[28] Following traditional aristocratic patronage patterns, Miller had lived and worked in Scotland entirely at Stewart's expense, and all his finished output (though not his preparatory or "field" sketches) belonged to Stewart. Stewart, in turn, had a large degree of input into Miller's work, choosing which scenes from their journey Miller should sketch, which sketches should be rendered in oil, and how they should be executed. In payment, Stewart offered Miller what the artist characterized as "generous" payments rather than set prices for individual works.

In Baltimore, however, Miller could not expect sustained patronage from a single person. He needed to expand beyond the initial group of patrons that had supported him before his move to New Orleans and form a much broader network of buyers, each of whom might purchase no more than one or two of his works over their lifetime. Certainly a location like the Law Buildings gave Miller access to lawyers and merchants who could, and did, form such a network. Baltimore was at the time the nation's third largest city and a growing transportation hub, with ports and railroads connecting international markets with domestic as far inland as Ohio. The Law Buildings were located in the heart of Baltimore's commercial district, near the courthouse and the Mercantile Exchange, which posted the daily rates of foreign and domestic currency as well as the prices for Baltimore's chief commodities of sugar, flour, coffee, pork (or provisions), and tobacco. Though the rooms in the Law Buildings were small and cramped, Miller's studio was situated to receive foot traffic from some of the wealthiest and most influential of Baltimore's business class.[29]

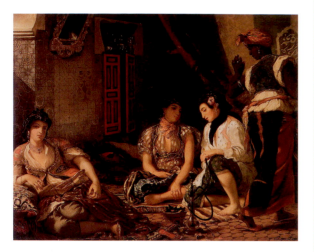

PLATE 10 Women of Algiers in Their Apartment, 1834

Eugène Delacroix (1798–1863)

Oil on canvas, 71 × 90 inches

Musée du Louvre, Paris

Miller's studio certainly would have offered an enticing destination for visitors, crowded as it was with European Old Master copies, plaster casts, oil-on-canvas paintings of the Rocky Mountains, and portfolios of western sketches. Although it is tempting to conclude that the exotic western scenes in Miller's studio offered Baltimore businessmen a welcome respite from their daily cares, evidence suggests Miller's works may have instead encouraged their professional ambitions. Miller did, in fact, succeed in building a lucrative clientele among Baltimore's businessmen. From his earliest recorded commissions, for merchant-collector Benjamin Coleman Ward (1784–1866) and Johns Hopkins, to his last series of forty watercolors, for a partner in the old Baltimore banking and credit firm of Alexander Brown and Sons, Miller painted for a niche of Baltimore merchants involved in trade with the western territories. Their sustained patronage would make Miller Baltimore's de facto painter to the domestic merchant elite for a generation. Thus it is important to understand Miller not as a painter of the West, per se, but as one whose works reflect the close relationship between the artist, his western subject matter, and the economic and social life of his native city.

Alfred Jacob Miller as Western Artist

To say that western art is not simply about the West is not to say anything new. The Smithsonian Institution's 1992 exhibition *The West as America* famously made the argument that western American art was about such central national concerns as race, gender, immigration, and westward expansion.[30] Miller's work has itself been interpreted in similar terms, even by his contemporaries. One of his best-known works, *The Trapper's Bride,* was the inspiration for a famous passage in Walt Whitman's "Song of Myself" (1855):

> I saw the marriage of the trapper in the open air in the far west.... the bride was a red girl,
> Her father and his friends sat near by crosslegged and dumbly smoking.... they had moccasins to their feet and large thick blankets hanging from their shoulders;
> On a bank lounged the trapper.... he was dressed mostly in skins.... his luxuriant beard and curls protected his neck,
> One hand rested on his rifle.... the other hand held firmly the wrist of the red girl,
> She had long eyelashes.... her head was bare.... her coarse straight locks descended upon her voluptuous limbs and reached to her feet.

Whitman used the scene that Miller portrayed as one of a series of vignettes that aimed to convey what was, for the poet, America's unique *national* identity. His scene of a white trapper and an Indian woman joined together in matrimony made literal the very process of cultural amalgamation that created the American people.[31] Although Whitman is an atypical contemporary of Miller's and his

passage was a creative act unto itself, his poetic interpretation of the scene pointed to the extent to which Miller's painting, and his larger body of western subjects, could have been understood in its own time as speaking to the concerns of the nation. Certainly this has been the approach that scholars in the twentieth century and today have taken to Miller's work, and Whitman's passage is a testament to those studies' validity.

Historian Dawn Glanz, for instance, has argued that *The Trapper's Bride* pictures the peaceful amalgamation between Indian and white peoples that Thomas Jefferson (1743–1826) had prophesied. On a broader level, she writes, the painting offers "one of the most trenchant visual statements of the theme of reconciling wilderness and civilization to be produced in American art during the nineteenth century."[32] Taking the same general approach, but reaching the opposite conclusion, a second scholar has argued that Miller's painting reveals the artist's pessimism about the prospects of reconciliation between American civilization and "savagery" when founded on interracial unions.[33]

Such scholarship addresses the work's significance on a national level, but what about the local? Other scholars have noted the provincialism of the artist himself following his return to Baltimore in 1842, but none have taken Miller's mileu as a starting point for interpreting his work.[34] Compared to artists like John Mix Stanley (1814–1872) and George Catlin, who traveled the country promoting their works before a national audience, Miller does appear to have been reclusive.[35] For the remainder of his career, he lived in or near his native city. He kept a studio in various locations in downtown Baltimore until his retirement in 1872 and sold and exhibited his work in the city almost exclusively. It is important to note, however, that Miller did, in fact, exhibit occasionally outside the city. Early in his career, he sent Old Master copies to exhibitions in Boston.[36] Following his return to Baltimore, he exhibited in Washington, D.C., New York, and Philadelphia. Initially, he sent portraits and genre scenes to National Academy of Design shows, but the obvious popularity of western scenes shown at the American Art-Union prompted him to try exhibiting his western works as well.[37] From 1851 to 1852 he exhibited seven western scenes at the American Art-Union, the Pennsylvania Academy of the Fine Arts, and the Metropolitan Mechanics Institute in Washington, D.C. He must have changed his mind about exhibiting western works, however, and returned to exhibiting genre scenes the few times he did submit works outside Baltimore after 1853.[38] Miller may have given up exhibiting outside Baltimore because he had relatively little success with sales, but it is also true that he did not need to leave Baltimore to promote his work. He had a loyal circle of students, colleagues, and patrons there. He joined the city's nascent art organizations and remained active in the Baltimore art community until late in his life. Miller was a founding member of the Maryland Academy of the Fine Arts (1838–39), the Maryland Art Association (1847), the Artists' Association of Baltimore (1855–58), and the Allston Association (1858–63). He also participated in the annual art exhibitions of the Maryland Historical Society (est. 1844).[39] In 1871, a local paper recorded Miller's attendance at the auction of a popular exhibition of Maryland art held by Butler, Perrigo and Way, Miller's dealer for nearly twenty years.[40]

Perhaps more important, unlike Catlin and Stanley, Miller did not lack for patronage. On average, Miller earned about $2,000 per year selling portraits, western scenes, and a small number of Old Master copies, during a period when a middle-class clerk or artisan made $1,000 per year.[41] Beginning in 1848, Miller invested his proceeds in a number of banks and companies directed by his patrons, amassing a fortune of nearly $120,000 over his lifetime.[42]

In quoting these figures, I do not mean to equate Miller's financial success with artistic success or importance. My point is pragmatic; Miller achieved what so many artists—Catlin and Stanley particularly come to mind—then, as now, sought to achieve.[43] He supported himself and his family through painting. In Baltimore during the period he worked, this was no mean feat. His achievement suggests an artist who was particularly insightful in capturing and codifying the concerns of his patrons. As I hope the following chapters demonstrate, Miller's significance as an American artist stems less from the subject matter he portrayed than from his astute ability to make it relevant to the local or regional audience for whom he painted.

An example of Miller's acuity can be found in the 1845 *The Trapper's Bride* (see chapter 3, plate 1). In the painting, there is a light-gray horse striding in from the right. The animal has an arched neck, flaring nostrils (with a slight suggestion of breath exhaled), and ears that point steeply inward. It also has a slight dish-curve to the profile of its muzzle. An observation often made about Miller's western work is that he portrayed the herds of wild ponies he saw on the American prairie as dashing Arabians.[44] His *Wild Horses* (plate 12), executed as part of the set of eighty-seven watercolor and wash sketches he made for Stewart immediately following his return from the West, shows horses with the classic features of the sought-after breed. They have small muzzles, flared nostrils, dish-shaped facial profiles, curving necks, and inward pointing ears.[45]

Scholars have typically cited Miller's misrepresentation because it seems so readily to capture his fanciful, even fictitious, response to the whole of his western subject matter. But upon investigation, Miller's Arabians have other insights to offer. Historians of American horse breeding note that the wild horses that populated the Plains were descended from Arabian horses introduced to North America by the Spanish.[46] Although it is unlikely that the wild horses possessed all the characteristic physical traits of a purebred Arabian, they certainly would have possessed some. Perhaps more significant was American horse enthusiasts' *belief* that the western herds were populated by fine examples of Arabian-bred stock. Arabians were a desirable breed in antebellum America, particularly in Virginia and Maryland, where purebred Arabians could be bred into existing Thoroughbred lines to improve the performance of racehorses. Purebred Arabian stallions and mares had been imported from England since 1730, but they were still difficult to acquire in America before the Civil War. One of America's most reputable early sporting magazines, *American Turf Register and Sporting Magazine*, published in Baltimore from 1829 to 1838, contained numerous articles, illustrations, and bloodlines of famous Arabians.[47] The inaugural volume, for instance, carried a portrait of one of Europe's most

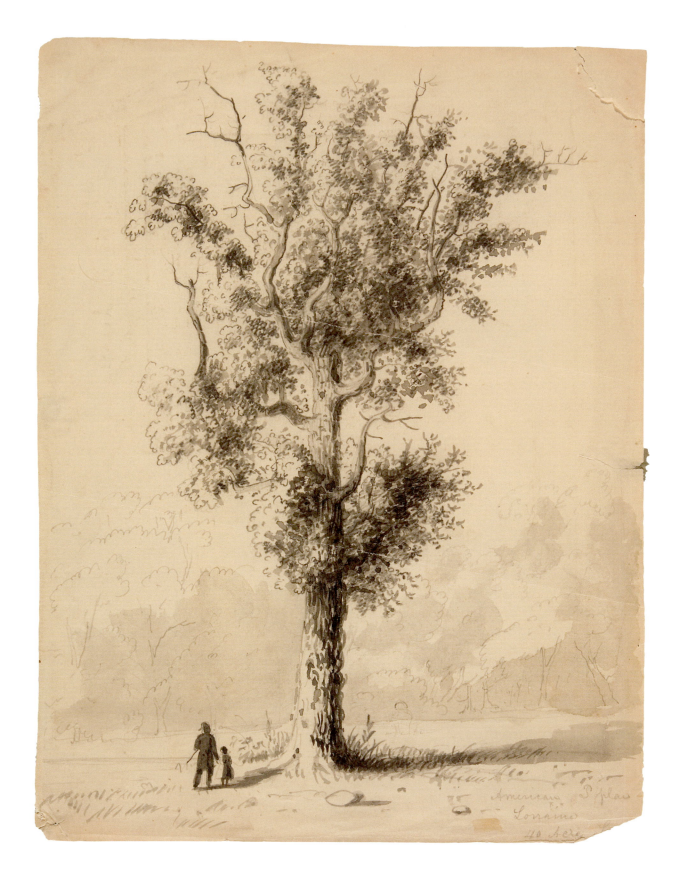

American Poplar
Lorain
40 Acre

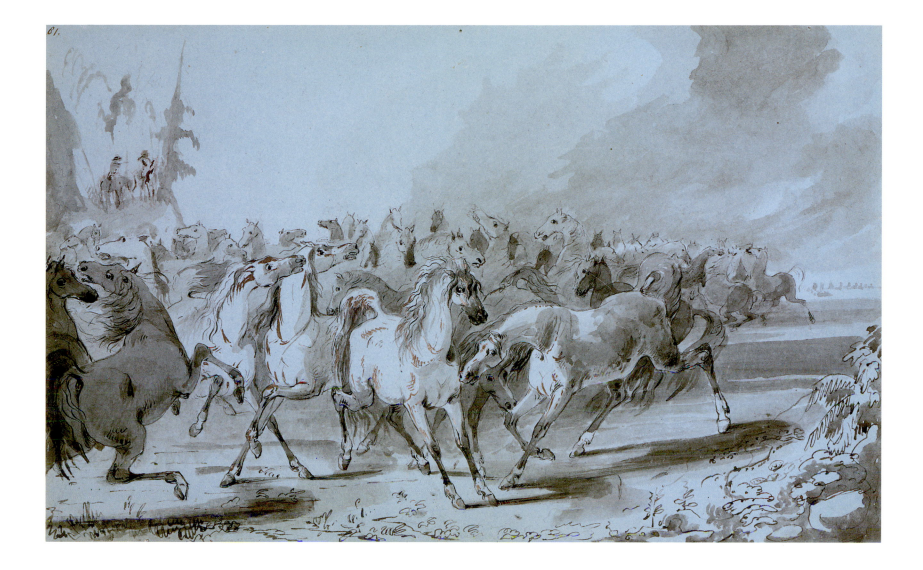

PLATE 11 Lorraine–40 Acres–American
Poplars, n.d.
Pencil, pen and ink, and wash on paper, 11¼ × 8½ inches
Gilcrease Museum, Tulsa, Oklahoma

PLATE 12 Wild Horses, ca. 1837
Pen and ink with gray wash heightened with white
on blue paper, 8½ × 13¾ inches
Buffalo Bill Historical Center, Cody, Wyoming;
Gift of The Coe Foundation

famous examples of the breed, the Godolphin Arabian, which is believed to be one of three Arabian progenitors of all British and American Thoroughbreds (plate 13). In 1832–34 several articles written by an agent at Fort Gibson, in what is today Oklahoma, appeared in the journal extolling the virtues of wild horses captured by the Osages. These horses were said to be descended from Spanish Arabians and possessed several of their traits. They were "lofty, elegantly formed, active and durable." According to the author, the Shoshones valued mules above them and would sell them for a handful of beads. Unsurprisingly, the author had not yet succeeded in procuring one, but the letters he sent recorded his efforts to obtain a good example for interbreeding with Thoroughbreds.[48] The editor of the journal responded in an open letter asking, "What are the advantages … enjoyed by the desert or mountain steed of Arabia over ours of the prairies?"[49]

Beliefs about the superiority of wild horses that were descended from Arabians likely circulated among the Baltimore upper class, among whom horse racing was always a favorite sport.[50] Thoroughbred racing dated back to the eighteenth century, and Baltimore had at least one racetrack near the city throughout the century. At least one of Miller's patrons, William C. Wilson, was listed as a subscriber to the *American Turf Register*.[51] Robert Gilmor bred and raced horses, and one of Miller's patrons, Jacob Brandt, was an officer in the Maryland Jockey Club.[52] But it is also likely that Miller was acquainted with the journal and with the history and desirability of the Arabian breed. His sketchbooks, which contain numerous drawings of horses, indicate the artist himself had an interest in the animal. Whether or not Miller specifically knew the *American Turf Register,* the implication that some of his patrons believed (or wanted to believe) that fine horses of Arabian descent were present on the prairie suggests that Miller's motivation for his representational choice could have been as practical as it was romantic.

The issue of Miller's romanticism and its place in Miller scholarship is important in this study. Miller is widely understood to have been influenced by French romanticism. And he is also frequently described as a "romantic," one who is fanciful, imaginative, escapist, and prone to the sensational. For early scholars of Miller who valued the artist principally as a witness to the fur trade, his romanticism was a source of discomfort. In his widely acclaimed account of the Rocky Mountain fur trade, historian Bernard DeVoto introduced the artist as follows:

> Mr. Alfred Jacob Miller was twenty-six years old and an artist, a Romantic painter who had had nearly two years of the brisk wind that was blowing through the studios of Paris and Rome. He had talked many nights away with Horace Vernet and his young men, at many cafés, in many ateliers. He had sat at the feet of Horace Greenough, had traveled to Rome with [Nathaniel Parker] Willis … , had abjectly worshiped Thorvaldsen. He had discussed the beautiful with all the young men. And he had made an impression too: in Paris they called him 'the American Raphael.' Conceivably that was a title not difficult to earn in 1833.[53]

PLATE 13 The Godolphin Arabian, 1829
After George Stubbs
Anonymous engraving
American Turf and Sporting Register, no. 1
(September 1829), p. 1
The Maryland Historical Society, Baltimore, Maryland

DeVoto's condescension is palpable. Miller is tractable (blown by the brisk winds of European studies), sycophantic, a lover of beauty, and, in the end, not very good. DeVoto makes out what he can from the evidence Miller's paintings offer, but Miller's imaginative tendencies repeatedly threaten to distort and misrepresent: "Several times a band of broomtails, the runty wild horse of the plains … thunders by and makes our romantic gape with 'the beauty and symmetry of their forms' which didn't exist, and 'their wild spirited action, long sweeping manes and tails, variety of color, and fleetness of motion,' which did."[54] Significantly, it is the aesthetic, beautiful qualities of the horses that DeVoto discounts in favor of their more active ones. DeVoto also makes a point of correcting Miller on the subject of romance: "He found romance to paint, too, though he seems to have misunderstood some of it. If a sketch called 'Indian Elopement' is not made up, there was a runaway marriage at the rendezvous, but it must have been a wife-stealing and not, as Miller thought, an intertribal love story."[55] Miller's romantic or aesthetic sensibilities, DeVoto is quick to remind us, were not appropriately applied to their western material.

But it was just those qualities—Miller's aesthetic sensibility, his romanticism, and his sentimentalism—that made the works so resonant with his contemporaries. Putting aside the question of whether or not any western artist was capable of true, objective reportage, Miller's work seldom appears to have been promoted by the artist or contemporary critics as illustration. It is true that the artist, for the most part, reproduced a core group of images ostensibly based on field sketches rather than "inventing" new narrative scenes, a technique that would appear to privilege the authority of scenes witnessed in the field. He did not, however, conceive of his enterprise as scientific illustration, as George Catlin or Karl Bodmer did, nor did he include testimonials as to the accuracy of his accounts. Rather, at the very outset of his trip he compared the process of painting Native Americans to that of poets weaving verbal garlands out of flowers: "It's a new and wider field both for the poet and painter—for if you can weave such beautiful garlands with the simplest flowers of nature—what a subject her wild sons of the West present, intermixed with their legendary history."[56] In a similar vein, contemporary reviews complimented Miller's work not for its accuracy in illustrating western scenes, per se, but for capturing "'the very form and pressure' of the romantic and dangerous life led by these travelers."[57] Other reviewers considered the works on their artistic merits, praising Miller's draftsmanship, perspective, or mastery of equine anatomy or censuring him for the "glare of the Italian which he seems to imitate" in his coloring.[58]

Critics have not previously alluded to Miller's sentimentalism, but it forms a key feature of his work. The terms "sentiment," "sentimentalism," and "sentimental" have similar roots, but their historical meanings are distinct. In Scottish Enlightenment thought, sentiments, or feelings themselves, were theorized to be a sixth sense, akin to sight, hearing, and taste. According to the theory of sentimentalism, sentiments could serve as a natural or inborn guide to moral judgments. Genuine "sensibility," or the ability to feel sentiments easily or forcefully, was thus a key to the proper working of

morality according to sentimentalism, as was "sympathy," the core sentiment that enabled humans to discern right or wrong in the treatment of others. British sentimental fiction, in its earliest incarnations, gave narrative voice to the philosophical theories of sentimentalism.[59] Novels such as Henry MacKenzie's *The Man of Feeling* (1771), Oliver Goldsmith's *The Vicar of Wakefield* (1766), and Laurence Sterne's more ironic *A Sentimental Journey through France and Italy* (1768) present parables of the power of sentiments to guide moral actions. The best of American sentimental fiction drew on the British sentimental tradition, not just in the conventional plots of the novel, but also on its theoretical Enlightenment underpinnings. Novels such as Harriet Beecher Stowe's *Uncle Tom's Cabin* (1852), for instance, sought to understand the nature and sources of both human good and evil and found its answers in a belief of expressed or repressed innate moral senses.[60] *Uncle Tom's Cabin*'s portrayal of great and public displays of emotion, however, has also been branded by critics today as "sentimental" in the more common parlance—as excessively emotional and insincere in its seeming focus on the subject, rather than the objects, of pity. The worst of American sentimental fiction has been portrayed as sentimental in this latter sense of the word.[61]

In chronological terms, Miller was working in a period, roughly 1840–60, when a particularly dramatic brand of American sentimentalism held sway. Philosophically, however, he seems to have hewed closer to the earlier British form. He drew illustrations for British sentimental novels such as Goldsmith's *Vicar of Wakefield* and Sterne's *Tristram Shandy* (1767) and *Sentimental Journey*. In the spirit of Sterne, whose work stood on the edge of parodying the very form it embodied, a composition like Miller's *The Trapper's Bride* (see chapter 3, plates 1–4) explores the limits of sentiment as a guide to action. Others of Miller's late watercolors can also be interpreted as offering a critique of the female-dominated sentimentalism of antebellum America by presenting a masculinized sentimentalism that eschewed the strong, tearful reactions portrayed in, and presumably elicited from, American sentimental novels. Nevertheless, his treatment of American Indian subjects ultimately shares more with the work of Stowe insofar as his images are not a call for action on behalf of native peoples, but rather an invitation merely to sympathize with the foregone conclusion of their demise.

Miller's sentimental and romantic themes should not, of course, be viewed as obstacles to the content of his work, as DeVoto has suggested, nor should they be seen merely as an endorsement of the belief that his work was imaginative. Rather, these themes were constitutive to the works' meaning. In a period of Indian-white relations dominated by economic colonialism and government policies of removal, sentimental and romantic themes helped to conceptualize the artist and his patrons' relationship to Indian peoples in ostensibly positive terms. Taking for granted the gap between historical fact and Miller's fiction that haunts much pre– and some post–*West as America* scholarship on western art, I have located Miller's paintings more specifically within the nexus of relations between the artist, his patrons, and the relatively small, local audiences who would have seen them. How did Miller's images of the West suit his audiences' specific interests? And how did

Miller's romantic and sentimental outlook help to negotiate the political and social gaps between subject matter, audience, and artist?

Chapter one explores the relationship between Miller's patron, William Drummond Stewart, and the works Miller prepared expressly for him following their trip. Stewart appears to have exerted a large influence over Miller's production immediately following their excursion, and Miller subsequently resided with Stewart in Scotland for two years while he completed some of his most important oils. The chapter examines Miller's paintings in the context of a collection of Native American material culture and North American plants and animals that Stewart brought back. Stewart's collection grew out of a sustained interest in Native American life that cannot be explained solely in terms of a generalized romantic fascination with so-called exotic cultures. Rather, his interest in Native American culture was more likely founded in beliefs about similarities between Native American and Scottish Highland cultures and was prompted, in turn, by a growing interest in Scottish cultural identity during the 1820s and 1830s. Comparisons between Highlanders and Indians were initially meant as criticisms of the Highland way of life, but changing attitudes toward so-called primitive man during the eighteenth century cast the comparison in a more flattering light. Eighteenth-century Scottish Enlightenment thinkers, such as Adam Ferguson, argued that man's ideal state of civilization was in the middle—not fully primitive but not so overrefined as to lose the essential physical senses and emotions that served as the foundation of morality.[62] Native American life may then have offered a kind of salutary primitivism, or a needed corrective to the supposed refinement of Scotland wrought by its increasing cultural incorporation into Great Britain.

The chapter concludes with a consideration of Miller's monumental history painting, *An Attack by Crows…* (see chapter 1, plate 9).[63] The work depicts an 1833 encounter between Stewart's party and a band of Crow Indians and is closely connected to Stewart's larger collection of Indian material, not only by its subject matter but also by Miller's inclusion in the scene of many of the Native American objects Stewart had collected. But the painting's narrative content also provides a conceptual link to the salutary primitivism articulated by the collection. According to Miller, the Crows believed they could only make war on Stewart's party if they incited him to strike the first blow, and the painting depicts Stewart's triumphant emotional restraint in the face of their provocation.[64] What is of key importance in the painting is not that it advocates the absence of emotion, but that it acknowledges the strong emotions inspired by the presence of Indians. Indeed, the power of Stewart's feelings is the measure of his self-control. Since scholars of sentimental literature have suggested that Scottish Enlightenment theories of sensibility provided one of the foundations for later literary sentimentalism in the United States, *Attack by Crows* provides an intellectual link between the notions of human development that Stewart's collection promoted and the sentimentalism of Miller's later Baltimore paintings.[65]

Stewart's embrace of salutary primitivism must be understood within the context of a second narrative of indigenous aristocracy that is present in the assembly of subjects in the sketch album.

Chapter two discusses the significance of the subjects that Stewart selected from among the field sketches for inclusion in the album. Significantly, the images he chose show Stewart and Native Americans alike engaged in activities that constitute traditional aristocratic pursuits: big game hunting, deer stalking, horse racing, and archery competitions. In both content and style, these works establish parallels between Native American and Scottish aristocratic culture, suggesting that Stewart saw Native Americans as a kind of indigenous aristocracy. Highlanders were lauded for similar traits of honor, martial skill, and hospitality, and the images that show Stewart hunting and entertaining with Native Americans could make Stewart appear the more authentic Scotsman as well as aristocrat.

Notions of salutary primitivism and indigenous aristocracy might seem to be in conflict since aristocrats are generally assumed to be culturally refined, and it may well be that neither Stewart nor Miller recognized nor sought to resolve such contradictions. It is true, however, that the particular form of aristocracy depicted in the Stewart sketches was an older, martial form, which included activities such as hunting and warfare, rather than displays of cultured refinements such as etiquette or formal dress. It is also true that the period immediately preceding Stewart's trip saw the increasing incorporation of Scottish peers into the British (or English) aristocracy, so that the salutary primitivism of indigenous aristocrats could be understood as being a reinvigorating model for the overly Anglicized Scottish aristocrats as well. Scottish Enlightenment theories about the origins and development of political institutions also provided a possible foundation for a coherence of primitiveness and aristocracy.

Chapter three discusses Miller's return to Baltimore and his adaptation to the shift he underwent from aristocratic to commercial patronage. In particular, it focuses on changes in the production and meaning of one of Miller's most famous works, *The Trapper's Bride*, when painted in the environment of commercial Baltimore. Like so many other of Miller's paintings, *The Trapper's Bride* seems to focus on the emotional, rather than the commercial, aspects of the fur trade. But the painting's sentimental narrative could function as an idealized image of premodern trade practices and of Miller's merchant-patrons, who were frequently criticized by their contemporaries for their lack of sentiment. Travel writers in the eighteenth and nineteenth centuries frequently cloaked the political and economic interests that their travel advanced in the language of sentimentalism.[66] In *The Trapper's Bride,* Miller's sentimental subject matter and style seem to serve a similar purpose, packaging economic conquest as true love.

The final chapter considers Miller's watercolors of the journey west, focusing primarily on his images of trappers gathered around the campfire. Despite the popularity of the trapper as a subject in antebellum American art and literature, Miller's trapper images appear to have been the least popular with his Baltimore patrons. This chapter explores the possibility that Miller's trapper images presented a vision of manhood that was at odds with the prevailing ideal embraced by his patrons. For most Americans today, the image of men seated by a campfire suggests self-reliance and physical strength, qualities that for decades have defined notions of American manhood. Ideas of antebellum

masculinity, however, differed dramatically from those of the turn of the century. Miller's campfire scenes express a vision of sentimental manhood that contrasted with both the contemporary ideal of the active, financially successful, self-made man and the turn-of-the-century model of men "with the bark on." By portraying the trapper's campfire sentimentally, Miller participated in a wider effort of antebellum male authors to appropriate and use the female-dominated genre of sentimentalism for their own expressive purposes. In so doing, Miller associated established paragons of masculinity with traits of sentimentality that he, rather than his patrons, possessed.

The West has frequently served artists as a source for nostalgia or elegy. George Catlin, for instance, sought to preserve in his images what he believed was a dying Native American way of life, while Frederic Remington (1861–1909) and Charles Russell (1864–1926) used cowboys to lament changes in American society. But it is important to recognize that Miller's West was not only a place where older social forms could live again but a place that had the power to reform life back East. American Indians, as well as collections of their material culture, could reinvigorate an overly refined, increasingly Anglicized Scottish aristocracy; western markets could offer Baltimore merchants the opportunity to reimagine, if not participate in, older business practices; and the western setting could be used to construct a vision of masculinity that was sentimental, ruminative, and productive. The West of Charles Deas and William Tylee Ranney (1813–1857) was similarly seen by contemporary critics as having a restorative power—a power to restore older, artisanal forms of masculinity to increasingly effete American businessmen. But their images were considerably darker and more violent than Miller's halcyon images. In this sense, Miller's paintings presented a more positive, productive image of the West than did those of his contemporaries.

One final point: interpreting Miller's work within the narrower contexts of Scotland and Baltimore should in no way suggest that Miller's work did not deal with national concerns as well. Insofar as Miller's *The Trapper's Bride* offered the promise of expanded markets for Baltimore goods, it may be seen as participating in a larger national debate about westward expansion. Likewise, the paintings for the Stewart commission, although promoting a particular Highland, aristocratic view, can be understood in broader historical terms as offering an image of Scottish national identity. This poses an interesting question: How were such national issues experienced in specific milieus and, concomitantly, how did Miller's images participate in that experience? There has been much valuable scholarship in the past two decades on how western American art promoted American nationalist or expansionist ideologies. But what one scholar has said recently of American survey photography certainly holds true for painting as well: western American painting does not proceed "in lockstep conformity to an evolving national ideology."[67] We should expect to find regional, local, or personal variations. If the moment has come to bring finer distinctions to contextual studies of western American art, Miller offers us a timely opportunity to do so.[68] Indeed, localizing the context for Miller's paintings expands the scope of their meanings.

Notes

1. William R. Johnston, "The Early Years in Baltimore and Abroad," in *Alfred Jacob Miller: Artist on the Oregon Trail*, ed. Ron Tyler (Fort Worth: Amon Carter Museum, 1982), 7. This catalogue provides the definitive biography of Miller as well as the history of the Stewart commission. Robert Gilmor also says Miller's father ran a grocery store in Market Square, verso of A. J. M. to Robert Gilmor, 13 October 1842, Dreer Collection, Historical Society of Pennsylvania (microfilmed in Archives of American Art), P20, frame 522.

2. Decatur Miller Scrapbook, Vernon C. and Decatur Miller Collection, Baltimore; "Obituary of D. A. Miller," *Baltimore Sun*, 1 January 1891. Other tobacco merchants include William Sebastian Graff Baker (1835–1917) of William Baker and Co., tobacco merchants, *Wood's Baltimore Directory* (Baltimore: John W. Woods, 1860); Charles DeFord (1814–1858) of Charles D. DeFord & Co. Tobacco Commissions Merchants and Importers, and Patrick Henry Sullivan (1816–1874) of John Sullivan and Sons, Tobacco, *The Baltimore Directory for 1845* (Baltimore: John Murphy), 1845.

3. Alfred Jacob Miller, Journal, Walters Art Museum, Baltimore, 85–87. Miller's Journal is a 130-page manuscript that bears the title "A. J. Miller, 1832." As William R. Johnston has noted, errors in dating and references to events that occurred as late as 1871 suggest that the manuscript was written late in Miller's life. See Johnston "Early Years," 7. The names Welsh, Carr, and Gill appear in Miller's Account Book, Library, Walters Art Museum, Baltimore, as portrait patrons. Owen Gill, Miller's lifelong friend and patron, may be the Gill to whom he refers. For biographical information, see "Sudden Death from Heart Disease—Mr. Owen Gill," *Baltimore Sun*, 30 October 1874, 1, c. 7, and Margery Shapiro, *A Short History of the Martin Gillet Tea Co.* (Baltimore, May 1938 [pamphlet]), Maryland Historical Society.

4. Miller, Journal, 90.

5. Maud G. Early, *Alfred J. Miller, Artist* (Baltimore: privately published, 1894).

6. William R. Johnston, "Portrait of Mrs. Decatur Howard Miller," cat. no. 14, in Tyler, *Artist on the Oregon Trail*. Johnston has also conjectured in personal communication that Miller may have studied with, or studied, the Peales.

7. Gretchen Cooke discusses the possible influence of Vanderlyn in "On the Trail of Alfred Jacob Miller," *Maryland Historical Magazine* (Fall 2002): 323–24.

8. Johnston, "Early Years," 9–15.

9. Miller, Journal, 31, 34, 36.

10. Johnston, "Early Years," 12.

11. Carol Clark, "A Romantic Painter in the American West," in Tyler, *Artist on the Oregon Trail*, 47–64; Joan Carpenter Troccoli, *Alfred Jacob Miller: Watercolors of the American West* (Tulsa, Okla.: Thomas Gilcrease Museum Association, 1990), 12–16; and Dawn Glanz, *How the West Was Drawn: American Art and the Settling of the Frontier* (Ann Arbor: UMI Research Press, 1982), 32.

12. *Baltimore American*, 8 December 1834, 3, col. 4.

13. Cooke, "On the Trail," 333.

14. Verso of A. J. M. to Robert Gilmor, 13 October 1842, Dreer Collection.

15. Cooke, "On the Trail," 333.

16. Miller, Journal, 61–64.

17. Ron Tyler, "Alfred Jacob Miller and Sir William Drummond Stewart," in Tyler, *Artist on the Oregon Trail*, 19–20; Miller, Journal, 54.

18. Miller, Journal, 54–57.

19. *Matchett's Baltimore Directory* (1829), 388, and (1833), 48, 304.

20. On the rendezvous, see Gordon B. Dodds, "The Fur Trade in the United States," in *The Reader's Encyclopedia of the American West*, ed. Howard R. Lamar (New York: Thomas Y. Crowell Co., 1977), 422–26.

21. Fred R. Gowans, *Rocky Mountain Rendezvous: A History of the Fur Trade Rendezvous, 1825–1840* (Provo: Brigham Young University Press, 1975), 191.

22. Bernard DeVoto, *Across the Wide Missouri* (Boston: Houghton Mifflin, 1947), 309–10; William H. Goetzmann and William N. Goetzmann, *The West of the Imagination* (New York: W. W. Norton & Co., 1986), 61–63, 66.

23. Tyler, "Alfred Jacob Miller and Sir William Drummond Stewart," 35–36; Peter Hassrick, Introduction, in Tyler, *Artist on the Oregon Trail*, 3; *Baltimore American and Commercial Daily Advertiser*, 17 July 1838, 1.

24. Tyler, "Alfred Jacob Miller and Sir William Drummond Stewart," 36–37.

25. Augustus Greele to William Drummond Stewart, New York, 17 May 1839, Bundle 21, Box 101, Murthly Muniments, Scottish Record Office, Edinburgh, Scotland.

26. Miller painted at least four religious paintings for Stewart, none of which are located. See Tyler, *Artist on the Oregon Trail*, cat. nos. 867–76.

27. Alfred J. Miller to Decatur Howard Miller (hereafter A. J. M. to D. H. M.), 10 February 1842, Mae Reed and Clyde H. Porter Papers, 6142, American Heritage Center, University of Wyoming, Laramie (hereafter Porter Papers). The two were most likely introduced by Stewart, who wrote Catlin in 1839 telling him of Miller's work and pledging to see him when they were both in London. Sir William Drummond Stewart to George Catlin, New York, May 1839, Catlin Papers, Bureau of Ethnology, Smithsonian Institution (Archives of American Art, Roll 2136, Frames 513–15).

28. At least one other artist, Edward Wellmore, portraitist, is listed as having a studio in the Law Buildings around the same time as Miller. *Matchett's Baltimore Directory* for 1842, 394.

29. For a description of the Law Buildings and their location, see their entry in the Passano Files, Maryland Historical Society, Baltimore.

30. Alexander Nemerov, "Doing the 'Old America'" in *The West as America: Reinterpreting Images of the Frontier, 1820–1920*, ed. William H. Truettner (Washington, D.C.: Smithsonian Institution Press, 1991), 303–8.

31. Edgeley W. Todd appears to have been the first to note Whitman's reliance on Miller. "Indian Pictures and Two Whitman Poems," *The Huntington Library Quarterly* 19, no. 1 (November 1955): 1–11; Kenneth Price makes this argument in *To Walt Whitman, America* (Chapel Hill: University of North Carolina Press, 2004), 23–34.

32. Glanz, *How the West Was Drawn*, 37–41.

33. Susan Prendergast Schoelwer, "The Absent Other," in *Discovered Lands, Invented Pasts: Transforming Visions of the American West*, ed. Jules David Prown et al. (New Haven: Yale University Press, 1992), 146–54.

34. Early, *Alfred J. Miller, Artist*; Vernon Young, "The Emergence of American Painting," *Art International*, 20 September 1974, 14; William R. Johnston, "Back to Baltimore," in Tyler, *Artist on the Oregon Trail*, 65.

35. See Hassrick's discussion of Miller's contemporaries in Introduction, in Tyler, *Artist on the Oregon Trail*, 4–5.

36. Robert F. Perkins Jr., and William J. Glavin III, eds. *The Boston Athenaeum Art Exhibition Index, 1827–74* (Boston: Library of the Boston Athenaeum, 1980), 98.

37. Mary Bartlett Cowdrey, *National Academy of Design Exhibition Record, 1826–1860*, 2 vols. (New York: New-York Historical Society, 1943), 2:24.

38. Mary Bartlett Cowdrey, *American Academy of Fine Arts and American Art-Union, 1816–1852* (New York: New-York Historical Society, 1953), 236; Anna Wells Rutledge, *Cumulative Record of Exhibition Catalogues: The Pennsylvania Academy of the Fine Arts, 1807–1870* (Philadelphia: American Philosophical Society, 1955), 142; *Catalog of the First Annual Metropolitan Mechanics Institute Exhibition* (Washington, D.C., 1853), 41.

39. See Linda Ann Thrift, "The Maryland Academy of the Fine Arts and the Promotion of the Arts in Baltimore, 1838–1839," Master's thesis, University of Maryland, 1996; Jean Jepson Page, "Notes on the Contributions of Francis Blackwell Mayer and His Family to the Cultural History of Maryland," *Maryland Historical Magazine* 76, no. 3 (September 1981): 224; Ottilie Sutro, "The Wednesday Club: A Brief Sketch from Authentic Sources," *Maryland Historical Magazine* 38, no. 1 (March 1943): 60–68; Anna Wells Rutledge, "Early Art Exhibitions of the Maryland Historical Society," *Maryland Historical Magazine* 42, no. 2 (June 1947): 124–36; Latrobe Weston, "Art and Artists in Baltimore," *Maryland Historical Magazine* 33, no. 3 (September 1938): 213–27.

40. Unidentified news clipping, 26 April 1871, Arthur J. Way Scrapbook, J. Hall Pleasants Papers Special Collections, MS 194, Box 13, Maryland Historical Society, Baltimore; Weston, "Artists in Baltimore," 225–26; Miller, Account Book. In January of his last year, Miller's patron W. S. G. Baker submitted his copy of *The Lost Greenhorn* to a Charity Art Exhibition, in which one newspaper reported, "all of the Baltimore artists contribute." *Baltimore American*, 27 January 1874, 4, c. 2, 19 January 4, c. 2.

41. Miller, Account Book; Stuart M. Blumin, *The Emergence of the Middle Class: Social Experience in the American City, 1760–1900* (Cambridge: Cambridge University Press, 1989). According to Blumin in 1850 the average yearly wage for a skilled worker was $300 while a family's expenses averaged $500–$600, p. 110; he quotes Walt Whitman as saying a clerk made $1,000 per year in 1858.

42. "Last Will and Testament of Alfred Jacob Miller," Alfred Jacob Miller Estate Papers, M 3329-5, Maryland Historical Society, Baltimore.

43. On Catlin's and Stanley's struggles for patronage, see Brian W. Dippie, *Catlin and His Contemporaries: The Politics of Patronage* (Lincoln: University of Nebraska Press, 1990).

44. See, for instance, Tyler, "Alfred Jacob Miller and Sir William Drummond Stewart," 34–35.

45. George H. Conn, *The Arabian Horse in America* (New York: A. S. Barnes and Company, 1957, 1972).

46. Ibid., 10.

47. Pegram Johnson III, "The *American Turf Register and Sporting Magazine*: 'A Quaint and Curious Volume of Forgotten Lore,'" *Maryland Historical Magazine* 89, no. 1 (Spring 1994): 5–9. The American Periodical Series online lists 510 hits for "Arabian" in *American Turf Register*.

48. "American Wild Horses," *American Turf Register and Sporting Magazine* 4, no. 1 (September 1832), 8; "On the Origin and Qualities of the Wild Horse of the Prairies of the South-West," 6, no. 2 (October 1834): 61–66; "On the Origin and Qualities of the Wild Horse of the Prairies of the South-West, part 2," 6, no. 3 (November 1834): 118–24.

49. J. S. Skinner, "Letter to Gen. Gratiot on the Importance of Procuring the Best Wild Stallion from our Prairies," *American Turf Register and Sporting Magazine* 5, no. 5 (January 1834): 1.

50. Thomas J. Scharf, *History of Baltimore City and County from the Earliest Period to the Present Day: Including Biographical Sketches of Their Representative Men*, 2 vols. (Philadelphia: Louis H. Everts, 1881), 2:848.

51. See the inside cover of vol. 8, no. 3 of *American Turf Register*.

52. Scharf, *History of Baltimore City and County*, 2:851.

53. DeVoto, *Across the Wide Missouri*, 307–8.

54. Ibid., 315.

55. Ibid., 324–25.

56. Alfred J. Miller to Brantz Mayer, Esq., Saint Louis, 23 April 1837, Brantz Mayer Papers, Special Collections, Maryland Historical Society, Baltimore. Also reprinted in Robert Combs Warner, *The Fort Laramie of Alfred Jacob Miller: A Catalogue of All the Known Illustrations of the First Fort Laramie* (Laramie: University of Wyoming, 1979), 146.

57. "Romantic Expedition Across the Rocky Mountains," *New York Weekly Herald*, 11 May 1839, 149.

58. "Apollo Gallery—Original Paintings," *New York Morning Herald*, 16 May 1839, 2, c. 3; "Baltimore Artists," *Baltimore Monument* 2 (July 1838): 343.

59. My synopsis here relies heavily on Gregg Camfield, "The Moral Aesthetics of Sentimentality: A Missing Key to *Uncle Tom's Cabin*," *Nineteenth-Century Literature* 43, no. 3 (December 1988): 323–27; June Howard, "What Is Sentimentality?" *American Literary History* 11, no. 1 (Spring 1999): 69–73.

60. Camfield, "The Moral Aesthetics of Sentimentality," 326–27.

61. Howard, "What Is Sentimentality?" 63, and Camfield, "The Moral Aesthetics of Sentimentality," 319–22.

62. Adam Ferguson, *An Essay on the History of Civil Society*, ed. Duncan Forbes (Edinburgh: Edinburgh University Press, 1966).

63. Ron Tyler, *Alfred Jacob Miller: Artist as Explorer: First Views of the American Frontier* (Santa Fe: Gerald Peters Gallery, 1999), 9.

64. Alfred Jacob Miller in Marvin C. Ross, ed., *The West of Alfred Jacob Miller* (Norman: University of Oklahoma Press, 1968), pl. 179.

65. Elizabeth Barnes, *States of Sympathy: Seduction and Democracy in the American Novel* (New York: Columbia University Press, 1997); Fred Kaplan, *Sacred Tears: Sentimentality in Victorian Literature* (Princeton: Princeton University Press, 1987).

66. Mary Louise Pratt, *Imperial Eyes: Travel Writing and Transculturation* (New York: Routledge, 1992).

67. Robin Kelsey, "Viewing the Archive: Timothy O'Sullivan's Photographs for the Wheeler Survey, 1871–1874," *Art Bulletin* 85, no. 4 (December 2003): 719.

68. Ibid., 719. Kelsey's view of O'Sullivan's photography is more situational and biographical than previous studies of the photographer. Kenneth Haltman's work on Raphaelle Peale and Samuel Seymour likewise interprets their works in historically specific and biographical terms. See *Looking Close and Seeing Far: Samuel Seymour, Titian Ramsey Peale, and the Art of the Long Expedition, 1818–1823* (University Park: Penn State University Press, 2008).

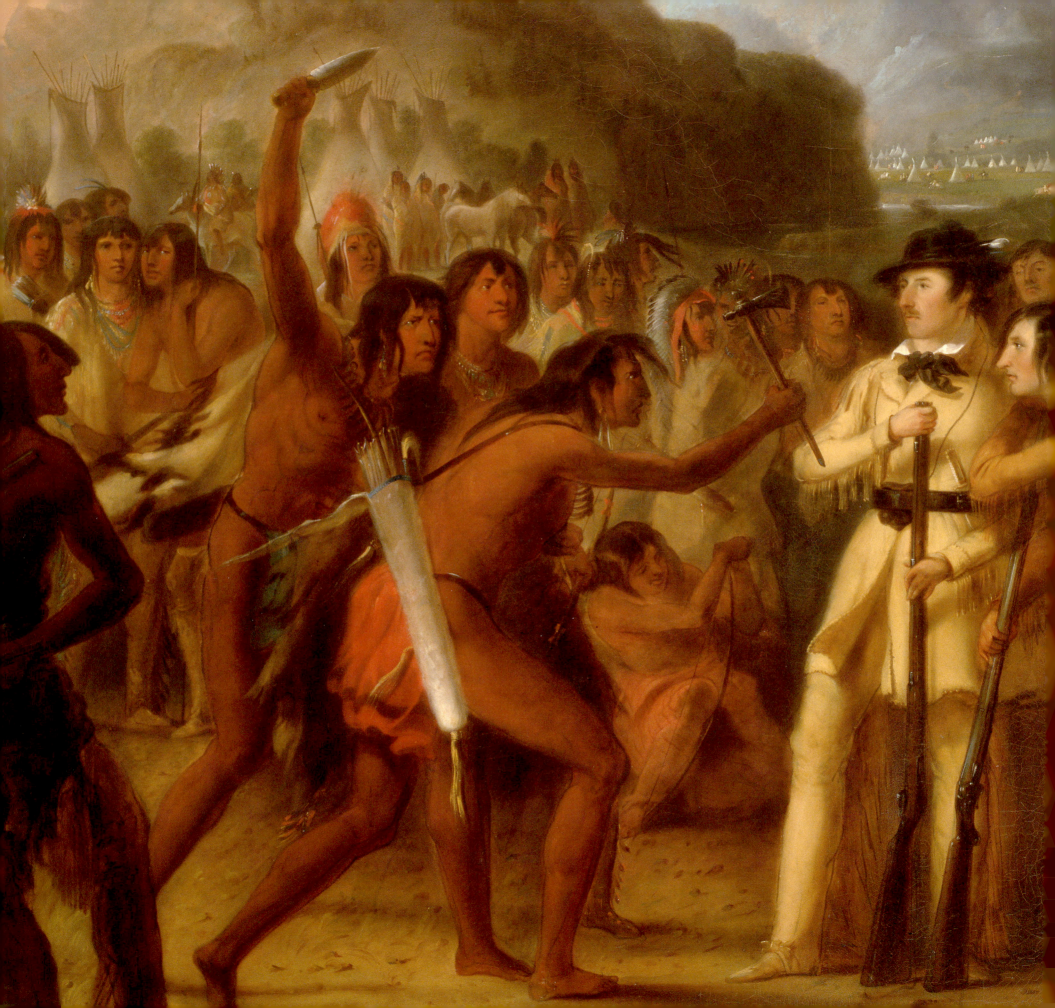

AMERICAN INDIANS, HIGHLAND IDENTITY, AND

SIR WILLIAM DRUMMOND STEWART'S COLLECTION

W HEN SIR WILLIAM DRUMMOND STEWART returned to his home in Perthshire, Scotland, in 1839 after seven years traveling in the American West, he brought with him his hunting guide, Antoine, and two Native American gamekeepers. He brought, too, a vast array of artifacts, plants, and animals, including Native American weapons, tools, clothing, bedding, buffalo grass, tobacco root, several bison, and a bear.[1] They had been collected in the Rocky Mountains, crated and carried across the Great Plains, floated down the Mississippi River to New Orleans, and, finally, shipped to Scotland. Once at Stewart's estate, the animals were released, the plants were planted on the grounds, and the artifacts were distributed around the castle for both use and display. These materials were followed by a shipment of Alfred Jacob Miller's watercolor sketches and oil-on-canvas portraits, genre works, and hunt scenes of Stewart and his crew of camp employees or *engagés,* as well as Shoshones, Crows, and Sioux.[2]

Taken together, the artifacts, plants, animals, and paintings constituted a purposeful collection of material from Stewart's journey. Choice is the defining factor in the process of collecting, and the objects Stewart collected were, first and foremost, chosen from among a virtually infinite number of things he might have acquired in his American travels.[3] Stewart's letters from Scotland to trader William Sublette indicate that he specifically chose the artifacts or types of artifacts, plants, and animals that he assembled in his collection.[4] "Common identity" is also a defining criterion for a collection and a key to understanding its meaning.[5] Although the objects Stewart collected share an origin in the American West, they have a more specific common identity in their relationship to Indian life. Stewart did not gather everything he could find, either natural or manufactured, from the West; there are no beaver skins, beaver traps, or other trappers' equipment and accoutrements. Rather, there are *Indian* tools and weapons, the animals they hunted, and the plants from their environment. The plants Stewart collected, for instance, include bunch grass, which buffalo ate, and

Valeriana, a parsniplike root that Stewart's botanist, Karl Geyer, claimed Plains Indian peoples cooked and ate year-round.[6]

The context of an object's display is also essential for determining its meaning.[7] If Sir William brought home elk horns and placed them among a number of other parts of the elk, for example its skeleton, hide, and hooves, we might regard them to be a part of a zoological collection of North American animals. As a part of a collection containing Indian weapons, pipes, and clothing, however, the elk horns become part of a collection of American Indian life. Here Miller's paintings are particularly significant. Exhibited as they were, adjacent to the objects, the paintings demonstrated that the collection was not a comprehensive one of American Indian material culture, but, rather, a collection based explicitly on Sir William's travels and experiences among the Indians.

Yet Stewart's collection from his trip should not be dismissed as merely souvenirs; rather, his collecting must be understood as both a creative and interpretive act with larger cultural meanings. Collections themselves can be narratives that tell their stories through the selection and arrangement of their contents.[8] But, significantly, the contents of Stewart's collection served as more than objects on display. Many of them were also consumed—that is, they were not only selected and purchased or acquired, but also *used.*[9] Pipes were smoked, tobacco root and dried buffalo tongues were eaten, and buffalo robes were slept on.

A recent history of modern consumerism argues that while the traditional consumer seeks pleasure through physical stimuli, the modern consumer finds added pleasure through emotional stimuli brought on by daydreams. The modern consumer selects and uses goods in an attempt to create reality from the scenarios he or she has dreamed about (or, in Stewart's case, reminisced about). Material goods figure in modern consumerism not as ends in and of themselves, but as bridges to close the gap between the imagined world longed for by the consumer and reality. Thus the primary or lasting sources of pleasure are not the goods themselves, but rather the meanings ascribed to them by an individual and the daydreams those meanings foster.[10] For Stewart, a variation of this premise seems to have been especially true. As will be discussed below, the objects were a reminder or souvenir of his journey, prompting reveries or longings for things he had already experienced. But, in a more traditional sense, they also seem to have been used by Stewart in an attempt to re-create, reconstitute, or make real the physical pleasures of the West of his memories in a Scottish environment.

Stewart's fascination with the West should not, however, be read simply as a craving for the exotic in general. Stewart took an interest in other cultures and traveled widely, visiting Russia, Egypt, and Turkey. He hunted tigers in India, collected hookahs and Persian carpets, and even had his portrait painted wearing Arab garb.[11] Yet a generalized desire for the exotic cannot explain Stewart's (or, perhaps, any European's) particular interest in one culture over another. Stewart did not develop the abiding interest in Eastern European, North African, or Asian culture that he did in American Indian. He spent portions of seven years in the American West, far longer than the six months to a year he spent

in his other destinations. Stewart even took the extraordinary step of spending a winter out West, traveling from the Wind River range of the Rocky Mountains to Fort Astoria in the Pacific Northwest. He also wrote two novels based on his western American travels, *Altowan: or Incidents of Life and Adventure in the Rocky Mountains* (1846) and *Edward Warren* (1854). In fact, he spent much of his time en route to Turkey in 1840 writing *Altowan*.[12] Nor can exoticism fully explain the great lengths to which Stewart went, over a number of years, to compile a collection of Indian material of the size and scope he did. If the exotic were all he longed for, why not collect from places such as North Africa or East Asia, where transportation of animals or plants would have been easier?

Stewart's patterns of consumption have their basis in specific cultural and historical beliefs about Scottish Highland people. His collecting answered his desire to articulate for himself and his peers an authentic Scottish identity in the wake of serious challenges to the Highland way of life from which that identity derived. The interplay between the particular and the universal qualities of humankind is important in the development of ideas of national character. All nations have flags, but particular flags are necessary to distinguish one nation from another.[13] As flags are a central component of developing nationalism, so, too, is the ascription of particular national traits from among a group of more general ones: Americans are egalitarian, Germans industrious, etc. The ascription of these traits helps nations imagine themselves. Although the traits themselves are stereotypes, they are often based on deeply held historic beliefs or values disseminated through images, print, and oral history.[14] This suggests that Stewart's *particular* choice of western material originated in a longstanding European belief in a shared "primitiveness" of Scottish (Highland) and North American Indian people. Comparisons between Scottish Highlanders and American Indians, both favorable and unfavorable, had a long history in British thought and were described explicitly in this period by Sir Walter Scott (1771–1832), among others. But for Stewart, Indian life may have provided more than just a window into the history of the Scottish people. Following the success in the 1820s of England's policy of Highland Clearances, which suppressed the traditional clan system, Highland and Lowland Scots alike grew increasingly nostalgic about the lost Highland way of life.[15] For Stewart, the collection and consumption of Indian culture may have been a means of reconnecting with what were widely regarded as Scotland's defining cultural characteristics. Viewed within the context of a resurgence of interest in Scottish culture during the 1820s and 1830s, Stewart's adoption of various American Indian customs (as illustrated in the sketches) and material culture may, in Stewart's view, have constituted a reinvigoration of Scottish identity.

The question remains as to how Stewart's interest in American Indians fits in with romantic beliefs of the period and with collecting patterns of other Europeans abroad. It was not unusual for mid-nineteenth-century Europeans to travel abroad and commission artwork as a record of the journey, or to write travel accounts.[16] Alexis de Tocqueville, Lord Byron, and Gustave Flaubert are among the best-known travelers of the period, and much has been written about the psychological and cultural

meanings of their travels in the Middle East.[17] Lesser-known figures, however, such as the Prussian Prince Maximilian von Wied-Neuwied (1782–1867) and the Scottish nobleman Charles Augustus Murray (1806–1895), the second son of the fifth Earl of Dunmore, traveled in the American West in the 1830s.[18] In 1832–33, Maximilian ventured up the Missouri River accompanied by Karl Bodmer, who painted portraits to illustrate Maximilian's *Travels in North America*. Charles Augustus Murray spent 1833–36 in the West hunting and fishing and returned with a collection of hunting trophies and Indian artifacts. He later wrote two accounts of his travels: *Travels in North America* (1839) and *Prairie Bird* (1844). Neither of these excursions has been examined specifically in terms of the collections they produced, though a study of these collections may likewise yield broader cultural or national meanings. In fact, Harry Liebersohn has recently argued that Bodmer's artwork may be the product, in part, of Prince Maximilian's search for authentic aristocratic values that he believed could be found among American Indian peoples.[19]

Stewart's interest in Indian culture may be nothing more than a manifestation of a romantic fascination with cultures regarded as exotic. Yet, this again does not explain Stewart's specific focus on collecting American Indian materials, nor does it account for its conjunction with wider beliefs in Scottish primitivism. Moreover, one could approach the argument from the opposite direction and say that if we dismiss Stewart's collecting practices as merely one form of romantic thought, namely exoticism, we miss their substantial contribution to a more nuanced understanding of romantic ideas.[20] Stewart's collection produces a specific form of romantic exoticism within the specific historical and cultural contexts of cultural nationalism and Scottish primitivism. By understanding Stewart's collection as an expression of interest in American Indians, we may gain a better grasp of how romantic sensibilities were shaped by localized sociohistoric situations, such as that of the Scottish Highland aristocracy, in the wake of significant social and economic changes.

Setting the Stage: The Sketch Album

The paintings that Stewart commissioned from Alfred Jacob Miller in 1837 were likely intended as a memoir or souvenir of his trip. One of Stewart's biographers has suggested that he sought an artist to accompany him west in 1837 because he had reason to believe that the 1837 excursion would be his last.[21] He had lately received word that his older brother, the sixth baronet of Murthly, was ill, and Stewart knew he could soon inherit the title and be forced to return to Scotland to assume the duties of the estate. Whatever their initial purpose, the paintings provided a crucial context for the items in Stewart's collection by introducing viewers to scenes of the Rocky Mountain rendezvous and illustrating the manufacture and use of many of the objects in the collection. Miller produced twenty-eight oil paintings as well as eighty-seven sketches for Stewart between 1837 and 1842. The sketches and eighteen of the oils were completed in New Orleans in the fall of 1837 and in Baltimore between 1837 and

1839; the oils were exhibited at the Apollo Gallery in New York in 1839 to favorable reviews before being shipped to Scotland.[22] In 1840 Stewart invited Miller to Murthly, where the artist lived and worked for two years. During that period, Miller painted ten more oils including two of his most important paintings, *An Attack by Crows . . .* (plate 9) and *The Trapper's Bride* (unlocated).

Several images in the collection that show Stewart eating, smoking, or conversing with Indians during visits to their camps constitute one of the dominant subthemes within the sketch album.[23] Stewart's use of identifiable artifacts, particularly pipes, is marked in these images. In *Interior of an Indian Lodge* (plate 1), Miller portrays Stewart, at the lower right, beside three seated Indians. Opposite him is Antoine, his Métis hunting guide. Antoine was Stewart's constant companion during his American sojourn. His distinctive facial features, belted jacket, and loose-brimmed hat are recognizable in over a third of Miller's sketches.

In the painting, Stewart is shown reclining and smoking a pipe. The attentiveness with which Antoine and the Indians watch Stewart as he smokes suggests that the five members of the party share one pipe. This interpretation is further supported by the composition itself, which traces the circular route of the pipe as it would be passed from person to person. In Plains Indian culture, tobacco could be smoked informally by an individual, but it also had numerous ritual and religious significations. These included the ceremonial exchange of one pipe, or calumet, as it is referred to in its ritual context, among members of a party to symbolize good faith and kinship ties between two groups.[24] Again, the composition itself serves as a metaphor for the symbolic role of the calumet. Just as smoking the calumet solidified kinship relations between Indians and whites, so, too, the calumet provides the formal link between the Indians and Stewart.

Trappers and traders were familiar with the calumet ceremony because of its many uses in the fur trade. The calumet ceremony facilitated trade relationships, established kinship between trading partners, solemnized agreements, and legitimized diplomatic relations between Indians and whites.[25] Its complex meanings are not fully understood today, but the calumet surely functioned, if imperfectly, as a tie that bound Indians and whites in relationships of mutual obligation. Miller understood, at least partially, the significance of the calumet. In a note accompanying a set of watercolors based on the album sketches painted in 1858 for William T. Walters, Miller described Stewart "smoking the Calumet," and wrote that "this has a universal meaning amongst them, and signifies friendship and good will."[26] Another note lists a wide range of meanings associated with the calumet:

> . . . the violation of a friendship formed by the pipe is deemed infamous among the Indians and hence it is of the utmost importance to join in this ceremony. It is used on some occasions as a religious observance—by it they declare war & secure peace, invoking the sun and moon as witnesses to their sincerity. It is also sometimes sent on long journeys to parties

with whom they wish to form treaties. In all cases it is regarded as a solemn oath and sacred engagement.[27]

In a passage in *Altowan,* Stewart not only demonstrated his technical knowledge of American Indian smoking practices, he also made evident a more subtle understanding of its meaning to a white practitioner. In the scene, Auguste, a white man living as an Indian, prepares a pipe to welcome the protagonists to his camp:

Auguste having, by dint of much search in his possible-sack, found a piece of tobacco as large as a nutmeg, began to mingle a part of it, scraped off, among the dried leaves of the dwarf arbutus, which forms the principal ingredient of Indian fumigation. It is rare that those who voluntarily live the life of savages, omit the smallest part of the customs peculiar to their adopted caste; and poor Auguste was peculiarly careful to neglect nothing of the Indian ceremonial. The three pipefuls were smoked, and the eatables began to claim their share of consideration.[28]

Miller and Stewart's understanding of the calumet and some of its meanings makes plausible the possibility that Miller employed the pipe iconographically as well as formally within the sketches to signify Stewart's close friendship, even kinship, with the Indians. The context in which the sketches were exhibited may also have allowed Stewart to demonstrate his familiarity with the pipe by explaining the particular circumstances of the scenes to his European visitors.

As Miller's letter mentions, calumets were among the objects that Stewart collected, and, as will be discussed below, Indian pipes were displayed in Stewart's room. *Interior of an Indian Lodge* served also to contextualize the pipes, demonstrating how they were used and Stewart's mastery of their use. In fact, although the pipe unites white and Indian in a communal ritual in *Interior of an Indian Lodge,* it is Stewart who holds the calumet, actively performing American Indian rituals as Indian participants look on. This and other of the images make explicit Stewart's ability to adapt to Indian customs and authenticate that adaptation through the implied sanction of Indian witnesses. That this meaning was understood, at least by an American audience, is suggested by the response of one reviewer to an oil-on-canvas work showing Stewart similarly posed with a pipe. The critic for the *New York Weekly Herald* saw *Pipe of Peace at the Rendezvous* (plate 2) at the Apollo Gallery and described it as showing "The traveler, Sir William D. Stewart, reclin[ing] among the Indians quite *en famille.*"[29]

It may be tempting, at first, to see in such images the suggestion of Stewart's "going native." Yet, it is imperative to recognize that such images never portray Stewart compromising his European, Scottish identity. Nor does he compromise his aristocratic station. In *Interior of an Indian Lodge* and at least six other images in the sketch album, we see that Miller places Stewart in the foreground, with

PLATE 1 Interior of an Indian Lodge, ca. 1837
Graphite, pen and ink, and wash on paper, 7⅞ × 6¹¹⁄₁₆ inches
Joslyn Art Museum, Omaha, Nebraska

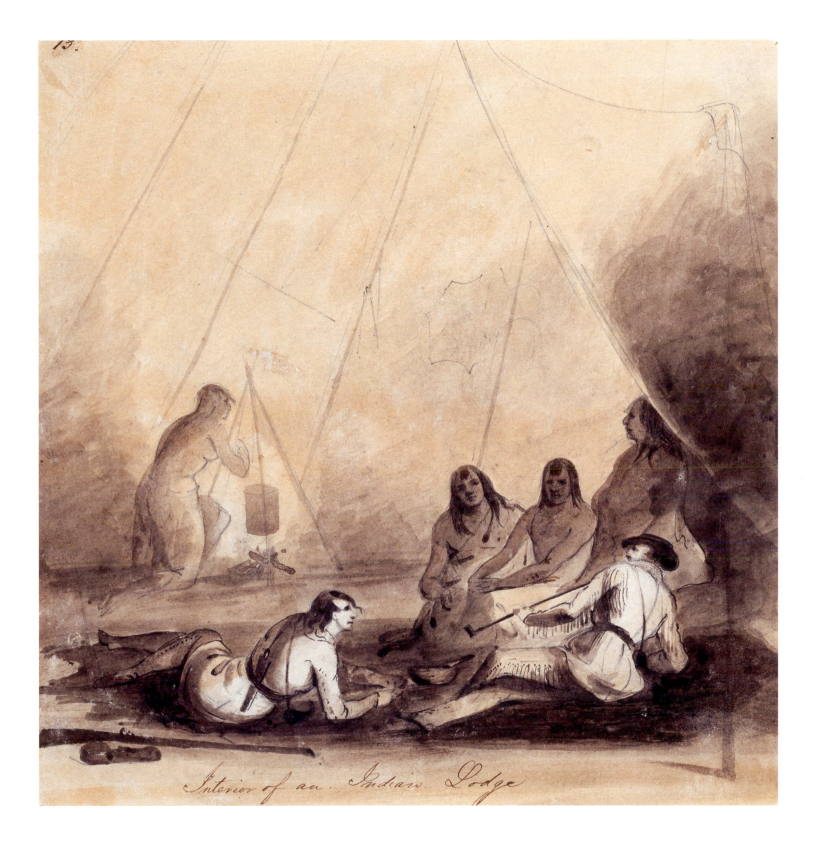

Interior of an Indian Lodge

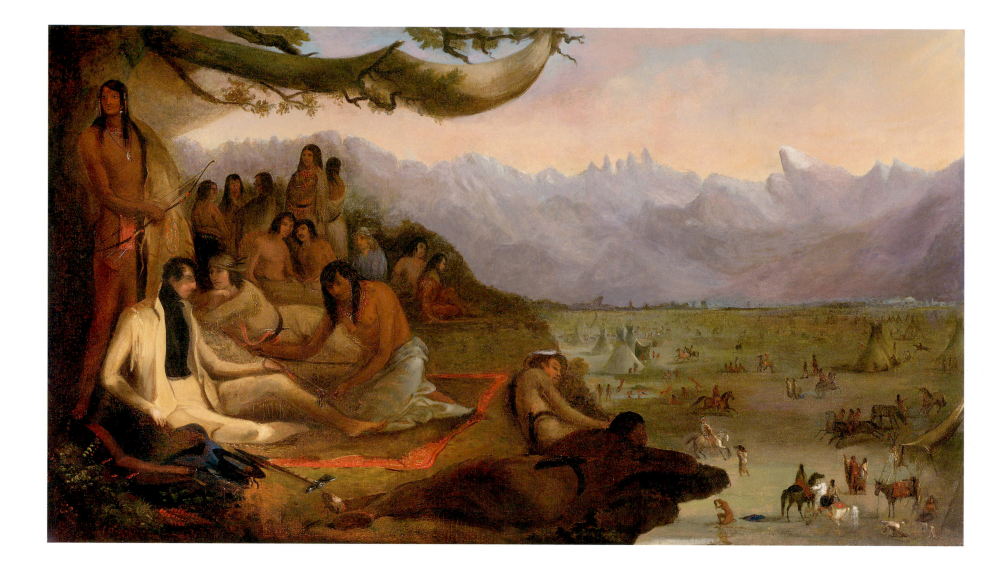

PLATE 2 Pipe of Peace at the Rendezvous, ca. 1839
Oil on canvas, 39¼ x 69¼ inches
Stark Museum of Art, Orange, Texas

his back turned to the viewing audience, facing inward toward his hosts.[30] This device serves a variety of expressive or dramatic purposes, but what it chiefly does is set him apart from the action taking place in the sketch.

This division is further illustrated by *Camp Fire by Moonlight* (see chapter 4, plate 10). The image shows a group of Indian men and women around a campfire. They are broken into four groups of three: two groups in the foreground around the fire, and two in the dimly lit background. In these groupings, Stewart is the odd man out. He is the single figure with no counterpart except the flanking tree on the right side of the image. Stewart and the tree form framing devices, standing slightly apart from the rest of the image, as if in a separate plane, almost like an audience at the theater.[31] Miller, nevertheless, asserts Stewart's inclusion in the image by positioning him so that he turns toward the group. His posture is one of ease, comfort, and familiarity: he rests one elbow casually on an embankment behind him and crosses his right leg easily over his knee. The golden tinge in his white buckskin suit similarly blends in with the tonality of the rest of the image. Stewart's attention mirrors the ambivalence of his position within the image. He faces inward, yet he tilts his head downward as if in private contemplation, hovering irresolutely between the intimacy and engagement of the one group and the private reverie of the others. The rock to his right formally blocks the image of his body from coming any closer to the Indians behind and at the same time serves to hold him inside the plane of the picture, providing the final point of demarcation between the interior of the picture world and the viewer on the exterior.

Stewart plays an ambivalent dual role: he is allied with the viewer, yet more knowledgeable than the viewer or the Indians he observes. This separation preserves his status as ultimately defined by his difference from the Indians with whom he is so often linked. The turned back serves as a metaphor for the role that he played as the patron of the sketches about his own adventure, as the traveler returning home to tell his stories. He stands between us, the ones who view his story, and them, the people whom the story is about. Each group, the Indians within the picture and the viewers without, sees something of Stewart that the other group cannot. Yet Stewart, with the power to turn both ways, sees all. He is the conduit through which information is passed, controlling what is seen or known of the other by each group.

The Buckskin Suit and Cultural Intermediation

The dynamic of Stewart's cultural exchange with American Indians is nowhere clearer than in the example of the buckskin suit Miller shows Stewart wearing in every image. The white buckskin suit consisted of a long jacket with a collar, belted waist, and fringed sleeves, and tight-fitting fringed trousers. A variation of this buckskin ensemble was standard dress for trappers and mountain men in the West during the early nineteenth century.[32] The style of the suit, particularly in the use of

Going to meet a band of Buffalo on
the moor.—

PLATE 3 Going to Meet a Band of Buffalo on the Move, ca. 1837
Ink and gray wash over graphite underdrawing on paper, 8½ × 6⅝ inches
Amon Carter Museum, Fort Worth, Texas

PLATE 4 The Author Painting a Chief at the Base of the Rocky Mountains, 1841
George Catlin (1796–1872)
Letters and Notes on the Manners, Customs and Condition of the North American Indians (London: 1841)
Amon Carter Museum, Fort Worth, Texas

trousers rather than the traditional leggings and breechclout, has a European flair. The buckskin material and fringe establish its Indian origins. We may now take for granted the buckskin suit as a distinct form of European-American frontier garb, yet its origins lay in the buckskin breechclout, tunic, and leggings worn traditionally by many American Indians. The buckskin suit adapted the more revealing breechclout and leggings into trousers accompanied by a tunic.

Stewart's suit can be read as a hybrid form of garb that makes clear and pointed reference to the traditions of both Indian and white cultures. In *Going to Meet a Band of Buffalo on the Move* (plate 3), Stewart's buckskin jacket and trousers are clearly illustrated. The material and conspicuous fringing linked the suit to American Indian clothing, but the *cut* of the suit, particularly the proportions of a nipped waist and full, tight-fitting bodice in the jacket, were indicative of prevailing European fashion. At the close of the eighteenth century, a paradigmatic shift took place, recasting the ideal aesthetic of a male body from the potbellied physique of the eighteenth-century aristocrat, which connoted a privileged, sedentary lifestyle, to the more physically fit neoclassical athletic, barrel-chested, long-legged frame.[33] The modern suit, with a tight jacket, short waistcoat, and long, high-waisted trousers, served to slim and elongate the proportions of the wearer in accordance with the ideal physique of classical sculpture.[34] In addition, the tight fit was also meant to simulate the appearance of a classical nude male.[35]

Stewart's buckskin suit in *Going to Meet a Band of Buffalo . . .* is cut like the modern British suit. This is clearer still in *Pipe of Peace at the Rendezvous* (plate 2) with Stewart's jacket unbuttoned to reveal a short, tight-fitting, double-breasted waistcoat, most likely of European make, along with his shirt and cravat. In *Going to Meet a Band of Buffalo . . .* the proportions of his body are clearly visible through his suit. Careful pen lines and chiaroscuro wash indicate the musculature of Stewart's extended arm through the sleeve of his jacket as he points toward the herd. The curves of his long, slim legs and the supple outline of his pectorals are also visible through the implausibly thin and formfitting buckskin. Stewart, when viewed against contemporaneous British fashion, may be read as a model of European masculinity, rather than simply as a European in an American suit.

The cut of the suit is important insofar as it delimits the boundaries of the wildness that Indian buckskin could connote. By emphasizing the cut of the suit, Miller reintroduced the specter of white civilization in the midst of what would have been regarded by most of his audience as savagery, taming and domesticating the fringed leather. The cut of the suit is similarly important in George Catlin's sketch of himself painting Mato Tope (ca. 1795–1837), a Mandan second chief (plate 4). Here the buckskin and fringe of Catlin's suit are reminiscent of Mato Tope's dress. The link is made more explicit by a kind of doubling that takes place as Catlin and Mato Tope face one another in complementary stances with one leg forward, Mato Tope holding his lance and Catlin his brush. What helps to set them apart is the cut of the suit. Catlin's full chest and slim waist are accented by the formfitting buckskin bodice and the flaring waist of his jacket. His buckskin pants also conform to his

outstretched leg, revealing the musculature beneath. The wearing of buckskin and the superior cut mark Catlin as both similar to his Indian sitter and exceptional among white men. Similarly, in Miller's images the suit may be interpreted as a metaphor for the wearer himself—a hybrid entity composed of the raw material of Indian culture polished and refined by the culture of Europe.

Miller's representations of Stewart as a cultural intermediary may have been influenced by the novels of Sir Walter Scott. One literary historian has argued persuasively that Scott's *Waverley* (1814) "explains" Scottish culture to a British audience through the device of the middleman: the Englishman, Edward Waverley, who crosses over the Highland line and, like a participant-observer, experiences, understands, and returns to explain what he has learned to his countrymen. Waverley initially finds Highland culture almost unintelligible. A metaphor for this condition is a scene in which he arrives at the Baron of Branwardine's castle only to find the doors locked. Waverly's loud knocks frighten away the servants, leaving only a fool whose babblings are unintelligible.[36] Over the course of the novel, however, Waverley comes to understand and empathize with the Highlanders: "Edward's progress over the course of the novel parallels the passage inscribed in ethnography's mythic self-conception, from outsider's status to insider's, that occurs with the achievement of *rapport* and the shedding of ethnocentric blinkers."[37] That rapport is suggested by the final scene in which Waverley returns and gains admittance to the mansion accompanied by his new Highland wife, Rose, the baron's daughter.[38]

Miller was an enthusiastic reader of Scott. He referred to Scott's *Fair Maid of Perth* (1828) in one of his letters and mentioned in his journal that Scott, in fact, used another of Stewart's estates, Grandtully, as a setting for a castle in *Waverley*.[39] He also quoted from *The Lady of the Lake* (1810) and *Rob Roy* (1818) in a set of notes he wrote to accompany a later collection of watercolors. His sketchbooks contain illustrations of scenes from *Waverley, The Antiquary* (1816), *Old Mortality* (1816), and *St. Rowan's Well* (1823).[40] It is easily conceivable, then, that characters such as Edward Waverley may have served as a conceptual model for his depiction of Stewart. Like Waverley, we see Stewart establishing a rapport with the Indians in the sketches, his comfort and familiarity with their culture expressing empathy for their common humanity. Stewart's turned back and buckskin suit would thus record or stand for his ability to both see and translate Indian culture. As we will see below, what has been pointed out about Scott's work is likewise true for Stewart: that an act of supposed familiarization and translation in fact marks an invention of culture.

Stewart's Indian Collection

Stewart began soliciting tools, animals, and plant samples from his friends in the fur company before his departure from America in 1839 and continued to receive them after his arrival in Scotland in August of that year. Stewart's biographer mentions boxes of "mementoes of many types" arriving in

Scotland shortly after Stewart.[41] Miller himself noted a tomahawk, buffalo robes, and pipes among the articles Stewart collected.[42] Stewart's correspondence records his attempts to add an Indian lodge to his collection, as well as smaller articles such as bottle gourds "of the best form for dippers, also some large ones for bottles," a wooden bowl, and pipes.[43] The fur trade firm of Sublette and Campbell's correspondence indicates that the firm shipped four deer, two buffalo, two black-tailed deer, an antelope, and wild geese—all alive—to Stewart.[44] Miller wrote Stewart from New Orleans to inform him of the health of two buffalo and a grizzly bear en route to Scotland.[45] According to estate records, the collection also included "an Indian Chief's dress, with bows, arrows, quivers, etc.," as well as at least one hunting trophy.[46] In addition to tools and animals, Stewart also brought plant samples. Stewart's papers contain numerous letters from Sublette and Campbell regarding the procurement of plant slips such as buffalo berry, "mountain current," and chokecherry, and seeds of sugar maple, "May apple," "paughpaugh," and "brown acorn."[47]

The tools and weapons functioned in the broadest sense as souvenirs, insofar as they documented and thus authenticated Sir William's travels for his visitors. Souvenirs, in the process of documenting the collector's travels, lose their use value along with their intrinsic meaning. An arrow removed from the Plains no longer serves a function as a weapon; it will never be strung or shot at quarry or an enemy. Likewise, a set of elk horns mounted on a trophy plaque become proof of the hunter's skill rather than a defense for the elk. Such objects now have only aesthetic or symbolic value commensurate with their ability to prompt either a memory or an account of a particular experience from the collector's life.[48] Paradoxically, when objects become functionally obsolete in a new context, they may be preserved almost indefinitely. When the horns are removed from the body of the elk, or the arrow is removed from the quiver and exhibited on a table in Perthshire, their preservation is assured.[49]

Objects such as the elk horn trophy generally serve little practical purpose. Rather they are mementos of a trip and have a limited meaning apart from either a collection of related objects or a narrative of a journey. Yet Miller's account of the way in which Stewart treated some of his American Indian material suggests that these objects were not just displayed, but used or consumed. In a key passage from a letter to his brother, Miller described the arrangement of collected objects and artwork in Stewart's bedchamber, the "resting place of the 'Wanderer'":

The floor is overspread with Persian prayer carpets fringed with silk and the walls covered with cloth (crimson) hangings. Along the ceiling extend brass rods from which are suspended reminiscences of the Rocky Mountains painted by your unworthy brother. There are 'The Death of the Panther,' 'Return from Hunting,' 'Indian Belle Reclining,' 'Auguste,' 'Roasting the Hump-Rib,' 'Porte d'Enfer,' etc. etc. . . . On one side rises a cushioned divan of damask cloth, extending the length of the apartment and about three feet wide, over which is spread some magnificent buffalo robes. On these he sleeps. . . .

A glittering tomahawk, the one worn by him in the mountains, is placed on a small table near the divan. . . .

In one corner are numerous Indian pipes, Turkish chibouks, Meerchaumes, etc., with long cherry stems. A rich toilet table, richly garnished, occupies the center of one side, and the light is admitted through silk blinds which at once subdues and softens it.[50]

Miller's juxtaposition of passages describing Middle Eastern objects, sumptuous ornaments, and soft lighting subtly hints at the connections between luxurious idleness and the East found in orientalist texts. As discussed in the introduction, several art historians have likewise noted that orientalism colors Miller's images of Indians, particularly Indian women.[51] The version of *Indian Belle Reclining* that hung in Stewart's chamber is unlocated, but *Waiting for the Caravan* (see introduction, plate 9) shows what was likely a related scene. The formal arrangement of the image draws heavily on traditional eroticized odalisques and appears to share their orientalist assumptions about non-European women.[52] In the image, the recumbent woman suggests a sexual availability, a condition that was stereotypically viewed as characteristic of Eastern, and, by extension American Indian, culture in general.[53]

Stewart's first novel, too, links sensuality, even hedonism, with oriental imagery. Stewart presents his protagonist's hedonism with an aristocrat's sensibility, however, as something to embrace as pleasurable, because slightly immoral. In *Altowan* Stewart describes his protagonist Roallan's "days of feverish excitement, and nights of dissoluteness and unrepose" at the rendezvous following the loss of his lover: "His tent was a harem; and when he left the soft skins and the scarlet drapery which shed a rosy glow over the luxurious revelry within, it was to seek in male companionship and the [tobacco] bowl, a stimulant to flagging spirits, and a change from satiated joys."[54] Stewart's orientalism is here quite literal as he compared his tent to a harem and elides what he previously referred to as the "Oriental luxury" of the East with the pleasures to be had at the western rendezvous.[55] Stewart also may have been making this comparison manifest when he traveled west with a Persian rug, the same one that presumably he is shown seated on in Miller's *Pipe of Peace at the Rendezvous* (plate 2).[56]

In a broader sense, however, Stewart's arrangement of objects in his bedroom seems to have expressed a belief in shared humanity by displaying exotic goods from a number of regions together. His table includes German clay pipes, or meerschaums, side by side with Turkish chibouks, tobacco pipes with a clay bowl from which the meerschaum is derived. If the "Indian" pipes Miller refers to are indeed American Indian, they too would have a wood stem and a bowl of pipestone, or perhaps clay. As will be discussed at greater length later, Jean-Jacques Rousseau (1712–1778) and Scottish moral philosophers argued that all cultures share the same origins and move through the same stages of social development, if at different rates. Such a view of the general origins and development of cultures may underlie the juxtaposition of German, Turkish, and Indian pipes: as all mankind follows the same societal stages, so, too, all mankind shares human pleasures derived through like means.

What is of fundamental significance in the passage describing Stewart's bedchamber, however, is Miller's suggestion of how the collection was displayed *and used.* Miller tells us, for instance, that Stewart slept on the buffalo robes he brought back to Scotland, adding: "It is a doubt with me whether, in the last 8 years, he has ever touched a feather bed. Certainly not if he could possibly avoid it, for he heartily detests them."[57] By using the robes as they would have been used by Plains people, Stewart restored their original use value, if not to their physical or cultural context.[58] Indeed, the two dozen buffalo tongues that Robert Campbell, of the fur trading company Sublette and Campbell, sent to Stewart shortly after the latter's departure were specifically intended to be eaten rather than preserved. Campbell wrote: "You will receive by … conveyance two dozen Buffalo Tongues which Mr. Sublette has particularly selected for you and packed up in salt;—they will remind you of our mountain life."[59] Stewart also cultivated tobacco root (*Valeriana*) for personal consumption. According to botanist Karl Geyer, tobacco root was an indigenous American plant, a parsniplike vegetable that the Plains Indians dug, boiled, and ate year-round. Geyer, who visited Murthly in 1845, reported that Stewart showed him the plant growing successfully in his kitchen garden and told him it was "a very agreeable and wholesome dish" when properly prepared.[60] Thus the tobacco root was not simply recontextualized as part of an Indian environment; it was integrated into a new environment in which it might continue to serve similar needs. Stewart also imported or collected from the Rocky Mountains and Pacific Coast shrubs, trees, and other plants that he planted on his estate, creating an approximation of the proper, authentic environment for his animals. Geyer noted buffalo berry, *Shephardia argentea,* and *Triticum* as well as tobacco root, thriving at Murthly. According to Geyer, Stewart's bunch grass, *Festuca,* was doing particularly well: "Sir Wm. Stuart [*sic*], who, during his travels became acquainted with these grasses, has raised already a great many from seeds, which he gathered himself many years ago. Even there [Scotland] they preserve a great deal of their primitive character, and will, no doubt, surpass expectations."[61] According to the present-day owner of Murthly, Douglas fir and red maple still grow on the property. Many other plants and trees that Stewart introduced can still be seen growing on the estate today, particularly around Rohallion, Stewart's hunting lodge.

The live animals Stewart brought to Murthly were also, in a sense, consumed. Rather than being penned as exhibitions in a zoo, they were introduced onto the estate in hopes that they would breed and thrive there. Perthshire newspapers and correspondence indicate that Stewart brought home several pairs of buffalo he hoped to breed into a herd: "A fortnight ago two Buffaloes passed through Perth for Murthly Castle; and this week they have been followed by four young Moozedeer [*sic*]—all arrived in fine condition; and we understand an attempt is to be made to naturalize them in this climate."[62] In 1835, while still in America, he sent some buffalo to his friend the Marquis of Breadalbane.[63] Breadalbane seems to have been successful in breeding the buffalo. After a visit to Breadalbane's estate, Taymouth, Miller wrote in his journal, "I must not omit to mention that I saw at Taymouth seven buffalo presented to the Marquis by Sir William Stewart—they were in a thriving

PLATE 5 Mr. Brigg's Adventures in
the Highlands
John Leech (1817–1864)
Punch's Almanack, September 15, 1861

condition and two of them had already calved."[64] Queen Victoria's diary also mentions seeing Breadal-
bane's buffalo, which she described as "those strange hump-backed creatures from America."[65] Stew-
art's papers give no information about the success of his own buffalo-breeding enterprise, but an 1861
cartoon from *Punch* magazine (plate 5) showing Mr. Briggs and a companion encountering Stewart's
buffalo while out hunting suggests that the animals were still on the estate twenty years later.[66]

According to Porter, Stewart also brought two Indians along with him to Scotland to help tend
the animals, and Miller's correspondence makes frequent reference to Antoine's presence at Murthly
as well.[67] One of Miller's letters describes how Antoine dressed in black livery and served as Stewart's
valet, accompanying him on a trip to Constantinople before returning with Stewart to America in
1842.[68] The Indian and Métis men would have provided the definitive touches to Stewart's recon-
stituted American environment, offering a form of authentication that the souvenirs could only
suggest. In fact, one of Miller's letters records how Antoine dressed himself in Indian garb in
order to entertain some of Stewart's guests: "Murthly is full of company just now and yesterday
Antoine put on my Indian Chief's dress and made his appearance in the drawing room, to the aston-
ishment and delight of the company, for the dress became him admirably. Afterwards he made his
debut in the servants' hall to the great wonderment of the butlers and valets and to the horror of the
ladies' maids."[69]

Stewart's collected objects, as well as the paintings, were clearly important to him for their ability to stimulate pleasurable longings and memories of his trip. Miller addressed this directly in the same letter to his brother where he speculated on the combined impact of the paintings, robes, tomahawk, and pipes on his patron:

> Surrounded with such associations how often must his mind revert to scenes far distant; the happy hunting grounds of the poor Indian. How often must his imagination picture to him the broad boundless prairie, the rapid tumultuous whirl of the mountain torrent, the gigantic mountains themselves, the plain filled with innumerable herds of buffalo and the wild but picturesque sons of the forest amongst whom he has lived. These recollections must be to him grateful and pleasant for our remembrance of pleasure is always more vivid than the reality.[70]

The bedroom conjures up a host of images: "the rapid tumultuous whirl of the mountain torrent," "the innumerable herds of buffalo," and, of course, "the picturesque sons of the forest amongst whom he has lived." According to Miller, the pleasure of recollecting an experience is more intense than that of the experience itself. Such a sentiment is characteristic of modern consumerism. The consumer acquires goods in hopes of realizing his dreams, but his longing is never adequately sated by material possessions: "For it is in the nature of the images which we construct purely for pleasure that they are free of all blemishes and imperfections (they are the soft-focus photographs of life). Unfortunately, real life is different, and hence it is bound to be the case that whilst 'heard melodies are sweet, those unheard are sweeter.'"[71]

Yet, in an endless pursuit of the stimulation that variety provides, and in an eternal hope that objects can make the imagined world real, modern consumers continue to acquire goods.[72] Stewart's collecting follows a similar pattern. Stewart appears to have sought both variety and an increasingly direct connection to the West in his growing collection. He continued to write to his agents, Sublette and Campbell, requesting to have more and more western materials sent to him in Scotland. In particular he sought a lodge, which was a less traditional collectible than weapons and a more direct tie to the way of life he had left.[73] Stewart's letters also express a profound desire to return to the West and describe his repeated attempts to arrange another excursion to the Rocky Mountains.[74] He alluded to his possible motivation when he described in *Altowan* the way physical pleasures can be exhausted, leaving one jaded. In the same scene in which Roallan attempts to assuage the loss of one lover, Idalie, by taking others, Stewart wrote: "Dissipation of every sort, left but a sadder vacuum between the acts." His hero proposes to his companion a remedy in a change of scenery: "[I]n both a weariness of the useless life they led, was apparent; and the direction in which one would move to vary the scene, when he proposed to visit the meeting of the Pacific wave with the waters of the Columbia, showed the goal to which his wishes pointed."[75]

But Stewart's consumption of his collection suggests that it functioned as more than a reminder of his previous trips. The objects may have been part of Stewart's attempt to experience in reality the West he could now only dream about.[76] If we return to the description of his bedroom at Murthly, the image of the paintings juxtaposed with objects like the buffalo robes suggests that the paintings served as a kind of stage set, simulating the scenery of the rendezvous. The objects would have lent further authenticity to the scene, creating a space in which Stewart could not only remember but could reexperience his western adventures. In a revealing inversion, Miller's description of Stewart's chamber echoes Stewart's own description of his fictional character Roallan's tent in *Altowan:* "The apartment they now entered was large, and hung round with scarlet cloth, raised up below for the admission of air: the floor was of carpet, and the skins of the tiger and leopard lay by robes of the bison and elk in confused heaps."[77] Perhaps Stewart's bedchamber in Scotland was meant to simulate the interior of his tent at the rendezvous, as it was described in the novel. More provocatively, the interior of Roallan's tent, conceived as early as 1840 for the novel, may have been the daydream that Stewart realized through the decor Miller observed later that year at Murthly.

The paintings, artifacts, plants, animals, and even people created an environment with an American theme that ranged from the intimacy of the boudoir to the more public and wide-ranging effect of redesigned estate grounds. From the microcosm to the macrocosm, the collection and its consumption created a context that suggested an abbreviated narrative of Stewart's adventures. Insofar as the paintings, the robes, the pipes, and the tomahawk prompted recollections, they allowed Stewart the supreme pleasure of nostalgia. Integrated into a Scottish environment, the plants, animals, and artifacts helped to re-create the environment in which those adventures took place. As they grew, bred, or were used, the plants, animals, and artifacts gained new life, new meaning, and, in a very literal sense, reinvigorated the Scottish environment. Stewart's act of cultural translation, making the material culture of American Indians intelligible to Scotland, thus became a kind of cultural production as well.

The Bison Chairs

Stewart's commission for a pair of hall chairs enacted the kind of synthesis of New World and Old on a small scale that, as will be discussed further, was taking place on a larger scale on the grounds of the estate. In June of 1841, Miller recorded the appearance in the vestibule of two "buffalo chairs . . . richly carved of mahogany and . . . very curious"[78] (plates 6 and 7). They are not buffalo chairs in the sense that they contain buffalo motifs in the carving or possess upholstery made from buffalo hide or fur. Rather, they are carved mahogany in the form of individual buffalo: the backs are composed of huge heads covered in a pile of thickly carved curls with rosewood bison horns curving outward

Unknown maker
Mahogany with rosewood, 43 × 26 × 25 inches
Museum of the American West, Autry National Center,
Los Angeles, California

PLATE 7 Mae Reed Porter, photographer
Photograph at Murthly Castle, ca. 1952 (Mae Reed Porter
Papers, American Heritage Center, University of Wyoming,
Box 41, file 11.)
Written on reverse is "Present Owner of Murthly, Steuart
Fothringham with 'buffalo chair.'"
Courtesy American Heritage Center, University of Wyoming,
Laramie

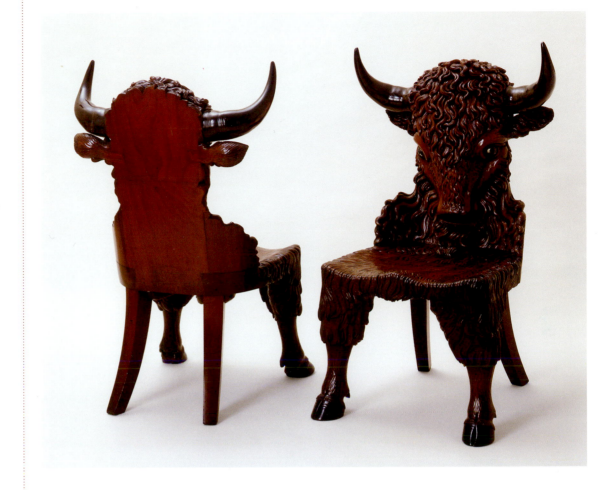

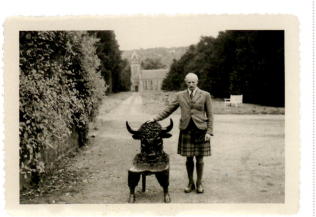

above stiffly protruding ears and glass eyes. The seats of the chairs, incised in low relief with softer, straighter fur, flow into two stout, hairy forelegs that end in rosewood hooves.

The pose of the chairs is striking. Spread wide and bowed slightly inward, the legs of the buffalo chairs appear to be firmly planted in an effort to resist a pressure downward and outward. With their seats carved to look like fur, and the hair of their manes falling across the seam where the back of the chair meets the seat, the chairs present one continuous body that slouches forward, hips slid outward, as if to create a wide lap for a sitter. As such, the chairs are not just composites of inanimate and unre-lated body parts put together to form a chair. They seem to be buffalo making themselves into chairs. Thus we are encouraged to imagine the chairs as whole living animals, transformed into domestic objects and transported to the vestibule for us to experience intellectually and physically, if we dare.

Their placement in the vestibule allows them to enter into a dialogue with other more stately and venerable objects in the room. Miller provided a description of the furnishings in the vestibule: "Cast

PLATE 8 The Last Oak of the Old Forest of
Birnam

From William Fraser, *The Red Book of Grandtully*, 2 vols.
(Edinburgh, 1868), facing p. xli

Courtesy American Heritage Center, University of Wyoming,
Laramie

your e'e upward. There are suspended rusty pikes, helmets with visors, gauntlets,—look at that old banner. Undoubtedly it has seen service. Many a time and oft it has 'braved the battle and the breeze.' Had it a tongue it would discourse most eloquently of blood and carnage.... Here is some old armour. Let me put this cuirass on you...."[79] Miller gave his account while seated in "the large Gothic chair from which the Stewarts in the olden time dispensed justice under the feudal system."[80] Located as they were in the vestibule, the bison chairs might have intimidated visitors, as hall chairs were typically intended to do.[81] But they also introduce us to a world where things Scottish commingle with a collection of Indian materials. Associated as the buffalo were with the Indian environment, the chairs might reasonably fall within the larger collection of American Indian material, and, by extension, stand as a synecdoche for it. Juxtaposed with ancient Scottish chairs, they suggest a broader compatibility between feudal Scotland and American Indian culture, which, in turn, is implicit in the consumption and display of the collection as a whole.

Bison and Birnam Hill

There is no better example of the way Stewart's collection reinvigorated the Scottish environment than Birnam Hill, which Stewart selected as one of the locations for planting his American trees. Birnam Hill, through its historic connection to Scottish ruler Macbeth, was a widely revered icon of Highland heritage; Birnam Wood was listed as an attraction in guidebooks, and Miller made several mentions of visits to the site in his letters.[82] The Hill seems to have been a source of acclaim both for Murthly and for the Stewart family; a sketch of the site is in a two-volume family history that Stewart commissioned in 1868, *The Red Book of Grandtully* (plate 8). According to Miller, only two trees from the ancient forest remained when he visited the estate. William Fraser, the author of *The Red Book*, noted, however, that by 1868, Stewart's replanting of the Hill had improved the bleak and dismal aspect of the area, and "has now rendered pointless the sarcasm of Mr. Tennant, that Birnam had never recovered the march to Dunsinane."[83] Fraser also notes that the southeast side of the hill, near the historic site of King Duncan's camp, was the habitat of Stewart's bison.[84] The fact that Stewart chose to plant American trees on the site and to stock it with bison suggests the potential and appropriateness of introducing America's natural world to reinvigorate or restore remnants of the Scottish past.

The possibility that the American trees might have offered a means of reinvigorating the imagery of Stewart's family history is more plausible than it might, at first, seem. Stewart's collection of American flora and fauna was part of a larger horticultural experiment in which North American plants and animals were brought to Scotland in order to diversify or restock Scottish flora and fauna. In correspondence, Sir Walter Scott noted the extinction of trees and animals such as the "wild bull or bison," elk, and "lowlands red deer" from Scotland, species that Stewart, in fact, imported. Plants and animals

from the Pacific Northwest were believed to be particularly good candidates for introduction to Scotland because the two regions shared similar climates. The *Perthshire Courier* reported that cages of several species of American antelope were on their way through Perth to Murthly, "with the view of attempting their naturalization in the Highlands." The paper noted that "their new place of abode might rival their native rocks in its romantic scenery," and hoped that Stewart's "experiment will meet with success."[85] The introduction of American plants to Scotland seems to have been interpreted as a patriotic act as well. By 1850, a horticultural society was formed in Edinburgh whose members included Prince Albert and many of Stewart's friends, notably one of Scotland's first recipients of American buffalo, Lord Breadalbane. According to an article in the *Constitutional Perthshire Agricultural and General Advertiser,* the association had been formed

> for the patriotic purpose of introducing from the hitherto imperfectly explored hills of Oregon, Mexico and California, trees, shrubs, and flowers, adapted to the climate of Scotland.... When we consider that there are only four or five forest trees indigenous to this country, and that the others have been introduced from different parts of the world, we have every reason to hope that the trees of a district, bearing a great resemblance in point of climate, to our own, and attaining a magnitude unknown here, will prove in the highest degree beneficial.[86]

By characterizing such an endeavor as "patriotic," the passage suggests that importing American plants would also improve Scotland as a nation.

Horticultural experiments offer a concrete example of contemporary Scottish beliefs about the potential of America to reinvigorate Scotland. But there is evidence to suggest that American Indian culture had a more significant salutary application to Scottish culture itself. As Miller's images, and many of the Indian-made souvenirs suggest, Stewart's interests in American Indian life ranged far beyond gardening and animal husbandry. Much of the imagery in the sketches, in particular, deals with Indian culture. Objects in the sketches, such as the pipes, are seen in use, clearly central to the human interactions depicted. Moreover, though the animals on Stewart's estate lived on as discrete entities, the images from the American trip suggest that it was not the animals per se that were of interest; it was the animals *as the objects of a hunt.* These paintings are less concerned with the habitat, habits, or appearance of the animals than with Stewart and the Indians' pursuit of them. It is Indian culture, and Stewart's place in it, that the sketches record, and it is the viability of Indian culture within a Scottish context that the collection, in part, attests to.

American Indians and Scottish Primitivism

Stewart not only collected but he also consumed American Indian material, and his collecting practices were aimed at integrating Scottish and Indian worlds. Such an integration had its conceptual basis in a longstanding belief in the essential primitiveness of Scottish, particularly Highland, character. Since at least as far back as the sixteenth century, Scottish Highlanders had been regarded by their European neighbors as a savage or barbaric people, owing, in part, to their cold, northern climate.[87] In sixteenth- and seventeenth-century art and literature other than their own, Highlanders were grouped together with demons, witches, and other supposedly primitive peoples of the north, such as Laplanders.[88] The Highlanders were believed to have inherited their barbaric nature from their ancestors, the Picts. Accounts of the Picts, so-called for their custom of tattooing themselves and painting their skin blue, first appear in Roman accounts of the conquest of Britain. Ptolemy and Tacitus described them as a warlike people living north of the River Tay—which, incidentally, bisected Stewart's estate—and the Firth of Forth (the estuary of the Forth River represents one of the traditional boundaries between Highland and Lowland Scotland), a people whom Roman soldiers were unable to subdue.[89] Eighteenth-century historians described the Highlanders as clannish, warlike, given to drink, uncivilized, indolent, and violent.[90] William Robertson, in his monumental *History of Scotland During the Reigns of Queen Mary and King James VI,* described the Highlanders as endowed with "natural fierceness ..., averse from labor and inured to rapine."[91]

The last Scottish uprising against the English ended with the Scots' defeat at the Battle of Culloden in 1746. The English blamed the Highland Scots in particular for the uprising and inaugurated new policies aimed at suppressing Highland culture and assimilating Scots into the British socioeconomic system. The English succeeded in doing so, in part, by breaking up the clan system, sending missionaries north to teach the Highlanders to speak English rather than Gael, and outlawing the wearing of kilts.[92] In a form of "imperialist nostalgia," as Highland culture disappeared, the Highlanders' primitivism came to seem admirable, not threatening, and elicited more sympathetic characterizations of the Highlanders from observers.[93] In 1812, one writer lamented the withering away of Highland culture: " . . . these distinctions are fast wearing away, and the character of the Highlander is rapidly assimilating itself to that of his neighbors on the south and east; . . . it is probable that in a few years, that which is now a matter of observation will depend only on record, or vague tradition, it seems more necessary, therefore, upon this occasion, to delineate some of the leading features in the picture, whilst it is yet in our power to trace them." The writer went on to praise Highlanders, who, "like every other people in the early stages of society are remarkable for their hospitality" as well as their valor and bravery, calling them, "the best soldiers in the world," and noting their ability to endure "fatigue, and hunger, and thirst, and heat, and cold, beyond what is credible by those who have been accustomed to the softer modes of life."[94] Another writer similarly described the Highlanders as primitive people who were brave, hospitable, and honest. Though they did occasionally engage in drunken

brawls and "violent, Pyrrhic" dances with swords, the writer was quick to defend them, warning Lowlanders not to judge Highlanders by those they meet in the inns.[95]

British encounters with American Indians in the sixteenth century resulted almost immediately in observers' drawing analogies between the two cultures.[96] In an early account of North America by Thomas Harriot (1560–1621), *A brief and true report of the new found land of Virginia* (1590), the author attempted to explain and generate empathy for American Indians among his British audience by comparing them to Picts.[97] The de Bry edition of *A brief and true report . . .* contains a section titled *Som Pictvre of the Pictes which in the olde tyme dyd habite one part of the great Bretainne,* which juxtaposes images of the Picts with those of painted Algonquin, as well as blue-pigment-dyed ancient Britons. In his introduction to the section, Harriot wrote that the pictures of the Picts are included "for to showe how that the Inhabitants of the great Bretannie haue bin in times past as sauuage as those of Virginia." The text accompanying the engraving of "Pictish Man Holding a Human Head" says that the Picts tattooed their bodies, wore iron rings around their necks and waists, and carried cymtars or Turkish swords, adding the salacious tidbit that " . . . when they hath ouercomme some of their ennemis, they did neuer felle to carye a we their heads with them."[98]

From the perspective of the Scottish Enlightenment, the comparison between Highlanders and American Indians was not necessarily an unflattering one. For Scottish moral philosophers in the eighteenth century, studies of supposedly primitive societies around the world provided a foundation for an inquiry into the essential nature of humanity.[99] Adam Ferguson (1723–1816), a representative figure for this period, argued that "[b]efore we can ascertain rules of morality for mankind, the history of man's nature, his dispositions, his specific enjoyments, and sufferings, his condition and future prospects, should be known."[100] American Indians provided one such example for study. In the second part of his *Essay on the History of Civil Society,* Ferguson wrote the following:

> It is in their [the Indians] present condition, that we are to behold, as in a mirror, the features of our own progenitors; and from thence we are to draw our conclusions with respect to the influence of situations, in which, we have reason to believe, our fathers were placed.
>
> What should distinguish a German or a Briton, in the habits of his mind or his body, in his manners or apprehensions, from an American, who, like him, with his bow and his dart, is left to traverse the forest; and in a like severe or variable climate, is obliged to subsist by the chace?[101]

Societies such as those of the American Indians provided a sound basis for comparison because, as Ferguson and his peers argued, humans everywhere were created equal and shared the same potential and capacities. Perceived differences in the level of civilization of humankind around the world were thought to exist because societies developed at different rates in response to variations in

environment, and particularly, climate. The governing metaphor for cultural development was individual human development: all peoples progressed through stages of childhood, adolescence, and maturity, just at different speeds.[102]

The "savagery" of Highland and American Indian people could be negatively construed as an argument for the suppression or destruction of their cultures, but it could also be revalued by the Scottish Enlightenment to argue for admirable qualities imperiled by civilization. In an expression of what could be described as a "salutary primitivism," the Scots lamented the loss of natural instincts and appetites along with physical vigor as humans became more civilized.[103] According to John Gregory, "when Men leave the plain road of Nature, superior knowledge and ingenuity, instead of combating a vitiated taste and inflamed passions, are employed to justify and indulge them; that the pursuits of commerce are destructive of the health and lives of the human species."[104] More importantly, for the sake of this argument, Lord Kames (1696–1782), and particularly Aberdeen scholar Thomas Reid (1710–1796), agreed with Gregory that social progress generally, but not necessarily, sickened and enfeebled humankind. Each argued that the deleterious effects of modern society could be counteracted or offset through a study of nature. For Gregory, in particular, cultivating natural instincts could help one achieve the ideal middling state, between savagery and civilization, where moral capacities are well developed without the softness and effeminacy of civilized life. Likewise, Ferguson argued that the dangers of civilized life inhered in its "state of mind," not in its institutions, and could be corrected.[105] He offered an example of the European child who regains vigor among American Indians:

> …the children of opulent families, bred in effeminacy, or nursed with tender care, have been made to contend with the savage. By imitating his arts, they have learned, like him, to traverse the forest; and, in every season, to subsist in the desert. They have, perhaps, recovered a lesson, which it has cost civilized nations many ages to unlearn, that the fortune of a man is entire while he remains possessed of himself.[106]

Ironically, English and Continental intellectuals of the period considered Scotland primitive or culturally backward compared to England. As an example of European condescension to the Scots, George Stocking quoted Voltaire's response to Lord Kames' *Elements of Criticism:* it was "an admirable result of the progress of the human spirit that at the present time it is from Scotland we receive rules of taste in all the arts…."[107] In the face of such attitudes, it is unsurprising that Scottish thinkers would seek to demonstrate the innate equality of talents among mankind, regardless of the state of their society, or that they would praise certain aspects of primitive character. Lord Kames, in fact, touted the Caledonians, ancestors of the Scottish people, as primitive yet "endowed with 'manners so pure and refined as scarce to be paralleled in the most cultivated nations.'"[108] Stocking suggests

that this was a "compensatory assertion of cultural nationalism on the part of a Scotsman who was at one and the same time systematically emulating English models and being patronized by Englishmen."[109] In fact, Ferguson was himself a Highlander, and one historian has interpreted his consideration of Greek Spartan and American Indian cultures as an expression of his concern over the fate of the Highlanders in the face of assimilation by the English. Although, as one historian notes, Ferguson never mentions the Highlanders in his *Essay,* references to Spartans and Indians, in effect, "clothe the Highland inspiration in fashionable garb."[110]

The ideas about the nature of mankind put forth by members of the Scottish Enlightenment continued to influence Scottish and American thinking on humanity in the nineteenth century. Sir Walter Scott, in particular, studied in Edinburgh with some of the youngest members of the Enlightenment circle, and scholars have traced his views about Scottish civilization to Scottish moral philosophy. In America, Scottish moral philosophy was so widely taught in primary schools and colleges in the first half of the nineteenth century that it constituted "the official metaphysics of America."[111]

In the nineteenth century, comparisons between Highlanders and Indians could be used either to condemn Highland culture or to celebrate it, depending on one's view of the Highlanders themselves. Thomas Babington Macaulay (1800–1854), who considered their culture to be an obstacle to economic development, characterized the Highlanders as indolent thieves who rejected commerce or labor in favor of hunting and warfare and compared them to other cultures he deemed barbarous, such as the Hottentots, Malays, and Mohawks. When pointing out the absurdity of Lowland Scots adopting the Highland kilt as their native dress, he made a more explicit comparison: "Few people seemed to be aware that, at no remote period, a MacDonald or a Macgregor in his tartan was to a citizen of Edinburgh or Glasgow what an Indian hunter in his war paint is to an inhabitant of Philadelphia or Boston. Artists and actors represented Bruce and Douglas in striped petticoats. They might as well have represented Washington brandishing a tomahawk, and girt with a string of scalps."[112]

Yet for Sir Walter Scott, the comparison between Indians and Highlanders pointed out the extent to which both represented the state of "man in nature." Scott compared the Highland clan system to that of the Iroquois: "It was not above sixty or seventy years . . . since the whole north of Scotland was under a state of government nearly as simple and patriarchal as those of our good allies the Mohawks and Iroquois."[113] In historical fact, Highland clan systems of kinship and obligation have much in common with the social structure of many Algonquin peoples, and historians of the fur trade have hypothesized that the success of Scots in the North West Company may be attributable to their familiarity with such systems. Sir William Johnston (1715–1774) made a point of recruiting Highlanders for training as members of the British Indian Department, and the majority of British citizens who were a part of the mixed Indian-white culture of the Indian Department were of Scottish and Irish ancestry.[114] Scott's quintessential Highland hero, Rob Roy, is also compared to an American Indian: "Thus a character like his, blending the wild virtues, the subtle policy, and unrestrained

license of an American Indian, was flourishing in Scotland during the Augustan age of Queene Anne and George I."[115]

The notion that European civilizations could be reinvigorated by cultivating some of the attitudes or habits of people in savage states may help to set the stage for understanding Stewart's particular interest in introducing pieces of indigenous America, and its inhabitants, to Scotland. Yet Stewart was also a Scotsman, and his interest in American Indians was likely determined not only by their identification with the Highlanders, but, in turn, with the Highlander's identification with essential Scottish characteristics.

Highlanders, Indians, and Scottish Nationalism

The image of the Highlander may have begun its shift from savage to noble savage in the eighteenth century, but it is Sir Walter Scott, in the nineteenth century, who codified the image of the Highlanders, transforming them from primitive clansmen to patriotic exemplars of Scottish national culture. In the wake of Scotland's political and economic incorporation into Great Britain following the Union of 1707 and, more particularly, Scottish cultural assimilation following the Jacobite Rebellion of 1745–46, nineteenth-century Scots expressed an interest in their cultural identity as distinct from the English. Both the renewed interest in Scottish history and newly invented traditions helped to recapture a sense of Scottish cultural versus political identity.[116] Many Highland traditions that are today believed to have ancient origins were, in fact, invented during the late eighteenth and early nineteenth century in Scotland. These included the creation of the kilt and the fabrication of an ancient tradition of plaid patterns that correlated to one's family clan.[117] Sir Walter Scott played a central role in the creation and popularization of Scotland's image in this period. He did extensive research on the early history of Scotland, including it in his widely popular novels about life in the Highlands. Scott was also instrumental in the rediscovery and return to Edinburgh of the Scottish crown jewels. This new notion of Scottish cultural identity received its most public articulation in 1822, when, in honor of the first state visit to Scotland by a British monarch, Scott orchestrated a pageant in Edinburgh. King George IV was welcomed into Edinburgh by bagpipe music, crowds in kilts, and Highland clan chiefs and their clansmen dressed in the plaid pattern appropriate to their clan.[118] Scottish culture represented at the pageant was largely a fiction, the culmination of a process by which the image of the Highlander supplanted that of Lowland Scots as the embodiment of Scottish culture as a whole. Although many at the time of the pageant were aware of the contradictions in Scott's presentation, by the 1840s, thanks in part to Scott and the London Highland Society's promotion of Highland culture, most Scots accepted the Highland tradition as emblematic of Scotland.

Miller's letters from Scotland record Stewart's and his peers' acceptance of this new ancient Highland heritage. Although Stewart and his neighbors did not share Highlanders' Celtic ethnicity or clan

culture, they lived in the Highland region of Scotland.[119] According to Miller, Stewart held balls at which all the guests wore kilts and danced the Highland fling, and he spent a great sum to purchase a kilt for Antoine to wear at such occasions. Miller also recorded a visit to the castle of Stewart's good friend Lord Breadalbane, where members of Breadalbane's staff all wore kilts and the household was roused every morning by a bagpipe player who marched through the halls. In addition, the inventory of the estate sale that took place after Stewart's death lists two portraits of Prince Charles Edward Stewart, the Scottish pretender to the British throne in 1719 and a folk hero to Scottish nationalists.[120]

Philip Deloria's work, *Playing Indian* (1998), provides an American parallel to Stewart's interest in Indian culture in terms of his own cultural identity. Deloria explores phenomena such as the Boston Tea Party, in which Americans self-consciously and temporarily acted out imagined Indian identities through costume and ritual. According to Deloria, the temporary adoption of Indian identities aided Americans in constituting their own national identity. Colonists who participated in the Boston tea party, for instance, dressed as Indians not only to disguise themselves, but also to link themselves to indigenous peoples, and, by association, to their ancestral claims to legitimate ownership of the American soil. Dressing as Indians helped the colonists to assert a distinctly American political identity for themselves as separate from the British. What is important to note in this case is that the participants identified with selected stereotypes of Indians that permitted various forms of self-expression. Stewart's album and collection seem to participate in a similar process of cultural identity formation, one that identifies with Indians as the embodiment of tribal or communal life and primitive virility that was being suppressed in Highland culture.[121]

Deloria points out that Indian identity provided a means by which Anglo-Americans could act out their own national or personal identities, but Stewart's case suggests that Indians could prove a rich field for European identities as well. Through the collection and consumption of Indian material culture, Stewart was able to express a concept of Scottish identity that drew on existing popular beliefs about the primitivism of Scottish people. His particular interest in American Indian culture, moreover, suggests that romantic exoticism could be manifested in culturally specific ways, as, paradoxically, the product of a search for cultural traits among exotic peoples that were similar to one's own. If, as some scholars have suggested, collections are often biographies of the collectors, then we may be safe in concluding that in collecting Indian material, Stewart was preserving himself.[122]

Miller's *Attack by Crows and Scottish Aristocratic Identity*

Miller's images played a supporting role in the articulation of Scottish identity in Stewart's collection. But in one of the most important images of the Stewart commission, *An Attack by Crows on the Whites on the Big Horn River East of the Rocky Mountains [Crows Trying to Provoke the Whites to an Act of*

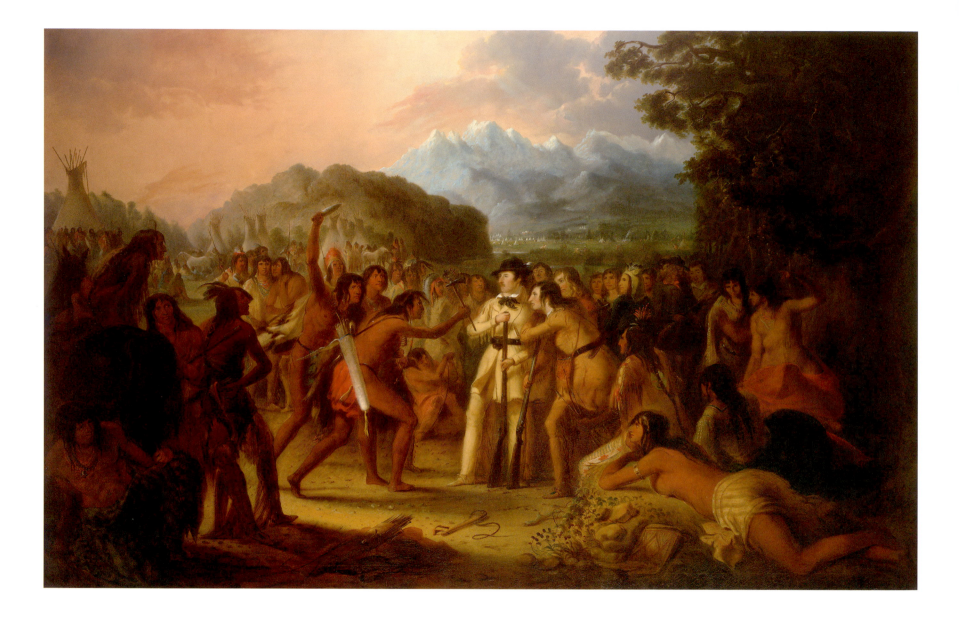

PLATE 9 An Attack by Crows on the Whites on the Big Horn River East of the Rocky Mountains [Crows Trying to Provoke the Whites to an Act of Hostility], 1841

Oil on canvas, 70¾ x 105¾ inches

Courtesy of The Anschutz Collection, Denver, Colorado.

Photograph by William J. O'Connor

PLATE 10 Stewart and Antoine
Detail of Plate 9

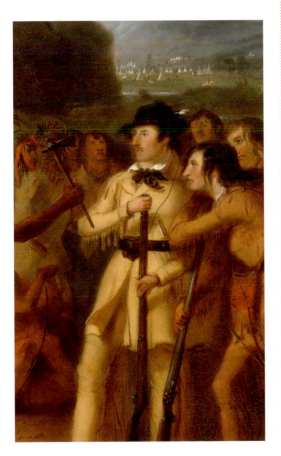

Hostility] (plate 9), Miller developed and expanded the scope of the collection's meanings in significant ways.[123]

Ironically, the image does not depict a scene from the 1837 rendezvous that Miller attended. *An Attack by Crows* is set in 1833 in Miller's present-day Montana, near the Rosebud and Little Bighorn rivers. The monumental 6-by-9-foot canvas depicts a decisive event in the fierce competition between the small, independently owned Rocky Mountain Fur Company and the larger, Saint Louis–based American Fur Company. Stewart had been left in charge of the camp when a large party of Crow men, probably eighty to one hundred, came and robbed the camp of its goods, including almost the entire stock of skins purchased by the Rocky Mountain Fur Company at the rendezvous, over one hundred horses, and a season's worth of supplies, along with Stewart's favorite horse and his watch.[124] The theft was a humiliating defeat for Stewart, because the Crows, who were allies of the rival American Fur Company, had, in fact, been sent by the company to prevent Stewart's party from further encroaching on lands customarily trapped by its men. The Crows succeeded in forcing Stewart's party to call off their fall hunt for lack of supplies, handing the Rocky Mountain Fur Company a devastating financial loss from which it apparently never recovered.[125]

The painting, however, tells a strikingly different story by contrasting the composure of Stewart to the violent aggression of the Crows. The painting is organized around the figure of Stewart (plate 10). He stands roughly at the center, highlighted by the light color of his buckskin suit and by a strong light that falls across the midground. Though it appears that his companion, Antoine, has just pulled him backward (the right flap of his jacket flips up slightly as if in response to the motion), his body nevertheless forms a strong vertical line reiterated by the barrel of his gun. Antoine, posed as if lunging forward to restrain Stewart, appears positioned as a kind of compositional brace for his patron. A stark contrast is apparent between the firm and compact contours of Stewart and Antoine and the raised and spread limbs of the two main Crow assailants, who threaten them with the knife and the tomahawk, respectively.

Although the event depicted ostensibly ended in Stewart's defeat, Miller's painting nevertheless represents Stewart in a moment of triumph. According to Miller's commentary on the image, the event unfolded as follows: The Crows arrived in camp and began by taunting Stewart's party and taking small items. Antoine, who spoke Crow, warned Stewart that the Crows had brought a shaman with them, and that the shaman had told them that if they wanted to win a battle with Stewart's party they must incite them to strike the first blow. In keeping with Miller's original title, *Crows Trying to Provoke the Whites to an Act of Hostility,* the painting showed Stewart prevailing over the Crows by keeping his calm, thus thwarting their efforts to wage war on his party and kill them.[126]

According to Miller, this story inspired a sermon by Cardinal Nicholas Patrick Wiseman (1802–1865), the clergyman credited with sparking the Catholic revival in Great Britain during this period. The Cardinal made a visit to Murthly, perhaps to welcome Stewart, a recent convert, into the church.

There he saw *An Attack by Crows* and, upon his return to London, lectured on the moral message it implied. Wiseman described the painting as portraying Stewart "at the head of his tribe."

The picture represents this gentleman at the head of his little body of men, surrounded by yelling and irritated savages, provoking him to strife and for this purpose thrusting their fists into his face, shaking their tomahawks over his head, using the most insulting gestures and uttering the most offensive words; but he stands calm and composed in the midst of them, knowing that the safety not only of himself, but of all who trust in him depends entirely upon his complete command of self. I consider that really an attitude and a position worthy of a hero.[127]

Wiseman's allusion to "command of self" places the emphasis on Stewart's ability to control the passions inspired by the insults of the Crows. But it also suggests the righteousness of his command over his party by virtue of his self-command (a righteousness that the actual event, in fact, called into question). Indeed, the painting seems to make this point formally as Stewart's upright posture and firm gaze create a visual anchor for a crowded and, in places, chaotic composition.

Although the painting would seem to absolve Stewart of any blame or embarrassment for the theft by emphasizing the correctness of his course of action, what the painting meant to Stewart likely had little to do with the event's significance to the fur trade. Nor does Cardinal Wiseman's account fully capture its possible significance. Wiseman characterized Stewart as essentially without emotion: calm and composed in essence, as well as in appearance. But the odd flip of the edge of Stewart's jacket suggests otherwise. Although the flap of the jacket looks at first like an inept or unresolved attempt at depicting movement, more likely it was a formal compromise that allowed Miller to distill two moments into a compressed continuous narrative: Stewart restrained from moving toward the Crow by Antoine, and Stewart standing still. As such, the flapping jacket may also be understood as an externalization of the tension between Stewart's desire to attack the Crow and his determination not to. This tension is also evident in the contrast between Stewart's calm facial expression and his tie, which seems to recoil in the face of his attackers in a way he does not. A watercolor of Stewart and Antoine (plate 11), which appears on the basis of pose and expression to have been a preparatory sketch for *An Attack by Crows,* shows only the two men's heads. Isolated on the page, their faces, and Stewart's tie, which here lies still against his neck, reveal none of the drama of the completed painting. Thus in *An Attack by Crows,* Stewart is not without emotion; rather, he checks his emotions appropriately. The presence of each portion of the equation is significant because it makes the painting about more than just Stewart's stoicism. It is also about the power of the Indians to elicit those feelings in him.

By representing the strength of the feelings that the Indians elicit, the painting portrays the positive effects of primitivism. Stewart, at home in a Highland culture that was facing extinction, risked

PLATE 11 Sir William Drummond Stewart and Antoine (Canadian Half-Breed), n.d.
Watercolor, gouache, and graphite on paper, 7¹¹⁄₁₆ x 10¹⁄₁₆ inches
Gilcrease Museum, Tulsa, Oklahoma

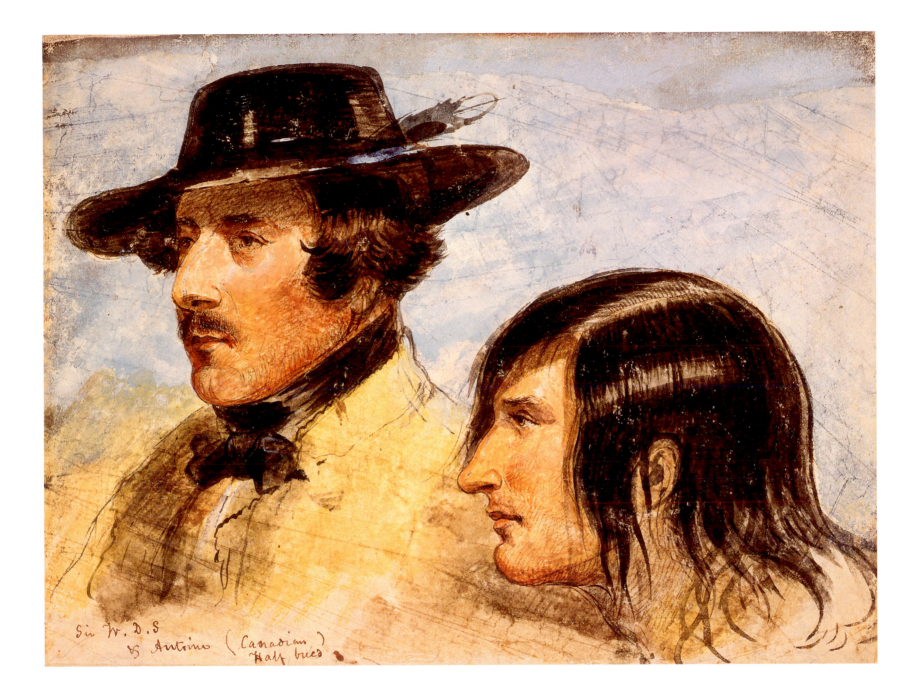

Sir W. D. S
& Antoine (Canadian)
Half breed

PLATE 12 Quiver and crop
Detail of Plate 9

PLATE 13 Reclining woman, bag
Detail of Plate 9

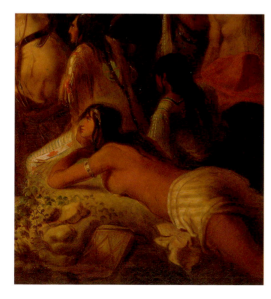

losing touch with the elemental passions and senses that could still be found among American Indians. The painting presumes to demonstrate the extent to which Stewart's travels acted as a kind of tonic against softness and effeminacy that threatened to follow in the wake of Scotland's Anglicization. By being "made to contend with the savage," he could remain, in more ways than Adam Ferguson surely intended, "possessed of himself."[128]

If the painting portrays the salutary effects that Indian culture could have on Stewart, it is significant that it appears to be laden with the very objects that were to help Stewart maintain those effects once back in Scotland. *Attack by Crows* was commissioned and executed at Murthly Castle during the period in which Miller resided there. Stewart's collection would have presented Miller with explicit models for objects to include in the painting. Certainly the presence of American Indian material culture would have conveyed an air of authenticity to the image, yet the inclusion of so many of the objects, and the detail with which Miller rendered them, seems to be gratuitous within the painting's ostensible narrative. Why, for instance, include the bandolier bag leaning against the rock in the foreground, or the riding crop on the ground before Stewart? (plate 12). And if authenticity was all that Miller was after, shouldn't one expect him to not make mistakes, as he does in the figure of the Indian woman lying at lower right, scantily clad in a fabric wrap, as ethnohistorians tell us she would not have been, and sporting a hair bow adornment worn customarily by men?[129] (plate 13). The placement of the objects, conspicuously laid out in the foreground for our study, further suggests that their representation was an end unto itself. So, too, does the level of detail in which they are executed, which is at odds with other more vaguely rendered passages of the foreground such as the rocks and the plants. A later watercolor sketch, *Attack by Crow Indians,* that Miller executed in America shows none of the detail of the oil, inviting two related explanations: that the objects portrayed in the oil were part of Stewart's collection and thus available for Miller's firsthand observation, or that in versions Miller made for other patrons, the presence of the objects was no longer relevant (plate 14). Miller's inclusion of the collected objects in the painting helps to contextualize them, but it also contextualizes the painting itself within the larger web of meaning created by the collection.

In response to the argument that the portrayal of the Crows' violence undermines a positive portrayal of them as emissaries of salutary primitivism, one might note that the hostile party here is the Crows. Stewart, as did all fur traders, distinguished between Indian peoples who were allies and those who were enemies. The Shoshones, the people most often portrayed by Miller, were allies, the Blackfeet, enemies, and the Crows could be either, depending on the circumstances. It is also important to note that there are Indians on both sides of the painting. The figure from Stewart's party at the lower right bears the features of a Shoshone chief named Ma-Wo-Ma, a loyal ally of Stewart's who appears often in Miller's sketches. Moreover, Miller formally mitigated the Crows' menace. The Crow men's waving limbs express the violence of their emotions, yet Miller subtly suggested their harmlessness as well. The man wielding a knife has a menacing posture and a heavily muscled physique to back it up.

The power of his threat, however, is undermined by the expression of mere annoyance on his face. Moreover, his gesture has a strange artifice to it that is not entirely accidental. He holds his knife underhand, with the blade pointing upward, making it impossible to strike a downward blow. The third assailant, whose hands are visible stringing his bow just behind the breast of the man with the tomahawk, has an expression on his face friendlier than that of many of Stewart's party.

Miller's *Attack by Crows* presents a markedly different portrayal of American Indian violence than does his contemporary Karl Bodmer's *Fort McKenzie, 28 August 1833* (plate 15), a print that Miller likely knew from Stewart's collection.[130] Bodmer recorded a disturbing incident in which a party of Assiniboines attacked a camp of Blackfeet allied with the American Fur Company outside Fort McKenzie. Like Miller's painting, Bodmer's aquatint contains figures posed with their limbs extended outward from their bodies, as in the figure in the foreground center with scalp and scalping knife raised over his head. Yet Bodmer too subtly undermined the power of the Indian attackers. For instance, a man at midleft raises a lance over his head, but his wrist is sharply twisted to reveal the back of his hand rather than the front. If we take his gesture to its logical physical conclusion, he points the lance inward at himself. But in Miller's work, the violent gestures seem almost a caricature of menace that renders them benign, rather than self-destructive.

There is another important difference in the two artists' renderings of violence. In Miller's image there is nowhere a loss of human dignity so great as in Bodmer's, where the Blackfeet's gestures have an ugliness that comes not just from their violence but from their animality. The left hand of the Indian raising his lance curls inward, pawlike. It is as if Bodmer portrayed his violence as literally inhuman. Likewise, the man at center right curled over his bow and arrow, or the figures crouching to either side of the man raising the lance, hunch their shoulders up above the line of their backs in an animal-like way that may be compared to the posture of the grizzly bear defending its prey in another aquatint after Bodmer from the same volume, *Hunting of the Grizzly Bear* (plate 16).[131] In Miller's image, however, the Crow attackers and Stewart's mixed party of white, Métis, and Indian men and women share a baseline humanity. The figure with the tomahawk leans toward Stewart but does not hunch his back or raise his shoulders, as do the figures in the Bodmer print. Moreover, the faces of Bodmer's assailants show a heavy, overhanging brow that, within the contemporary pseudoscience of phrenology, connotes inherent racial inferiority, and that they contort in expressions of brutality.[132] In contrast, Miller's Crows are angry, watchful, quizzical, but never inhumane. The Crow figure just to the left of Stewart, for instance, holds himself as erect as, and with an expression as thoughtful as, that of the Scotsman himself.

Much of the recent scholarship on western American art has focused on how western images articulate American national concerns or address issues in American western history. A study of Miller's work within the context of trans-Atlantic patronage, however, suggests that his images, as well as their subjects, could be a rich source for European identities as well. Through the collection

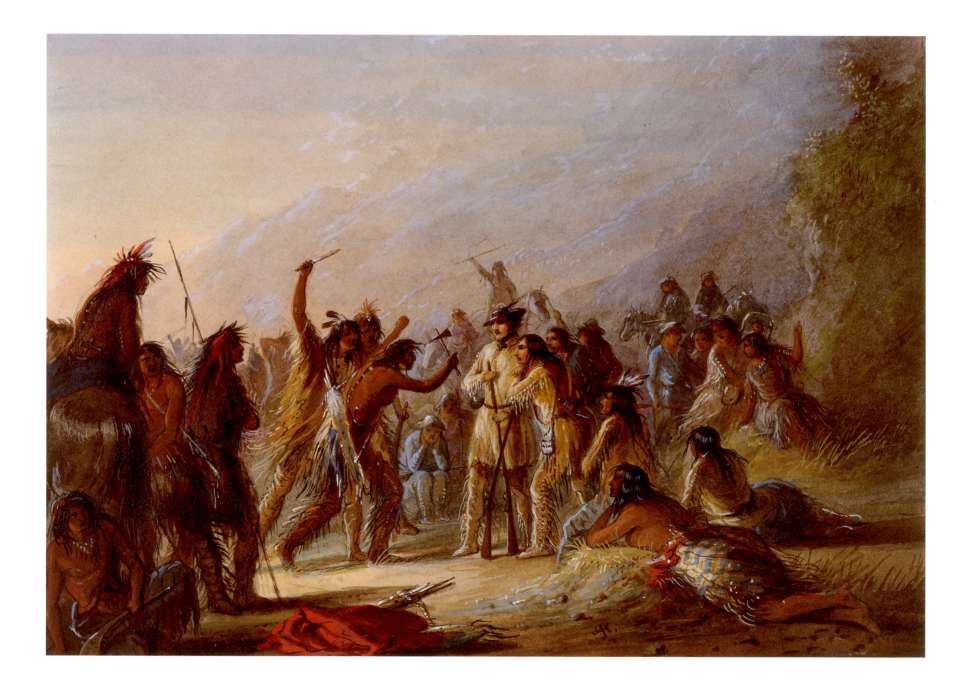

and consumption of Miller's sketches and of American Indian material culture, Stewart was able to express a concept of Scottish identity that drew on popular beliefs about the primitivism of Highland Scots. His particular interest in Indian culture, moreover, suggests the extent to which romantic exoticism could be manifested in culturally specific ways, as, paradoxically, a search for cultural traits among "exotic" peoples that were similar to one's own.

There is yet one more important dimension of *Attack by Crows* to consider. More than twenty-five years after it was first painted, Stewart had the work lithographed for inclusion in *The Red Book of Grandtully* (plate 17). The lithograph presents a scaled-down version, but the essentials of the composition remain: Stewart and most of his party, the menacing Crows, and the all-important flap of the jacket. The lithograph's status as the sole depiction of Stewart in a history of two hundred years of the baronetcy of Murthly is significant.[133] It is made even more so by the recognition that more traditional portraits, including a bust-length image by Henry Inman (1844, Joslyn Art Museum) and a full-length portrait of Stewart in military garb commemorating his participation in the Battle of Waterloo (ca. 1825, Murthly Castle) were passed over in favor of *Attack by Crows*.

Certainly *Attack by Crows'* serious subject matter, moral message, and connotations of salutary primitivism make it appropriate for reproduction in a book about twelve generations of a Highland family. But the image's placement within a book tracing the lineage of a Scottish aristocratic family suggests that its Indian themes might provide an important gloss not only on the identity of a Scottish Highlander, but of a British aristocrat as well. As the next chapter discusses, American Indian peoples appear to have offered a model not only of salutary primitivism compatible with Scottish identity but also of indigenous aristocracy that could stand as an example for the British aristocracy.

PLATE 14 Attack by Crow Indians, 1858–60
Watercolor on paper, 9⁷⁄₈ x 13⁵⁄₈ inches
The Walters Art Museum, Baltimore, Maryland

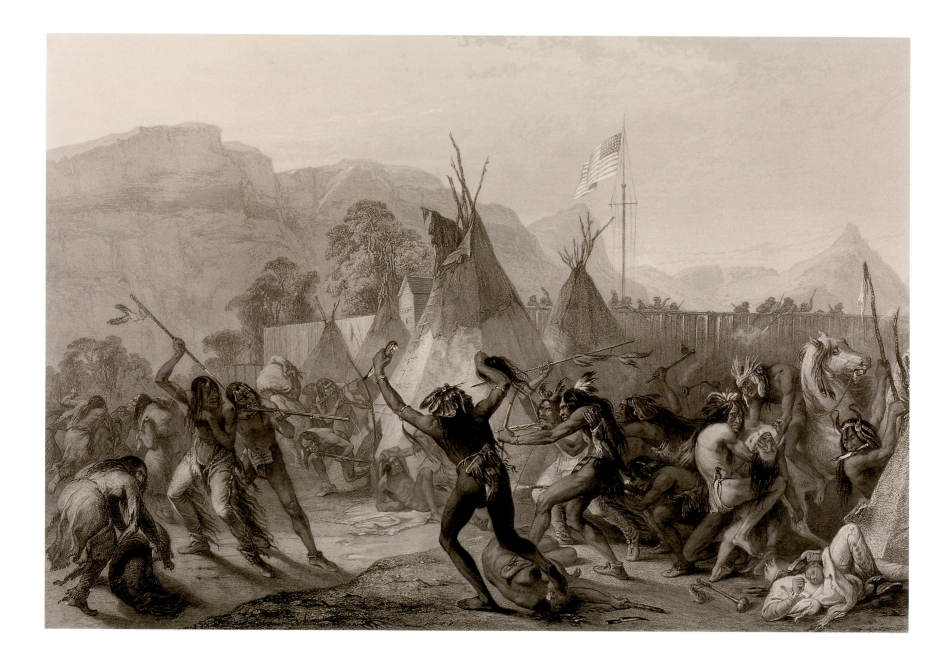

PLATE 15 Fort McKenzie, 28 August 1833

Aquatint after Karl Bodmer, Prinz Maximilian von Wied-Neuwied,
Reise in das innere Nord America in den Jahren 1832 bis 1834,
(Paris: A. Bertrand, 1840–43), Atlas, Tableaux, no. 42.
Amon Carter Museum, Fort Worth, Texas

PLATE 16 Hunting of the Grizzly Bear
Aquatint after Karl Bodmer, Prinz Maximilian von Wied-Neuwied,
Reise in das innere Nord America in den Jahren 1832 bis 1834,
(Paris: A. Bertrand, 1840–43), Atlas, Tableaux, no. 36.
Amon Carter Museum, Fort Worth, Texas

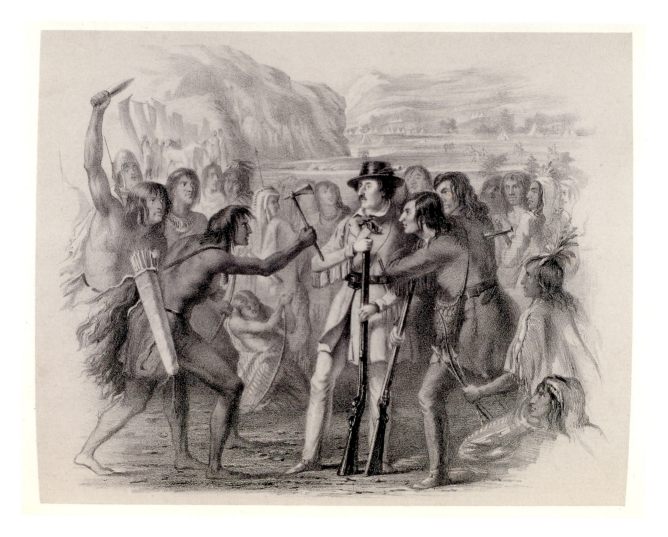

PLATE 17 Scene in the Rocky Mountains of America
From William Fraser, *The Redbook of Grandtully*, 2 vols. (Edinburgh, 1868),
facing p. ccxli
Courtesy American Heritage Center, University of Wyoming, Laramie

Notes

1. *Perthshire Courier,* 1 August 1839: 3, c. 2; Mae Reed Porter and Odessa Davenport, *Scotsman in Buckskin: Sir William Drummond Stewart and the Rocky Mountain Fur Trade* (New York: Hastings House, 1963), 179; DeVoto, *Across the Wide Missouri,* 360.

2. See Tyler, "Alfred Jacob Miller and Sir William Drummond Stewart," in Tyler, *Artist on the Oregon Trail,* 19–46, for a catalogue raisonné of Miller's works and a discussion of the Stewart commission.

3. Ibid., 27.

4. W. D. S. to William Sublette, New Orleans, 17 December 1838; London, 26 November 1839; New Orleans, 14 January 1844; Murthly Castle, 3 July 1844; 1 March 1845, Sublette Papers, Missouri Historical Society, Saint Louis.

5. Susan M. Pearce, *On Collecting: An Investigation into Collecting in the European Tradition* (New York: Routledge, 1995), 159.

6. Charles A. Geyer, *Notes on the Vegetation and General Character of the Missouri and Oregon Territories, Made During a Botanical Journey from the State of Missouri, Across the South-pass of the Rocky Mountains, to the Pacific, During the Years 1843 and 1844* [privately published], 1846.

7. Susan Stewart, *On Longing: Narratives of the Miniature, the Gigantic, the Souvenir, the Collection* (Baltimore: Johns Hopkins University Press, 1984), 155.

8. Mieke Bal, "Telling Objects: A Narrative Perspective on Collecting," in *The Cultures of Collecting,* ed. John Elsner and Roger Cardinal (London: Reaktion Books, 1994).

9. I have used Colin Campbell's definition of consumption: "The selection, purchase and use of goods and services. . . ." *The Romantic Ethic and the Spirit of Modern Consumerism* (New York: Basil Blackwell, 1987), 1.

10. Ibid., 89–91.

11. For an account of Stewart's travels, see Porter and Davenport, *Scotsman in Buckskin.* The portrait of Stewart has never been photographed, but it still hangs at Murthly today and was seen there by the author.

12. Porter and Davenport, *Scotsman in Buckskin.* On the timing of Stewart's authorship of *Altowan,* see his correspondence with his publisher in the J. Watson Webb Papers, MS 683, Manuscripts and Archives, Yale University Library, New Haven.

13. Michael Billig, *Banal Nationalism* (London: SAGE Publications, 1995), 1–12, 93–127.

14. Benedict Anderson, *Imagined Communities: Reflections on the Origin and Spread of Nationalism* (New York: Verso, 1999), 67–82.

15. Peter Womack, *Improvement and Romance: Constructing the Myth of the Highlands* (London: Macmillan Press, 1989), 1–3.

16. Barbara Maria Stafford, *Voyage into Substance: Art, Science, Nature, and the Illustrated Travel Account, 1760–1840* (Cambridge:

MIT Press, 1984); Christian F. Feest, "The Collecting of American Indian Artifacts in Europe, 1493–1750," in *America in European Consciousness, 1493–1750,* ed. Karen Ordahl Kupperman (Chapel Hill: University of North Carolina Press, 1995), 324–60.

17. Denis Porter, *Haunted Journeys: Desire and Transgression in European Travel Writing* (Princeton: Princeton University Press, 1991); Harry Liebersohn, *Aristocratic Encounters: European Travelers and North American Indians* (Cambridge: Cambridge University Press, 1998).

18. David C. Hunt, et al., *Karl Bodmer's America* (Lincoln: University of Nebraska Press, 1984); John I. Merritt, *Baronets and Buffalo: The British Sportsman in the American West, 1833–1881* (Missoula, Mont.: Mountain Press Publishing Company), 1985.

19. Liebersohn, *Aristocratic Encounters,* 135–64.

20. In *Imperial Eyes,* Mary Louise Pratt argues that Alexander von Humboldt's fascination with South American flora and fauna was an expression of a form of "planetary consciousness" in which the imperial aims of Germans in South America are reconfigured as disinterested scientific study. In defending this argument against those who countered that Humboldt was simply a romantic, Pratt wrote that "to the extent that something called romanticism constitutes or 'explains' Humboldt's writings on America, those writings constitute and 'explain [romanticism],'" 137.

21. DeVoto, *Across the Wide Missouri,* 309.

22. Tyler, "Alfred Jacob Miller and Sir William Drummond Stewart," in Tyler, *Artist on the Oregon Trail,* 40, and A. J. M. to D. H. M, Murthly Castle, 16 October 1840, Porter Papers, reprinted in Warner, *Fort Laramie,* 154. Although little mention is made of them, some of the sketches may have been exhibited at the Apollo Gallery in New York in 1839 along with the eighteen oil-on-canvas paintings. The reviews only mention the oils by name, but a review in the *New York Weekly Herald* described the works exhibited as "a number of original sketches and views" and later says Miller's sketchings *and* paintings are on view in the gallery. 11 May 1839, 149, c. 2.

23. *Indian Encampment Near the Wind River Mountains,* no. 170; *Receiving a Draught of Water from an Indian Girl,* no. 459A; *Visit to an Indian Encampment,* no. 419; *Visit to the Lodge of an Indian Chief,* no. 189A; *Interior of an Indian Lodge,* no. 415; *Interior of an Indian Lodge,* no. 93A; and *Indian Hospitality—Conversing by Signs,* no. 417A in Tyler, *Artist on the Oregon Trail.*

24. James Warren Springer, "An Ethnohistoric Study of the Smoking Complex in Eastern North America," *Ethnohistory* 28, no. 3 (1981): 217–35.

25. Ibid., 222–25; Richard White, *The Middle Ground: Indians, Empires, and Republics in the Great Lakes Region, 1650–1815* (Cambridge: Cambridge University Press, 1991), 6, 20–23, 40, 372.

26. Miller in Ross, *The West of Alfred Jacob Miller,* pl. 186.

27. Ibid., pl. 167.

28. [Sir William Drummond Stewart], *Altowan; or, Incidents of Life and Adventure in the Rocky Mountains by an Amateur Traveler,* ed. J. Watson Webb, 2 vols. (New York: Harper & Bros., 1846), 1:142; earlier the pipe is referred to as "the emblem of peace," 1:46.

29. *New York Morning Herald,* 16 May 1839, 2, c. 3.

30. See also *Indian Procession, Headed by the Chief Ma-Wo-Ma, Indian Race, Hunting the Argali in the Rocky Mountains, Herd of Wild Horses,* and *Racing—Near Wind River Mountain;* catalog numbers 178, 181, 138A, 447A, 183 in Tyler, *Artist on the Oregon Trail.* All are illustrated in Parke-Bernet Galleries, *A Series of Watercolour Drawings by Alfred Jacob Miller, of Baltimore: Artist to Captain Stewart's Expedition to the Rockies in 1837.* 6 May 1966 (New York: Parke-Bernet Galleries, 1966), sale number 2436.

31. Joan Troccoli has commented on Miller's images as "theatrical in flavor," and notes that Miller often composed his images like a stage set in *Watercolors of the American West,* 13. On Miller's interest in the theater, see Johnston, "Back to Baltimore," in Tyler, *Artist on the Oregon Trail,* 70, and Miller, Journal, 24, 72.

32. Allen Chronister and Clay Landry, "Clothing of the Rocky Mountain Trapper, 1820–1840," in *The Book of Buckskinning VII,* ed. William H. Scurlock (Texarkana, Tex.: Scurlock Publishing, 1995), 2–41; Pat Tearney, "The Clothing," in *The Book of Buckskinning,* ed. William H. Scurlock (Texarkana, Tex.: Rebel Publishing, 1981), 97–116; Linda R. Baumgarten, "Leather Stockings and Hunting Shirts," in *American Material Culture: The Shape of the Field,* ed. Ann Smart Martin and J. Ritchie Garrison (Winterthur: Henry Francis du Pont Winterthur Museum, 1997), 251–76.

33. Anne Hollander, *Sex and Suits* (New York: Alfred A. Knopf, 1994), 81–92.

34. Ibid., 88.

35. Ibid., 87.

36. James Buzard, "Translation and Tourism: Scott's *Waverley* and the Rendering of Culture," *Yale Journal of Criticism* 8, no. 2 (1995): 43.

37. Ibid., 38.

38. Ibid., 43–44.

39. ". . . I received from some 'fair maid of Perth' a valentine a few weeks since." A. J. M. to Harriet A. Miller, Murthly Castle, 22 March 1841, Porter Papers.

40. Miller in Ross, *The West of Alfred Jacob Miller,* pls. 130, 154, 183, and 196. My thanks to William R. Johnston for his generosity in sharing his research on Miller's literary sources in the notes. See also William R. Johnston, "Alfred Jacob Miller—Would-Be Illustrator," *The Walters Art Gallery Bulletin* 30, no. 3 (December 1977), unpaginated. For the sketches, see nos. 892–49, 892–1, 892–6, and 888–85 in Tyler, *Artist on the Oregon Trail.*

41. Porter and Davenport, *Scotsman in Buckskin,* 183.

42. A. J. M. to D. H. M., Murthly Castle, 25 December 1840, Porter Papers.

43. W. D. S. to William Sublette, London, 3 July 1844; Murthly, 1 March 1845; New Orleans, 17 December 1838; Robert Campbell to W. D. S., Saint Louis, 29 August 1839, Sublette Papers.

44. William Sublette to W. D. S., Saint Louis, 5 January 1842, Murthly Muniments GD 121, Box 101, Bundle 22, no. 31.

45. A. J. M. to W. D. S., New Orleans, 27 March 1839, Murthly Muniments, GD 121/101/21/99.

46. "Sale of Antique Furniture and Tapestry from Murthly Castle," *The Scotsman,* 19 June 1871: 2, c. 4; see also *The Scotsman,* 22 May 1871: 8, c. 2, 29 May: 8, c. 2, 5 June: 8, c. 2, and 12 June: 8, c. 2. The advertisements for the estate sale at Chapman's of Hanover include a reference to "Indian Dresses and Arms."

47. Robert Campbell to Sir William D. Stewart, Saint Louis, 29 August 1839, Murthly Muniments, GD 121/101/21/122; William Sublette to W. D. S., Saint Louis, 16 June 1841, Murthly Muniments, GD 121/101/22/5; 13 January 1842, Murthly Muniments, GD 121/101/22/33; 22 November 1843, Murthly Muniments, GD 121/101/22/77.

48. Stewart, *On Longing,* 135.

49. Ibid., 142.

50. A. J. M. to D. H. M., Murthly Castle, 25 December 1840, Porter Papers.

51. Jennifer McLerran, "Trappers' Brides and Country Wives: Native American Women in the Paintings of Alfred Jacob Miller," *American Indian Culture and Research Journal* 18, no. 2 (1994): 1–41; Troccoli, *Watercolors of the American West,* 11–12.

52. Troccoli, *Watercolors of the American West,* 31; Clark, "Romantic Painter," in Tyler, *Artist on the Oregon Trail,* 58.

53. See McLerran's discussion of this issue in "Trappers' Brides and Country Wives," and Linda Nochlin, "The Imaginary Orient," *Art in America* 71, no. 5 (May 1983): 118–31, 187–91.

54. Stewart, *Altowan,* 2:111–12.

55. Ibid., 1:101.

56. Porter and Davenport, *Scotsman in Buckskin,* 132, 154; DeVoto, *Across the Wide Missouri,* 354.

57. A. J. M. to D. H. M., Murthly Castle, 25 December 1840, Porter Papers.

58. Stewart, *On Longing,* 135.

59. Robert Campbell to W. D. S., Saint Louis, 29 August 1839, Murthly Muniments, GD 121/101/21/122.

60. Geyer, *Notes on The Vegetation and General Character of the Missouri and Oregon Territories,* 66.

61. Ibid., 55–56.

62. *Perthshire Courier,* 4 July 1839, 2, c. 6; "Moozedeer" refers to moose deer.

63. Lord Breadalbane to W. D. S., Taymouth, 1 November 1832, Murthly Muniments, GD 121/101/21/23.

64. Miller, Journal, 51.

65. Porter and Davenport, *Scotsman in Buckskin,* 187, 206–7.

66. Rev. William James Anderson, "Sir William Drummond-Steuart [sic] and the Chapel of St. Anthony the Eremite, Murthly," *Innes Review* 15, no. 2 (1964): 161, 164.

67. Porter and Davenport, *Scotsman in Buckskin,* 179; A. J. M. to D. H. M., Murthly Castle, 31 October 1840 and 1 November 1841, Porter Papers.

68. A. J. M. to D. H. M., 31 October 1840, Porter Papers; Porter and Davenport, *Scotsman in Buckskin,* 184, 204.

69. A. J. M. to D. H. M., Murthly Castle, 1 November 1841, Porter Papers.

70. A. J. M. to D. H. M., 25 December 1840, Porter Papers.

71. Campbell, *Romantic Ethic,* 86; the line of poetry Campbell quotes is Keats, "Ode on a Grecian Urn," in *The Poetical Works of John Keats,* ed. H. W. Garrod (Oxford: Clarendon Press, 1958), 260–62.

72. Campbell, *Romantic Ethic,* 63, 89–90.

73. W. D. S. to William Sublette, 3 July 1844, 1 March 1845, Sublette Papers, Missouri Historical Society.

74. W. D. S. to William Sublette, Murthly, 26 November 1839; 23 August 1841; 3 November 1841; 20 February 1842; 3 April 1842, Sublette Papers, Missouri Historical Society.

75. Stewart, *Altowan,* 2:111–12.

76. Campbell, *Romantic Ethic,* 86.

77. Stewart, *Altowan,* 1:61.

78. A. J. M. to Theodore H. Miller, Murthly Castle, 24 June 1841, Porter Papers. My thanks to James Nottage for bringing the chairs to my attention. There are, in fact, two pairs of chairs, both of which I have examined for this account: the originals still at Murthly Castle, and a second pair that Stewart had made as a gift, which are now at the Autry National Center. On the provenance of the Autry chairs, see "Scotch-Miscellaneous Data, Story of the Buffalo Chairs," Porter Papers, box 47, folder 2, and unidentified news clipping in the Autry accession files

identifying the Urrard House, Killiecrankie, as the family that received the chairs as a wedding gift from Stewart; see also Phillips, Scotland, *The Contents of Knockdow: Toward, Dunoon, Argyll: to Be Sold by Auction within Our Glasgow Salerooms on Tuesday 3 July, Wednesday 4 July and Thursday 5 July 1990* (Glasgow: Phillips of Scotland, 1990). According to Porter and Phillips, the chairs contained real bison horns and hooves, but conservation examination at the Autry and private correspondence with the present owners at Murthly reveal that the horns and hooves of each pair are of rosewood.

79. A. J. M. to D. H. M., Murthly Castle, 31 October 1840, Porter Papers.

80. Ibid.

81. Kenneth L. Ames, "Meaning in Artifacts: Hall Furnishings in Victorian America," in *Common Places: Readings in American Vernacular Architecture,* ed. Dell Upton and John Michael Vlach (Athens: University of Georgia Press, 1986), 240–60.

82. John Preston Neale, *Jones' View of the Seats, Mansions, Castles, etc. of Noblemen and Gentlemen in England, Wales, Scotland and Ireland, and other Picturesque Scenery Accompanied with Historical Descriptions of the Mansions, Lists of Pictures, Statues &c. and Genealogical Sketches of the Families and Their Possessors; Forming Part of the General Series of Jones' Great Britain Illustrated.* London: Jones & Co., 1831), 12, 16; the auction advertisements indicate Stewart owned all six volumes of *Jones' Views; see The Scotsman,* 19 June 1871, 8, c. 2; Queen Victoria also mentions Birnam Hill in her journal; see *Victoria in the Highlands,* ed. David Duff (London: Frederick Muller, 1968), 38; A. J. M. to D. H. M., Murthly Castle, 16 October 1840; A. J. M. to Brantz Mayer, Murthly Castle, 18 October 1840; A. J. M., Murthly Castle, 24 June, 1841, Porter Papers.

83. William Fraser, *The Red Book of Grandtully,* 2 vols. (Edinburgh: privately published, 1868), 1:xlii.

84. Ibid., 1:xl–xli.

85. *Perthshire Courier,* 20 June 1844, 3, c. 2.

86. *Constitutional Perthshire Agricultural and General Advertiser,* 6 March 1850, 2, c. 5.

87. Arthur H. Williamson, "Scots, Indians and Empire: The Scottish Politics of Civilization 1519–1609," *Past and Present: A Journal of Historical Studies* 150 (February 1996): 46–83.

88. Ibid., 48–52.

89. Sally M. Foster, *Picts, Gaels, and Scots: Early Historic Scotland* (London: B.T. Batsford, 2004), 11, 15–18.

90. Alexander Cunningham, *The History of Great Britain: From the Revolution in 1688, to the Accession of George the First* (London: Thomas Hollingbery, 1787), and Thomas Pennant, *A Tour in Scotland MDCCLXIX,* 2nd ed. (1772) as quoted in Womack, *Improvement and Romance,* 27.

91. William Robertson, *The History of Scotland, During the Reigns of Queen Mary and King James VI. Until His Accession to the Crown of England; with a Review of the Scottish History Previous to that Period: And an Appendix Containing Original Papers,* 2 vols. (Albany, N.Y.: E. and E. Hosford, 1822), 2:263.

92. On this process, see John Prebble, *The Highland Clearances* (Harmondsworth, U.K.: Penguin Books, 1969); A. J. Youngson, *After the Forty-Five: The Economic Impact on the Scottish Highlands* (Edinburgh: Edinburgh University Press, 1973); N. T. Phillipson and Rosalind Mitchison, eds., *Scotland in the Age of Improvement* (Edinburgh: Edinburgh University Press, 1970).

93. Murray G. H. Pittock, *The Invention of Scotland: The Stuart Myth and the Scottish Identity, 1638 to the Present* (London: Routledge, 1991), esp. chap. 3, "The Invention of Scotland," 73–98; Peter T. Murphy, "Fool's Gold: The Highland Treasures of MacPherson's Ossian," *ELH* 53, no. 3 (1986): 567–92.

94. Patrick Graham, *Sketches of Perthshire* (Edinburgh: J. Ballantyne and Co. for P. Hill, 1812), 225–26, 235, 236.

95. John Ramsay of Ochtertyre, *Scotland and Scotsmen in the Eighteenth Century,* ed. Alexander Allardyce, 2 vols. (Edinburgh: William Blackwood and Sons, 1888), 394, 402, 406–7, 409.

96. See Michael Gaudio's discussion of DeBry's illustrations which, the author argues, allowed "Europeans [to] look across the ocean and see themselves as they once were." *Engraving the Savage: The New World and Techniques of Civilization* (Minneapolis: University of Minnesota Press, 2008). See also David Beers Quinn, *The Elizabethans and the Irish* (Ithaca: Cornell University Press, 1966), esp. chap. 9, "Ireland and America Intertwined," 106–22.

97. I thank Alexander Nemerov for directing me to John White's depictions of Pict and Algonquian peoples. Thomas Harriot, *A Briefe and True Report of the New Found Land of Virginia with Engravings by John White.* Published by Theodor de Bry. Frankfurt-am-Main, 1590, facsimile with an introduction by Paul Hulton (New York: Dover Publications, 1972); David B. Quinn, "Thomas Harriot and the New World," in *Thomas Harriot: Renaissance Scientist,* ed. John W. Shirley (Oxford: Clarendon Press, 1974), 36–53; and William M. Hamlin, "Imagined Apotheosis: Drake, Harriot, and Raleigh in the Americas," *Journal of the History of Ideas* 57, no. 3 (July 1996): 405–28.

98. Paul Hulton, *America, 1585: The Complete Drawings of John White* (Chapel Hill: University of North Carolina Press, 1984), figs. 28–29, 130–31. T. D. Kendrick, *British Antiquity,* (London: Methuen & Co., 1950), 121–25.

99. Gladys Bryson, *Man and Society: The Scottish Inquiry of the Eighteenth Century* (Princeton: Princeton University Press, 1945), 15–17. I thank Elizabeth Hutchinson for directing me to the Scottish Enlightenment as a source for Scottish primitivism and for generously sharing her bibliography on the topic with me.

100. Adam Ferguson, *Institutes of moral philosophy: For the use of students in the College of Edinburgh,* 2nd ed. (Edinburgh, 1773), 11, as quoted in P. B. Wood, "The Natural History of Man in the Scottish Enlightenment," *History of Science* 28, no. 79 (March 1990): 100.

101. Ferguson, *Essay on the History of Civil Society,* 80. George W. Stocking, Jr., "Scotland as the Model of Mankind: Lord Kames' Philosophical View of Civilization," in *Toward a Science of Man: Essays in the History of Anthropology,* ed. Timothy H. H. Thoresen (The Hague: Mouton Publishers, 1975), 75–76; Bryson, *Man and Society,* 99–100.

102. Bryson, *Man and Society,* 1–29, 45; Wood, "Natural History of Man," 89–123, esp. 107.

103. Stocking, "Scotland as the Model of Mankind," in Thoresen, *Toward a Science of Man,* 76–77. Bryson, *Man and Society,* 99–100; Duncan Forbes in Ferguson, *Essay on the History of Civil Society,* xxxii–xxxviii; Wood, "Natural History of Man," 106. I thank Professor Viktor Gourevitch for the term "salutary primitivism."

104. John Gregory, *A comparative view of the state and faculties of man with those of the animal world,* 7th ed., (London, 1777), 69–70, as quoted in Wood, "Natural History of Man," 107.

105. Wood, "Natural History of Man," 108; Stocking, "Scotland as the Model of Mankind," in Thoresen, *Toward a Science of Man,* 80; Ferguson, *Essay on the History of Civil Society,* xl.

106. Ferguson, *Essay on the History of Civil Society,* 228. Ferguson does not specify American "savages" in the passage quoted, but in his introduction, Duncan Forbes interprets that as his meaning, xxxv.

107. Stocking, "Scotland as the Model of Mankind," in Thoresen, *Toward a Science of Man,* 72.

108. Lord Kames, *Sketches of the History of Man,* 2nd ed., 4 vol., (Edinburgh, 1778), 1: 424–25, 494, as quoted in Stocking, "Scotland as the Model of Mankind," in Thoresen, *Toward a Science of Man,* 76.

109. Stocking, "Scotland as the Model of Mankind," in Thoresen, *Toward a Science of Man,* 76.

110. Ferguson, *Essay on the History of Civil Society,* xxxix.

111. Stocking, "Scotland as the Model of Mankind," in Thoresen, *Toward a Science of Man,* 86, and George W. Stocking, Jr., *Victorian Anthropology* (New York: Free Press, 1987), 17; Bryson, *Man and*

Society, 99–100; Duncan Forbes, "The Rationalism of Sir Walter Scott," *Cambridge Journal* 7, no. 1 (October 1953): 20–35; Peter D. Garside, "Scott and the 'Philosophical' Historians," *Journal of the History of Ideas* 36, no. 3 (July–September 1975): 497–512; and Jana Davis, "Sir Walter Scott's *The Heart of Midlothian* and Scottish Common-Sense Morality," *Mosaic* 21, no. 4 (Fall 1988): 55–63. Terence Martin, *The Instructed Vision: Scottish Common Sense Philosophy and the Origins of American Fiction* (Bloomington: Indiana University Press, 1961), vii. Bryson, *Man and Society*, 4–5, 11–12.

112. Thomas Babington Macaulay, *The History of England from the Accession of James II*, 5 vols. (Chicago: Belford, Clarke & Co., 1884), 3:276, 285. On Macaulay's view of the Highlanders as an obstacle to the incorporation of Scotland into the British economy, see Frank Palmeri, "The Capacity of Narrative: Scott and Macaulay on Scottish Highlanders," *Clio* 22, no. 1 (1992): 37–52.

113. Sir Walter Scott, dedicatory epistle to *Ivanhoe* as quoted in Alexander Welsh, *The Hero of the Waverley Novels* (New York: Atheneum, 1968), 90.

114. Sylvia Van Kirk, "Fur Trade Social History: Some Recent Trends," in *Old Trails and New Directions: Papers of the Third North American Fur Trade Conference*, ed. Carol M. Judd and Arthur J. Ray (Toronto: University of Toronto Press, 1980), 162; Heather Devine, "Roots in the Mohawk Valley: Sir William Johnson's Legacy in the North West Company," in *The Fur Trade Revisited: Selected Papers of the Sixth North American Fur Trade Conference, Mackinac Island, Michigan, 1991*, ed. Jennifer S. H. Brown, et al. (East Lansing: Michigan State University Press, 1994), 225–26; Colin G. Calloway, "Neither White Nor Red: White Renegades on the American Indian Frontier," *The Western Historical Quarterly* 17, no. 1 (January 1986): 43–66.

115. Sir Walter Scott, "Introduction," *Rob Roy* (1829 ed.) as quoted in Welsh, *Hero of the Waverley Novels*, 90.

116. On the importance of the distinction between Scotland's quest for cultural and political nationalism, see H. J. Hanham, *Scottish Nationalism* (Cambridge: Harvard University Press, 1969), 25–39; Christopher Harvie, *Scotland and Nationalism: Scottish Society and Politics 1707–1994* (New York: Routledge, 1994), 7, 13, 33–35; I. G. C. Hutchison, "Preface" in *A Political History of Scotland, 1832–1924: Parties, Elections and Issues* (Edinburgh: John Donald Publishers, 1986); Linda Colley, "A Scottish Empire?" in *Britons: Forging the Nation 1707–1837* (New Haven: Yale University Press, 1992), 117–32.

117. Hugh Trevor-Roper, "The Invention of Tradition: The Highland Tradition of Scotland," in *The Invention of Tradition*, ed. Eric Hobsbawm and Terrence Ranger (Cambridge: Cambridge University Press, 1983), 15–42.

118. Marilyn Stokstad, "Romantic Images in Art," in *The Scottish World: History and Culture of Scotland*, ed. Harold Orel, et al. (New York: Harry N. Abrams, 1981), 260. See also Hanham, *Scottish Nationalism*, 70, and Trevor-Roper, "Invention of Tradition," 29–31. Trevor-Roper writes that "the idea of differentiated clan tartans, . . . seems to have originated with the resourceful manufacturers," who saw a large potential market for differentiated tartans in preparation for the royal visit to Edinburgh. "In these circumstances, the first duty of the firm was to keep up the supply and ensure that the Highland chiefs were able to buy what they needed. So Cluny Macpherson, . . . was given a tartan from the peg. For him it was now labeled 'Macpherson', but previously, having been sold in bulk to a Mr. Kidd to clothe his West Indian slaves, it had been labeled 'Kidd', and before that it had been simply 'No. 155'," 30.

119. The Highlands is traditionally defined as the area north of the Highland line, which runs diagonally from Dumbarton (near Glasglow) to Stonehaven (just south of Aberdeen). Stewart's estate, located between present-day Perth and Dunkeld, was just north of the Highland line. See "Highlands," *The Columbia Encyclopedia*, 3rd ed. (New York: Columbia University Press, 1963).

120. A. J. M. to D. H. M., Murthly Castle, 3 December 1840, Porter Papers; Miller, Journal, 49; *Scotsman*, 17 June 1871: 2, c. 4. Artist Henry Inman, who visited Stewart and painted his portrait in 1844, also wrote to him subsequently regarding a ring he saw for sale bearing a miniature portrait of Prince Charles Edward, saying that he would have felt remiss had he not brought it to his attention. Henry Inman to William Drummond Stewart, Amberside, 27 August 1844, Murthly Muniments, GD 121/101/22/116.

121. Philip J. Deloria, *Playing Indian* (New Haven: Yale University Press, 1998), 5, 22, 28–32, 187.

122. James Clifford, *The Predicament of Culture: Twentieth-Century Ethnography, Literature, and Art* (Cambridge: Harvard University Press, 1988), esp. 216–30; Donna Haraway, "Teddy Bear Patriarchy: Taxidermy in the Garden of Eden, New York City, 1908–1936," *Social Text* (Winter 1984): 20–63; Werner Muensterberger, *Collecting: An Unruly Passion* (Princeton: Princeton University Press, 1994); and Diana Fane, et al., *Objects of Myth and Memory: American Indian Art at the Brooklyn Museum* (Brooklyn: Brooklyn Museum, 1991).

123. The painting is signed and dated 1841. It hung at Murthly Castle until Stewart's death and was auctioned in 1871 with *The Trapper's Bride*. An article in the *Scotsman* described it as "Interview of Sir William Drummond Stewart with the Indians of the Rocky Mountains, a grand gallery picture." Saturday, 17 June 1871, 2, c. 4. On *An Attack by Crows*, see Tyler, "Alfred Jacob Miller

and Sir William Drummond Stewart," in Tyler, *Artist on the Oregon Trail*, 41–42, no. 377A, and Tyler, *Artist as Explorer*, 9, 114–15. Joan Carpenter Troccoli, *Painters and the American West: The Anschutz Collection* (New Haven: Yale University Press, 2000), 89, 92–95.

124. Several accounts of the story exist. See DeVoto, *Across the Wide Missouri*, 125–37, 179, 185; Porter and Davenport, *Scotsman in Buckskin*, 71–73; Thomas D. Bonner, *The Life and Adventures of James P. Beckwourth* (Lincoln: University of Nebraska Press, 1972), 274–91; Washington Irving, *The Adventures of Captain Bonneville U.S.A. in the Rocky Mountains and the Far West*, ed. Edgeley Todd (Norman: University of Oklahoma Press, 1961), 150–51; Miller in Ross, *West of Alfred Jacob Miller*, pl. 150; Hiram Martin Chittenden, *The American Fur Trade of the Far West*, 2 vols. (New York: Francis P. Harper, 1902), 1:302–8; Gowans, *Rocky Mountain Rendezvous*, 1–22.

125. DeVoto, *Across the Wide Missouri*, 127.

126. Miller refers to the painting by this title in a letter to Decatur, Murthly Castle, 16 October 1840. One month later, in a letter to the Baltimore collector Dr. Benjamin Cockey, Miller refers to the painting by the title, "An Attack by the Crows on the Whites on the Big Horn River east of the Rocky Mountains," Murthly Castle, 15 November 1840. Porter Papers.

127. Miller provides a lengthy quote from the sermon in Ross, *The West of Alfred Jacob Miller*, pl. 179; on Cardinal Nicholas Patrick Wiseman, see *The Catholic Encyclopedia: A General Work of Reference for Art, Biography, Education, History, Law, Literature, Philosophy, the Sciences, Religion, and the Church* (New York: Gilmary Society, 1936), 976–77. In his rough drafts to the Walters notes, Miller provides a citation, presumably for the sermon: *Metropolitan Magazine*, 470, vol. 4. The Library of Congress lists four periodicals of that title for the time period in question; none matches the volume numbers and pagination of the citation.

128. Ferguson, *Essay on the History of Civil Society*, 228, see n. 121.

129. Through personal conversation with Ray Gonyea, curator of Native American art and culture, Eiteljorg Museum of American Indians and Western Art; see also Mary Jane Schneider, "Plains Indian Clothing: Stylistic Persistence and Change," in *Bulletin of the Oklahoma Anthropological Society* 17 (November 1968): 1–55; on hair bows and the hair pipes also worn in the painting, see "Three Ornaments Worn by Upper Missouri Dandies in the 1830's," in John C. Ewers, *Indian Life on the Upper Missouri* (Norman: University of Oklahoma Press, 1968), 91–97.

130. Joan Troccoli first observes the similarities between the two paintings in *Watercolors of the American West*, 48. Troccoli supposes Stewart, who had met Prince Maximilian in Saint Louis in 1833, might have purchased Bodmer's Picture Atlas

when it was published in 1840. On Bodmer, see David C. Hunt, et al., *Karl Bodmer's America* (Lincoln: University of Nebraska Press, 1984).

131. Though Bodmer's prints, in my view, are racialized portrayals of Native Americans to an extent that his watercolors are not, Bodmer closely supervised the production of images in the Atlas. On his prints, see George R. Tomko, "The Western Prints of Karl Bodmer," in *Prints of the American West: Papers Presented at the Ninth Annual North American Print Conference,* ed. Ron Tyler (Fort Worth: Amon Carter Museum, 1983), 47–56.

132. On phrenology in Indian imagery, see Charles Colbert, *A Measure of Perfection: Phrenology and the Fine Arts in America.* (Chapel Hill: University of North Carolina Press, 1997), and Bridget Luette Goodbody, "George Catlin's Indian Gallery: Art, Science, and Power in the Nineteenth Century," Ph.D. diss. (Ann Arbor: UMI, 1996). For a discussion of the differences between primitivist and racialized portrayals of Indians in literature, see Ezra F. Tawil, "Domestic Frontier Romance, or, How the Sentimental Heroine Became White," *Novel: A Forum on Fiction* 32, no. 1 (Fall 1998): 99–124.

133. "A Scene in the Rocky Mountains of America, Representing a Meeting Between Sir William Drummond Stewart and the Cro [*sic*] Indians, by Miller," is listed under the heading of "Portraits" in the table of contents, Fraser, *Red Book,* 1: iv.

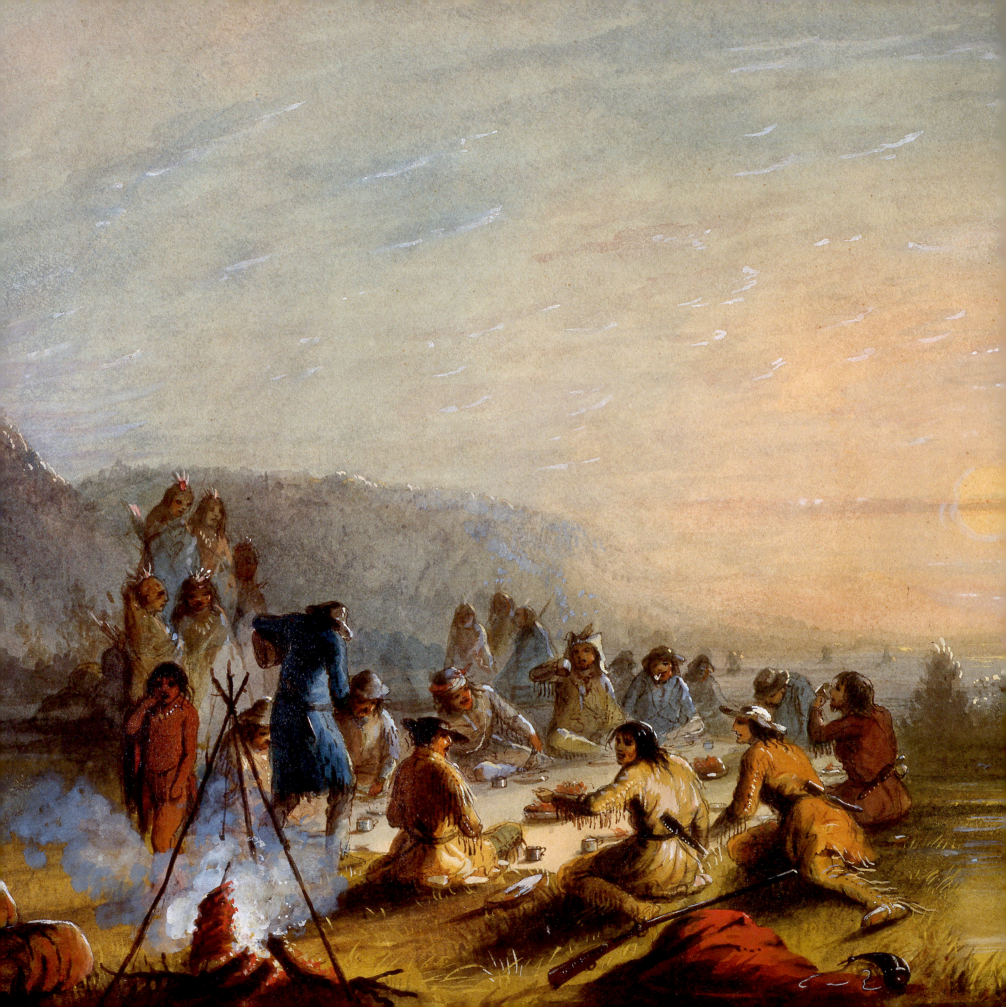

INDIGENOUS ARISTOCRACY IN

THE **STEWART COMMISSION**

*I*N OCTOBER 1837 a critic for the *New York Review* praised Washington Irving's newest book, *The Adventures of Captain Bonneville,* for illuminating the life of the Rocky Mountain fur trade:

> We heard there were hunters and trappers employed in gaining a dangerous and difficult livelihood from the peltries of the Columbia and Far Pacific . . . ; but we knew nothing of the life of adventure and excitement associated with that distant region . . . Irving has thrown a better light on the land for young and old. . . . Whether in fact or fable, may Irving continue to send forth more such delightful volumes.[1]

Given his enthusiasm for the subject matter, the reviewer would have been pleased to know that Alfred Jacob Miller had just returned to Saint Louis after a four-month tour of the West, bringing with him a rich cache of sketches depicting the fur trade. With public interest in trappers and the fur trade running high, one might expect that the trappers' revelries would inspire just the sort of "remarkable scenery and incidents of the journey" that Sir William Drummond Stewart had asked Miller to paint.[2] Indeed, many of the sketches Miller made in the field include portraits and genre scenes of trappers at the rendezvous (see chapter 4, plates 2–4). The selection of subjects in the twenty-eight oil-on-canvas paintings and an album of eighty-seven watercolor and pen-and-ink sketches that Miller prepared expressly for Stewart, however, is quite different. As may be expected, Stewart is shown in the majority of the images that have survived. Other whites appear only peripherally and in just a few of the scenes from the rendezvous.[3] American Indians, by contrast, have a strong presence in both the oils and the sketches included in the album. If we consider the album alone, fully one-third of the images are devoted exclusively to American Indian life, with Indians accompanying Stewart in half the images in which he appears. The narrow range of subject matter suggests that this iconography

represents not just a random grouping of Stewart's experiences at the rendezvous, but rather represents a set of conscious and/or unconscious choices that explicitly tell the story of Stewart's journey and implicitly reveal a larger body of attitudes about aristocratic Europeans and Indians.

Not only do the works prepared for Stewart focus on American Indians, Miller's correspondence also indicates that his patron took an active interest in the way in which Indians were portrayed. In the spring of 1841, Miller began work on his monumental *The Trapper's Bride.* In a letter to his brother, he described his work on the image: "The picture of the Trapper's Bride is progressing rapidly and seems to give much satisfaction to Sir Wm Stewart, who visits the painting room almost every day after luncheon to examine and perhaps to offer a criticism on any point wherein he thinks I may be wrong and woe to the Indian who has not sufficient dignity in expression and carriage, for *out* he must come."[4] Leaving aside, for the present, Stewart's role as patron in the conception and execution of the work, what is striking about this quote is his particular attention to Miller's representation of the Indians. What was Stewart's stake in images of Indians and in their "dignity in expression and carriage"?

Many of the images in the album show Stewart and his American Indian companions engaged in aristocratic pursuits, establishing parallels between the lifestyle and character of a Scottish aristocrat and an Indian.[5] The selection of these subjects, excluding those that represent the specific activities of the fur-trade rendezvous, portrays American Indians literally as natural aristocrats, sharing both noble pursuits and noble traits of character with Stewart. The selection of images in the album is a product of the choices and concerns of artist and patron alike, each of whom had a stake in assembling images that enhanced the status of the patron and his class. A recent study of the development of a concept of indigenous aristocracy among Continental elites suggests that French aristocrats underscored their own aristocratic ideals of courage, honor, and independence by comparing themselves to American Indians.[6] Similarly, the depiction of indigenous aristocrats in the album may have helped to reconfirm and reinvigorate aristocratic values during a period in which the Scottish and the larger British aristocracy's power was being challenged.

The Sketch Album as Collection

This chapter will focus on the album of sketches rather than the oil-on-canvas paintings Miller executed for Stewart.[7] Bound together in an album, the sketches represent a body of evidence that is at once a more purposeful and comprehensive narrative of Stewart's journey than the oil-on-canvas works, which were dispersed throughout the castle in the drawing room, the library, and Stewart's bedroom.[8]

The sketches were mostly monochrome, rendered in pencil, pen and ink, wash, and watercolor on an assortment of papers and tinted cards, numbered, and, in some cases, titled. The bulk of them

appear to have been completed in New Orleans, where Miller had resided from 1835 to 1837, and later in Baltimore between 1837 and 1839.[9] Upon completion they were shipped to Scotland along with eighteen oil-on-canvas paintings.[10] Once at Murthly, the sketches were bound and the album prominently exhibited in the drawing room. Miller himself traveled to Murthly that fall, and his letters home describe the album as "a richly bound portfolio [which] form[s] one of the chief attractions of the drawing room to his [Stewart's] distinguished visitors who are profuse in their compliments to me as regards both sketches and paintings."[11]

The sketches were numbered, bound together, displayed, and viewed in an album, indicating that they should be understood not discretely, but as a focused collection within Stewart's larger collection of Indian material. By considering what scenes were selected for inclusion in the album, we may begin to understand their common identity, and thus, their meaning.[12]

Artist and Patron

If Miller's portrayal of American Indians as indigenous aristocrats reflected Stewart's interests as a Scottish aristocrat, what was Miller's role in the album's conception? The selection of subjects in the album and the style and content of the sketches offer two separate, yet related, bodies of evidence. It appears that Stewart, at the very least, influenced the selection of scenes in the album, but his influence on the composition of individual sketches is less clear. Yet, the way in which the subjects are treated is consistent in many cases with the theme of the subject matter in the album, suggesting that Miller and Stewart were sympathetic to, or cooperated with, one another's vision of the album's content.

Stewart seems to have played a role in selecting both what Miller would paint and which images would be included in the sketch album. According to Miller, Stewart chided him during the trip for failing to sketch scenes of interest to Stewart. In notes Miller wrote to accompany a later set of western watercolors commissioned by William T. Walters, he complained about Stewart's demands: "Our Captain, who took great interest in this matter [my sketching], came up to me one day while so engaged, & said 'you should sketch this and that thing' and so on. 'Well!' I answered (possibly with a slight asperity), 'if I had half a dozen pair of hands, it should have been done!'"[13] Stewart also took an active interest in the progress of the commission once Miller had returned to his studio in New Orleans, visiting him there in 1838 and sending his agent to check on Miller's progress thereafter.[14] Moreover, Miller's letters indicate that Stewart selected the subjects of his oil paintings from among the eighty-seven watercolors.[15]

Although there is no evidence that this was his original intention, Stewart's correspondence indicates that by 1844 he had plans to use the sketches to illustrate his semiautobiographical novel, *Altowan; or, Incidents of Life and Adventure in the Rocky Mountains by an Amateur Traveler,* ultimately published in

New York in 1846 without illustrations.[16] Stewart had finished a draft of the novel by 1841, and in 1842 Miller declined a commission from Stewart for some lithographs based on the album sketches that may have been intended to illustrate the novel.[17] The link between the sketches and Stewart's novel, either before or after he wrote it, indicates the extent to which he felt the sketches reinforced or reflected his own vision of his journey.

Stewart may initially have been interested in the content and rendering of the images because so many are, in effect, portraits of him. In the strictest sense, the images do not conform to the conventions of portraiture in pose or proximity to the sitter; in those regards they are closer to genre scenes than portraits.[18] However, as far as the images' ability to confer information about Stewart's appearance, character, and activities, the images, as a group, achieve the objectives of portraiture with even greater effectiveness than a conventional portrait might. In fact, Miller had a moderately successful career as a portraitist before their trip, perhaps as a result of his ability to perceive and represent his patrons' self-images.[19] What is clear from the prominent display of the sketch album and other Miller paintings at Murthly, and from Stewart's continued patronage, is that Miller, at the very least, represented Stewart in a way he approved of, if not in a way that he specifically dictated.

Miller's letter describing Stewart's requirements for the "sufficient dignity and bearing" of the Indians represented in *The Trapper's Bride* suggests that Stewart was directly involved in Miller's portrayal of Indians as natural aristocrats. Miller's anecdote shows that Stewart influenced him in shaping a particular portrayal of American Indians. Stewart was engaged in a form of aristocratic patronage in which Miller, the artist, would reside with him for a period of time and paint exclusively for him. Under such an arrangement an informed patron often took an active role in the conception of a picture.[20]

The Murthly version of *The Trapper's Bride* has since been lost, so it is unclear how well the painting met Stewart's objectives. In his letter, however, Miller went on to assess the relative importance of Stewart's criticisms: "His conception of a picture, both as regards composition and coloring, is excellent and when I see the justice of his criticism, of course, I alter, but if I do not, I take my own way…."[21] If we take Miller here at his word, to what extent might we take him, and the sketches, to be sympathetic to Stewart's aristocratic concerns? One might expect that Miller, as a nineteenth-century American, would be hostile to the hereditary rule and conspicuous consumption of the European aristocracy. His letters from Murthly, however, betray an ambivalence. In a letter to his brother, for instance, Miller noted: "I shall not say anything about the manner in which I travel here or you will begin to think that my republicanism is fast oozing away. For an unpretending personage like myself it must be confessed that it is a little out of character but it is the spirit of the place and I 'maun' submit."[22] Despite this professed uneasiness, the majority of his letters home indicate that he was enamored of life at Murthly. His letters include elaborate descriptions of the castle, the art collection, and of his own fishing and hunting excursions as well as of elegant dinner parties and balls he attended.[23]

Both Baltimore and New Orleans were southern cities, and the South had always been more receptive to aristocratic values and lifestyle than other regions of the country. Miller may thus have been more favorably inclined toward the notion of an aristocracy than, for instance, a northern artist would have been.[24] Miller's father was at points in his career a prosperous merchant and farmer, and he did send Miller to one of the finest schools in Baltimore, where his son had the opportunity to befriend the city's social elite. Miller also seems to have moved in refined circles. His diary tells of a visit to George Washington's nephew, Major Lawrence Lewis (1767–1839), for a shooting weekend and also tells of invitations to Washington's home in Georgetown and to the White House.[25]

Miller may consequently have seen himself, in culture and education, as Stewart's peer. This idea is borne out in Miller's account of their journey. During the trip, Miller balked at being assigned the same duties as Stewart's camp employees; he did not want to stake his horse or do night watch like the other men and was thankful to Stewart for granting him the small favor of allowing him to hire someone else to serve in his stead as night guard. Once the two were back in Scotland, however, Miller commented happily upon the change in their relationship:

> Nothing could be in greater contrast than in the treatment I received here, with that I experienced on the prairies:—there he was the military martinet and rigidly exacted from me all the duties of the camp—said I had been spoiled at home—he insisted, among other things that I should catch my horse of a morning . . . so that I had to run a considerable distance in moccasins with the additional difficulty of securing him when I came up with him. . . . But at his home all this was changed—one of the best chambers in the castle was allotted to me, and a room next the library for a studio,—At his table I met some of the most distinguished of the nobility.—The Staffords, Pagets, Atholds, Breadalbanes, etc, etc. some of these given me pressing invitations to visit them.[26]

Miller's sense of his own position in society may thus have made him more sympathetic to Stewart as an aristocrat and, therefore, more sensitively attuned to Stewart's class concerns in the sketches.

It is also possible that political turmoil in both Scotland and Maryland in the years before their trip to the West provided another source of class sympathy between artist and patron. The Voting Reform Act of 1832 imperiled the British aristocracy's power by enfranchising large numbers of poor rural voters. Similarly, in 1836–38 Maryland enacted a series of constitutional reforms that made the state's electoral process more egalitarian. In what one historian has described as a "clash between advocates of democratic reforms and the defenders of the aristocratic old order," the Maryland legislature reapportioned House representation on the basis of population and made the election of senators and governor by popular vote.[27] Miller's political allegiance is unclear. In the early thirties, he supported slavery and made several visits to the Andrew Jackson White House, suggesting that he

was a Democrat. Later in his career, however, he renounced his views on slavery and supported the Union in the Civil War, two views generally associated with Whigs. His best friend and many of his important patrons were Whigs, and he did request that his brother forward a Whig newspaper to Scotland.[28]

Miller may also have been predisposed to see the rendezvous in chivalric terms. The metaphor appears at roughly the same time in Irving's *Bonneville* when the author describes the fur trade as "a wild, Robin Hood kind of life" and an example of mountain chivalry.[29] The reviewer for the *New York Review* complimented Irving for showing his readers that "here in these worn-out times of the world, there is a last foothold left for a remnant of chivalry in the wild life of the Far West."[30] Similarly, David Brown, a trapper also in attendance at the 1837 rendezvous, characterized the event as a kind of medieval fair where the encampment resembled old English engravings of knights and warriors' tents, and the Indian men were "dusky and Apollo-shaped forms of the flower of Indian chivalry." A scene at the rendezvous prompted the following reverie from Brown:

As I gazed in rapt admiration upon this, to me, dream-like exhibition, my mind instantly reverted to the storied wonders of my childhood and early youth, and I almost expected every moment to see issuing from the bosom of this Indian cantonment, in martial pomp and pride, the mailed and steel-clad forms of the old feudal times, so striking was its resemblance to the pictures already enshrined in my imagination from pouring over the delightful pages of Scott and Froissart, whose inimitable descriptions floated before my mental eye.[31]

Chivalry and warrior valor were the standards for aristocratic conduct, but they were also familiar notions to American readers of Sir Walter Scott. As discussed in the previous chapter, Miller was an enthusiastic reader and illustrator of Scott, so the idea of a bastion of chivalry in the West may have appealed to Miller simply for its romance. As late as 1860 Miller made general comparisons between the Indian men he painted and noblemen. He described Si-roc-u-an-tua as having a "bearing ... of a prince—courageous and self-reliant." Of Shim-a-co-che, Miller wrote "his behavior ... was full of dignity, and such as you might look for in a well-bred civilized gentleman," and he referred to Indian men several times in his notes as "lords of the prairie."[32]

There is no way of knowing the extent to which the ideas expressed in the album originated with Stewart or with Miller. Nevertheless, the artist's descriptions of Stewart's patronage as well as his own affinity for aristocratic life strongly suggest that the two worked closely together on the commission in an air of intellectual sympathy. In this sense, the album may perhaps be best understood as a collaboration in which Miller's generalized notion of Indian men as "lords of the prairie" was realized literally under Stewart's influence as images of an indigenous aristocracy.

Stewart as New World Aristocrat

Stewart inherited the title of seventh baronet of Murthly Castle in 1838.[33] Although baronets were not a part of the peerage proper and could not sit in the House of Lords, they were considered part of the same aristocratic order.[34] Stewart's family was comparatively wealthy, and his upbringing and early years in Scotland seem to have been typical for a member of the aristocracy.[35] His father hired him a private tutor and, when William was seventeen, purchased him a commission in the British army, where he rose to the rank of captain and fought at the Battle of Waterloo.[36] Stewart subsequently made several trips abroad, both to the Continent and on big game hunting expeditions to India and Turkey. In 1830, at the age of thirty-five, Stewart fathered a child with a maid, Christina, whom he later married.[37] Although he never lived with her and seems rarely to have seen her, he did acknowledge the child as his legitimate heir and gave him a traditional upbringing.[38] After his return to Murthly in 1839, he assumed all the duties of a Scottish aristocrat: he entertained, made improvements on his estate, devoted careful attention to the administration of his properties, and attended to the needs of his tenants.

Despite the relative exoticism of the setting, Miller's Indian sketches portray Stewart engaged in the same kind of aristocratic activities in the West that he would have engaged in on his own estate in Scotland. These activities, and the way Stewart is characterized while undertaking them, assert his gentlemanly status. According to historians of the British aristocracy, aristocratic status was identified as much by landownership and lifestyle as by political or legal privileges.[39] The main activities that marked such a lifestyle, including entertaining, participating in local government, and engaging in sports, particularly hunting, appear with frequency in the album and are emphasized through repetition and careful articulation. Moreover, the sketches characterize Stewart as skillful, generous, and dignified—qualities that were generally attributed to British noblemen by supporters of the aristocracy of the time.[40] Stewart was an avid hunter, and approximately one-quarter of the watercolors included in the collection are hunting scenes. Although hunting served a practical purpose for the participants at the rendezvous, providing their principal means of sustenance, certain images treat hunting as an entertainment. They stress the challenge of the hunt itself and the character, sportsmanship, and skill of Stewart as a hunter. To the extent that these images represent Stewart's activities during his trip, they are indicative of an established European tradition of illustrated travel journals or albums.[41] However, the sketches' particular emphasis on the hunt as a sport and on the skill of the hunter allows these images to function not just as a means of recording Stewart's exploits, but also as key elements in the governing metaphor of natural aristocracy.

In *Hunting the "Argali" in the Rocky Mountains* (plate 1) we see Stewart at the lower right dressed in a white buckskin suit and feathered cap, accompanied by his guide, Antoine, to his left. The two crouch behind a row of rocks, stalking a herd of mountain sheep (or argali). The sheep in the middle ground flee their pursuers, bolting up a curving mountain path at full speed. One sheep skids onto its side,

PLATE 1 Hunting the "Argali" in the Rocky Mountains, 1837–39

Pencil and pen and ink with gray and brown washes on white card blind-stamped "London Superfine," 8⁷⁄₁₆ × 7¼ inches

Courtesy of the High Desert Museum, Bend, Oregon

careening off the path to the right. It is significant that Miller has chosen to depict a moment when the hunters are *stalking* their prey, rather than shooting or killing it. According to contemporary accounts, the greatest challenge in hunting mountain sheep came in the pursuit, when the sheep's steep and rocky habitat proved hazardous to hunters on foot. According to one trapper, Osborne Russell (1814–1892):

Hunting sheep is often attended with great danger especially in the winter season when the rocks and precipices are covered with snow and ice but the excitement created by hunting them often enables the hunter to surmount obstacles which at other times would seem impossible.[42]

Similarly, another British traveler in the West wrote:

> It is no easy matter to get within rifleshot of the cautious animals. When alarmed they ascend still higher up the mountain; halting now and then on some overhanging crag and looking down at the object which may have frightened them, they again commence their ascent, leaping from point to point and throwing down an avalanche of rocks and stones as they bound up the steep sides of the mountain.

He concluded that the mountain sheep was the "game par excellence of the Rocky mountains."[43]

Miller further underscored the sportsmanship involved in the hunt by pitting the physical advantages of the sheep, well suited to maneuvering in their rugged mountain habitat, against the mental skills of the hunters. The row of rocks that Stewart and Antoine crouch behind divides the picture diagonally from the lower left to the mid-right. The image contains a number of oppositions between the upper and lower registers of the painting that help to establish the respective advantages of the hunters and their prey. The sheep have a bright open space in which to exercise their superior speed, and a rocky outcropping provides both another means of escape and an additional challenge to the substantially less agile hunters. In contrast to the furious motion of the sheep, Stewart and Antoine enjoy strategic superiority as they lurk quietly below in a dark enclave. Stewart kneels gracefully on one knee with his legs stretched wide apart and his torso forward, his physical composure serving as a metaphor for the mental poise necessary to successfully stalk and kill the nimble sheep.

By matching the mental superiority of the hunter with the physical superiority of his prey, Miller portrayed the hunt as fair and thus sportsmanlike. In addition, the skill and bravery of the hunters is implied by the level of the challenge that the sheep present. This emphasis on sportsmanship in the images helps to contextualize Stewart's hunting as primarily a sporting rather than a practical affair, in contrast to the role it actually played for participants in the fur trade who were dependent on the success of the hunt for their sustenance. By placing hunting within a British sporting context, these images affirm for the viewer of the sketch book that, although he has entered the wilds of America, Stewart remains an aristocrat in both his manner and his pursuits.

A number of images in the collection also depict Stewart playing the role of a diplomat or honored guest among the Indians. In the watercolor *Reconciliation Between Delaware and Snake Indians* (plate 2), Miller places Stewart prominently at the center of the page, his figure clearly articulated amid a large group of Indians. Miller established Stewart's role as a mediator by situating him strategically between the two factions. Stewart's figure falls within the horizontal band of figures running across the center of the sheet, yet his white suit along with the open space that lies at his feet sets him apart from the Delaware and Snake on either side, distinguishing him as a third party. In addition, he faces one group while pointing to the other, suggesting both his ability to consider each side of the

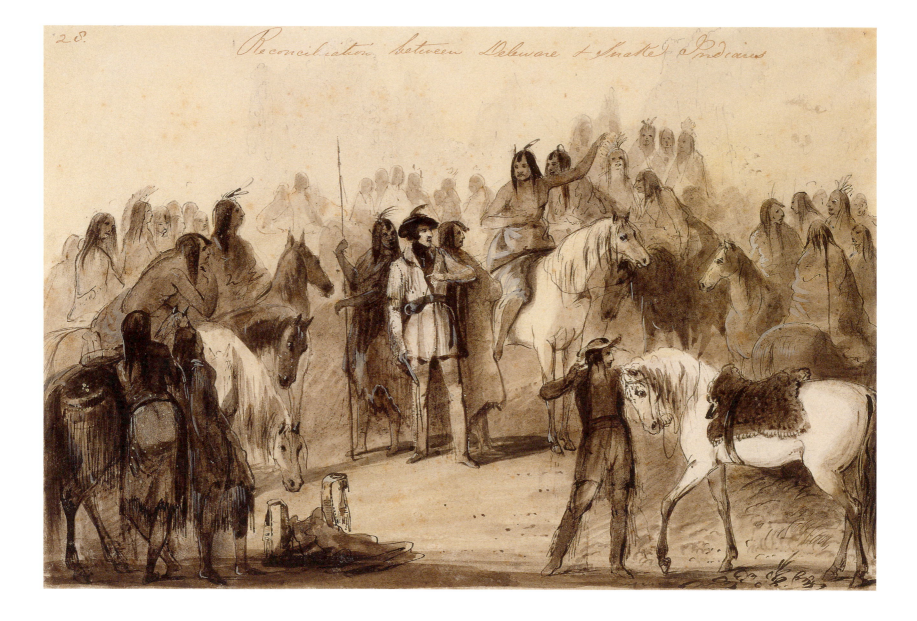

'28.

Reconciliation between Delaware & Snake Indians

PLATE 2 Reconciliation Between Delaware and Snake Indians, 1837–39

Ink, ink wash, and opaque white over graphite underdrawing on paper, 7¼ × 10⅝ inches

Amon Carter Museum, Fort Worth, Texas

PLATE 3 Indians Assembled in Grand Council to Hold a Talk, ca. 1837

Wash drawing on paper, 8¾ × 10⅞ inches

Buffalo Bill Historical Center, Cody, Wyoming; Gift of the Coe Foundation

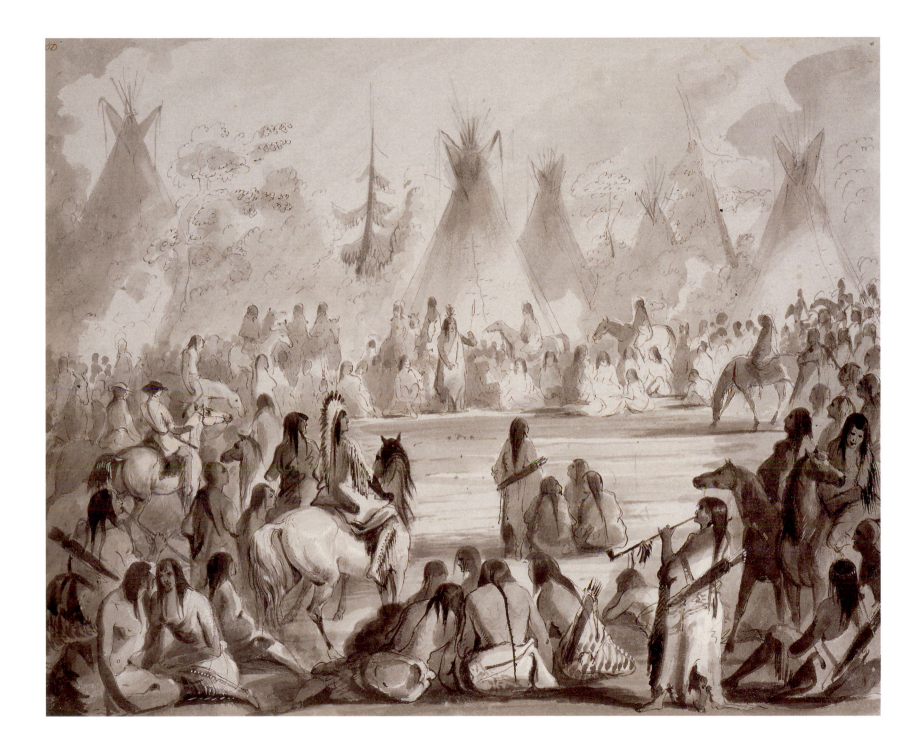

matter and his capacity to channel information from one party to the next. Diplomacy, along with the military, was considered among the professions suitable to the younger sons of the aristocracy, so that Stewart's adopted position as mediator on the Plains was also entirely suited to his class.[44]

In *Indians Assembled in Grand Council to Hold a Talk* (plate 3), Miller again depicted Stewart taking part in American Indian politics. Here Stewart is the only white present at an Indian gathering, yet his formal and physical incorporation into the group both indicates his acceptance by the council and implies his participation in it. Stewart's supposed participation in an Indian council parallels the role of the aristocracy as members of local government. By asserting Stewart's ease and familiarity with Delaware and Snake affairs and his political importance to them, both images imply that Stewart's behavior remains consonant with that of a nobleman.

American Indians as Indigenous Aristocrats

Miller did not present Stewart as a lone aristocrat in the wilds of America. In certain images, American Indians share in aristocratic pursuits such as hunting, racing, and diplomacy. Moreover, Miller frequently drew visual analogies between his patron and the Delaware and Snake, suggesting that the Indians shared aristocratic character as well as its attendant pursuits. In *Indians Assembled . . .* , Stewart's figure on horseback echoes the figure of the "chief" in a feathered warbonnet on horseback in the foreground to Stewart's right. Their poses reinforce their mutual presence, lending greater prominence to both. Yet the formal similarities suggest a further conceptual analogy between "chief" and "nobleman." The concept of an Indian chief as a single hereditary leader was essentially a white construction based on misconceptions of American Indian culture. The position of "chief" as whites understood it, however, paralleled the tradition of hereditary rule among the aristocracy, thus forming a point of imagined similarity between the two cultures.[45] In Miller's sketches and in notes written later, the Shoshone leader, Ma-Wo-Ma, played a political role similar to that of Stewart as protector and mediator. According to Miller, Ma-Wo-Ma was "a man of high principle, in whom you could place confidence"; and he goes on to recall how, "when our commander on a former journey had a difficulty with the Indians, and lost all his horses, this Indian exerted himself in his behalf and recovered the most of them:—he stated also to him that if he had placed himself under his (Ma-Wo-Ma's) protection in the first place, he would not have lost any."[46] The systems of debt and obligation that existed between Indian chief and kin (in this case Ma-Wo-Ma and Stewart) and between aristocrat and tenant are analogous. Moreover, if we return to *Reconciliation Between Delaware and Snake Indians,* we notice that the Indians share Stewart's dignified bearing. Although the title of the sketch suggests that a dispute has taken place, none of the participants appear hostile or unruly. The Indians closest to Stewart lean inward, appearing to listen carefully to the discussion, while a man at left on horseback sits with his chin in his hand in a contemplative gesture. These figures suggest that here reason rather

than emotion will prevail. Their civilized conduct is thus at odds with prevalent period stereotypes depicting Indians as highly emotional or subject to animal passions. The oddly conventional poses of the man with the lance who looks back over his shoulder to listen to Stewart, and the figure in the foreground holding the horse, which extends one leg delicately outward, further defuse any real sense of conflict. These mannered poses further suggest a refinement both in the style of the painting and also in the character of the Delaware and Snake themselves.

Hunting, an important part of both American Indian and Scottish aristocratic life, provided one of the most obvious similarities between the two cultures. In the watercolor *Indians Tantalizing a Wounded Buffalo* (plate 4), three Indian men display skill and bravery in the buffalo hunt. In the image, Miller shows two men enticing a wounded buffalo to chase them while a third man takes aim at the lower left side of the buffalo in order to pierce his heart with an arrow. Although a wounded buffalo was notoriously dangerous, the man in the foreground raises his arm up in the air, blithely tossing his head and laughing as his horse gallops away from the wounded animal. The figure behind him similarly laughs, his mouth wide open in an exaggerated grin. His courage is matched by the skill of the third warrior who is able to take such careful aim while racing around the wounded animal on horseback. This image is significant not only because its presence in the album calls attention to the shared tradition of the hunt but also because it shows the two men in the foreground visibly enjoying the process of the hunt itself. The gesture of tossing one's head and waving one's arm also connotes feelings of liberation or freedom, which is suggestive when considered within the context of a British hunting tradition. Until 1832, British game laws had ensured that hunting remained an exclusive privilege of the landowning aristocracy. While the primary outward purpose of hunting was entertainment, the enjoyment of hunting as a privilege *in itself* played an important role among the gentry and nobility in establishing a unified sense of class identity.[47] Hunting meant something different to each of the Plains Indian groups, but for most it served both a deeply symbolic function, as an integral part of religious beliefs and social identifications, and a practical function, as a principal means of livelihood.[48] In *Indians Tantalizing a Wounded Buffalo,* however, the Indian hunt is characterized in aristocratic terms as a matter of entertainment and privilege rather than as an important social or religious act. In this way as well it presents American Indians as natural aristocrats.

Other examples of American Indians engaged in recognizably aristocratic pastimes appear frequently in the album. *Indian Race* (plate 5), for instance, shows Indians attending and participating in a horse race, with Stewart joining others in the foreground to watch.[49] *Trial of Skill—With the Bow and Arrow* (plate 6) presents a perfect union between the medieval, chivalric associations of an archery competition and the bow and arrow as symbol of authentic American Indian life. The three Indian figures prepare to shoot arrows at a target, gracefully posed in a circular configuration that suggests three stages in the motion of the shoot: selecting the arrow, stringing the bow, and taking aim at the target. While the poses of the three archers invite formal comparisons to such classical sculptures as

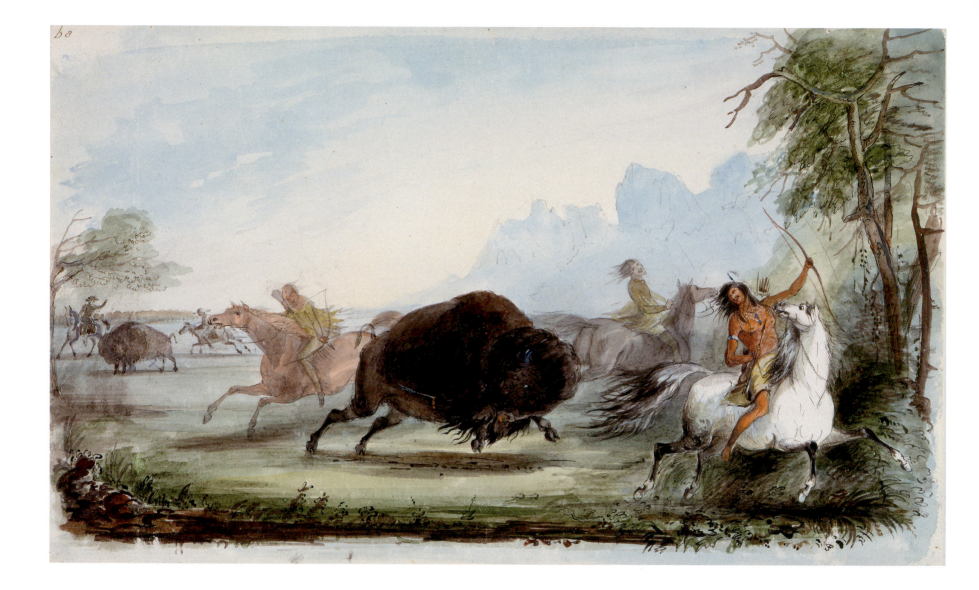

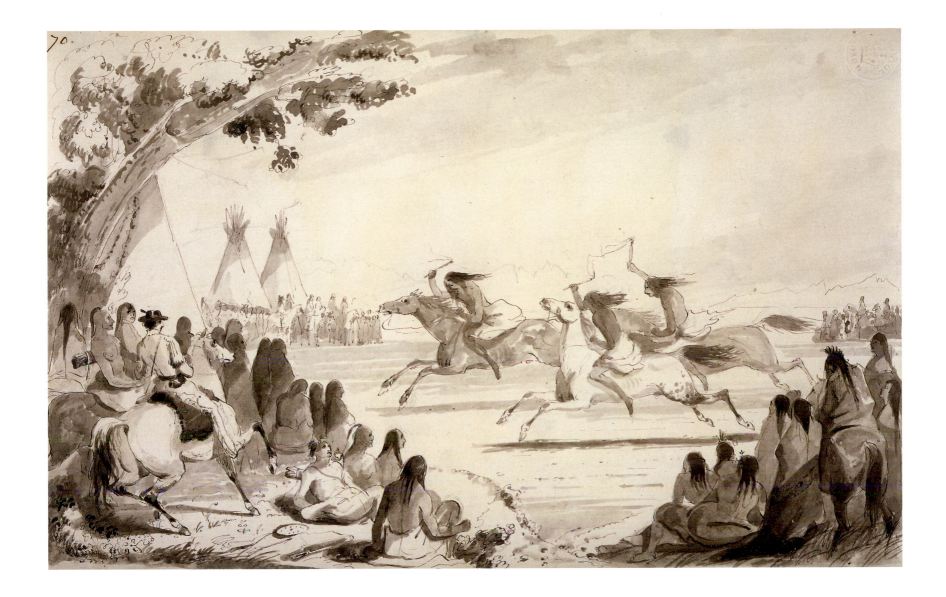

70.

PLATE 4 Indians Tantalizing a Wounded Buffalo, 1837
Ink, ink wash, and opaque white over graphite underdrawing on paper,
8½ × 13¾ inches
Amon Carter Museum, Fort Worth, Texas

PLATE 5 Indian Race, ca. 1837
Pen and ink with gray wash on paper, 7⅝ × 12⅛ inches
Buffalo Bill Historical Center, Cody, Wyoming; Gift of the
Coe Foundation

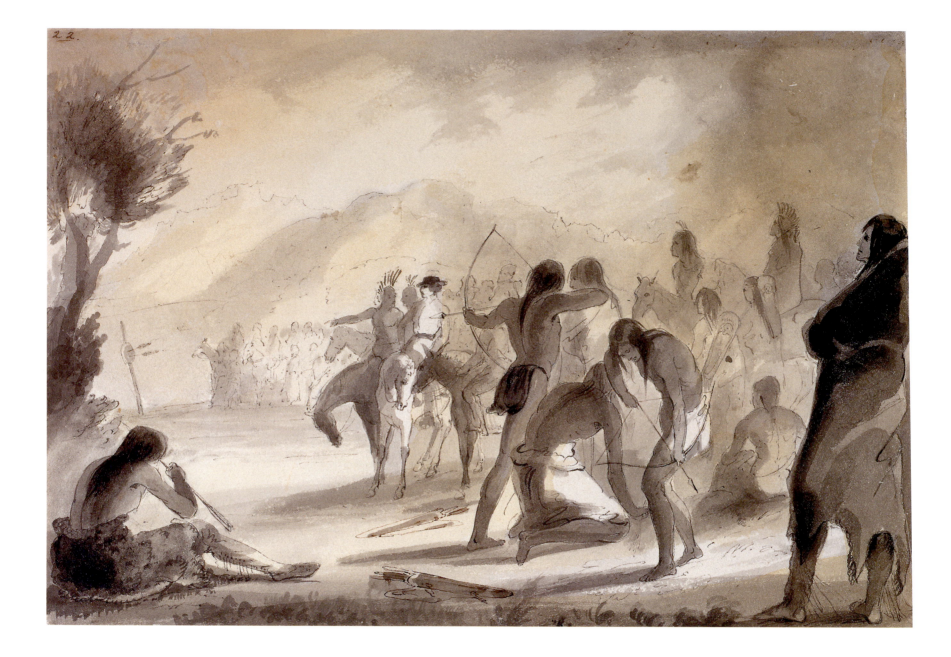

PLATE 6 Trial of Skill—With the Bow
and Arrow, ca. 1837
Pen and ink with gray and yellow washes on paper,
7⅜ × 10¼ inches
The Walters Art Museum, Baltimore

Myron's *Diskobolos* (450 B.C.), their activities recall the feats of Robin Hood in Sir Walter Scott's *Ivanhoe* (1819), a figure legendary for his honor and warrior valor as well as for his skill with bow and arrow.

Just as Miller's sketches suggest parallels between Indians and aristocrats by showing them enjoying similar pursuits, Stewart, in his novels, went further to suggest that it is in contemporary Indian life that one has the best opportunity to develop the qualities that define authentic aristocracy. Following a scene in which the Métis character Altowan oversees a bow-and-arrow competition similar to the one shown in Miller's sketch, he waxes philosophical on the advantages of life on the prairies, asking: "What are the pleasures of civilized life to me, who am already blooded in the wild Indian chivalry? There is no war among the whites, where I could rise to command, but by long and servile submission; there is no tourney, there is not hunting-field among them, where danger is courted, and manhood holds a place such as here is accorded to its prowess."[50] Altowan has no impetus to leave the new world where he can live as a natural aristocrat; in civilization he will be socially demoted by virtue of his race. Moreover, since Altowan possesses neither land nor title, there would be no opportunity in civilization for his true nobility of character to manifest itself, for him to rise to command or to experience the challenge of real danger.

The portrayal of indigenous aristocracy in the sketches is further supported by a significant omission within the album. Although the collection illustrates Stewart's experiences at the fur-trade rendezvous, and a few images do include the supply-wagon caravan, there are no images within the album that record trapping or trading. Stewart's correspondence indicates that he was acting as one of the crew chiefs for the American Fur Company at the 1837 rendezvous. Together with the omission of images of the trappers themselves, the exclusion of any images that depict the fur trade helps to focus the subnarrative of the album on aristocratic rather than commercial themes.[51]

Indigenous Nobility in European Thought

The sketch album, along with Stewart's novel, establishes parallels between American Indian and aristocratic culture in a way that had a precedent in continental European thought. Mid-nineteenth-century French aristocrats reworked the idea of noble savagery to fit their own historic situation, transforming it into a discourse on indigenous nobility. Eighteenth-century theorists of noble savagery, basing their ideas loosely on Jean-Jacques Rousseau's *Second Discourse* (1754), saw indigenous people as living in a state of nature, free from social hierarchies. As such, the discourse of noble savagery could be used to critique institutions such as the aristocracy itself. As French society became increasingly egalitarian in the wake of the Revolution, however, noblemen who had been stripped of much of their political power relied on the perpetuation of a noble lifestyle and values to distinguish themselves from nonaristocrats. Aristocratic travelers, such as Alexis de Tocqueville (1805–1859) and

Adelbert von Chamisso (1781–1838) found in indigenous cultures a source for an imaginative revival of aristocratic ethos. Both described how qualities such as independence, honor, and freedom, which marked European aristocratic behavior, could also be found among indigenous peoples. American Indian "chiefs" were believed to inherit their positions, and like the aristocracy, they were stereotypically viewed as making their living principally from hunting and warfare, unlike white American farmers and merchants.[52]

If identification with American Indian aristocrats proved to be a means for Continental elites to reassert the importance of (and to naturalize) aristocratic values in the wake of a dramatic loss of political power, it had very different ramifications for the British elite. When Stewart departed from Scotland for the United States, Britain was in the midst of political turmoil that resulted in the Voting Reform Act of 1832. The Reform Act transformed the British electoral system, giving power to the middle class by substantially lowering the property requirement for enfranchisement and by revising districts in favor of small towns versus large estates. The Act had its most profound effect in Scotland, where new voters increased by 1,400 percent. The eighteen months leading up to the passage of the bill were a time of crisis for the aristocracy, particularly in Scotland, where reformers rioted and smashed windows. Many in Britain feared an uprising of reformers against the nobility, and in the winter of 1831–32 some fortified their country homes.[53]

While 1832 marked the beginning of a slow and steady decline in aristocratic power and influence in Britain, what was remarkable about the aftermath of the reform, according to many historians, was the extent to which the aristocracy was nevertheless able to maintain its influence over national government. Although the 1832 reform meant a large shift in the demographics of the electorate, members of the aristocracy and landed gentry continued to make up most of the House of Commons.[54] According to British historian W. L. Guttsman, the continued success of the aristocracy after 1832 rested on the belief of aristocracy and citizens alike that the nobility were the class of British society most qualified to rule:

> This largely undisturbed enjoyment of political power by the traditional ruling class cannot be explained solely in terms of political institutions and parliamentary situation. It is doubtful whether the aristocracy would have been so successful if, on the whole, it had not been convinced of the justification of its own exercise of power and, in addition, had managed to persuade a large section of the population of the righteousness of its claim.[55]

This justification for rule rested, in part, on three beliefs: that inherited wealth among rulers resulted in an unbiased government, that the aristocratic class possessed a character suited to rulership, and that a tradition of aristocratic rule ensured social stability. Inherited wealth and property supposedly allowed aristocrats to make decisions unimpeded by the personal ambition of the business class.[56]

As Hippolyte Taine, a Frenchman traveling in Britain, wrote of the British aristocracy in 1872, "A man of business, constantly obliged to think of profit and details of profit all day long, is not a gentleman and never can be.... The man who deals in money or business is inclined to selfishness; he has not the disinterestedness, the large and generous views, proper to leaders of a Nation."[57] As evidence both of their wealth and their disinterest in money, aristocrats were expected to live lives of conspicuous consumption. Inherited wealth not only made for disinterested rulership, it also ensured the superiority of aristocratic conduct. Aristocrats had the leisure time to develop the education, social skills, and honorable virtues that working classes could not.[58] An aristocratic lifestyle thus became a means of identifying members of the aristocracy as well as justifying aristocratic power and, ultimately, preserving it.

The social stability supposedly brought about by inherited rulership likewise provided an argument in favor of aristocratic rule. Yet the period preceding Stewart's travels in America was one characterized by enormous social change within the British aristocracy. During this period, there was a consolidation and reallocation of older estates together with a marked increase in the creation of new peerages. Many new peerages were conferred on newly monied industrialists who had purchased estates sold off by older families. In fact, many of Britain's most distinguished families during the nineteenth century could trace their wealth back only two or three generations. As one historian has noted, "The ultimate paradox of Britain's so-called ancient regime was thus not that it was so old, but rather that it was so new."[59] More important, perhaps, from Stewart's perspective, the Scottish peerage was also being amalgamated into the British. Peers were distinguished from the lower aristocracy (baronets, knights, and the gentry) by their exclusive right to serve in the House of Lords. But after the unification in 1707, only those who held British or English titles were eligible to claim this right. Thus, if a person held a Scottish title that had previously entitled him to sit in Scottish parliament, that right did not transfer to the British parliament. By the nineteenth century, "To a Scotch peer, nothing could be so desirable as a British peerage."[60] In fact, the number of applications increased following a spate of British peerage conferrals in 1790–1830. Though Stewart held the title of baronet, he could have applied for a higher-ranking British peerage and likely watched as other of his peers did. The Duke of Breadalbane's father, for instance, had applied for and received a British title in 1806.[61]

In order to preserve the appearance of social stasis, the aristocracy asserted its antiquity in a variety of ways. During the mid-nineteenth century, it was the fashion for the nobility in England, Scotland, Ireland, and Wales alike to renovate palaces in revival, particularly neo-Gothic, styles. Stewart's friend Lord Breadalbane made such improvements to his home in the 1830s.[62] A letter from the architect James Gillespie Graham to Stewart in Saint Louis describes the additions to Breadalbane's estates as being "in the character of the Scottish Castle proposed by the barons of old," and says that Breadalbane's library "now has the appearance of a grand gothic tower of past centuries."[63] Stewart himself

participated in this trend, overseeing the construction of a new wing to Murthly Castle in 1845 in an Elizabethan style (complete with a stone bearing the date 1675) and a new Chapel, St. Anthony of Eremite, designed by Graham in a neo-Gothic style.[64] Such improvements formed a means for the Scottish nobility to link themselves to the medieval roots of the aristocracy at a time when the aristocracy was for all intents and purposes reinventing itself through the incorporation of new peers.[65] This emphasis on indigenous aristocracy in the sketch album underscores the values and lifestyle on which British aristocrats based their claims to rulership. Stewart's Indian companions, like himself, appear to be brave, honorable, and free to enjoy the leisured activities of an aristocratic class.

An image such as *Conferring Presents on Indian Chiefs* (plate 7) even more so rejects middle-class values in favor of aristocratic ones by misconstruing the commercial activity of the fur trade as an act of generosity. In the image, Miller shows Stewart placing a necklace around the neck of an Indian man. Below him to his left sits Antoine with a trunk full of beaded and feathered objects. Exchanging gifts in Plains Indian culture was a means of establishing ties of friendship or even kinship between unrelated people. Historians of the American fur trade discuss the importance of gift exchange in structuring trade.[66] Trade between whites and Indians was initially enacted as an amended form of gift exchange, with the Indians conceiving of the exchange in social rather than economic terms and whites seeing it from the reverse perspective. *Conferring Presents* thus casts the trade in terms of gift exchange, rather than as an extension of eastern commercial activity.

Stewart made a show of disdaining commercial activity in favor of acts of generosity, and Miller appears to have been aware of the importance of that stance to his patron's sense of himself. An article in the *New York Morning Herald* in 1839 cites Miller's account of the following incident:

> As we were coming down to St. Louis, we had a large train of valuable horses, and I observed one day to Captain St., that his horses would bring him a large sum of money at St. Louis. He looked at me a moment and replied: "Mr. Miller, have you never been informed that I never sell anything?" On my answering in the negative, he said, "then Sir, you will now understand that I never do." All his fine horses were accordingly given away.[67]

Miller believed that the anecdote suitably characterized his patron.

The literal comparison between Stewart's aristocracy and the indigenous aristocracy of American Indians portrayed in Miller's sketches may also have helped to reinforce the idea of the aristocracy as an old order. Some scientists in this period believed that American Indians represented an early stage of human evolution. Prince Maximilian von Wied-Neuwied, for instance, sought to prove such a thesis through his study of American Indians residing along the upper Missouri River.[68] For the album's aristocratic audience back in Scotland, the sketch album may have presented a vision of the origins of the aristocratic order, a glimpse into their own past.

PLATE 7 Conferring Presents on Indian Chiefs, ca. 1837
Pencil and gray wash on paper, 6⅞ × 6½ inches
Unlocated

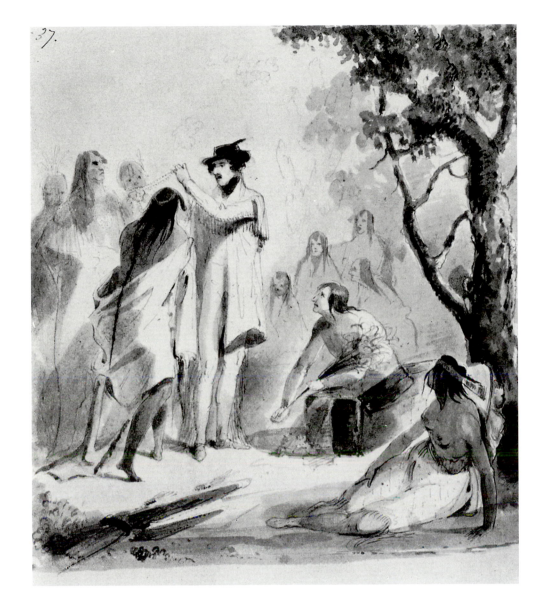

Comparing European and Indigenous Aristocrats

So far we have considered the way in which Miller's sketches present parallels between the activities of Stewart and the American Indians. We have not, however, discussed the relationship between the two groups. Do shared aristocratic traits mean Stewart interacts with his Indian companions in these images peer to peer, or do their relations remain hierarchical?

Aristocratic French travel writers developed their ideas about indigenous aristocracy as a reaction against French Enlightenment beliefs. Whereas Rousseau and his followers argued that peoples like

American Indians lived more moral lives because they were uncorrupted by the institutions of government and its concomitant social hierarchies, Liebersohn claimed that writers like Adelbert von Chamisso "fashioned for themselves and their readers the fiction of natural aristocrats, unchanged since the creation, whom one could glimpse just before the democratic civilization of Anglo-America surged over and forever buried them. Their travel writings offered a vision of aristocracy as the natural condition of man before the turmoil and decay of historical time."[69] Such texts thus transformed the image of European aristocracy from an artificial and corrupting institution as described by Rousseau to a naturally occurring expression of human values and traits.

Scottish Enlightenment ideas about the progress of mankind presented a vision of the aristocracy compatible with that of French aristocrats. As discussed in the previous chapter, the governing metaphor for cultural development was individual human development: various groups progressed through the stages of childhood, adolescence, and maturity, only at different speeds. Like French Enlightenment thinkers, the Scots believed that all human cultures developed from a savage to a civilized state, but the Scots differed from French Enlightenment thinkers by arguing that political institutions were a natural, rather than corrupting, condition of human culture. The key difference between so-called savage and civilized peoples, then, consisted in the levels of polish in, among other things, political institutions such as the aristocracy.[70] Thus, within the framework of Scottish Enlightenment thought, aristocracies themselves could exist in a primitive state. The concept of indigenous aristocracy thus operated not as a critique but as a logical extension of Scottish Enlightenment views.

Scottish Enlightenment theories of human development nevertheless allowed for a concept of social, as opposed to inherent ethnic or racial, inequality. Stewart and Miller both made clear that American Indians were savage aristocrats, while Stewart was a civilized one. When the eponymous character in Stewart's novel *Altowan* asks, "What are the pleasures of civilized life to me, who am already blooded in the wild Indian chivalry?" he clearly distinguishes the wild chivalry of Indian aristocracy from that of Europe. Throughout his writings, Miller consistently contrasted Indians and whites in Enlightenment terms as savage versus civilized.[71]

On the basis of such distinctions, Miller's album sketches suggest that the savagery of Indians accorded them a lower social status than that enjoyed by Stewart in their interactions. In *Conferring Presents*, Stewart gives gifts to a number of Indians identified by the title as chiefs. In its composition the image bears a resemblance to Jacques-Louis David's (1748–1825) painting of Napoleon crowning Josephine, titled *Coronation* (1808). It is possible that Miller was acquainted with the image and even with its overtones of political usurpation of ecclesiastical power. In the image, Stewart is in Napoleon's position as the bestower, with the unnamed Indian chief bowing his head to receive his gift. The fact that the gift is a necklace may also be significant. The U.S. Government provided peace medals, worn on a ribbon around the neck, to American Indians who visited Washington as part

of treaty delegations, a practice familiar to Miller since he painted portraits of several Indians wearing the medals.[72] The medals were bestowed upon select persons by the president himself both as tokens of Indian loyalty and as a sign of the government's promise to protect the interests of those who wore the medals. In such ceremonies, the government termed itself the Great Father, and American Indians its children or kin. As the latter, Indians were presumably obliged to provide gifts, such as furs or land, to the Great Father in return for his protection.[73] Even Miller's use of the word "conferring" in the title, rather than "giving" (as it appears in the title of a later copy in the Walters collection), suggests a military or civic honor. *Conferring Presents* thus connotes potent political ceremonies both in Europe and in America. What is important for the sake of this inquiry, however, is that in the case of either prototype, Stewart functions in the position of Great Father, patron, or benefactor—one who justifies his position of power through acts of generosity, similar to the way an aristocrat might bestow samples of the bounty of his estate upon his tenants.[74] Thus here, in their relationships to one another, Stewart remains the lord, while the Indians play the role of his vassals.

Another image in the album distinguishes between Stewart and Indian peoples by assigning the latter a lower class status within established fur-trade social hierarchies. *An Early Dinner Party near Larrimer's [Laramie] Fork* (plate 8) shows Stewart and his Métis employees sitting in a circle enjoying conversation and a meal, while shadowy Indian women and children stand in the background watching. The fur trade observed strict hierarchies in occupations and the privileges that accrued to them. Company partners occupied the highest rung, followed by their employees: clerks (or recordkeepers), interpreters, hunters, and voyageurs or general laborers. At the fort, partners and clerks ate at the "first table," enjoying their pick of the fare. Underlings such as interpreters and hunters ate afterward at the "second table," dining on what was left.[75] In his later commentary on *Breakfast at Sunrise* (plate 9), a version of *An Early Dinner* completed for William T. Walters in 1858–60, Miller described the Indians as "looking on patiently, in order to be ready for the 2nd table,"[76] suggesting that Indians occupied the fur trades' lower social rungs.

This social distinction between Indians and whites was generally reflected in Stewart's own treatment of Antoine and two Indians who accompanied him to Murthly in 1842. At Murthly, the Indians were not treated as indigenous aristocrats, but as servants who lived in the carriage house in the garden and acted as gamekeepers to the animals that Stewart had imported. Antoine, too, was treated explicitly as a servant. Whereas Miller, as earlier noted, was elevated from the lowly position he was assigned on the plains to that of a peer at Murthly (he was even allowed to play the role of host, carving at the dinner table while Stewart was away), Antoine was "metamorphosed into a Scotch valet and waits on the table in a full suit of black and this is everything that he does."[77]

As previously noted, Miller's treatment of Indians in the sketches and his later discussion of Indian peoples in the text he wrote to accompany the watercolors for William T. Walters in 1858–60 suggest that he saw them in terms of Enlightenment ideas of civilization and savagery. But Miller's images of

an Early Dinner Party,
near Larimdes Fork.

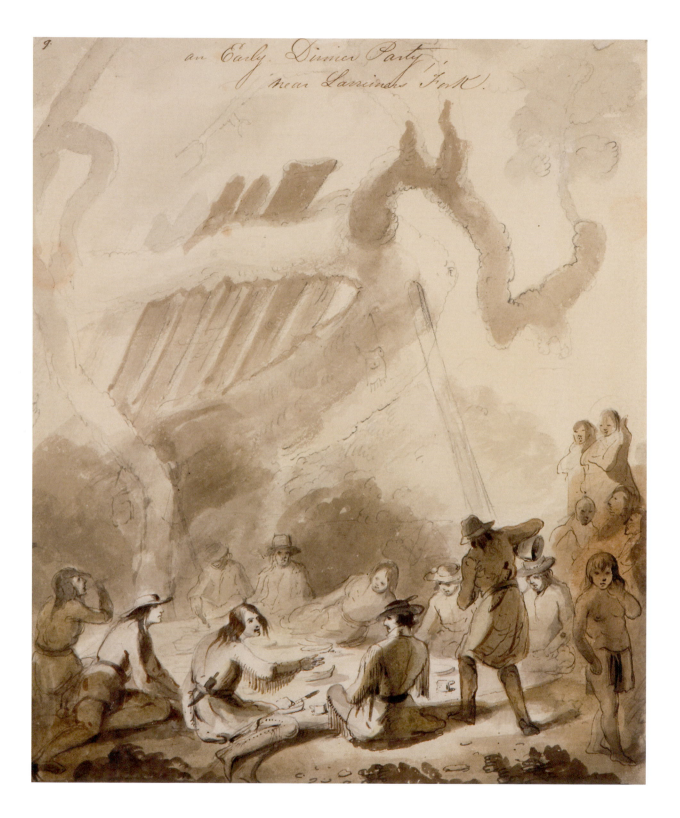

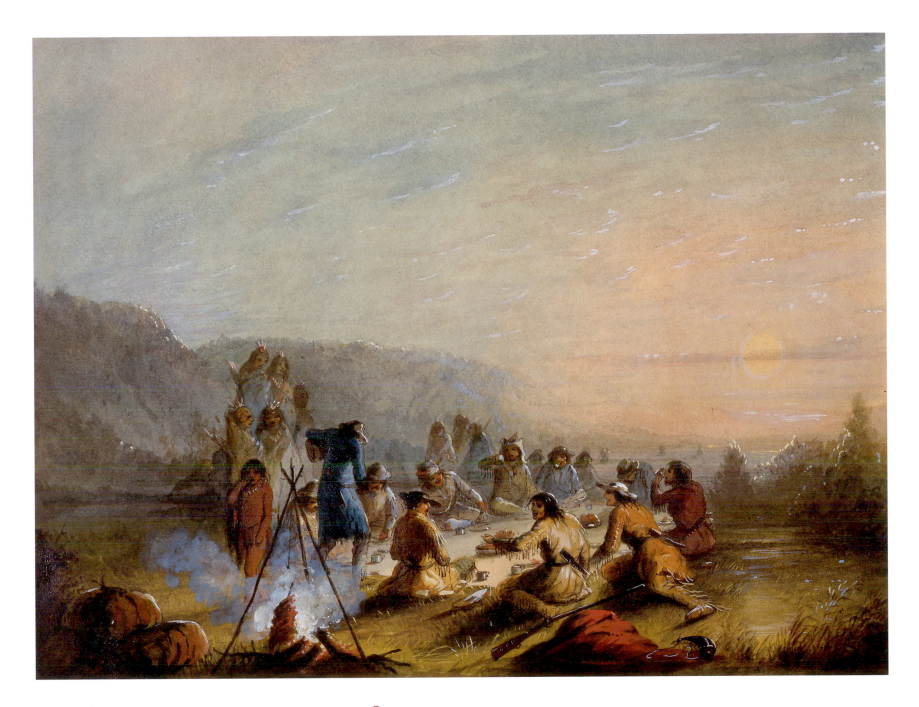

PLATE 8 An Early Dinner Party near Larrimer's [Laramie] Fork, ca. 1837
Pencil with brown and yellow washes on paper, 11½ × 8 inches
Fred Jones Jr. Museum of Art, The University of Oklahoma,
Estate of Eugene B. Adkins, Tulsa, Oklahoma

PLATE 9 Breakfast at Sunrise, 1858–60
Watercolor on paper, 10¼ × 13⅞ inches
The Walters Art Museum, Baltimore, Maryland

INDIGENOUS ARISTOCRACY IN
THE STEWART COMMISSION

PLATE 10 The Indian Guide, ca. 1837

Pen and ink with gray wash on buff card, 9 × 11 inches
Denver Art Museum Collection: Gift of Mr. and Mrs. John B.
Bunker and Lemon Saks

Antoine and the other Métis camp employees, or engagés, present a more complicated view of civilization and race than his images of Indians alone suggest. The Métis played a key role in the American fur trade, but they almost always occupied the lowest ranks of the trade. Miller's images may, at first glance, be taken as representative of the subordinate role that the Métis played in Stewart's camp. For instance, in *Conferring Presents*, Antoine is shown seated or kneeling behind the box of presents holding a large plume, appearing literally to play the role of servant as he hands Stewart the gifts. In other images, however, Miller seems to exceed the imperatives of his narrative in portraying the Métis not just as occupationally subordinate, but as socially and essentially inferior. In *The Indian Guide* (plate 10), Miller shows Stewart at roughly center, receiving information from an Indian man. Antoine, seated on a mule in the shadows at the right foreground, leans inward, straining to hear. A similar dynamic is repeated in *An Indian Giving Information of a Party Who Have Passed in Advance, by Impressions Left on the Ground* (plate 11), where Antoine, located behind Stewart at the right edge of the composition, again must lean over Stewart to see the signs to which the Indian points. Since Antoine, as guide and, presumably, interpreter, should have been the one speaking directly to the source, Miller has here underscored Antoine's subordinate position even at the expense of accurate reportage.

More important, however, Miller used subtle formal means to characterize Antoine as inferior. In *The Indian Guide,* Antoine is presented as slightly out of scale in relation to the other figures. Although he is located in the foreground, closer to the picture plane than Stewart, he is smaller. The same phenomenon is visible in *Herd of Wild Horses* (plate 12) and *Reconciliation Between Delaware and Snake Indians* (plate 2), where Antoine, despite his foreground placement, appears smaller than Stewart. This subtle distortion creates two effects. It makes Antoine seem smaller in stature, suggesting his physical inferiority to Stewart, and it makes him seem compositionally out of place.

Significantly, both of these qualities correspond to negative stereotypes of the Métis prevalent in America by midcentury. Scholars of Métis history have argued that an identifiable Métis culture, distinct from Indian and white cultures alike, began to emerge in the early nineteenth century in Canada and the United States.[78] The American response to that culture followed one of two lines. Whites either saw the Métis in Enlightenment terms, as a positive force that could serve as a bridge between savage Indian culture and civilized whites, or they saw them in racial terms, as a dangerous mixture between superior and inferior races.[79] The latter view characterized the Métis as hybrids who were socially out of place, fitting into neither white nor Indian society. The Métis hybrid was also seen as sedentary and lazy, socially impotent in a way that was analogous to the sexual infertility of animals that were crossbred.[80] Significantly, art historian Kenneth Haltman has observed in this regard that Miller often portrayed the Métis riding mules. If Miller was indeed portraying Stewart's Métis engagés as inherently, rather than situationally, inferior to Indians and whites, then his views in this respect were influenced by ideas of race rather than culture. Indeed, Miller's portrayal of Antoine as small in stature and compositionally marginalized may reflect his own deep-seated prejudices about the Métis,

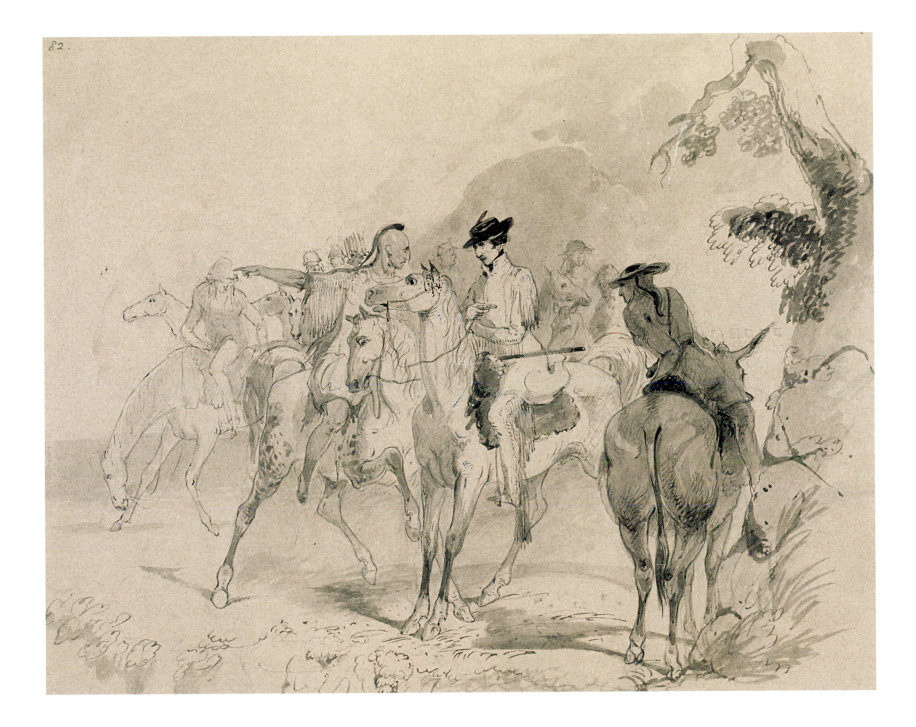

An Indian giving information of a party who have passed in advance, by impressions left on the ground. —

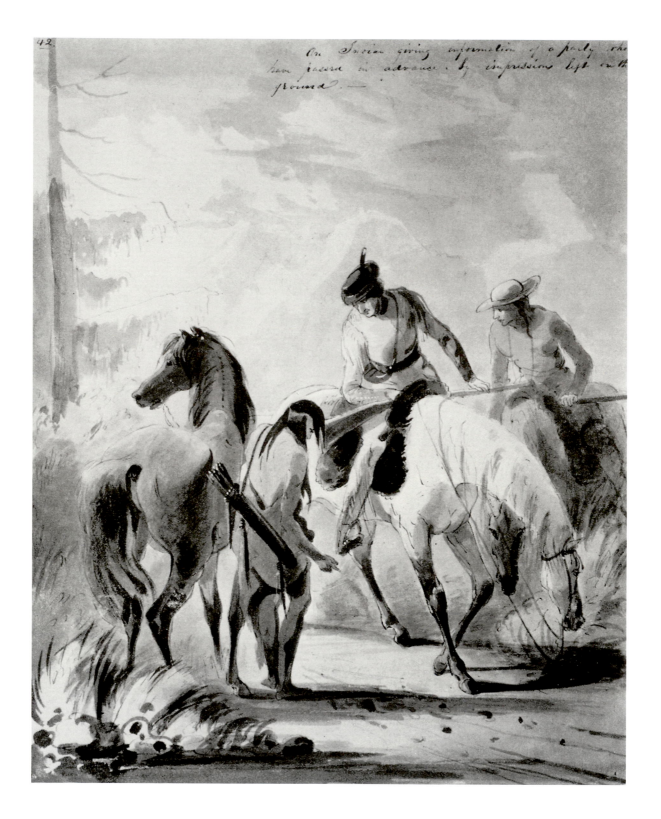

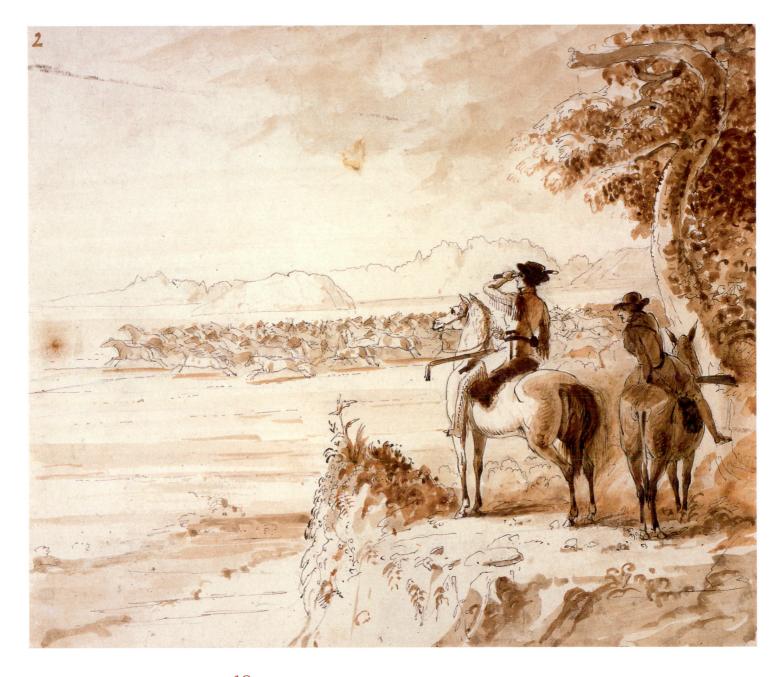

PLATE 11 An Indian Giving Information of a Party Who Have Passed in Advance, by Impressions Left on the Ground, ca. 1837
Gray wash with touches of white on gray card, 10⅛ × 8¾ inches
Unlocated

PLATE 12 Herd of Wild Horses, ca. 1837
Pen and ink with brown wash on paper, 7⅛ × 8½ inches
Buffalo Bill Historical Center, Cody, Wyoming; Bequest of Joseph M. Roebling

prejudices which were founded on racist ideas that directly challenged Scottish Enlightenment beliefs underpinning the ideal of indigenous aristocracy.

Stewart's decision to include a print of Miller's *Attack by Crows* in his history of the Stewart lineage, *The Red Book of Grandtully,* makes all the more sense in the context of the idea of indigenous nobility. Ostensibly the print was included in *The Red Book* because it presented a portrait of a heroic and triumphant Stewart. However, insofar as Stewart's larger collection of paintings and Indian material suggests affinities between a primitive Highland aristocracy and the indigenous aristocracy of American Indians, the print may be seen as a means of reinfusing the Stewart family title with the essential traits of ancient Highland nobles. But in the context of a history of embattled breeds, namely the Highlander and the aristocrat, the confrontation between Stewart, his party, and some indigenous nobles with the supposedly thieving, ignoble Crows takes on the air of a "last stand" image as well. Last-stand images, usually identified with later nineteenth-century artists such as Frederic Remington and Charles Schreyvogel (1861–1912), presented lone, embattled European Americans who may be taken to personify some conservative social position attempting to fend off representatives of cultural change.[81] Thus it may also be no coincidence that Stewart selected *Attack by Crows,* which portrayed an event from the 1833 rendezvous, for inclusion in *The Red Book.* Nearly twenty years later, Stewart would recall 1833 as the last good year of the fur trade, "for with 1834 came the spoilers—the idlers, the missionaries and the hard seekers after money."[82]

Some of those hard seekers would be supplied with goods from Baltimore. As the century wore on, they would make their way west on the rails of the Baltimore and Ohio Railroad, backed by credit from Baltimore banks. The West they inhabited, as painted by Miller in the decades following his return from Murthly, would not look all that different from Stewart's. But in the context of antebellum Baltimore, it would acquire a rich set of new meanings.

Notes

1. *New York Review* 2 (October 1837): 439–40 as reprinted in *Critical Essays on Washington Irving*, ed. Ralph M. Aderman (Boston: G. K. Hall & Co., 1990), 111.

2. Miller , Journal, 58. Miller's correspondence refers to Irving's western novels and Catlin's "letters." A. J. M. to Brantz Mayer, Esq. Saint Louis, 23 April 1837, Brantz Mayer Papers, reprinted in Warner, *Fort Laramie*, 143–46. Irving's *Captain Bonneville* includes stories about Stewart; see, for example, 155.

3. Only two recorded images from the album treat the trapper as their main subject: *An Old Trapper Relating an Adventure*, ca. 1837, unlocated, cat. no. 95A, and *A "Bourgeois" of the Rocky Mountains*, cat. no. 268A. See Tyler, "Alfred Jacob Miller and Sir William Drummond Stewart," 19–46, and Karen Dewees Reynolds and William R. Johnston's catalogue raisonné in Tyler, *Artist on the Oregon Trail*.

4. A. J. M. to D. H. M., Murthly Castle, 26 July 1841, Porter Papers, reprinted in Warner, *Fort Laramie*, 179–80.

5. I am indebted to Joan Troccoli for her observation that Miller's genre scenes in the Gilcrease collection often portray Indians as "a sort of aboriginal aristocracy" that engaged in such aristocratic pursuits as hunting, gambling, warfare, and religious observances. While these subjects are not consistently treated in Miller's work as a whole, they are given particular emphasis in Stewart's sketch album. See *Watercolors of the American West*, 10.

6. I take the term "indigenous aristocracy" from Liebersohn, *Aristocratic Encounters*.

7. Originally, there were eighty-seven sketches that Franc Nichols Stewart inherited following Stewart's death in 1871. Nichols Stewart sold them shortly thereafter at Chapman's, Edinburgh, to Bonamy Mansell Power, who willed them to Edward Power, by descent to Major G. H. Power, who sold them at auction at Parke-Bernet, New York, 6 May 1966. At the time of the New York sale, only eighty-three sketches remained. Number 64, formerly thought lost, was given by one of the previous owners to Buffalo Bill Cody's niece as a wedding gift and is now in a private collection. See A. J. Miller Files, Buffalo Bill Historical Center, Cody, Wyo. Numbers 35, 57, and 77 remain missing. See Parke-Bernet Galleries, *Series of Watercolour Drawings;* and Ross, *The West of Alfred Jacob Miller,* xxxi–xxxvi.

8. Those oils commissioned from the sketches were: *One of the Sources of the Colorado*, ca. 1839, no. 266A, and *One of the Sources of the Colorado of the West-Wind River Mountains*, ca. 1839, no. 266B, both from *Crossing One of the Sources of the Colorado of the West, in the Mountains of the Winds*, ca. 1837, no. 266; *Pipe of Peace at the Rendezvous (Camp of the Indians at the Rendezvous of the Whites near the Mountains of the Winds)*, ca. 1839, no. 170A from *Indian Encampment near the Wind River Mountains*, ca. 1837, no. 170; *Hunting the Argoli* [sic], *at Big Horn, on Sweet Water River*, ca. 1839, no. 138B from the sketch *Hunting the Argali in the Rocky Mountains*, no. 138A; *Butchering the Buffalo*, ca. 1839, no. 118 from *Taking the Hump Rib*, ca. 1837, no. 117A; and *Cavalcade (Indian Grand Parade) (Indian Procession)*, 1839, no. 178A from *Indian Procession, Headed by the Chief Ma-Wo-Ma*, ca. 1837, no. 178 in *Alfred Jacob Miller: Artist on the Oregon Trail.* The above were completed in America and exhibited at the Apollo Gallery. *Return from Hunting*, 1840, no. 119A from the sketch *Return from Hunting*, ca. 1837, no. 119; *Indian Belle Reclining*, 1840, no. 463B from *Shoshone Girl Reclining on Buffalo Robe*, no. 463; *Snake Indians*, 1840, no. 396A from *Reconnoitering*, ca. 1837, no. 396, were painted in Scotland; Tyler, *Artist on the Oregon Trail.* For the location of the oils, see A. J. M. to D. H. M., Murthly Castle, 16 October 1840; 25 December 1840, Porter Papers, reprinted in Warner, *Fort Laramie*, 154–56, 168–70.

9. Tyler, "Alfred Jacob Miller and Sir William Drummond Stewart," in Tyler, *Artist on the Oregon Trail*, 40; and A. J. M. to D. H. M., Murthly Castle, 16 October 1840, Porter Papers, reprinted in Warner, *Fort Laramie*, 154–56.

10. The oil paintings had been exhibited that May at the Apollo Gallery to favorable reviews. For an account of their exhibition, see Tyler, "Alfred Jacob Miller and Sir William Drummond Stewart," in Tyler, *Artist on the Oregon Trail*, 35–41. Some of the sketches may also have been exhibited at this time. A review in the *New York Weekly Herald* describes the works exhibited as "a number of original sketches and views" and later says Miller's sketchings *and* paintings are on view in the gallery. 11 May 1839, 149, c. 2.

11. A. J. M. to D. H. M., Murthly Castle, 16 October 1840, Porter Papers, and A. J. M. to Brantz Mayer, Murthly Castle, 18 October 1840, Brantz Mayer Papers; both reprinted in Warner, *Fort Laramie*, 154–56; 157–60. J. Watson Webb records seeing the sketches displayed at Murthly during a visit in 1844; "Dedication," in [Stewart], *Altowan*, 1:x.

12. See the discussion of "common identity" in the previous chapter, and Pearce, *On Collecting*, 159; Stewart, *On Longing*, 154. Mieke Bal similarly argues that collections are themselves narratives which tell their stories with objects. See "Telling Objects," in Elsner and Cardinal, *The Cultures of Collecting*, 97–115.

13. Miller in Ross, *The West of Alfred Jacob Miller*, pl. 139. William T. Walters was a wealthy Baltimore native who commissioned a set of 200 watercolors illustrating scenes from Miller's journey. The works and their accompanying notes were completed between 1858 and 1860. For more information about the commission, see ibid., xxvii.

14. John Crawford to W. D. S., New Orleans, 11 October 1838, Sublette Papers, Missouri Historical Society, Saint Louis.

15. "He is delighted with the last pictures I sent him & from the sketches has already selected subjects that will occupy me all the winter in transferring to Canvass [sic]." A. J. M. to Brantz Mayer, Murthly Castle, 18 October 1840, Brantz Mayer Papers, reprinted in Warner, *Fort Laramie*, 157–60. For a list of the oils commissioned from sketches, see note 8.

16. The editor's note indicates that Stewart had commissioned Henry Inman to prepare illustrations based on Miller's sketches in 1844, but the artist died before he could complete the commission. Webb, Dedication, in [Stewart], *Altowan*, 1:x. I thank William H. Gerdts for assisting me in my research on the Inman-Stewart connection. On Inman, see William H. Gerdts, *The Art of Henry Inman* (Washington, D.C.: National Portrait Gallery, Smithsonian Institution, 1987). Stewart appears to have found someone else to complete the commission after the book's publication because he wrote to Webb in 1846 to tell him he was sending "four lithograph prints taken from scenes in the mountains to illustrate a copy of Altowan…. I can let you have as many more as you choose." W. D. S. to James Watson Webb, Murthly Castle, 28 December 1846, Webb Papers.

17. W. D. S. to J. Watson Webb, Murthly Castle, 3 November 1841, Webb Papers. A. J. M. to W. D. S., London, 25 February 1842, Murthly Muniments, GD 121, Box 101, Bundle 22, as quoted in Tyler, "Alfred Jacob Miller and Sir William Drummond Stewart," in Tyler, *Artist on the Oregon Trail*, 43.

18. According to Maurice Grosser, "A portrait can be defined as a picture painted at a distance of four to eight feet of a person who is not paid to sit." *The Painter's Eye* (New York, 1951), 15–16, as quoted in Richard Brilliant, *Portraiture* (Cambridge: Harvard University Press, 1991), 71–72. See also Brilliant's discussion of the conventions of portraiture, 23–44.

19. An account of his success in New Orleans is given in Miller, Journal, 53; Johnston, "Back to Baltimore," in Tyler, *Artist on the Oregon Trail*, 65–76.

20. For a definition of aristocratic versus bourgeois patronage, see Alan Wallach, "Thomas Cole: Landscape and the Course of American Empire," in *Thomas Cole: Landscape into History*, ed. William H. Truettner and Alan Wallach (New Haven: Yale University Press, 1994), 33–42.

21. A. J. M. to D. H. M., Murthly Castle, 26 July 1841, Porter Papers, Box 45, reprinted in Warner, *Fort Laramie*, 179–80.

22. A. J. M. to D. H. M., Murthly Castle, 16 October 1840, Porter Papers, Box 45, reprinted in Warner, *Fort Laramie*, 154–56.

23. A. J. M. to D. H. M., Murthly Castle, 31 October 1840; 3 December 1840; 25 December 1840; 19 May 1841; 24 June 1841; 26 July 1841; and 1 September 1841. 1 November 1841 letter included a menu: "We eat tremendous dinners and I send you one of Monsieur Marque's dinner cartes." A. J. M. to Harriet A. Miller, Murthly Castle, 22 March 1841, Porter Papers, Box 45, also reprinted in Warner, *Fort Laramie*, 161–85.

24. I thank Neil Harris for this observation.

25. Johnston, "The Early Years in Baltimore and Abroad," in Tyler, *Artist on the Oregon Trail*, 7–9; Miller, Journal, 3–4, 27–28; on Miller's father, see Cooke, "On the Trail," 321.

26. Miller, Journal, 44–45.

27. A. Clarke Hagensick, "Revolution or Reform in 1836: Maryland's Preface to the Dorr Rebellion," *Maryland Historical Magazine* 57, no. 4 (December 1962): 346, 357; and W. Wayne Smith, "Jacksonian Democracy on the Chesapeake: The Political Institutions," *Maryland Historical Magazine* 62, no. 4 (December 1967): 381–93. The less populous eastern shore was home to many of the state's most influential, aristocratic families, while Baltimore was generally a hotbed of Democratic fervor. Many of the families who patronized Miller for portraiture alone were from old, eastern shore families such as the Berkelys, Dashiells, and Wilsons. See Miller, Account Book.

28. Miller, Journal, 7–13, 27–28; Johnston, "Back to Baltimore," in Tyler, *Artist on the Oregon Trail*, 75; Brantz Mayer, as well as many of the founders of the Maryland Historical Society, were Whigs. See Page, "Francis Blackwell Mayer," 222. A. J. M. to D. H. M., Murthly Castle, 1 September 1841, requesting that he send copies of the *Baltimore American and Daily Advertiser* (a Whig paper) rather than the *Baltimore Sun* (Democrat), in Bernard DeVoto Papers, Macgill James File, Stanford University Library, Palo Alto. On political affiliations of periodicals, see Thrift, "Maryland Academy of Fine Arts," 53.

29. Irving, *Captain Bonneville*, 11–12, 34.

30. *New York Review* 2 (October 1837): 439–40 as reprinted in Aderman, *Critical Essays on Washington Irving*, 111.

31. David L. Brown, "Three Years in the Rocky Mountains," *Cincinnati Daily Morning Atlas, 1840* (New York: Edward Eberstadt & Sons, 1950), 10–11.

32. Miller in Ross, *The West of Alfred Jacob Miller*, pls. 22, 25, 39, 64, 105. Such comparisons were relatively common, and can be found in the writing of other artists of the time. See , for instance, George Catlin's description of Native American men as a "noble race" and "knights of the forest," in *Letters and Notes on the Manners, Customs, and Condition of the North American Indians*, 2 vols. (London: George Catlin, 1844), 1:15. See also William H. Truettner's discussion in *The Natural Man Observed: A Study of*

Catlin's Indian Gallery (Washington, D.C.: Smithsonian Institution Press, 1979), 73.

33. Stewart inherited the title from his brother, John, who died in 1838 after an extended illness. Stewart was aware of the illness and of its possible ramifications as early as 1836. His biographers have suggested that he may have commissioned Miller believing that his 1837 journey might be his last. See Murthly Muniments, nos. 77–81; Porter and Davenport, *Scotsman in Buckskin*, 126; DeVoto, *Across the Wide Missouri*, 309. His family had purchased Murthly in 1615 and was granted the title of baronet shortly thereafter. For Stewart's family history, see Porter and Davenport, *Scotsman in Buckskin*, 7–9; Anderson, "Sir William Drummond-Steuart," 151–70; and Fraser, *Red Book*.

34. For information on the baronetage and peerage, see L. G. Pine, *The Genealogist's Encyclopedia* (New York: Weybright and Talley, 1969), 222–24, 264; *Encyclopedia Britannica* (Chicago: William Benton Publishers, 1973), c.v. Peerage; and M. L. Bush, *The English Aristocracy: A Comparative Synthesis* (Manchester, U.K.: Manchester University Press, 1984), 2, 20–23. For a discussion of class consciousness, see "Prologue" in David Cannadine, *The Decline and Fall of the British Aristocracy* (New Haven: Yale University Press, 1990), 20–24.

35. In 1872, Stewart's estate encompassed 33,274 acres and generated an income of approximately 15,000 pounds per year when 1,000 acres was the minimum estate size for a member of England's aristocracy and the average peer or baronet in Scotland had an annual income of 3,000–10,000 pounds. *Scotland, Owners of Lands and Heritages*, 17 & 18 Vict. Cap. 91, 1872–73, as quoted in Anderson, "Sir William Drummond-Steuart," 168; David Spring, *European Landed Elites in the Nineteenth Century* (Baltimore: Johns Hopkins University Press, 1977), 3; and Norman Gash, *Aristocracy and People, Britain 1815–1865* (Cambridge: Harvard University Press, 1979), 19.

36. According to historian F. M. L. Thompson, a crucial element of the cultural uniformity found among members of the aristocracy was an individual's upbringing, which almost invariably involved education by a private tutor. *English Landed Society in the Nineteenth Century* (London: Routledge & Kegan Paul, 1963), 82–83. It was also common for the minor sons of an aristocratic family to pursue careers in the military, the clergy, or foreign service. Stewart's younger brother Thomas entered the clergy and George became a diplomat. See Anderson, "Sir William Drummond-Steuart," 153, 157; and Thompson, *English Landed Society*, 93.

37. Porter and Davenport, *Scotsman in Buckskin*, 17–18.

38. Sir William's son, George, received a private tutor and went on a grand tour through Europe. Their letters to one another and between Sir William and George's tutor, Sir Bonamy Man-

sell Power (the same B. M. Power who purchased the sketch album at auction in 1871), indicate Sir William's close supervision of George's education. When he reached the age of eighteen, his father purchased him an army commission. See Porter and Davenport, *Scotsman in Buckskin*, 254–55. On typical education and upbringing of children, see Thompson, *English Landed Society*, 82–87.

39. M. L. Bush writes, "The paucity of corporate privileges made land ownership and life-style of prime importance in the identification of aristocratic status." *English Aristocracy*, 35; see also Thompson, *English Landed Society*, 95.

40. Thompson, *English Landed Society*, 95.

41. On Stewart's professed interest in the hunt as a sport, see Troccoli, *Watercolors of the American West*, 12–13.

42. Osborne Russell, *Journal of a Trapper*, ed. Aubrey L. Haines (Portland, Ore.: Champoeg Press, 1955), 134.

43. Frederick Ruxton, as quoted in Merritt, *Baronets and Buffalo*, 63.

44. David Cannadine, *Aspects of Aristocracy: Grandeur and Decline in Modern Britain* (New Haven: Yale University Press, 1994), 22–23. One of Stewart's family traditionally served as a British diplomat to Italy; Porter and Davenport, *Scotsman in Buckskin*, 16.

45. See Harry Liebersohn's discussion of this comparison among French elites, "Discovering Indigenous Nobility: Tocqueville, Chamisso, and Romantic Travel Writing," *The American Historical Review* 99 (June 1994): 760.

46. Miller in Ross, *The West of Alfred Jacob Miller*, pl. 35.

47. Thompson, *English Landed Society*, 137–49.

48. See for instance Richard White, *The Roots of Dependency: Subsistence, Environment, and Social Change Among the Choctaws, Pawnees, and Navajos* (Lincoln: University of Nebraska Press, 1983).

49. Thompson, *English Landed Society*, 97.

50. [Stewart], *Altowan*, 1:228.

51. Stewart's mode of travel at the rendezvous was also indicative of the conspicuous displays of consumption that further distinguished the nobility from the bourgeoisie. He traveled west with cases of fine brandy and canned oysters and held elaborate dinners at which he served these delicacies. Stewart also traveled with a manservant who kept his hair and moustache trimmed. Porter and Davenport, *Scotsman in Buckskin*, 39, 132; and DeVoto, *Across the Wide Missouri*, 309–10; for conspicuous consumption as an indicator of aristocratic life, see Bush, *English Aristocracy*, 35, 61–75.

52. Liebersohn, "Discovering Indigenous Nobility," 748, 750, 756, 760. On the eighteenth-century use of noble savagery as a critique of the aristocracy, see Hayden V. White, "The Noble Savage Theme as Fetish," in *Tropics of Discourse: Essays in Cultural*

Criticism (Baltimore: Johns Hopkins University Press, 1978), 183–96.

53. Hutchison, *Political History of Scotland,* 1. According to Christopher Harvie, the Reform Bill "was the 'political birth' of Scotland," *Scotland and Nationalism,* 14. For more on the effects of the Reform Bill on Scotland, see, T. C. Smout, *A Century of the Scottish People, 1830–1950* (New Haven: Yale University Press, 1986), 7–31.

54. F. M. L. Thompson, "Britain," in Spring, *European Landed Elites,* 24; on the aristocracy's maintenance of power, see also Cannadine, *Aspects of Aristocracy,* 1–36; Thompson, *English Landed Society,* 269–91; Gash, *Aristocracy and People,* 129–55, 347–50.

55. W. L. Guttsman, *The British Political Elite* (New York: Basic Books, 1963), 61. See also Thompson, "Britain," in Spring, *European Landed Elites,* 22–44; Gash, *Aristocracy and People,* 347–50.

56. Guttsman, *British Political Elite,* 62.

57. Hippolyte Taine, *Notes on England,* translated by E. Hyams as reprinted in W. L. Guttsman, ed., *The English Ruling Class* (London: Weidenfeld and Nicolson, 1969), 37.

58. Guttsman, *British Political Elite,* 60–71, 112–13; on lifestyle as a justification for aristocratic rule, see also V. G. Kiernan, *The Duel in European History: Honour and the Reign of Aristocracy* (Oxford: Oxford University Press, 1986), esp. 153–55; Thompson, *English Landed Society,* 144; Bush, *English Aristocracy,* 75.

59. Cannadine, *Aspects of Aristocracy,* 29, 30–31, 34, 35; on the consolidation of estates, see also Gash, *Aristocracy and People,* 19; Guttsman, *British Political Elite,* 117.

60. Lord Elgin to Spencer Perceval, 1811 as quoted in Cannadine, *Aspects of Aristocracy,* 31, n. 100; Michael W. McCahill "The Scottish Peerage and the House of Lords in the Late Eighteenth Century," *The Scottish Historical Review,* LI, no. 2:152 (October 1972): 175; Michael W. McCahill, "Peerage Creations and the Changing Character of British Nobility, 1750–1830," *The English Historical Review,* 96, no. 379 (April 1981): 261–63.

61. McCahill "Scottish Peerage," n. 5, 176.

62. Cannadine, *Aspects of Aristocracy,* 26, 35–36; Thompson, *English Landed Society,* 87.

63. Murthly Muniments, nos. 80–81.

64. Murthly Muniments, nos. 156–57, 163; and Anderson, "Sir William Drummond-Steuart," 155–56. Stewart also oversaw the construction in 1840–42 of a hunting lodge named Rohallion, which includes a neo-Gothic turret; see A. J. M. to D. H. M., Murthly Castle, 3 December 1840 and A. J. M. to D. H. M., Murthly Castle, 24 June 1841, Porter Papers, Box 45, reprinted in Warner, *Fort Laramie,* 164–67, 176–77.

65. Cannadine, *Aspects of Aristocracy,* 36.

66. On the significance of gift exchange, see especially White, *Middle Ground,* 15–16, 112–19; and Arthur J. Ray, *Indians in the Fur Trade: Their Role as Trappers, Hunters, and Middlemen in the Lands Southwest of Hudson Bay, 1660–1870* (Toronto: University of Toronto Press, 1974); see also, Marcel Mauss, *The Gift: The Form and Reason for Exchange in Archaic Societies* (London: Routledge, 1990); and Castle McLaughlin, *Arts of Diplomacy: Lewis and Clark's Indian Collection* (Seattle: University of Washington Press, 2003).

67. *New York Morning Herald,* 5 October 1839, 2, c. 5.

68. Prince Maximilian was a student of the German professor of anatomy and natural history Johann Friedrich Blumenbach (1752–1840), who had also taught Alexander Von Humboldt (1769–1859). Blumenbach believed that the so-called primitive peoples of America represented either an early stage of man's evolution or a late stage of his degeneration. See William H. Goetzmann, "Introduction: The Man Who Stopped to Paint America," in Hunt, et al., *Karl Bodmer's America,* 5–6.

69. Liebersohn, *Aristocratic Encounters,* 5, 10.

70. Wood, "Natural History of Man," 107; Bryson, *Man and Society,* 45ff, 201–5.

71. Tawil, "Domestic Frontier Romance," 99–124.

72. Herman J. Viola, *The Indian Legacy of Charles Bird King* (Washington, D.C.: Smithsonian Institution Press and Doubleday & Co., 1976), 22–43. For an example of a peace medal in Miller's work, see Miller in Ross, *The West of Alfred Jacob Miller,* pl. 35.

73. See Viola, "Portraits, Presents, and Peace Medals," in *Indian Legacy,* 22–43.

74. Thompson, *English Landed Society,* 96–97.

75. William R. Swagerty, "A View from the Bottom Up: The Work Force of the American Fur Company on the Upper Missouri in the 1830s," *Montana: The Magazine of Western History* 43, no. 1 (1993), 23; and William R. Swagerty and Dick A. Wilson, "Faithful Service Under Different Flags: A Socioeconomic Profile of the Columbia District, Hudson's Bay Company and the Upper Missouri Outfit, American Fur Company, 1825–1835," in Brown, et al., *Fur Trade Revisited,* 250.

76. Miller in Ross, *The West of Alfred Jacob Miller,* pl. 52.

77. A. J. M. to D. H. M., 31 October 1840, Porter Papers.

78. Olive Patricia Dickason, "From 'One Nation' in the Northeast to 'New Nation' in the Northwest: A Look at the Emergence of the Métis," and Jacqueline Peterson, "Many Roads to Red River: Métis Genesis in the Great Lakes Region, 1680–1815," in *The New Peoples: Being and Becoming Métis in North America,* ed. Jacqueline Peterson and Jennifer S. H. Brown (Lincoln: University of Nebraska Press, 1985), 30–32, 64.

79. According to Stocking, polygenist (or racist) views held sway after the 1830s, *Victorian Anthropology,* 18–21. David D.

Smits, "'Squaw Men,' 'Half-Breeds,' and Amalgamators: Late Nineteenth-Century Anglo-American Attitudes Toward Indian-White Race-Mixing," *American Indian Culture and Research Journal* 15, no. 3 (1991): 29–61.

80. Gary C. Anderson, "Joseph Renville and the Ethos of Biculturalism," in *Being and Becoming Indian: Biographical Studies of North American Frontiers,* ed. James A. Clifton (Chicago: Dorsey Press, 1989), 17–18, 21–23, 24–25, 59–81, esp. 62.

81. See Alexander Nemerov's discussion of Remington and "last stand" imagery in "Doing the 'Old America': The Image of the American West, 1880–1920," in Truettner, *The West as America,* 297–305. As in so many of the late nineteenth-century versions of this type of imagery, *Attack by Crows* was not a pointed allegory of these struggles (see Nemerov, 303, on this point). Rather it was an unconscious attempt by artist and patron to fight and win those struggles in paint.

82. [Sir William Drummond Stewart], *Edward Warren,* 2 vols. (London: G. Walker, 1854), 274.

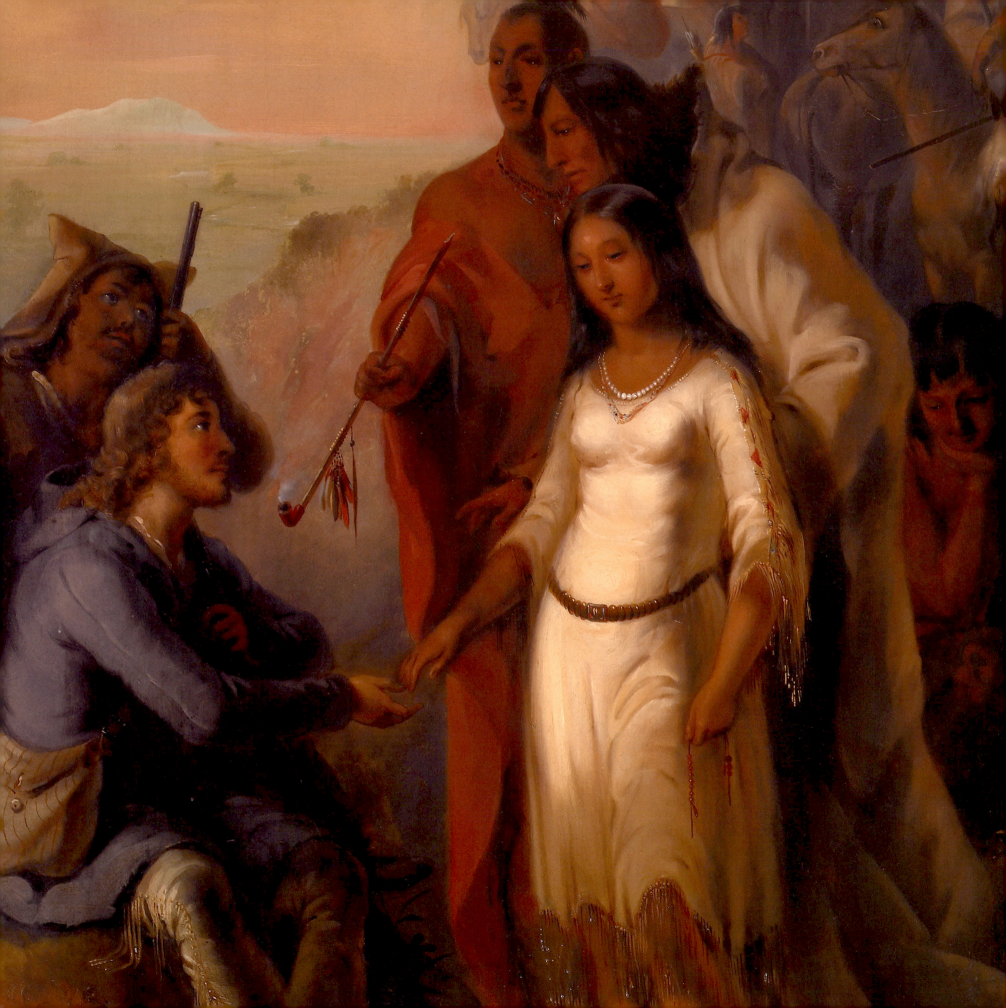

CHAPTER THREE | SENTIMENT, COMMERCE,

AND **THE TRAPPER'S BRIDE**

ALFRED JACOB MILLER RETURNED FROM SCOTLAND to Baltimore in the spring of 1842. He purchased a farm in Catonsville and, after what appears to have been a brief hiatus, returned to work in a studio in downtown Baltimore. There, he began work on one of his most successful images, *The Trapper's Bride.* The painting of a young, handsome trapper marrying an equally youthful and attractive bride was first painted at Murthly in 1841 and reproduced at least six times in Baltimore over the following twenty years. Previous analyses of the work have discussed its meanings within a national context, considering how the painting reflected American attitudes toward Indian-white intermarriage and westward expansion. Such interpretations are useful for broadly framing the work, but this chapter considers more particularized meanings that emerge when we consider its local patronage and circulation. Although *The Trapper's Bride* received wider circulation than many of Miller's other western works (copies were exhibited publicly in Washington, D.C., Philadelphia, and probably New York), it was nevertheless painted, sold, and displayed within a specific niche of Baltimore society. Miller and his patrons as a whole formed a tightly knit social circle. Some of Miller's earliest patrons were his father's customers or personal friends. Several of them, in turn, served with one another as directors of banks, insurance companies, and railroads, particularly the Baltimore and Ohio. Consequently, the meanings of an image like *The Trapper's Bride* are inseparable from the economic and social interests of the Baltimore elite for whom it was reproduced. Consistent with its nationalist interpretation, the painting has been discussed as a metaphor for the reconciliation of Indians and whites. Within a local context, however, the union could be understood more particularly as between Baltimore and its newly opened western markets. The terms in which that union is rendered—more specifically, the sentimentality of the wedding's portrayal—suggest an analogous emphasis on the kind of premodern business relationships that the Baltimore mercantile establishment idealized.

While the promise of westward expansion and the pressure to modernize business practices were not unique to Baltimore, the particular centrality of these issues to the city's mercantile enterprise and their status as an outgrowth of its economic history make their articulation at once distinctive and of wider relevance to American culture. The same can be said of Miller's art. Scholars have noted, almost dismissively, his position as a local artist following his return from Scotland. The belief that he was insulated from the larger art world (arguably he was not) and his almost exclusively Baltimorean clientele have served to marginalize him in a national context. Yet, insofar as he operated outside of the artistic core of New York and Philadelphia, he is representative of a large number of American artists. If we are to broaden our understanding of American art as something more than the artistic output of an elite few in the metropolises of New York and Philadelphia, Miller's career in Baltimore is a good place to start.

There are five oil-on-canvas versions of *The Trapper's Bride*.[1] Since patronage is, for this image, as significant, if not more so, than other defining features of the painting such as date or present location, each version is identified by its initial purchaser. The first version, now unlocated, was the monumental 8-by-10-foot Stewart *Trapper's Bride*, painted at Murthly in 1841.[2] The second was *Bartering for a Bride*, the Ward *Trapper's Bride* (plate 1), painted in 1845 and sold in 1846 to prominent Baltimore collector Benjamin Coleman Ward (1784–1866); the third was the Hopkins *Trapper's Bride* (plate 2), painted in 1846 at the behest of the merchant and philanthropist Johns Hopkins (1795–1873); the fourth was the Oelrichs *Trapper's Bride* (plate 3), painted and sold in 1850 to Baltimore merchant Heinrich Ferdinand Oelrichs (1809–1875); and the fifth was the De Ford *Trapper's Bride* (probably the version illustrated in plate 4), painted in the early 1850s, exhibited in Washington, D.C., Philadelphia, and New York in 1852–53, and sold to merchant Charles D. De Ford (1814–1858) in 1856.[3] The last two versions of *Trapper's Bride* were painted in watercolor. The first has been identified as a sketch made in the field, but given its close compositional conformity to the second watercolor, it is probably an 1857 sketch made preparatory to the final version (plate 5). That version, the Walters *Trapper's Bride* (plate 6), was painted in 1857–58 as part of a commission for two hundred watercolor sketches with accompanying notes of commentary that Miller prepared for one of America's most prominent collectors, Baltimore merchant William T. Walters (1819–1894).

The following discussion is divided roughly into two parts. The first part considers the oil-on-canvas paintings as a group; the second considers the watercolors. In providing a formal analysis of *The Trapper's Bride*, I chose for simplicity to refer to only one version—Ward's *Bartering for a Bride* (*The Trapper's Bride*)—because it was the first and likely the version that was familiar to all of the patrons. Hopkins surely saw it when he visited Miller's studio just days before Ward came to pick it up. His own version is the closest in composition to the Ward. Oelrichs, De Ford, and Walters probably saw it as well either at Ward's home or when Ward exhibited it in Baltimore in 1848.[4]

PLATE 1 Bartering for a Bride (The Trapper's Bride), 1845

Oil on canvas, 36 × 28 inches

Courtesy of the Eiteljorg Museum of American Indians and Western Art, Indianapolis, Indiana

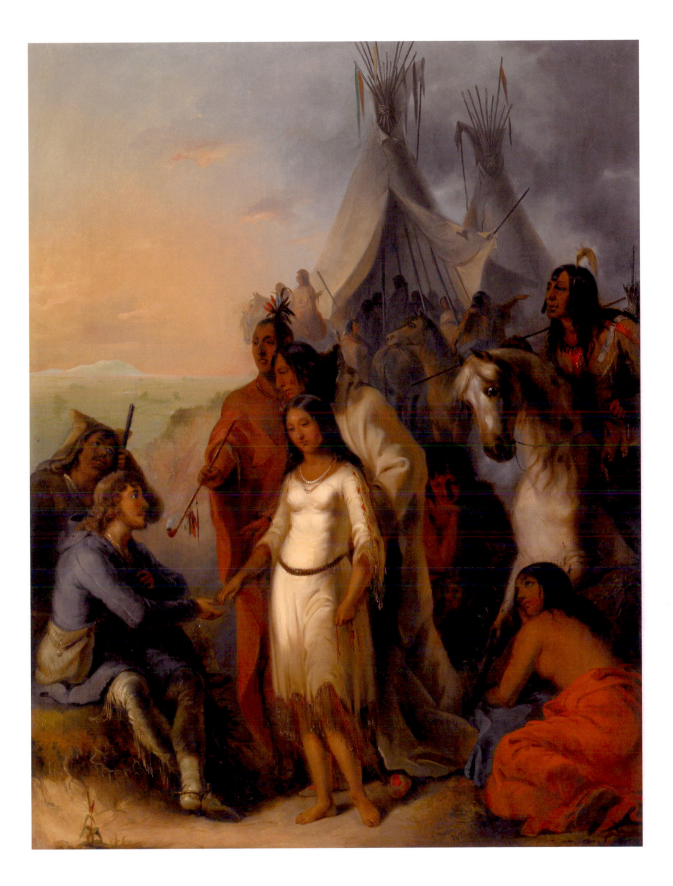

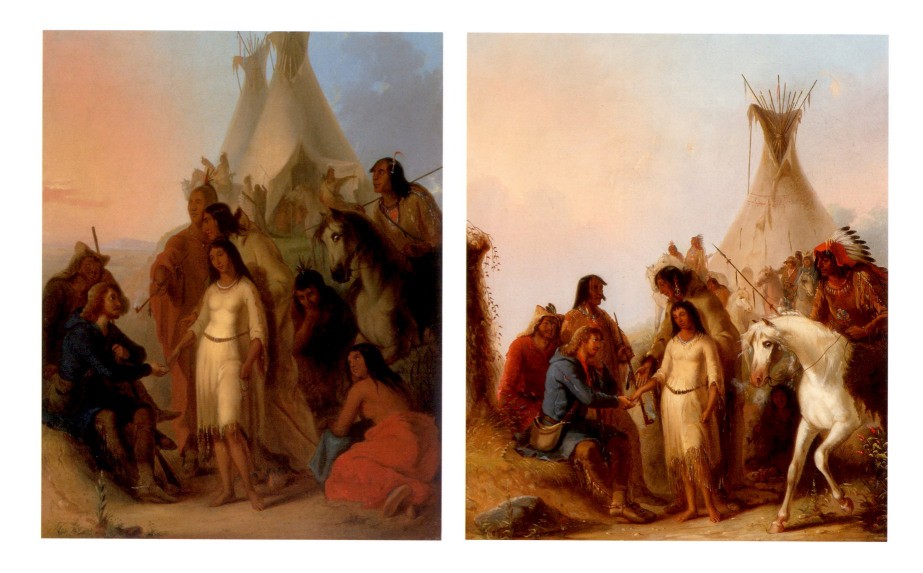

PLATE 2 The Trapper's Bride, 1846
Oil on canvas, 35½ × 28½ inches
The Alan Mason Chesney Medical Archives of The Johns
Hopkins Medical Institutions, Baltimore, Maryland.
Photograph by Aaron Levin

PLATE 3 The Trapper's Bride, 1850
Oil on canvas, 30 × 25 inches
Joslyn Art Museum, Omaha, Nebraska

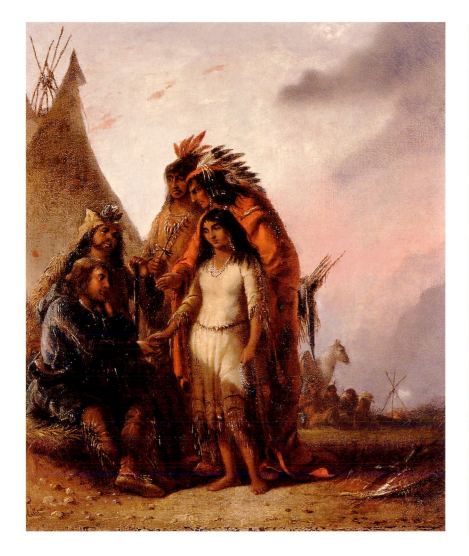

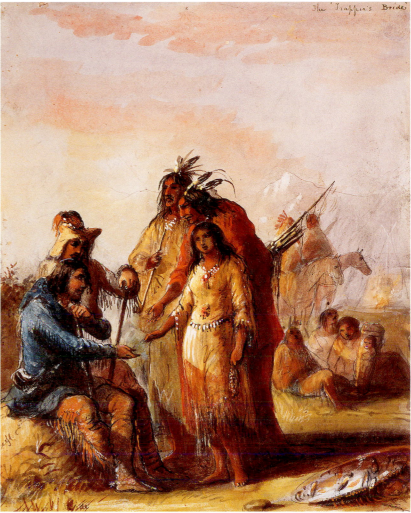

PLATE 4 Trapper's Bride, early 1840s
Oil on canvas, 19 x 16 inches
Hunter Museum of American Art, Chattanooga, Tennessee
Gift of Mr. and Mrs. Scott L. Probasco, Jr.

PLATE 5 The Trapper's Bride, n.d.
Watercolor, gouache, glazes, pen and ink, and graphite on paper,
10¾ x 8¾ inches
Gilcrease Museum, Tulsa, Oklahoma

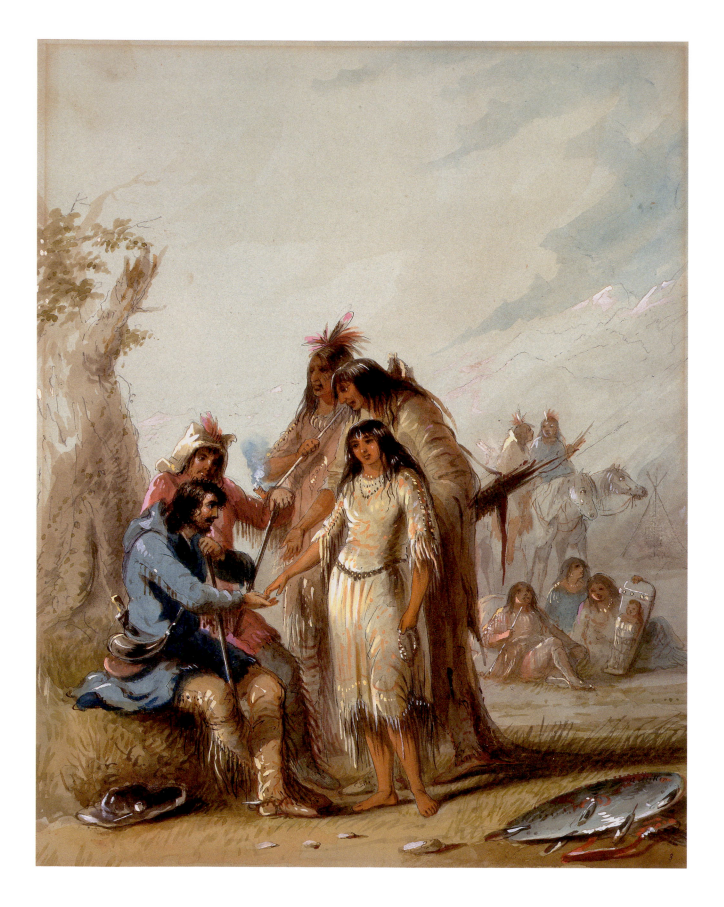

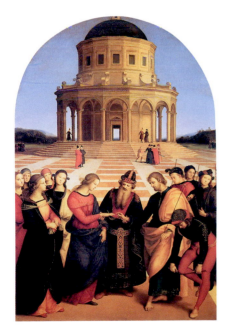

Marriage as Metaphor in The Trapper's Bride

Some scholars have argued that Miller raised the subject matter of *The Trapper's Bride* from the level of genre to that of metaphor through his use of Old Master sources.[5] Dawn Glanz was the first to note Miller's reliance on Raphael's *Marriage of the Virgin* (1504, plate 7). More recently, Alex Nemerov has surmised that Miller based the composition of the Ward *Trapper's Bride* on Peter Paul Rubens' *The Judgement of Paris* (1639, plate 8), which Miller could have known through Stewart's print collection.[6] In the Ward *Trapper's Bride*, Miller followed Rubens' composition down to its idiosyncratic particulars: the trapper leaning on his gun, his companion behind him, and the bride in the pose of the *Medici Venus*.

Miller's use of history paintings as compositional sources signaled his own ambitions not simply to raise his subject matter to the level of metaphor, but to give it the universal relevance of a history painting. Indeed, the only two pieces of contemporary commentary on the painting, apart from the artist's own, suggest that the work was understood as a history painting. The Stewart *Trapper's Bride* has been unlocated since shortly after Stewart's death, but a contemporary account of the 1871 auction referred to it as a "grand gallery picture," a term that implied the formality of execution and seriousness of scope of a history painting.[7] Its monumental dimensions, 8 by 10 feet, were also typical for a work in that genre.[8] Moreover, an American version of the painting appears, in one contemporary instance, to have been classified as a history painting. In 1853, Miller submitted what was probably the De Ford *Trapper's Bride* (plate 4) for competition in the inaugural exhibition at Washington, D.C.'s Metropolitan Mechanic's Institute. A panel of judges, including Titian Ramsey Peale, divided the numerous oil-on-canvas submissions into four categories: historical paintings, genre, landscapes, and portraits. According to their statement in the catalogue, *The Trapper's Bride* was the only work to

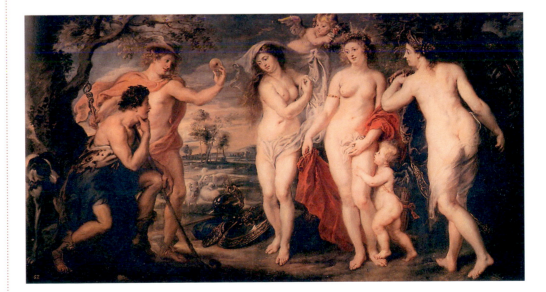

PLATE 9 Hands of the bride and groom
Detail of Plate 1

be classed as a history painting: "There was only one picture of that kind exhibited, painted by Alfred Miller, representing the *Trapper's Bride,* and a group of Indians in amity with the Trapper."[9] If the De Ford *Trapper's Bride* was the painting in question, its categorization as a history painting was certainly not because of its size (it was only 19 by 16 inches) or for any recognizable reliance on Old Master compositions. Miller has changed enough of the background scenery to have lost the immediate comparison to Raphael, retaining only the core elements of Rubens' composition. Nor was its classification a function solely of its western subject matter. Miller's other western submissions, *A Prize from the Enemy's Camp* and *Devil's Gate,* were not classified as history paintings. (Neither was John Mix Stanley's *An Apache War Chief Reconnoitering the Command of General Kearny on his March from Santa Fe to California in 1846,* clearly a historical, as well as a western, subject.) Rather it seems that the panel of judges saw the painting's subject matter—a white trapper marrying an Indian woman—as a metaphor for something of universal human importance.[10] Many of Miller's western works can be classified as genre paintings, or scenes of daily life, albeit in an exotic setting. Indeed *The Trapper's Bride* has at times been approached as a face-value representation of Indian-white marriage. Taken as metaphor, however, *The Trapper's Bride* could address two subjects ostensibly of universal importance that had particular resonance for Miller's Baltimore patrons: sentiment as a distinguishing characteristic of civilized society and its place in the establishment of productive and honorable trade relations.

Miller was almost certainly familiar with the kind of Indian-white intermarriage he pictured in *The Trapper's Bride* (plate 1). Marriage *à la façon du pays,* or "according to the custom of the country," was common among both Rocky Mountain and Canadian fur traders. Miller claimed to have attended one such ceremony, and Stewart described the practice in *Altowan.*[11] The marriage ceremony generally followed Indian customs. The groom paid a "bride price," or a kind of reverse dowry, to compensate the family for the loss of the woman's industry. On the day of the marriage, the bride bathed and dressed in white buckskin before being presented to the groom. Vows were not exchanged, but the couple was lectured on the duties of married life, and a calumet was smoked to solemnize the ceremony.[12] Thus the white dress and the smoking calumet represent Miller's attempt to portray some of the details of Plains life that would lend the work an air of accuracy.

Although aspects of the wedding ceremony appear to derive from Plains custom, the joining of the right hands of the bride and groom (plate 9) was a central feature of the Christian ceremony. Christian marriage ceremonies in antebellum America followed the general outline of the "Rite of Solemnization of Marriage" from the *Book of Common Prayer.* According to the text of the rite, the clergyman instructs the groom to take the bride's right hand in his right with the injunction: "Let us now join hands." The moment occurs roughly in the middle of the ceremony, after the clergyman has offered his sermon on the social import of marriage and immediately before the couple recite their vows.[13]

If there is a central moment in the Christian ceremony, it is this one. By showing the ceremony at the point where the couple is about to join hands and recite their vows, Miller came as close as he

could to isolating the pregnant moment of transition when groom becomes husband and bride becomes wife. Miller underscored the sense of the transition by highlighting the couple's hands against the open space between them. He also added suspense in the Ward version by posing their hands such that they just barely overlap formally without actually touching in space; they appear to be simultaneously touching and not.

The marriage ceremony enacts one public facet of the social transformation that renders a couple man and wife, but intrinsic to the marriage ceremony is the consummation to follow. The sermon immediately preceding the joining of hands would have informed its participants that marriage is "ordained for the procreation of children…" and also "ordained for a remedy against sin, and to avoid fornication."[14] Insofar as a consummated marriage channels erotic desire into productive, procreative sexual relations, *The Trapper's Bride* alludes to this carnal transformation as well.

Art historians have commented on the sexually charged nature of this and other of Miller's images.[15] Indeed in each version of *The Trapper's Bride,* the bride has a curvaceous figure: broad, curving hips, rounded breasts, belly, and navel, all visible through her improbably tight buckskin dress. Miller posed her at a three-quarter angle to the picture plane so that the contours of her breast and hips are highlighted in the S-curve of her profile. Her hourglass figure is echoed in the outline of her resting, bent leg; the curves of her torso are repeated in each of her slightly bent arms. One art historian has even noted the eroticism of the bride's feet, citing Stewart's reference in *Altowan* to "bare feet as a particularly attractive feature of young Indian women."[16]

But, more important, aspects of *The Trapper's Bride* call particular attention to the procreative, productive nature of the bride's sexuality. Light in the image radiates from the sun at the midleft so that the horse's left flank, for instance, is in shadow. The bride, however, basks in a second, artificial source of light emanating from just below and behind the trapper. The light falls most starkly on her torso, from her shoulders down to the top of her thighs. A strong diagonal line demarcates the divide between her lightened midsection and her knees, which are cast in shadow. The effect of the light on her white buckskin dress serves particularly to highlight those parts of her body involved in reproduction: breasts, belly, and hips.[17]

Some art historians have suggested that the bare-breasted woman clad in red at the lower right represents a stereotype of the highly sexualized Indian woman. Such a woman would form one pole of the dichotomy of what has been called the "Pocahontas perplex," in which Indian women are typed either as innocent princesses or exotic temptresses.[18] Seated at the lower left, the groom, who looks up tenderly at his bride, is the visual complement of the woman in red. Both pose with legs loosely crossed, their bent knees facing inward toward the bride as if to bracket her. So positioned, the trapper's body forms the base of an axis of a compositional triangle that runs through his body, along the stem of the calumet, through the feathered headpiece of the Plains man to culminate in the tipi on the hill behind. The red-clad woman initiates a second axis that runs through the horse's head to join the

PLATE 10 The Halt, n.d.
Oil on canvas, 24 × 20 inches
Sheldon Memorial Art Gallery and Sculpture Garden,
University of Nebraska–Lincoln, Gift of Norman Hirschl.
Photograph © Sheldon Memorial Art Gallery

PLATE 11 Giving Drink to a Thirsty Trapper, n.d.
Watercolor on paper, 8¹⁄₁₆ × 7⁵⁄₁₆ inches
Beinecke Rare Book and Manuscript Library, Yale University,
New Haven, Connecticut

opposite side of the tipi. The tipi opens its flaps wide to reveal a crowd of figures, members of the community among whom the newly married couple may take their place. If the red-clad woman indeed represents carnality, then the triangle, read from left to right, traces an ideal trajectory from the groom, who embodies love, across the bride (and the ceremony itself) to the red-clad woman, who stands for desire, to the apex at the tipi, which embodies home and hearth.[19] In the De Ford *Trapper's Bride* (plate 4), Miller replaced the background figures with a small family grouping including a woman with a child in a cradleboard, making explicit the domestication of sexual impulses in marriage.

If *The Trapper's Bride* encapsulates the passage of sexual desire into the socially productive bond of marriage, it may be understood as the culmination of that process in relation to a second painting. In *The Halt* (plate 10), Miller represented an Indian woman offering a trapper a drink of water, a gesture that, in Lakota custom, signaled her desire to marry.[20] A version of *The Halt*, titled *Receiving a Draught of Water from an Indian Girl* (ca. 1837–39, Amon Carter Museum), appeared in Stewart's album.

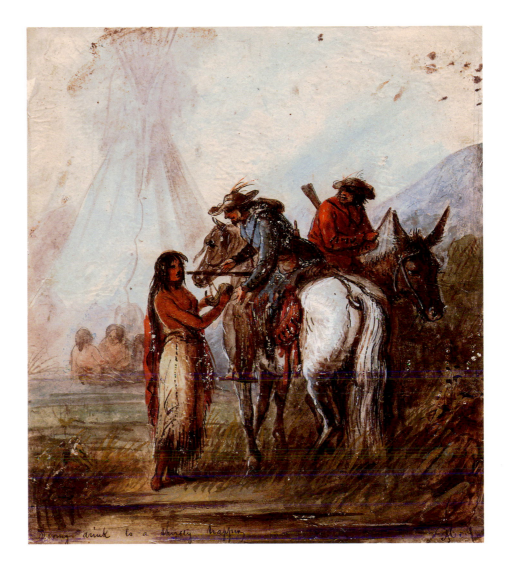

Miller sold at least four more, one to the Art-Union and three to Baltimore collectors, making the subject among his most popular.[21] In *The Halt*, the drama significantly unfolds in a more private context by the shore of a lake opposite a village. The Indian woman in *The Halt* appears to be an amalgamation of the bride and the red-clad woman in *The Trapper's Bride*. She is lithe and beautiful, wearing a white, fringed buckskin skirt that hovers at midcalf. Her upper body is bare, her breasts and nipples clearly articulated. Like the red-clad woman in the former painting, the woman in *The Halt* wears a red garment, though it appears almost as an afterthought, draped down her back with no visible support at her neck or waist. The trapper closely resembles the groom from *The Trapper's Bride*. He is handsome, bearded, has blond curls, and wears a blue hooded jacket. His companion is, again, a darker, bearded

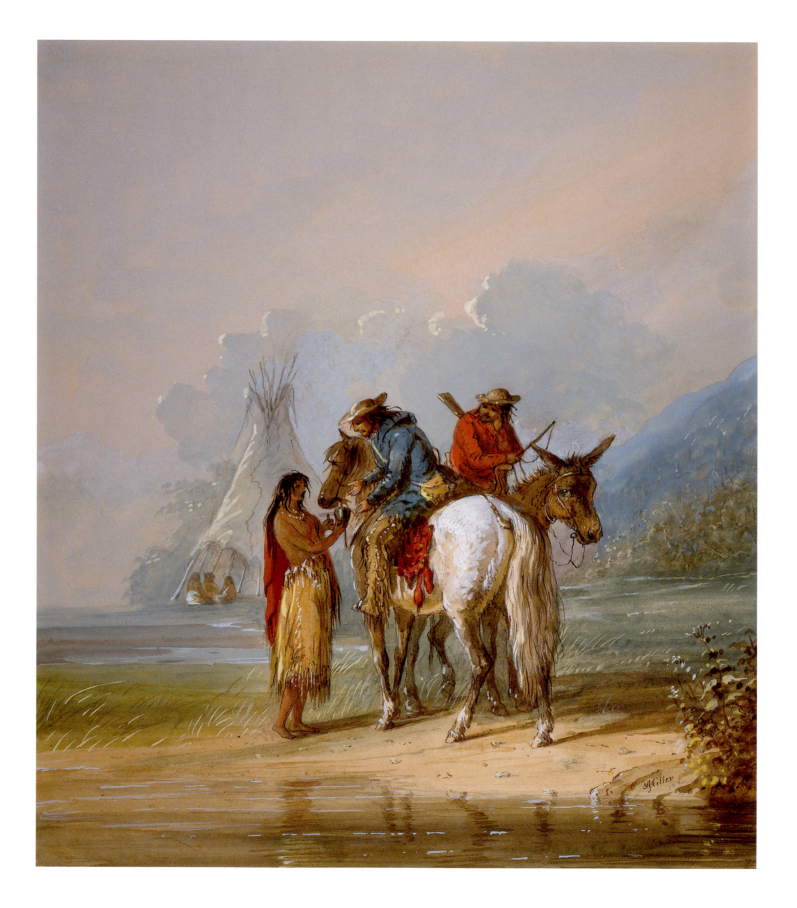

man located just behind him, this time on a mule. In *The Halt,* however, the positions of the woman and man have reversed. Now it is she who is below him, holding up a cup of water toward his outstretched hand.

The cup appears to have been fashioned out of a buffalo horn, but the woman holds the cup sideways, so that its foreshortened appearance is that of a rounded bowl, which echoes the form of her breasts. The position of the cup suspended in the air between the woman's breasts and the man's hands furthers the breast-cup analogy, suggesting she offers more than the cup itself to the trapper.[22]

Miller experimented with other potentially suggestive elements in the composition. In a working watercolor, inscribed with the title *Giving Drink to a Thirsty Trapper* (plate 11), Miller added a gun to the trapper's equipment.[23] The barrel of the weapon, which apparently rests on the trapper's saddle, protrudes from the trapper's lap, stopping just short of the woman's face. It appears to have been added after the image was otherwise complete, since the fully realized tips of the trapper's fingers are still visible underneath translucent passages of black paint. Miller was coy about the addition of the feature in the finished version of the watercolor, *The Thirsty Trapper* (plate 12), painted for William T. Walters. In the latter version, Miller lightly penciled in the barrel of the gun, then neither erased it nor painted over it in watercolor (plates 12, 12A). Though the Indian woman is still bare-chested in the watercolors, a second oil version, which Miller sold to the American Art-Union in 1851, appears to balance out the sexually charged addition of the gun by clothing the woman in a heavy hunting shirt and rendering her figure more athletic than curvaceous (plate 12B).[24]

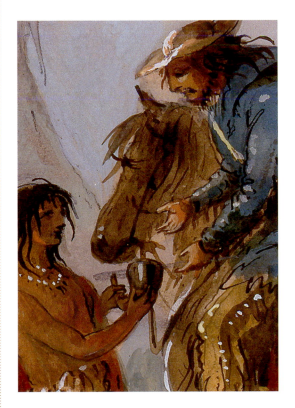

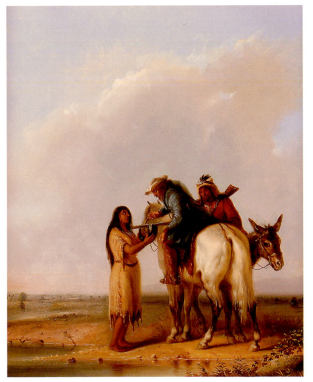

An explanatory note written by Miller to accompany the Walters version subtly echoes the visual pun of sexual and bodily thirst with a parallel textual juxtaposition:

> One of the greatest privations to be combated on the prairies is the want of water. The Trapper leaves his camp in the morning, and after traveling all day under a hot and oppressive sun, his tongue parched and swollen, and almost cleaving to the roof of his mouth;—you may fancy, under such circumstances with what delight he hails at a distance, the life-giving stream.
>
> The subject of the sketch is an Indian girl supplying an exhausted Trapper with a draught of water, which she has brought in a Buffalo horn.
>
> To fully appreciate the boon, one must absolutely go through the ordeal, by being subjected to the privation,—it is impossible otherwise.[25]

Though the painting's double entendre may have been unconscious, Miller's correspondence suggests that such sexualized metaphor was commonplace in his circle of artists and friends. One of Miller's students, Francis Blackwell Mayer (1827–1899), wrote to his mentor several times from Paris, often asking after an attractive widow who lived next door to Miller. In one letter, Mayer wrote "I can imagine you enjoying [Mr. William T. Walters'] conversation and Miss Harriett pouring out a cup of that beautiful *pink* tea. Bye the Bye How's the widow? If I don't get somebody to pour out *my* tea I shall crystallize into a stalactite of celibacy in the course of another year." Significantly, Mayer appears to consider such comments as appropriate for a public forum. In the same letter he alluded to Miller's having read their previous correspondence aloud to fellow artists and Mayer likely expected the same treatment for this letter since he marked a later passage, in which he asked Miller the favor of an introduction to Stewart, "Private."[26]

At one level *The Trapper's Bride* may be understood as a meditation on the nature of courtship and marriage itself, but marriage lends itself naturally to metaphor, and here both bride and groom are, after all, national symbols. Since the eighteenth century the figure of the Indian woman had been used to personify the American landscape: fertile and indigenous. By the 1840s, the trapper had become a popular symbol of westward expansion through portrayals in western novels and serials.[27] In *The Trapper's Bride,* bride and groom personify West and East, respectively, and their marriage is a first step toward the literal domestication of the western territories.[28] Indeed, debates about the Mexican War often portrayed the annexation of western territory as a marriage; Texas came "to the United States as a bride adorned for her espousals," and California was annexed "before her wedding garment has yet been cast about her person."[29] Popular fiction depicting the war often presented American men euphemistically rescuing and marrying Mexican women. "These visions of imperial expansion as marital union carried within them the specter of marriage as racial amalgamation," a theme hinted at also in *The Trapper's Bride,* particularly in later versions with a baby in the background.[30]

Sentiment and The Trapper's Bride

If *The Trapper's Bride* portrays economic conquest through the metaphor of marriage, it is significant that it does so with a metaphor so emphatically nonviolent. Indeed, the conquest it depicts is ultimately one of the heart, or more precisely, of the sentiments; in an ironic and strategic reversal, the vanquished are not the Indian or the Mexican women, but white men. Miller's imagery can be understood as part of a broader attempt by American artists to gloss over Indian-white territorial conflicts by depicting peaceful scenes. More particularly, *The Trapper's Bride* operates to mask Baltimore's economic conquest of native peoples in terms that flattered Miller's specific audience.[31]

Miller particularly described the trapper's sentiments in the painting. The handsome trapper looks up at his bride gently, but purposefully, with an expression of earnest admiration (plate 1). His hand, resting over the muzzle of his gun, lies just above his heart, so that he appears to offer a pledge of love. Seated directly behind him, his companion amplifies the groom's expression by tilting his head to his left, his cheek resting on the barrel of his own gun in a gesture of exaggerated sentiment. The trappers, harbingers of settlement, bring with them the seed of tender emotions.

Yet their sentiments seem lost on the pair of Indian men who stand directly behind the bride. The bride's father stands behind her, his hand on her back pushing her toward her groom. His right hand hovers above her arm, pointing as if to guide her toward her betrothed. The father gazes downward at the point where their hands will meet, his face bearing no trace of emotion. The man to his immediate right stands up tall, his chin slightly raised, his arm tensed, fist clenched around the calumet he boldly inserts between the bride and groom. Significantly, it is the two Indian men who threaten to interrupt the reverie of the couple by thrusting the calumet—the single recognizably Indian element of the ceremony—between the love-struck groom and his bride. The two men's taut physiques suggest the possibility that they suppress whatever emotions they may feel, as do the well-known figures in Jacques-Louis David's *Oath of the Horatii* (1784). But their physical expressions also invite the viewer to conclude that while they may have emotions, they are not sentimental. Indeed, Miller elsewhere wrote, "It may as well be remarked here, once for all, that the Indian is not a sentimental creature."[32]

If the loving white man and the stern Indian men represent the opposite poles on the spectrum of sentiments, the bride hovers somewhere between, hesitant but in need only of some persuasion. If she does not wholly return her groom's feelings, she is certainly, Miller suggests, worthy of them. Her pose and physique are inspired by the classical paragon of beauty, the *Medici Venus,* which Miller saw during his tour of Italy. Miller made a point in his journal of noting that the sculptor of the *Venus* lent beauty to her feet by carving the second toe slightly longer than the others, a feature that Miller gave to his bride as well.[33] The cool white of the bride's dress and the sculpted quality of her rounded breasts and belly further recall her sculptural source.

Her smooth, rounded face with its delicate features would have been beautiful by the standards of Miller's audience as well. Joan Troccoli has observed that Miller often rounded the features of his

PLATE 13 Hayne Hudjihini (Eagle of Delight),
1825
Charles Bird King (1785–1862)
Oil on panel, 17 × 14 inches
Gilcrease Museum, Tulsa, Oklahoma

PLATE 14 A Young Woman of the Flathead
Tribe, 1858–60
Watercolor on paper, 11 1/16 × 9 7/16 inches
The Walters Art Museum, Baltimore, Maryland

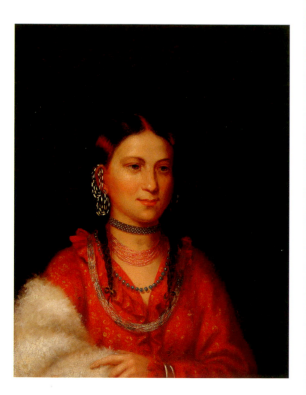

Indian subjects, making them "generally look like dark-skinned Caucasians."[34] Charles Bird King (1785–1862), a contemporary painter of Indian subjects whose work Miller knew, made the features of Indian women whom he wished to portray as attractive look more Caucasian. A contemporary account of Hayne Hudjihini, an Oto woman who visited Washington City in 1821, described her as beautiful in spite of her Indian features. "She . . . is—quite a pretty woman. At least, she is, no doubt considered so in her own nation, and even with us, her modest, goodnatured countenance would pass here for comely, notwithstanding her broad face and high cheek bones."[35] King downplayed Hayne Hudjihini's Indian features in her portrait (plate 13), by giving her particularly pale skin, an oval face, a rounded chin, and indicating her cheekbones by lines rather than more striking contours. The painting was one of King's most popular, and he received numerous commissions for copies of it.[36] Elsewhere in Miller's work, Indian women have still more pronounced Caucasian features. Miller's *A Young Woman of the Flathead Tribe* (plate 14) portrays the unrequited love of a handsome blond trapper named Phillipson. She is shown with rounded cheeks and chin and skin light enough to reveal a blush on her cheek, together with long eyelashes, large eyes, and full lips.

Miller also portrayed the trapper's bride as modest, even a little reluctant. Her expression is serious, her eyes downcast; her father's arm behind her appears to be pushing her toward her prospective groom. Yet she turns and steps toward her groom, reaching her hand out to him by her own volition. In a description of the bride in the Stewart version, Miller characterized her as pensive and dreamy, adjectives that could apply to the Ward, Hopkins, and Oelrichs versions as well.[37] Perhaps the indecisiveness of her posture reflects her inner thoughts. She is weighing both the material advantages of marrying the trapper, as suggested by the string of beads she holds in one hand, and the emotional advantages, as suggested by the couple's outreached right hands. She is not yet in love, but potentially so. Although her modesty, like her beauty, makes her a fitting romantic heroine for the painting's drama, Miller's overall portrayal is more coy than unresolved. The bride may go through the motions of indecision within the painted narrative, but in the composition, her central position, near-frontal pose, and clearly illuminated anatomy present her for the easy delectation of the painting's audience.

Ultimately, the painting's narrative locates the refined sentiment of love, as distinguished from mere animal passion, across a spectrum from white man to Indian woman to Indian man. The Enlightenment view of Indians and whites held that racial difference was a matter of levels of civilization rather than inherent traits. All peoples shared nascent abilities to smell, taste, reason, or emote; they simply differed in the level of refinement they had achieved in each of these respects. Miller's sketches for Stewart presented Indian men as possessing an indigenous nobility that inhered in their natural qualities of martial valor and honor. The ability to feel and control emotions such as anger was another natural human propensity, as Miller demonstrated in *An Attack by Crows* (see chapter 1, plate 9). The proper refinement and regulation of emotions and passions, not the mere possession

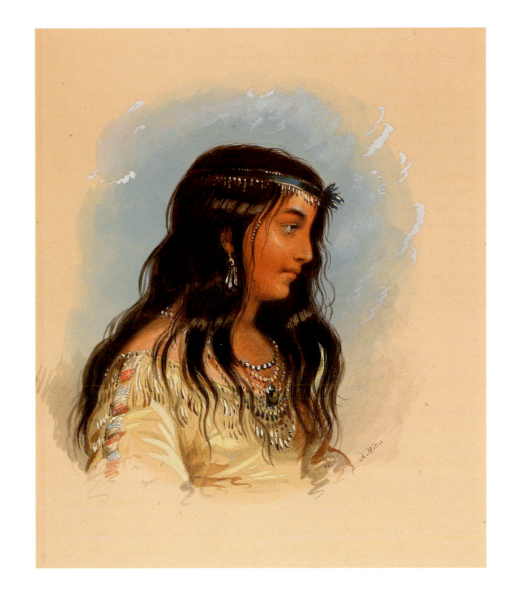

of them, was what marked civilized man. Thus it appears that Miller's trajectory of sentiment also traces a trajectory of civilization, with sentimental whites at one end, and unsentimental Indian men at the other. The bride's hesitance serves two potential functions beyond melodrama. She demonstrates the Indian ability to manifest more tender sentiments (a quality often denied in contemporary frontier fiction) and, to the extent that the trapper succeeds in eliciting those sentiments from her, she also demonstrates the fundamental way in which whites might hope to civilize Indians.

Scholars have classified Miller's work as romantic, and Miller certainly does employ many of the representational strategies of the romantic movement. His subject matter was, by the standards of

his audience, exotic. Carol Clark has noted French romantic painter Eugène Delacroix's influence on Miller's subject matter and his use of color.[38] But Miller's focus on the subject of sentiment in a painting of a subject that was itself sentimental suggests that sentimentalism as a representational strategy is also at play in the image.

Sentimentalism, or "the belief in the power of sincere and refined sentiments to guide moral action," found wide expression in American popular literature between 1840 and 1860.[39] Novels such as Catherine Maria Sedgwick's *Hope Leslie* (1827), Susan Warner's *The Wide, Wide World* (1850), and Maria Cummins' *The Lamplighter* (1852) told of victorious heroes or heroines who were guided by their sentiments, particularly by their ability to empathize with the plights or feelings of others.[40] Periodicals included stories and poems that either inspired or modeled sentiments for their readers. Gift books, which were editions of periodicals offered annually for holiday purchase, packaged sentimental poems, illustrations, and short stories in rich bindings and delicate gilt pages. During the period of Indian Removal, sentimental portrayals of Indian peoples were particularly popular because they helped Americans assuage their guilt over divesting Indian peoples of their homes. Portraying Indians with sympathy helped American artists and audiences to at once certify their own humanity while distancing themselves from the losses the Indians had already, irrevocably, sustained.[41] Although periodicals and gift books were aimed at a female readership, and often were authored by women as well, male writers and artists also employed the strategies of sentimentalism in works aimed at men.[42] There are a handful of studies on aspects of sentimentalism in the visual arts, but there has been no overarching, synthetic study of stylistic traits or representational strategies. It is not the aim of this study to codify a list of traits that could comprise a visual rhetoric or style of sentimentalism. Rather, it focuses on Miller's particular articulation of sentimentalism, which drew on established modes of representation in sentimental art, book illustration, and literature.

In her study of late eighteenth-century sentimental French painting, Linda Walsh argues that facial expression and gesture were significant in denoting the subject's sentiment. "The dreamy, faraway look, suggestive of reverie, could be seen as an appropriate expression of *sentiment,* of a capacity for feeling enriched or guided by thought."[43] The bride seems particularly thoughtful as she casts her eyes downward, her face expressionless. Miller described the bride in the Stewart version in terms that echo Walsh: "The Indian girl hath a pensive, dreamy expression and the 'womankind' say beautiful exceedingly."[44] Though the groom in each of the oil versions appears at first glance to be looking toward the bride, in fact he gazes just past her. The trapper behind him also gazes off into space, chin in hand. A slight raise in the eyes, as we see in the trapper behind the groom, was a method used in particular by Jean-Honoré Fragonard (1732–1806) to suggest sensibility. Finally, Walsh points to the tilt of the head as a common sentimental visual trope depicting tender, lighthearted feelings. The gesture appears particularly in images of women with children or in scenes depicting coquettishness or flirtation. In Miller's painting, the tilted head is most readily apparent in the trapper's companion,

PLATE 15 Baptism of Pocahontas, 1836–40

John Gadsby Chapman (1808–1889)

Oil on canvas, 144 × 216 inches

United States Capitol Rotunda, Architect of the Capitol,
Washington, D.C.

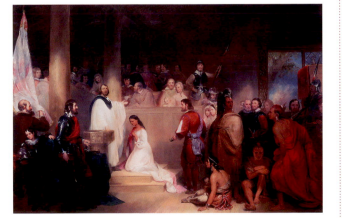

though the rendering of the groom's profile reveals he, too, tilts his head slightly, but perceptibly inward in the Ward, Hopkins, and Oelrichs versions.

The subtlety of the expressions discussed is itself significant. Walsh points out that sentiment was distinct from pure emotion or passion because, as the basis of moral judgment, it was tempered by reason or common sense. Because it was not synonymous with pure emotion, Walsh argues, it could not easily be revealed in conventional facial expressions: "… [H]ow was virtuous emotion to be expressed in the faces of figures? This was, I believe, a significant dilemma for eighteenth-century artists. Faced with a different social code, that of moral sensibility, they had no easy or obvious precedent to follow other, perhaps, than sacred and devotional images."[45]

Miller was certainly familiar with French eighteenth-century art from his studies in Paris, but he also had access to such visual approaches in British sentimental book illustration or singly issued prints illustrating popular novels. William Wynne Ryland's stipple engraving after Angelica Kauffman of *Maria* (1779), a character in Laurence Sterne's sentimental novel *Tristram Shandy* (1759–67), shows its subject with a pensive expression, tilted head and uplifted eyes not altogether different from the trapper's companion. The image was "one of the most familiar images of the age of sensibility, and was used to decorate objects of all kinds, from ceramics to embroidered fire-screens."[46] Baltimore bookstores advertised the availability of single-issue prints, and illustrated copies of books may also have been available to Miller through public and private libraries in Baltimore.[47] Miller's private sketchbooks included illustrations (presently unlocated) for Sterne's *Tristram Shandy* and *Sentimental Journey,* so it is possible that the artist may even have sought out such prints as sources.

The pose and expression of the figures in the painting suggest their sentimentality, but the narrative of *The Trapper's Bride* is sentimental as well. The very subject of Indian-white intermarriage was sentimentalized in novels and dramatizations, particularly in the case of Pocahontas. Miller did at least one Pocahontas sketch, and possibly an oil on canvas as well.[48] George Washington Parke Custis' play *Pocahontas* and John Gadsby Chapman's *Baptism of Pocahontas* mural for the Capitol Building (1836–40, plate 15) offered sentimental portrayals of the subject with which Miller was surely familiar since the artist counted both men as friends.[49] In fact, Chapman's rendering of King Powhatan in *Baptism,* with his stiff pose and sharply turned head, resembles the rigid posture of the Indian man holding the calumet in Ward's and Hopkins' *Trapper's Bride*s (plates 1 and 2); Pocahontas' rejected suitor, Matocoran, seated with his hands on his knees, echoes the figure seated chin in hand behind the bride's father; and the bearded John Rolfe bears some resemblance to Miller's groom. Chapman's rendering of Pocahontas, incidentally, is said to have been based on a copy of Charles Bird King's *Hayne Hudjihini* in his own collection.[50]

The Trapper's Bride's narrative is sentimental not just because of its subject matter, but because its action, even its drama, is determined by the sentiments of the participants. The groom is guided in

his actions by his feelings of love for the bride, and, to the extent that he wears his emotions on his sleeve, we are invited to empathize with his tender feelings. Scholars of American sentimental literature have located the moral underpinnings of sentimentalism in Adam Smith's *Theory of the Moral Sentiments* (1759), which argued that the source of moral judgments could be found not in God or in reason, but in humankind's unique ability to empathize with others.[51] That sympathy would, in turn, guide the sympathizer to make correct moral choices. Consequently, many of the classic American sentimental novels—Harriet Beecher Stowe's *Uncle Tom's Cabin* (1852) is one example—invite readers to sympathize with their characters as a means of moral improvement. *The Trapper's Bride* seems in this respect to invite us to sympathize with the bride as well as the groom. Insofar as an imagined similarity between two people forms a basis for empathy, the Euro-American features of Miller's bride made her easier for Miller's audience to empathize with. Like Chapman's Pocahontas, she looked like American women, shared some of their traits, and consequently could be equally subject to both sympathy and chivalry.

Miller himself modeled such sympathies in his notes to the Walters sketches, when he repeatedly explained and defended the behavior of Indian women on the basis of their similarity to white women. In one instance, he told his readers not to conclude that Indian mothers lacked maternal affection simply because they carried their infants in a cradleboard. After all, he wrote, "they cry as much at the prospect of danger to their children as all 'absurd women kind.'" Miller's sympathies were particularly inspired by Indian women forced to marry Indian men rather than trappers: "should they become … the squaws of Indians, their lives are subjected to the caprices of a tyrant too often, whose ill treatment is the rule and kindness their exception." He imagined that, in response, Indian women fantasized about being rescued by a princely trapper: "The Arabian Nights is a sealed book to her,—not unlikely however she has in day dreams brooded and waited for a kind of Prince 'Firouz Schah' with his enchanted horse, who had but to turn a peg and mount into the air with her, to go away & be forever happy—her Prince generally comes in the guise of a free trapper—but she has (like many another poor girl) waited in vain for the 'Prince.'"[52] Miller's sympathy found a parallel in the narrative that sculptor Hiram Powers (1805–1873) penned to accompany the enormously successful nationwide tour of the *Greek Slave* in 1847–48. Powers' narrative invited his audience to sympathize with the plight of a young Greek woman who had been enslaved by Turkish captors. The woman's Christianity was the key in permitting the audience to identify with her. Her classical, rather than Euro-American, features provided further means of absolving her nudity. As the wedding itself excuses the frank sexuality of the trapper's bride, the redeeming narrative of the sculpture exempts the woman (and, of course, the artist) from censure for her nudity.[53]

While the narrative of Miller's painting may be profitably compared with scenes from mainstream sentimental art and literature, it is perhaps the subgenre of sentimental travel literature that offers the most fruitful comparison. In her study of colonial travel literature, Mary Louise Pratt has defined

sentimental travel narratives as those that use the first person and include subjective description of personal experiences and emotional engagement with foreign peoples.[54] She describes such novels as "anticonquest" insofar as their seemingly innocent narrators appear to passively befriend the people that they are, in a larger sense, conquering and colonizing economically.[55] The central trope of sentimental anticonquest travel narratives, she argues, is the "mystique of reciprocity": "In the human encounters whose sequence makes up [such a] narrative, what sets up drama and tension is almost invariably the desire to achieve reciprocity, to establish equilibrium through exchange."[56] In a characteristic storyline, a narrator shares his food with a native inhabitant he encounters and later, in a moment of need, meets that same person and receives supplies in return. This emphasis on reciprocity, even equity, in encounters with native peoples substitutes for a narrative of commercial exchange. Sentimental travel authors who came to Africa and South America under the auspices of trade associations with the explicit purpose of performing reconnaissance on commercial goods or routes and who visited in a period, 1820–40, that saw the rapid economic expansion of colonial powers in foreign markets, chose to downplay or omit discussions of economic activity. Their brief mentions of the construction of a trading post or the richness of farmlands or mines are subsumed into descriptions of their own subjective responses to the people and places they saw. Thus according to Pratt, "Expansionist commercial aspirations idealize themselves into a drama of reciprocity."[57] The mystique of reciprocity feeds the myth of anticonquest, just as the idea of even exchange forms the central myth of capitalism.

It is certainly the case that the fur trade was first and foremost commercial, and the kind of conquest that it actively and consciously undertook was economic.[58] This fact was likely not lost either on Miller or Stewart. Miller's acquaintance George Catlin was vocal in his indictment of the fur traders' economic exploitation of Indian peoples in the wake of Indian Removal. As Catlin noted repeatedly throughout his two-volume *Letters and Notes on the Manners, Customs, and Condition of the North American Indians* (1841), traders attempted to seduce Indian peoples into trading for "useless gewgaws" that they did not need. Without the trappers, Catlin claimed, the Indians' souls would have remained "unalloyed by mercenary lusts." The collusion of speculators and traders in the economic exploitation of Indian peoples constituted what he characterized as a "wholesale and retail system of injustice."[59]

The fur trade rendezvous where Miller presumably first witnessed marriage *à la façon du pays* was a gathering specifically for fur traders to exchange their goods with trappers and Indians, yet Miller showed us none of the actual trading taking place. Images of trappers at work make only a brief appearance in Miller's finished work, and scenes of the caravan of supply wagons usually appear only as tiny elements in the distant landscape. Given the suppression of economic and political concerns in *The Trapper's Bride*, the interest in romantic reciprocity expressed in the painting takes on more complex dimensions, calling into question the future, not simply of the marriage, but also of

Indian-white trade relations that were at the heart of what was then one of the world's most extensive international trade networks.

The Trapper's Bride should certainly be understood within a wider context of sentimental literature about Indian peoples that proliferated in antebellum America. But further examination of Miller's patronage suggests that the meaning of *The Trapper's Bride* might be more complicated still. For like anticonquest sentimental travel narratives, the painting does not deny trade networks so much as recast them in terms at once more visually appealing and flattering to the patrons who bought the work.

The Trapper's Bride *and Merchant Patronage in Baltimore*

In late October 1848, Brantz Mayer (1809–1879), founder of the Maryland Historical Society, gave an address in honor of the society's newly constructed home, the Baltimore Athenaeum (plate 16). The three-story Renaissance revival structure would house the Maryland Historical Society; the Library Company of Baltimore, an exclusive lending library patronized by the city's oldest and most prestigious families; and the Baltimore Mercantile Library, a second library established for the education of young merchants (or clerks).[60] Mayer's address, "Commerce, Literature and Art," considered the role of merchants in Baltimore's art patronage.[61] He opened by lavishing praise on Baltimore's merchant community, the building's principal benefactors. Mayer decried critics who had said Baltimore's merchants would never contribute to a project from which they could receive no direct remuneration.

> Let it be our boast, as Baltimoreans, that we have now a nobler monument in our midst [than the Washington Monument or the War of 1812 Monument], to which cupidity has not paid the tribute of a cent,—in which selfishness has not set a single stone,—with which the vanity of the living or the dead has no concern, and to which time, money, intelligence, have been unstintingly devoted as a labor of love.[62]

As if to make sure no reader had missed his point, the text printed in all capitals Mayer's claim that the Athenaeum was "A GIFT FROM WHICH NO PECUNIARY RETURN WHATEVER WAS TO BE DERIVED."[63]

Mayer's defensiveness on this point should be understood as a response to a longstanding criticism of Baltimore merchants. As early as 1816, one foreign traveler derided Baltimore merchants for their single-minded focus on accumulating wealth:

> The impulse is fixed, the habit is formed, the love of gain internalized; it would be impossible for them to keep busy with anything but mercantile affairs and speculation and to lose sight

of lovely perspectives on lucre. The commercial towns offer little nourishment for curiosity; they are ordinarily the grave of talent and letters.[64]

This reputation hardened following a catastrophic banking scandal that forced Baltimore merchants to be much more vigilant over the daily transactions of their businesses, earning the reputation of "busy men" consumed wholly by business to the exclusion of family, civic duty, or promotion of the arts. In 1838, the founders of Baltimore's first art institution, the Maryland Academy of the Fine Arts, argued that Baltimore lagged behind its peer cities of New York and Philadelphia in public support of the arts to the detriment of the city's reputation. Its failure prompted a bitter editorial in the city's literary journal about the lack of taste and sensitivity to the arts on the part of the mercantile community.[65]

Though Mayer was at pains to dismiss the accusation of self-interest from merchant patronage, he apparently could not resist appealing to his audience's pragmatism. He went on to argue that patronage of the arts and literature would benefit merchants economically as well as spiritually by educating them about the customs and habits of their customers, the geography of shipping routes, or the rates of exchange for goods. "The well informed merchant," said Mayer, "is always the safest and happiest, if not the richest of his class." It was in the interests of art, literature, and commerce, therefore, that they should support one another. Indeed, Mayer declared, "Were I asked to design a group to be carved in marble and placed over the portal of our Athenaeum, I would link, hand in hand, Commerce, Art and Literature, as the Christian Graces of the nineteenth century."[66]

The thrust of Mayer's address was surely not lost on two of his audience members, Benjamin Coleman Ward, a member of the Building Committee, and Johns Hopkins, the committee's director.[67] Ward and Hopkins each purchased a version of *The Trapper's Bride*—Ward in 1846 and Hopkins in 1847. If not for Mayer's lecture, the two patrons might seem to represent different poles of Miller's patronage. Ward was, according to an article in the *New York Herald,* an established collector who owned works by minor European masters as well as works by John Singleton Copley (1738–1815), George Loring Brown (1814–1889), and Richard Caton Woodville (1825–1855).[68] The Maryland Historical Society Annual Exhibition Records show Ward exhibited works by Manuel Joachim de Franca (1808–1865), Herman van Swanevelt (ca. 1600–1655), and Giovanni Paolo Panini (1692–1765), and a sketch after Salvatore Rosa (1615–1673). He likely knew Miller through their mutual ties to other artists, collectors, and dealers within the Baltimore art community, particularly Mayer.[69] From Miller, Ward had previously purchased *Ruth and Boaz* (ca. 1845) (probably an Old Master copy) and *Olivia and Sophia, Consulting the Gypsy Fortuneteller* (ca. 1845), a frequently illustrated scene from Oliver Goldsmith's sentimental novel *The Vicar of Wakefield* (1766).[70] In contrast, the few paintings Hopkins owned included some Old Master copies and two portraits by Miller.[71] Though Hopkins was a member of literary and art institutions in the city, he knew Miller because he had patronized

Miller's father's tavern.[72] Yet Ward and Hopkins significantly shared an identity as Baltimore merchants, and this is central to understanding not only why they patronized Miller but also what *The Trapper's Bride* meant within the context of their patronage. Mayer's address describes an ideology of Baltimore mercantile patronage that framed their collecting activities and that was exemplified by *The Trapper's Bride.*

Trade had historically played a central role in Baltimore's economy. Baltimore's rise as the new republic's third largest city was fueled in part by the financial successes of shipping merchants who operated as privateers during the War of 1812. Although the first generation of merchants following the war suffered from their inability to adapt to shifting alignments in international markets, the second and third generations—those of Miller's patrons—hoped to prosper by finding new markets in the trans-Allegheny, and later, the trans-Mississippi West. A small group of wealthy and influential Baltimore merchants proposed building a transcontinental railroad that would connect Baltimore with the Ohio Valley and beyond (even though a workable locomotive had yet to be invented).[73] The Baltimore and Ohio Railroad (hereafter B&O) was incorporated in 1827. Its prospectus made extravagant claims, predicting that the railroad would reach the Rocky Mountains, or even the Pacific, within thirty years.[74] It did not achieve that goal, but by 1853 it had linked Baltimore to the Ohio River. It reached Chicago in 1860 and Saint Louis ten years later.

Though many Baltimoreans stood to prosper at least indirectly from the growth of the city's mercantile economy, it appears that the majority of Miller's patrons had a direct stake in its westward expansion. Of the forty-five individuals listed in Miller's account book as purchasers of western scenes, one each was a surveyor, bookseller, publisher and banker; two were manufacturers; three were doctors; four made their incomes from rental properties; five were lawyers; and twenty-seven were wholesale and shipping merchants.[75] Although coffee and sugar from South America and the West Indies were two of Baltimore's most heavily traded goods, none of Miller's patrons exclusively traded in them.[76] Rather, Miller's patrons specialized in goods traded to and from the West, such as wholesale groceries, flour, provisions (lard and bacon), and tobacco.[77] As an example, Miller's account book lists John Cassard, the purchaser of *Trappers Saluting the Rocky Mountains* of 1864 (plate 17), as a provisions dealer whose supply came principally from Chicago.[78] The painting shows two trappers on a precipice firing their guns across the water toward distant mountains as if to claim the territory before them. P. H. Sullivan, who purchased several trapper scenes, including *Killbuck and La Bonté* (presently unlocated), based on a novel by George Frederick Ruxton (1821–1848), began his career as a wholesale commissions merchant and later became a banker. He served on the B&O's board of directors.[79]

None of Miller's patrons had so direct a stake in western trade and in the completion of the B&O as did Johns Hopkins. Hopkins, who made his money initially as a commissions merchant, enriched his fortune following his retirement in 1847 by investing in businesses and real estate, particularly

PLATE *17* Trappers Saluting the Rocky Mountains, 1864

Oil on canvas, 25 × 37⅞ inches
Buffalo Bill Historical Center, Cody, Wyoming
Gift of The Coe Foundation

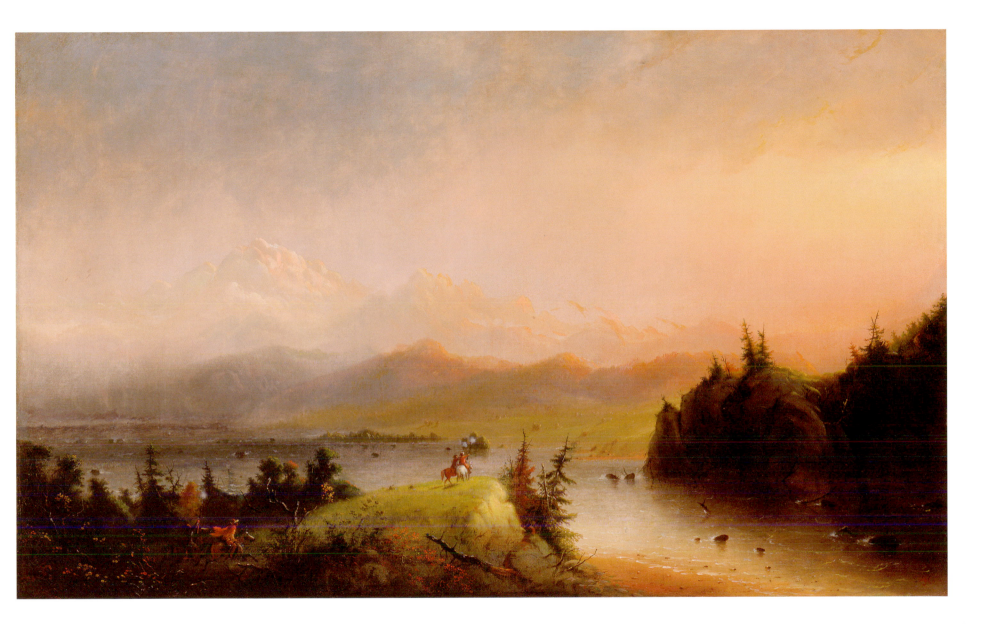

commercial warehouses, in Baltimore. His experience as a merchant made him a strong supporter of the B&O. According to his biographer:

> That Johns Hopkins should promptly recognize the promise in the proposed railway connection for Baltimore was not surprising. His great Conestoga wagons, each crammed with sufficient merchandise to fill a small warehouse … were crossing and re-crossing the Alleghanies [*sic*] to the new States beyond.… On one occasion he sent a load of merchandise weighing four tons to Mount Vernon, Ohio, a distance of four hundred miles. The wagon brought back three tons and a half of Ohio tobacco.[80]

Hopkins would become the largest private stockholder in the B&O, privately owning 15,000–17,000 shares. In 1847, the year he paid for and received *The Trapper's Bride,* he joined the B&O's board of directors; he became head of the finance committee, a position of de facto directorship, in 1855. He would bail out the railroad with his own money during the panics of 1857 and 1873.[81]

Within the context of Hopkins' investment in the B&O railroad, the union of white trapper and Indian bride pictured in *The Trapper's Bride* can easily be read as a metaphor for Baltimore merchants and their productive new markets. Miller's commentary for Walters occasionally refers to the trappers romantically as "princes." But merchants were also commonly compared to princes in contemporary speech; Miller himself referred to the "merchant princes" in a letter to his brother written while he was at work on the Hopkins *Trapper's Bride.*[82] Moreover, the painting's emphasis on the productive channeling of erotic desire can be understood as a wish for a concomitant consummation of financial ties. Art historians have debated the meaning of the couple's outstretched hands. Does their failure to touch suggest the doomed nature of their union? Or is the gesture simply borrowed from an Old Master painting?[83] There is a suspense created by the couple's outreached hands, but Miller also used formal means to suggest the likelihood of their union. In each of the versions, the bride's forearm creates a graceful line downward toward the groom's gently proffered hand. Her father's arm reiterates her gesture, as does the line formed by the calumet. Miller's repetition of downward lines helps to create a momentum toward the point at which the bride and groom's hands will unite. The groom's arm, once raised to meet his bride's, will complete the line from her elbow to his. The gesture, and the union itself, will be consummated. The open and glowing horizon above the couple suggests the limitless prospects of its outcome.[84] The tension surrounding the consummation of the bride and groom's gesture thus captures the excitement and anticipation felt by a patron with a very real, material stake in western commerce. Hopkins, a lifelong bachelor because he was forbidden to marry his cousin, viewed business contracts as analogously binding as marriage contracts. Hopkins refused to put into a position of responsibility any man he knew to be unfaithful to his wife because "he considered such conduct a breach of contract."[85]

Each of the other three purchasers of *The Trapper's Bride*—Benjamin Coleman Ward, Henry Oelrichs, and Charles De Ford—also had a stake in expanding the market for Baltimore goods and improving the means of transporting them. They were all commissions merchants, or merchants who could procure goods on request to retailers for a commission. Ward's company, Tiffany and Ward, was listed in the Baltimore Directory as a domestic commissions firm, indicating that they supplied goods for retailers in neighboring states and the West rather than Europe. Oelrichs, of Oelrichs and Lurman Commission and Shipping Merchants, exported goods including flour from the Ohio Valley to Europe. De Ford, of Charles D. De Ford and Company, was a tobacco commissions merchant with suppliers along the B&O rail line in Virginia, and possibly in the Ohio Valley as well.[86]

The Trapper's Bride may have appealed to Baltimore patrons insofar as it could be understood consciously as a metaphor for trade relations with the West, but it is likely the painting carried such associations for the artist as well. Without seeing the Murthly version of *The Trapper's Bride* it is impossible to know if Miller altered aspects of the composition to foster such associations, but the artist could hardly have escaped being aware of Baltimore's western business prospects when he painted the picture. Miller's various studios were all in the heart of Baltimore's commercial district. The B&O Railroad offices were just a few blocks from Miller's studio between 1845 and 1850, and just across the street from the studio he occupied from 1852 to 1864.[87] Moreover, the Baltimore and Ohio Railroad enjoyed wide popular support in the city. The initial public offering of stock in 1827 sold out all available shares in eleven days.[88] In general, the city staked its future economic development quite publicly on the promise of market expansion. In 1845, the publisher of *The Baltimore Directory,* a self-proclaimed voice of the Baltimore business community, identified the city's growth and success with the expansion of its trade networks:

> [T]he time is not far distant when the branches of her Railroads and Canals shall, like those of the tree mentioned by the psalmist "go to the rivers and the sea." These avenues of communication, branching off in all directions,—to the East, to the North, to the West, and to the South,—may be regarded as lines of radiation; by which the rays of an invigorating trade shall here meet and combine, as in a common focus; not merely imparting the glow of commercial prosperity to the centre, but also transmitting a reciprocal advantage to every region within the reach of its extended influence.[89]

Perhaps unsurprisingly, Miller shared some of the same financial interests that his patrons did. Miller's brother Decatur, who was ten years the artist's junior, rose to prominence as a tobacco commissions merchant in the 1850s. Possibly on the advice of his brother, or of his patrons, Miller began investing in a number of banks and railroads that had western ties and for which his patrons served as directors. In January of 1850, the year he painted his third version of *The Trapper's Bride,* Miller

invested nearly a year's income, or $1,250, in B&O Railroad bonds; in 1855 he bought another $4,000 worth. Between 1862 and 1873 the artist bought fifty-nine shares of stock in the company worth $9,572.00. In 1850 and 1856, respectively, Miller also began buying stock in the Western National Bank (1850–73) and the Farmers and Merchants Bank (1856–74). He also owned stock in a mine in Wyoming. At his death, Miller's investments in western markets via banks, railroads, and mining companies totaled $34,084 or one-third of the total estimated value of his property and investments.[90]

If Miller's painting offers a metaphor for Baltimore's westward expansion, the question arises as to what, precisely, Miller or his patrons gained by having it so portrayed. Certainly the painting can be understood fundamentally as a celebration of the natural, fertile, and benign prospects of such a union. But Patricia Hills' work on the American Art-Union raises the question of whether Miller and his patrons also aimed for the painting to persuade a wider audience of their expansionist vision. Hills has argued that members of the American Art-Union's Committee of Management purchased and distributed works of western genre (including Miller's *Giving Drink to a Thirsty Trapper*) because the works reflected their economic interests in westward expansion:

> Close examination of the institution's history and the managers who ran it reveals that both the words used to promote the goals of the organization and the artworks it favored matched the rhetoric of patriotism and the ideology of empire building that served to advance the interests of these managers in their business lives.[91]

She goes on to argue that the public patronage role of the Art-Union, particularly its well-attended annual exhibitions and its wide distribution of engravings, provided its managers with the opportunity to persuade a national audience of its views. Though Hills does not believe the AAU management committee consciously attempted to shape the public's attitudes toward westward expansion, she does demonstrate that they understood the power of art to help shape national consensus, and that they may unconsciously have sought to shape it in ways that were compatible with their interests.[92]

Unlike the management committee of the Art-Union, Miller's private patrons could not have held the expectation of a national audience for the paintings that they bought. Ward did serve on the hanging committee for the Maryland Historical Society's annual exhibition, and he did lend *The Trapper's Bride* for the inaugural show.[93] But other of Miller's patrons, including Hopkins, Owen Gill (1809–1874), and Patrick H. Sullivan (1816–1874), along with the artist himself, exhibited Miller portraits and Old Master copies rather than western subjects at the same annual exhibitions. Instead, it appears that *The Trapper's Bride* would principally have circulated privately, among the Baltimore elite.

In the 1830s and 1840s, Baltimore's elite fragmented into three rival groups: a social elite comprising older, moneyed families who lived off investments and rental incomes and who enjoyed a

somewhat dated aristocratic prestige (termed rentiers), and a functional elite divided between merchants and manufacturers.[94] It is important to note that what distinguished merchants from rentiers was not pedigree per se, but lifestyle. Johns Hopkins, for instance, came from an old, landed Quaker family from Maryland's eastern shore. He differed from William C. Wilson, one of Miller's rentier patrons, because Hopkins actively worked for his fortune. The manufacturers were devoted to their work as well, but seemed peculiar to the rentiers and the merchants for their intense, solitary involvement with the technological and engineering aspects of their businesses. Ross Winans (1796–1877), a Miller patron and inventor of the "camel" steam engine, was an example of such a manufacturer. Miller, in fact, enjoyed patronage from members of all three groups, but the bulk of his western patronage was merchants. These divisions were echoed and, moreover, qualitatively stratified, in the very architecture of the Baltimore Athenaeum, described in detail in an appendix to Mayer's published address.

The building was comprised of three floors. One each was dedicated to the offices, collections, and reading rooms of the Athenaeum's three member institutions. The materials and design of each floor appear to have been chosen to articulate the values and social position of the members of their respective institutions. The first floor belonged to the Mercantile Library Association, a public lending library for clerks. Its rooms were described as "fitted up appropriately" in the style of the Philadelphia Mercantile Library with "a gallery, extending entirely around the room, with [book] cases above and below, glazed in diamond lights and grained to imitate oak."[95] The second floor housed the Library Company of Baltimore, a private library founded and patronized principally by the rentiers.[96] Its rooms had been "magnificently" rather than merely appropriately "fitted up, with a gallery extending around the room, with ornamental glazed-book cases below and above."[97] It was paneled and furnished in solid, rather than faux, oak. The author of the appendix, Athenaeum architect Robert Cary Long (1810–1849), noted that the Library Company's "Sienna marbled pillars, its stately array of books, and its noble dimensions, [are] not excelled by any public Library in the country."[98] The top floor housed the library and gallery exhibition space of the Maryland Historical Society, whose membership included a cross section of the rentiers and merchants who had literary leanings and Whiggish politics.[99] Their quarters were not magnificent but tasteful. They were "fitted up in a chaste and elegant manner, with solid oak glazed cases, tables and chairs, the President's room having beautiful and appropriate furniture . . . designed to correspond with the style of the building."[100] Significantly, the manufacturers were, architecturally and institutionally, entirely excluded.

The local purchase and display of *The Trapper's Bride* did not permit the painting to promote the investments of its patrons among a wider regional or national audience. But Miller's painting would have had limited, but potentially important, influence as it circulated among the members of Baltimore's various elites. Many of Miller's patrons served with one another as directors on boards of banks, insurance companies, utilities, cultural institutions, and charities.[101] These business ties must

surely have fostered the kind of social relations that brought the elite into one another's homes. Since the rentiers made their money principally from investments in banks and businesses, Miller's painting could conceivably have promoted his patrons' western interests among the rentiers who saw them.[102] But Miller's particular means of portraying westward expansion in *The Trapper's Bride,* specifically his sentimentalization of Indian-white trade, could have promoted the merchants' idealized, purportedly unselfish view of themselves and their own trade practice over their social and political rivals even as it ostensibly found common ground between elite factions in their shared support of economic growth.

Baltimore's merchant elite adapted to economic and social change by adopting new models of business while proclaiming allegiance to old ones.[103] The economic expansion fueled by the Industrial Revolution forced Baltimore merchants to give up conducting business on the basis of gentlemen's agreements and personal transactions and to rely instead on more anonymous contracts, letters of credit, and promissory notes.[104] But the same merchants who achieved success by accepting the increasing standardization and institutionalization of business practices in the 1840s and 1850s professed to hold on to preindustrial business values that prized face-to-face dealings within a small, unregulated community.[105] An editorial in the old-guard *Baltimore Daily Exchange* made clear the perceived moral superiority of older business models and criticized merchants for "transacting their business in their own stores and counting-rooms, each dealer dwelling separate and apart from his fellows, like an oyster in its shell and pursuing his own course of petty dealing in a spirit of narrow and exclusive selfishness and isolation." The author reminisced about days when "daily intercourse promoted sympathy" between merchant and client and called for a return to the days when "larger and nobler views, and loftier purposes animat[ed] our merchant community."[106]

In *The Trapper's Bride,* trade, as symbolized by marriage, is presented in correlating lofty terms as an act of sympathy and a means of productive and beneficial procreation. The marriage pictured therein is the ultimate face-to-face transaction whose prospects must finally rest on the trapper's love and the as yet unfulfilled promise of the Indian woman's reciprocated feelings. Then again, perhaps Miller's trapper is unconcerned with reciprocity. Perhaps he has learned what Mayer's merchant patrons supposedly already knew: we do not live only to profit from our exchanges. "There is a higher existence of sympathy and love which should pervade society and fill it with unselfish meaning," Mayer reminded his audience.[107] Loving, like giving, is best done for its own sake.

The Trapper's Bride *Watercolors*

The Trapper's Bride ostensibly represents a romantic scene, but circumstances of its creation, circulation, and display suggest a strong commercial subtext for the painting. Although this commercial subtext can be understood through a combination of the painting's subject matter and its context, Miller gave the image an explicitly commercial subplot in a short note he wrote to accompany a watercolor version painted for Baltimore collector William T. Walters. In the note, Miller wrote:

The scene represents a Trapper taking a wife, or purchasing one. The prices varying in accordance with circumstances. He (the trapper) is seated with his friend, to the left of the sketch, his hand extended to his promised wife, supported by her father and accompanied by a chief, who holds the calumet, an article indispensable in all grand ceremonies. The price of acquisition, in this case, was $600 paid for in the legal tender of this region: viz: Guns, $100 each, Blankets $40 each, Red Flannel $20 pr. yard, Alcohol $64 pr. Gal., Tobacco, Beads &c. at corresponding rates.

A Free Trapper (white or half-breed), being top or upper circle, is a most desirable match, but it is conceded that he is a ruined man after such an investment, the lady running into unheard of extravagancies. She wants a dress, horse, gorgeous saddle, trappings, and the deuce knows what beside. For this the poor devil trapper sells himself, body and soul, to the Fur Company for a number of years. He traps beaver, hunts the Buffalo and bear, Elk &c. The furs and robes of which the Company credits to his account.[108]

Commentators have been quick to note that Miller's cynical text does not jibe with the more benign tone of the watercolor.[109] The overall composition of the Walters *Trapper's Bride* follows that of the oils with the same principal figures in roughly the same configuration. Some of the drama of the earlier oils, however, has been muted. Distant mountains have been sketched in, but there is no sense of a deep back or midground space, so that what was once a dramatic scene unfolding on a precipice over an open plain is now presented more humbly as an incident of daily life in camp, barely noticed by figures in the background. Some of the tension between the bride's side of the picture and the groom's is also gone. The two groups stand closer; their hands, elbows, guns, and pipes fill the small space between them with a network of lines. The emotional disconnect between the bride and groom has also been replaced with a more equitable, and thus less suspenseful, exchange of glances. Their hands also come closer to touching than in the oils.[110]

One overall effect of these changes is that the bride and groom in the Walters watercolor seem more equally matched in affections than they do in the oils. Though the trapper still gazes up at his bride with wide eyes, he no longer leans forward, arching his neck in an eager, almost pleading posture. If he seems slightly less inclined than his predecessors, the bride seems more so. She no longer

PLATE 18 Harry Dear . . . , n.d.
Pen and wash sketch on paper, 6½ x 4¾ inches
The Walters Art Museum, Baltimore, Maryland
Gift of Mr. and Mrs. J. William Middendorf II

hesitates, but holds her arm out straight in a firm, confident gesture. Here her gaze is directed toward her groom rather than at her feet. Her acquiescence is even more apparent in the sketch version where her face bears the trace of a smile (plate 5).

Although the text and image appear, at first, to be incongruous, Miller's juxtaposition of cynical text and sweet image may have been aimed at achieving comic irony. In the Walters commission, many of Miller's more obviously humorous notes are matched with seemingly straightforward genre images as if to point up the follies of trapper and Indian alike, particularly in matters of love. In his note accompanying *Scene on the Big Sandy,* a sketch showing two attractive young women in a stream watering their horses, Miller wrote:

> The sketch may be said to represent a small slice of an Indian paradise;—Indian women, horses, a stream of water, shade trees, and the broad prairie to the right, on which at times may be seen countless herds of Buffalo, Elk, and deer.
>
> The women look innocent enough, but some of the Trappers conceive them difficult studies. An experienced trapper giving his advice to a younger, who had been smitten by the charms of a dusky Venus, discoursed something in this wise,—"Look ye hyar now! I've raised the ha'r of more than one Camanche, and hunted and trapped a heap, Wagh! from Red River away up among the Britishers to Heely [Gila] in the Spanish Country, and from old Mis-sou-rye to the sea of Californey; b'ar and beaver sign are as plain to me as Chimley [Chimney] Rock on Platte, but darn my old heart if this child ever could shine in making out the sign lodged in a woman's breast." "Look ye sharp or you're a gone beaver, ye cus't green horn, I'll be dog gone if you ain't, Tiya! Wagh!!"[111]

A look into Miller's private sketchbooks reveals he often took on humorous subjects in his works on paper. Over his lifetime, Miller amassed at least six scrapbooks filled with scenes from daily life or from popular literature.[112] Miller's so-called "Baltimore sketchbook" illustrated many comic scenes from daily life. *Harry Dear,* a composition that is reminiscent of *The Trapper's Bride,* shows a young wife standing before her seated husband, a new dress draped across her outstretched arm (plate 18). Her husband looks up at her in dismay. Miller's caption below reads, "Harry, dear. Only see what a nice silk I have bought. Only $6. a yard—Dog cheap!" Harry (pulling a long face)—"'*Dearest* of Dears'— You have always proved inexpressibly *dear* to me."

Miller's pun would have drawn its humor from contemporary social anxieties about the role of wives as consumers among an emerging middle class. As the masters of the domestic realm and its wares, they occupied a position of power in the household, but they were also open to censure for their purported materialism: "The stereotypical caricature of women and women's work offer clues to male thinking about household gentility. Genteel women were charged with a slavish devotion to fashion,

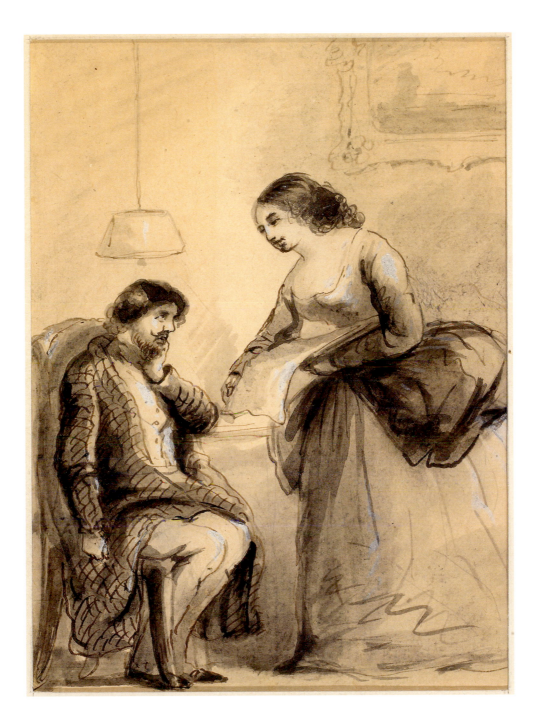

an excessive love of balls and fine clothes, a squandering of their husband's money on needless frip-peries."[113] Certainly the kind of cross-cultural comparisons that structured Miller's work for Stewart constituted a double-edged sword. As with the nobility, the follies or vanities of middle-class Ameri-cans could also be found among Indian peoples. But Miller's implicit comparison of Indian and white women was more likely underpinned by prevailing beliefs in the essential nature of women than in his quasi-Enlightenment beliefs about mankind. Antebellum America's "cult of domesticity," or the view that women were selfless, nurturing, and domestic *by nature,* encouraged white observers to see the same traits in Indian women. "The natural [Indian] woman," one historian has written, "was consis-tently defined not in opposition, but by extension from the characteristics and roles prescribed for contemporary [European-American] women."[114]

For the purposes of this discussion, however, the principal significance of the Walters *Trapper's Bride* is not the humorous gloss of Miller's note, but the central place that the note accords to commerce in an ostensibly romantic image. In Miller's narrative, the trapper does not court or seduce his bride; he buys her. The principal currency is not bartered American Indian goods, or objects of traditional value in Plains society, such as horses, but eastern-made guns, cloth goods, and alcohol. In Miller's text, the bride becomes the ultimate western consumer, requiring "unheard of extravagancies" in luxury goods such as "a dress, horse, gorgeous saddle, trappings," etc. In consequence, her suitor's love is expressed by (or even exchanged for) the amount of time he must work for the fur company to settle his debt.[115] Miller's characterization of the marriage in the note to the *Trapper's Bride* almost certainly plays on white observers' beliefs that the Plains custom of a "bride price" was in effect an outright sale of Indian women. His suggestion that the bride sought to profit from the alliance is echoed by a pas-sage in Stewart's novel that described how trappers promised their partners "bright ornaments, . . . —while the unusual blandishments and caresses which the women lavished on their lords, showed that it was a part of their system to impress upon them how much the charms of their connection were to be enhanced by liberality."[116] Indian-white marriages, popularly construed, were thus ripe with the kind of folly the artist enjoyed lampooning.

The Trapper's Bride arguably owes its appeal to the romance and exoticism of its subject as well as to its ability to frame the issue of Baltimore's westward expansion in accessible, intimate terms. It mirrors a truth about national phenomena like westward expansion. Although westward expansion may have its source in government policies of Manifest Destiny or Indian Removal, it was experienced "on the ground," so to speak, in countless small transactions between whites and Indians across the West. This discussion of *The Trapper's Bride* has sought to provide a similarly localized perspective on the painting itself. What did the promise of westward expansion mean to Baltimoreans? How did their existing values and sympathies cause them to view the impact of such an expansion? More to the point, how did Miller's own views as a Baltimorean, an investor in the West, and an artist, shape his representation of *The Trapper's Bride?* Offering a more nuanced reading of *The Trapper's Bride* in a

local context, however, does nothing to suggest that the painting has no relevance to a national one. On this subject, Walt Whitman's use of *The Trapper's Bride* in "Song of Myself" is instructive. In his poem, the image of an open-air marriage between a trapper and an Indian woman is—like an individual blade of grass in a field—a unique, constitutive part of what the nation is. By the same token, western art does not uniformly reflect a preexisting idea of American westward expansion. Rather, individual paintings like *The Trapper's Bride* help to constitute its ideology.

This chapter has only peripherally considered images from the Walters commission, but the commission was certainly the most important of Miller's Baltimore career. Not only was it the largest single commission Miller completed for a Baltimore patron, it also was likely the most liberal in terms of its conditions. The relative freedom Miller enjoyed in executing the commission, as well as its scope, permitted him to explore a wide variety of themes. The following chapter again takes up the topic of sentimentalism, this time in relation to portrayals of manhood in the Walters commission. In some of the Walters images, completed near the end of Miller's career, the artist plumbed his own experience to present a vision of sentimental, creative manhood that could compete with the popular ideal of the businessmen for whom he painted. If his multiple commissions for *The Trapper's Bride* reveal Miller to have been a shrewd businessman, the Walters watercolors reassert his status as artist.

Notes

1. Although there is no record of other *Trapper's Bride*s in the Stewart commission, it is possible that one of the lost album sketches depicted a *Trapper's Bride*. In a letter to an organizer of the annual exhibition of the Pennsylvania Academy of the Fine Arts, Miller claims that the painting was "from an original sketch made in Oregon [Territory]," A. J. M. to John I. Lewis, Esq., Baltimore, 7 April 1852. While in Scotland, Miller also referred to the painting in letters to his brother Decatur Howard Miller without providing an explanation of its subject or composition, suggesting that Decatur, who had seen some of the Stewart sketches before they were shipped from Baltimore, was already familiar with it. A. J. M. to D. H. M., Murthly Castle, 19 May 1841, Porter Papers. The catalogue raisonné lists nine versions, Tyler, *Artist on the Oregon Trail*, 191ff., but cat. no. 191B, the image from the Probasco Collection now at the Hunter Museum of Art, Chattanooga, Tenn., and cat. no. 191G, the one recorded in Miller, Account Book, as sold to Charles De Ford, are likely the same image. Cat. no. 191C, the version now in the Eiteljorg collection, and cat. no. 191D, the version sold to Benjamin Coleman Ward, are almost certainly the same image. A note in the painting file at the Eiteljorg states that the original stretcher bore the inscription B. Cunard, a likely mistaken transcription of B. C. Ward. Karen Dewees Reynolds to Harrison Eiteljorg, 14 September 1981, Harrison Eiteljorg to Karen Dewees Reynolds, 18 September 1981, paintings file, Eiteljorg Museum. We are thus left with a total of seven versions of the work.

2. The Stewart *Trapper's Bride* has been unlocated since it was auctioned with Stewart's moveable property following his death in 1871, but it likely resembled the Ward version. An account of the auction describes it as follows: "An American Indian marriage, Sir William Drummond Stewart and Attendants being present, a grand gallery picture L13m 2s, 6d," *Scotsman*, 17 June 1871: 2, c. 1. The Ward *Trapper's Bride* shows an Indian man riding in from the right on a white horse who is probably a substitution for Stewart. A party of trappers visible in the distance likely stands where Stewart's party would have been in the Stewart version. Miller's observation that the bride in the Stewart version was "the cynosure of all observers" suggests that she likely occupied the same central position in the composition that she does in later versions. A. J. M. to D. H. M., Murthly Castle, 2 October 1841, Porter Papers. Miller's account of Stewart's daily critiques, and his patron's particular interest in the "sufficient dignity in expression and carriage" of the Indian figures, as discussed in the previous chapter, suggests that the painting presented Indians in similar Enlightenment terms as other of his works at Murthly. A. J. M. to D. H. M., Murthly Castle, 26 July 1841, in Warner, *Fort Laramie*, 181–82.

3. The De Ford *Trapper's Bride* is likely the one now at the Hunter Museum, despite discrepancies in the number of figures present in each. The image at the Hunter appears stylistically close to other images painted in and around 1852, when Miller recorded having completed a new *Trapper's Bride*. By Miller's account, that version contained twelve figures rather than the nine that now appear in the Hunter, but it seems more likely that Miller painted three figures out than that he painted yet another *Trapper's Bride* between 1852 and 1856. If the Hunter version is the one painted in 1852, it has an interesting history. It was exhibited at the Pennsylvania Academy of the Fine Arts in 1852 and the Metropolitan Mechanic's Institute in 1853. In 1853 Miller made a notation in pencil in his account book that the painting was sent to New York for possible sale through a gallery, but since no such transaction is recorded in ink in his account book, it must not have taken place. If it was exhibited in New York, this may be the version that Walt Whitman saw and described in "Song of Myself."

4. *Catalogue of Paintings, Engravings, &c. at the Picture Gallery of the Maryland Historical Society. First Annual Exhibition, 1848.* (Baltimore: John D. Toy, 1848).

5. Glanz, *How the West Was Drawn*, 40–41. See also Troccoli, *Watercolors of the American West*, 45; McLerran, "Trappers' Brides and Country Wives," 9. Miller's skills as an Old Master copyist earned him the moniker "The American Raphael"; Early, *Alfred J. Miller, Artist*, n.p.; see also Johnston's discussion of Miller's copying at the Louvre, "The Early Years in Baltimore and Abroad," in Tyler, *Artist on the Oregon Trail*, 12–13.

6. "I have a delightful painting room and when tired of my work resort to the library where … [there] are port-folios of the finest and most valuable engravings." Alfred J. Miller to Dr. Benjamin Cockey, Murthly Castle, 15 November 1840, DeVoto Papers. Paintings of the *Judgement of Paris* often followed a similar compositional outline: Paris seated on an embankment at lower left, a companion behind him, with Aphrodite at the center between Hera and Athena. In the Prado version, however, Rubens turns Paris sideways in full profile, chin in hand, leaning on his staff.

7. "Sale of Antique Furniture and Tapestry from Murthly Castle," *The Scotsman*, 17 June 1871: 2, c. 1. I thank Pamela Fletcher for this observation.

8. Patricia M. Burnham and Lucretia Hoover Giese, eds., *Redefining American History Painting* (Cambridge: Cambridge University Press, 1995), 1.

9. *Record of the First Exhibition of the Metropolitan Mechanic's Institute*, 41.

10. On the importance of heroism in history painting, see Sir Joshua Reynolds, *Discourses,* ed. Pat Rogers (London: Penguin Books, 1992), Discourse IV, 117; and Barbara J. Mitnick, "The History of History Painting," in *Picturing History: American Painting 1770–1930,* ed. William Ayres (New York: Rizzoli International Publications, 1993), 29–31.

11. William R. Swagerty, "Marriage and Settlement Patterns of Rocky Mountain Trappers and Traders," *Western Historical Quarterly* 11, no. 2 (1980): 159–80; and John Mack Faragher, "The Custom of the Country: Cross-Cultural Marriage in the Far Western Fur Trade," in *Western Women: Their Land, Their Lives,* ed. Lillian Schlissel, et al. (Albuquerque: University of New Mexico Press, 1988), 199–216. Stewart himself refers to such marriages as temporary arrangements; "The custom of the country sanctioned periodical contracts of marriage, if such connection should be so called." [Stewart], *Altowan,* 2:39, though historians argue that such unions generally were stable and of long duration. Swagerty, "Marriage and Settlement Patterns," 164; Faragher, "Custom of the Country," in Schlissel et al., *Western Women,* 206.

12. Sylvia Van Kirk, *Many Tender Ties: Women in Fur-Trade Society, 1670–1870* (Norman: University of Oklahoma Press, 1980), 36; among northern tribes that Van Kirk discusses, the bride was also given a ritual cleansing and dressed in European clothes.

13. On antebellum American marriage customs, see Michael Grossberg, *Governing the Hearth: Law and the Family in Nineteenth-Century America* (Chapel Hill: University of North Carolina Press, 1985).

14. Rev. John Henry Blunt, *The Annotated Book of Common Prayer: Being an Historical, Ritual, and Theological Commentary on the Devotional System of the Church of England* (London: Rivingtons, 1866), s.v. "Solemnization of Matrimony."

15. Schoelwer, "The Absent Other," in Prown et al., *Discovered Lands, Invented Pasts,* 146; McLerran, "Trappers' Brides and Country Wives," 13.

16. Schoelwer, "The Absent Other," in Prown et al., *Discovered Lands, Invented Pasts,* 152.

17. I adapt this idea about Goya's *Nude Maja* from a lecture Janis Tomlinson gave at Columbia. Tomlinson argues that the artist likely contorted the woman's pose and rendered her skin pale in order to highlight those parts of her body involved in procreation. I have no evidence that Miller saw the *Maja;* perhaps he arrived independently at a similar formal approach.

18. Rayna Green, "The Pocahontas Perplex: The Image of Indian Women in American Culture," *Massachusetts Review,* 16, no. 4 (Autumn 1975): 698–714.

19. Schoelwer, "The Absent Other," in Prown et al., *Discovered Lands, Invented Pasts,* 153.

20. James R. Walker, *Lakota Society,* ed. Raymond J. DeMallie (Lincoln: University of Nebraska Press, 1982), 51; Walker made these observations while living on Pine Ridge Reservation from 1896 to 1914. According to DeMallie, Walker's reports on the structure of society form "some of the most reliable information ever recorded on the subject . . .," xii. Miller does not appear to have originally intended the two to be pendants. As the paintings were originally conceived for Stewart, the Scotsman takes the role of the trapper in *Receiving a Draught* but based on the description in *The Scotsman,* not in *The Trapper's Bride.* The first recorded oil version of the subject, titled *The Thirsty Trapper,* was probably on view in Miller's studio in September 1850, when Heinrich Oelrichs purchased his copy of the *Trapper's Bride.* The American Art-Union bought *The Thirsty Trapper* on 1 January 1851 and Oelrichs picked up his painting two weeks later. Though Miller may have worked on the two simultaneously, they do not share the same dimensions, as we might expect if they were meant to be pendants.

21. See Tyler, *Artist on the Oregon Trail,* no. 459ff.

22. I thank Kenneth Haltman for this observation.

23. *Giving Drink . . .* is likely a tracing of *Receiving a Draught of Water from an Indian Girl* from the Stewart album as it is rendered in exactly the size and scale as the Stewart version on tissue paper that has been mounted on heavier bond and painted over in gouache.

24. See Tyler, *Artist on the Oregon Trail,* no. 459B. The painting was sold to Smith Van Buren at the auction of the collections of the American Art-Union. *Catalogue of Pictures and Other Works of Art: the Property of the American Art-Union: to Be Sold at Auction by David Austen, Jr., at the Gallery, 497 Broadway, on Wednesday, the 15th, Thursday 16th, and Friday 17th, December, 1852 . . .* (New York: The American Art-Union, 1852), no. 167 (as *Indian Girl Giving Drink to a Trapper,* 20 × 24 inches); "American Art-Union, Conclusion of Sale," *New York Daily Times,* 18 December 1852, 6 (as *Indian Girl and Trapper*).

25. Miller in Ross, *The West of Alfred Jacob Miller,* pl. 26.

26. Francis Blackwell Mayer to A. J. M., Paris, 23 Rue de Sèvres, 5 March 1865. *The Halt* may also have been a part of a collection that featured mildly erotic subjects. In a later letter, Mayer told Miller of a presumably nude female figure he had just finished painting. It was his first, he said, and he planned to send it to their mutual friend Dr. David Keener, whose collection also included *The Halt.* Francis Blackwell Mayer to A. J. M., Paris, 23 Rue de Sèvres, 26 January 1866. "Artists' Letters to Alfred

Jacob Miller," ed. Marvin C. Ross, Typescript, 1951, Walters Art Museum Library, Baltimore; and Miller, Account Book.

27. McLerran, "Trappers' Brides and Country Wives," 4–5; and E. McClung Fleming, "The American Image as Indian Princess, 1765–1783," *Winterthur Portfolio* 2 (1965): 65–81; Henry Nash Smith, *Virgin Land: The American West as Symbol and Myth* (Cambridge: Harvard University Press, 1978); and Jules Zanger, "The Frontiersman in Popular Fiction, 1820–60," in *The Frontier Re-examined,* ed. John Francis McDermott (Urbana: University of Illinois Press, 1967), 141–53.

28. See Glanz's discussion of the east-west symbolism, *How the West Was Drawn,* 36–41. Amy Kaplan, "Manifest Domesticity," in *No More Separate Spheres!* ed. Cathy N. Davidson and Jessamyn Hatcher (Durham: Duke University Press, 2002), 186–87.

29. Sam Houston and President Zachary Taylor as quoted in Kaplan, "Manifest Domesticity," in Davidson and Hatcher, *No More Separate Spheres!,* 186.

30. Ibid., 186–87.

31. McLerran, "Trappers' Brides and Country Wives," 15–17.

32. Ross, *The West of Alfred Jacob Miller,* pl. 168.

33. Miller, Journal, 60.

34. Troccoli, *Watercolors of the American West,* 7.

35. Laura Wirt to Louisa Elizabeth Carrington, 24 February 1822, Cabbell-Carrington Collection, Manuscripts Division, University of Virginia Library, as quoted in Viola, *Indian Legacy,* 32.

36. Viola, *Indian Legacy,* 41.

37. A. J. M. to D. H. M., Murthly Castle, 1 September 1841, in Warner, *Fort Laramie,* 181–82.

38. Clark, "Romantic Painter," in Tyler, *Artist on the Oregon Trail,* 47–64.

39. This paraphrases Thomas N. Baker's definition in *Sentiment & Celebrity: Nathaniel Parker Willis and the Trials of Literary Fame* (New York: Oxford University Press, 1999), 9. Herbert Ross Brown, *The Sentimental Novel in America, 1789–1860* (Durham: Duke University Press, 1940). Shirley Samuels claims that "Sentimentality is literally at the heart of nineteenth-century American culture." *The Culture of Sentiment: Race, Gender, and Sentimentality in Nineteenth-Century America* (New York: Oxford University Press, 1992), 4.

40. On Sedgwick see Dana Nelson, "Sympathy as Strategy in Sedgwick's *Hope Leslie,*" in Samuels, *Culture of Sentiment,* 191–202; on Warner, see Jane Tompkins, *Sensational Designs: The Cultural Work of American Fiction, 1790–1860* (New York: Oxford University Press, 1985), 147–85.

41. Susan Scheckel, *The Insistence of the Indian: Race and Nationalism in Nineteenth-Century American Culture* (Princeton: Princeton

University Press, 1998), 3–14, esp. 5. Laura L. Mielke, "'native to the question': William Apess, Black Hawk, and the Sentimental Context of Early Native American Autobiography," *American Indian Quarterly* 26, no. 2 (March 2002): 246–70.

42. Kirsten Silva Gruesz, "Feeling for the Fireside: Longfellow, Lynch, and the Topography of Poetic Power," in *Sentimental Men: Masculinity and the Politics of Affect in American Culture*, ed. Mary Chapman and Glenn Hendler (Berkeley: University of California Press, 1999), 49.

43. Linda Walsh, "The Expressive Face: Manifestations of Sensibility in Eighteenth-Century French Art," *Art History* 19, no. 4 (December 1996), 537–38.

44. Miller's implication that his female audience was particularly receptive to his portrayal of the bride is also significant since in America, sentimentalism was widely viewed as a female trait. A. J. M. to D. H. M., 1 September 1841, Murthly Castle, in Warner, *Fort Laramie*, 181–82.

45. Walsh, "Expressive Face," 535–36.

46. David Alexander, *Affecting Moments: Prints of English Literature Made in the Age of Romantic Sensibility, 1775–1800* (York: University of York, 1993), 46–47.

47. As a clerk Miller's brother was eligible to join the Mercantile Library Association, and Miller's friends and patrons Brantz Mayer and Johns Hopkins could have sponsored his visits to the Library Company of Baltimore. See visitor and membership records, Library Company of Baltimore, 1795–1855, MS 80, Special Collections, Maryland Historical Society, Baltimore, and *Catalogue of the English Prose Fiction, Including Translation and Juvenile Fiction, in the Mercantile Library Association, of Baltimore, to October 1874* (Baltimore: J. W. Woods, 1874). Miller also had a library of eighty-six volumes and a large collection of prints and engravings at the time of his death. Alfred Jacob Miller Estate Papers; and Johnston, "Back to Baltimore," in Tyler, *Artist on the Oregon Trail*, 70.

48. Tyler, *Artist on the Oregon Trail*, no. 888–102, "Pocahontas and John Smith," presently unlocated.

49. Scheckel, *The Insistence of the Indian*, 41–69. Johnston, "Early Years in Baltimore and Abroad," and "Back to Baltimore," in Tyler, *Artist on the Oregon Trail*, 9, 65.

50. William M. S. Rasmussen and Robert S. Tilton, *Pocahontas—Her Life & Legend* (Richmond: Virginia Historical Society, 1994), 25.

51. Julia A. Sterne, *The Plight of Feeling: Sympathy and Dissent in the Early American Novel* (Chicago: University of Chicago Press, 1997), 7, 24–25; Howard, "What is Sentimentality?" 69–73; Camfield, "Moral Aesthetics of Sentimentality," 323–27.

52. Miller in Ross, *The West of Alfred Jacob Miller*, pl. 14, 71, 168.

53. Joy S. Kasson, *Marble Queens and Captives: Women in Nineteenth-Century American Sculpture* (New Haven: Yale University Press, 1990), 46–72.

54. Pratt, *Imperial Eyes*, 77–78.

55. Ibid., 79.

56. Ibid., 80. Here Pratt analyzes Mungo Park's *Travels in the Interior of Africa* (1799), but she takes the narrative to be characteristic of the genre she describes, 4.

57. Ibid., 81.

58. See for instance White's discussion of the tactics traders used to create a market among the Pawnee in *Roots of Dependency*, 189–92.

59. Catlin, *Letters and Notes*, 1:61, 2:249–50.

60. Robert Cary Long designed the building, which stood on the corner of St. Paul and Saratoga streets. It served as the home of the Maryland Historical Society until 1919, when it was leased to the city. It was demolished in 1930. See *Baltimore Sun*, 1 October 1846, 2, and Passano Files, Maryland Historical Society. A detailed description of the building written by Long appears in the index of Mayer's address.

61. Brantz Mayer, *Commerce, Literature and Art. Mr. Brantz Mayer's Discourse Delivered at the Dedication of the Athenaeum, Baltimore, October 23, 1848* (Baltimore: John Murphy, 1848).

62. Ibid., 9.

63. Ibid., 50.

64. [Baron de Montlezun], *Voyage Fait dans les Années 1816 et 1817 de New York à la Nouvelle-Orléans, et de l'Orénoque au Mississipi*, 2 vols. (Paris, 1818), 1:17, as quoted in Liebersohn, *Aristocratic Encounters*, 69. Gary Lawson Browne, *Baltimore in the Nation, 1789–1861* (Chapel Hill: University of North Carolina Press, 1980), 90–94.

65. On this subject, see Thrift, "Maryland Academy of Fine Arts," 8–13, 90; *Baltimore Literary Monument* (2 May 1839), 82, as quoted in Thrift, "Maryland Academy of Fine Arts," 90.

66. Mayer, *Commerce, Literature and Art*, 23, 47.

67. Mayer's elite audience was unsurprisingly receptive to his speech. Three days later a group of them wrote him a letter asking that "the sentiments of your valuable and eloquent address" be published. Ward was one of the signers of the letter requesting publication of the address. The letter noted that the undersigned were each present for the lecture. See the frontispiece to Mayer, *Commerce, Literature and Art*.

68. *New York Herald*, 27 March 1844, 3. The article claims Ward was a patron of the same stature as New York's Luman Reed and Philadelphia's Henry Carey. Alan Wallach doubts that this was the case since the purpose of the article was to discredit Ward's rival, Robert Gilmor; see Wallach, "'This is the Reward of Patronizing the Arts': A Letter from Robert Gilmor, Jr. to

Jonathan Meredith, April 2, 1844," *American Art Journal* 21, no. 4 (1989): 77; Benjamin Coleman Ward was born in Brookfield, Mass., 18 November 1784. In 1815 he entered into partnership with Nathan Appleton to form B. C. Ward and Company, 36 Broad Street, Boston, *The New England Historical & Genealogical Register and Antiquarian Journal* 16 (1862). He moved to Baltimore in 1831 where he opened the firm of Tiffany and Ward with Henry Tiffany. He left Baltimore sometime before 1859, when he appears on a list of the members of the New England Guards, *The New England Historical & Genealogical Register and Antiquarian Journal* 1, no. 4 (13 October 1859). Boston city directories list him as living at 13 Chestnut Street until 1862 and at the Hotel Pelham until his death, 4 April 1866. See *Baltimore Directory*, (Baltimore: John Murphy, 1845–55); Charles Martyn, *The William Ward Genealogy: the History of the Descendants of William Ward of Sudbury, Mass., 1638–1925* (New York, Artemas Ward, 1925), 169; Census Records, Baltimore, 1840 and 1850, Boston, 1860, and Massachusett's Vital Records. I thank Francis P. O'Neill, Senior Librarian for the Maryland Historical Society, for his generous assistance in tracking down Ward.

69. Ward and Mayer attended the same Unitarian church while Mayer, in turn, enjoyed a close, lifelong friendship with the artist. See Rebecca Funk and the First Unitarian Church of Baltimore, *A Heritage to Hold in Fee, 1817–1917* (Baltimore: Garamond Press, 1962); Johnston, "Back to Baltimore," in Tyler, *Artist on the Oregon Trail*, 62.

70. Ward exhibited the two paintings at the National Academy of Design in 1845. Cowdrey, *National Academy of Design Exhibition Record*, 2:24.

71. For biographical information on Hopkins, see Helen Hopkins Thom, *Johns Hopkins: A Silhouette* (Baltimore: Johns Hopkins Press, 1929); Walters Art Gallery, *The Taste of Maryland: Art Collecting in Maryland, 1800–1934* (Baltimore: Walters Art Gallery, 1984), 8–9; *Catalogue of Paintings, Engravings, &c. &c. at the Picture Gallery of the Maryland Historical Society. Second Annual Exhibition, 1849* (Baltimore: John D. Toy, 1849).

72. Cooke, "On the Trail," 321.

73. Scharf, *History of Baltimore City and County*, 1:319. See also Browne, *Baltimore in the Nation*, part 2, esp. 84–85; *Encyclopedia Britannica*, s.v. "Baltimore and Ohio Railroad." Scharf notes that by 1831, the practicability of steam engines had been proven by Ross Winan's invention of the "camel" engine; *History of Baltimore City and County*, 1:323. Winan also patronized Miller, see Account Book.

74. Robert J. Brugger, *Maryland: A Middle Temperament, 1634–1980* (Baltimore: Johns Hopkins University Press, 1988), 204.

75. Complete names, addresses, professions and work addresses for Miller's patrons can be found in the *Baltimore Directory; Matchett's Baltimore Directory; Wood's Baltimore Directory;* and the Diehlman-Heyward Biographical Files, Maryland Historical Society, Baltimore. Francis P. O'Neill's invaluable *Index of Obituaries and Marriages in the [Baltimore] Sun, 1866–1870*, 2 vols. (Westminster, Md.: Family Line Publications, 1996), provided death dates used to locate obituaries, another source of information on Miller's patrons.

76. In the 1850s, Oelrichs and Lurman Commission and Shipping Merchants traded in coffee from Brazil and flour from the midwest. See Records of the Oelrichs and Lurman Company, Gustavus W. Lurman Papers and Genealogy, 1833–1945, MS 541, Special Collections, Maryland Historical Society, Baltimore. Commissions merchants traded in a variety of goods, depending on customer orders, though they often did specialize in such things as china and pottery or tobacco.

77. "…the completion of the Baltimore and Ohio Railroad to the West in 1853 made the West Baltimore's chief supplier of beef, grain, port and tobacco." Browne, *Baltimore in the Nation*, 171.

78. Scharf, *History of Baltimore City and County*, 1:231; "Mr. John Cassard Dead," *Baltimore Sun*, 22 May 1911.

79. *Baltimore Sun*, 28 November 1874, 2c, 4c; 30 November 1874, 4d.

80. Thom, *Johns Hopkins*, 35.

81. Ibid., 35–36.

82. "But of all places commend me to the battery. The reservation of this beautiful spot does honour to the merchant princes, and the 'upper ten' are beginning to appreciate its advantages for I believe it is becoming fashionable." A. J. M. to D. H. M., Clinton Hotel, New York, 7 June 1846, Porter Papers. His reference to the "upper ten" is surely from his friend Nathaniel Parker Willis' notorious "Who Are the Upper Ten Thousand," *New York Evening Mirror*, 11 November 1844.

83. Clark, "Romantic Painter," in Tyler, *Artist on the Oregon Trail*, 57; Troccoli, *Watercolors of the American West*, 9; Glanz, *How the West Was Drawn*, 37; Schoelwer, "The Absent Other," 150, 153.

84. The Ward painting, when viewed left to right, implies that the clouds are clearing to reveal the rosy sunset behind. As if to correct any possible misconception, Miller included only a slight wisp of clouds in the upper right of subsequent versions.

85. Thom, *Johns Hopkins*, 27–29.

86. Diehlman-Heyward Biographical Files, Maryland Historical Society, Baltimore; "Henry Oelrichs," *New York Times*, 29 June 1875; "Death of Mr. Charles De Ford," *Baltimore Daily Exchange*, 23 February 1858.

87. Miller's studio was located in the Law Buildings, located at Lexington and Saint Paul streets from 1842 to 1845. From 1852 to 1864 his studio was in Carroll Hall, at 201–203 East Baltimore Street. The B&O railway offices were on the same block, off Hopkins Place. Passano Files, Maryland Historical Society, Baltimore.

88. Brugger, *Maryland*, 204.

89. *Baltimore Directory, for 1845*, 15.

90. Last Will and Testament of A. J. Miller…, Alfred Jacob Miller Estate Papers, 1842–1875, MS 1624. On Decatur Howard Miller, see Diehlman-Heyward Biographical Files and D. H. Miller family scrapbook, sketchbook, letters. Decatur H. and L. Vernon Miller Collection, Baltimore.

91. Patricia Hills, "The American Art-Union as Patron for Expansionist Ideology in the 1840s," in *Art in Bourgeois Society, 1790–1850*, ed. Andrew Hemingway and William Vaughan (Cambridge: Cambridge University Press, 1998), 315.

92. Ibid., 314, 326–27.

93. Ward served on the committee from 1848 to 1850. The inaugural exhibition was held in 1848. Photocopies of the Maryland Historical Society Annual Exhibition catalogs for 1848–1850 are available in the Pleasants Files, Curatorial Division, Museum of the Maryland Historical Society, Baltimore; and the Alfred Jacob Miller Vertical File, Smithsonian American Art Museum, Washington, D.C.

94. Browne, *Baltimore in the Nation*, 90–95.

95. R. Carey Long, "Appendix," in Mayer, *Commerce, Literature and Art*, 51.

96. Stuart C. Sherman, "The Library Company of Baltimore, 1795–1854," *The Maryland Historical Magazine* 39, no. 1 (1944): 6–24.

97. Robert Cary Long, "Appendix," in Mayer, *Commerce, Literature and Art*, 51.

98. Ibid.

99. Kevin B. Sheets, "Saving History: The Maryland Historical Society and Its Founders," *Maryland Historical Magazine*, 89, no. 2 (1994): 133–55; and Rutledge, "Early Art Exhibitions of the Maryland Historical Society," 124–36.

100. Long, "Appendix," in Mayer, *Commerce, Literature and Art*, 52.

101. For instance, the 1847–1848 *Matchett's Baltimore Directory*, lists William H. Graham and Joseph Henry Meredith on the Board of the Maryland Academy of Art; Graham and Johns Hopkins on the Board of the Merchant's Mutual Insurance Company; and Hopkins, Joseph Reynolds, and Gustav Lurman, Oelrichs' partners on the Board of the Merchant's Bank. Patrick Henry Sullivan, Alexander Reiman, and Johns Hopkins each served on Baltimore's Board of Trade, see Scharf, *History of Baltimore City and County*, 1:437–40. In addition to Ward and

Hopkins, Thomas Edmondson, Owen Gill, J. Stricker Jenkins, Joseph Meredith, Henrich Oelrichs, Joseph Reynolds, Patrick H. Sullivan, William Colman Wait, and William C. Wilson were members of the Maryland Historical Society and exhibited pictures at the annual exhibitions. Members, officers, and exhibitors are listed in the *Catalogue[s] of Paintings, Engravings, &c. of the Maryland Historical Society, 1848–1858.*

102. The Ward party is described in some detail in the *New York Herald*, 27 March 1844, 3.

103. Browne, *Baltimore in the Nation*, 180.

104. Ibid., 136–37.

105. Ibid., 228.

106. *Baltimore Daily Exchange*, 10 March 1858.

107. Mayer, *Commerce, Literature and Art*, 9.

108. Miller in Ross, *West of Alfred Jacob Miller*, pl. 12. These prices were exorbitant by Baltimore standards (the price of the sketch itself was $12 and Miller's own bedroom furniture was valued at less than the price of the blanket he mentions); Miller lists them to make this point. Alfred Jacob Miller Estate Papers.

109. Troccoli, *Watercolors of the American West*, 45.

110. In the earlier oil versions, the groom's hand is foreshortened so that the hands overlap formally, without meeting in the pictured space. But here, Miller has rendered the groom's hand closer to parallel with the picture plane, thereby reducing the presumed space between the two.

111. Miller in Ross, *West of Alfred Jacob Miller*, pl. 20.

112. The catalogue raisonné lists six extant albums, but the inventory of Miller's will lists fifteen scrapbooks of drawings. On Miller's literary works, see Johnston, "Alfred Jacob Miller—Would-be Illustrator."

113. Richard L. Bushman, *The Refinement of America: Persons, Houses, Cities* (New York: Alfred A. Knopf, 1992), 443; see also Blumin's discussion of consumption, feminization, and the middle-class family in *Emergence of the Middle Class*, 179–91; For more on women as consumers, particularly of clothing, see Karen Halttunen, *Confidence Men and Painted Women: A Study of Middle-Class Culture in America, 1830–1870* (New Haven: Yale University Press, 1982), Chap. 3, "Sentimental Culture and the Problem of Fashion," 56–91.

114. Susan Prendergast Schoelwer, "Painted Ladies, Virgin Lands: Women in the Myth and Image of the American Frontier, 1830–1860," Ph.D. diss., Yale University (Ann Arbor: UMI, 1994), 115–16.

115. McLerran, "Trappers' Brides and Country Wives," 11; [Stewart], *Altowan*, 1:189.

116. [Stewart], *Altowan*, 1:189.

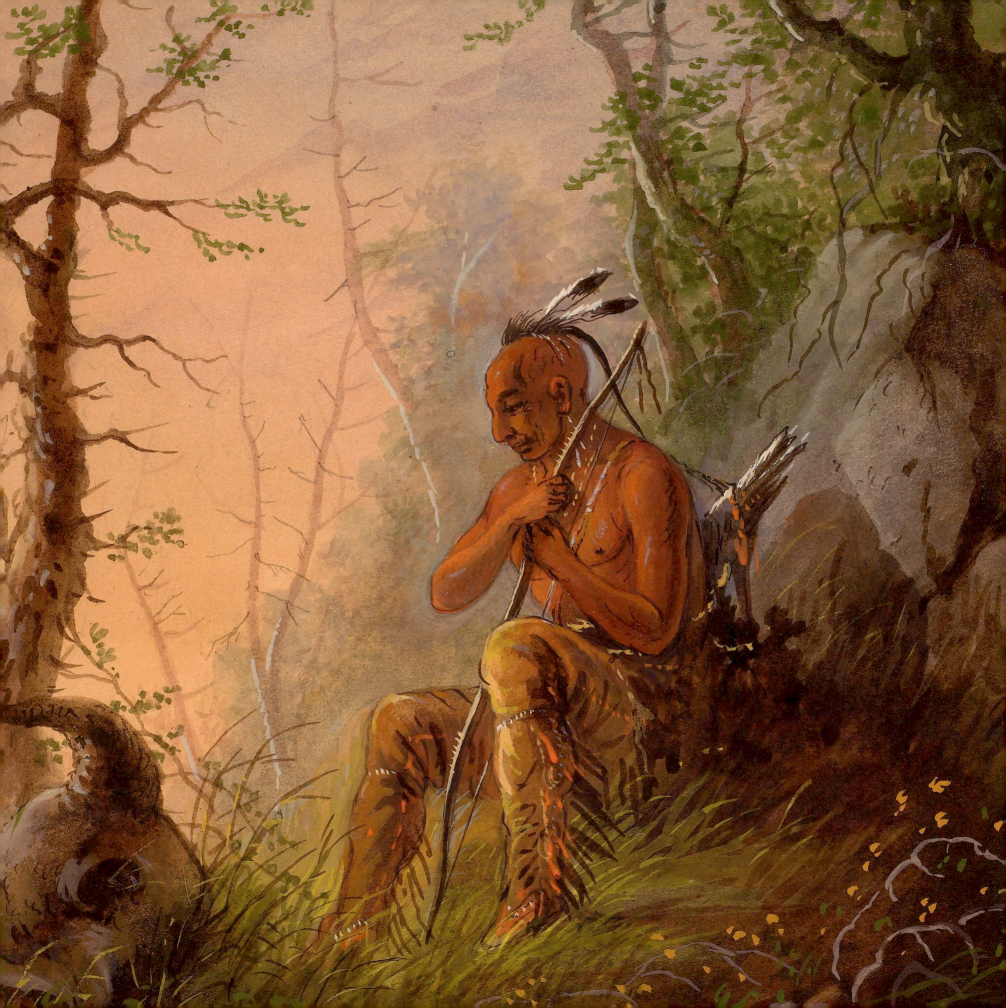

"THE THOUGHTS THAT BURNED AND GLOWED WITHIN":

MILLER'S CAMPFIRE SCENES

AND SENTIMENTAL MANHOOD

ALFRED JACOB MILLER'S BEST-KNOWN WORKS depict Rocky Mountain trappers. They are among his most widely reproduced images, used to illustrate novels, textbooks, and histories of the fur trade.[1] Yet the attention they receive from contemporary scholars belies their proportionately small number within Miller's oeuvre. Approximately 10 percent of Miller's western work takes the trappers explicitly as its subject, whereas images representing Indians make up nearly 50 percent.[2] Excluding *The Trapper's Bride,* the relative absence of trapper scenes likely reflects his patrons' demands. More than a third of Miller's trapper images went unsold, though the artist sought to promote a few of them through local and national exhibitions.[3] Landscape and Indian genre works outsold trapper images by four to one among Baltimore patrons. Miller's only significant commissioned works depicting trappers were the forty-four trapper scenes included among the two hundred watercolors he painted for William T. Walters in 1858–60, and their inclusion likely reflects Miller's choice rather than Walters'.

The absence of commissioned trapper scenes is curious because the trapper was a popular subject in American art and literature in the years following Miller's return from Scotland. Over one hundred works dealing with the fur trade were published between 1840 and 1860, including such classics as Josiah Gregg's *Commerce of the Prairies* (1844), David Coyner's *The Lost Trappers* (1847), and George Frederick Ruxton's *Life in the Far West* (1849).[4] Paintings of trappers were also popular among an antebellum American audience. Charles Deas' *Long Jakes, The Rocky Mountain Man* (plate 1), one of the highlights of the 1845 Art-Union exhibition, initiated what became a fairly uniform iconography featuring the mounted trapper in a western landscape, clad in buckskin and a bright red hunting shirt, clutching a gun.[5] Such imagery was so common that, by 1852, critics were complaining it had become a cliché. One writer described the genre as "a 'style' of painting that is becoming painfully conspicuous in our

PLATE 1 Long Jakes, The Rocky Mountain Man, 1844
Charles Deas (1818–1867)
Oil on canvas, 30 × 25 inches
Jointly owned by the Denver Art Museum and the Anschutz Collection. Purchased in memory of Bob Magness with funds from 1999 Collector's Choice, Sharon Magness, Mr. & Mrs. William D. Hewit, Carl & Lisa Williams, Estelle Rae Wolf–Flowe Foundation, and the T. Edward and Tullah Hanley Collection by exchange

PLATE 2 Mule Throwing off His Pack, n.d.
Pencil, pen and ink, and wash on paper, 5⅜ × 8½ inches
Joslyn Art Museum, Omaha, Nebraska

PLATE 3 Fontenelle Chased by a Grizzly Bear, n.d.
Pen and ink and wash on paper, 5 × 7¾ inches
Joslyn Art Museum, Omaha, Nebraska

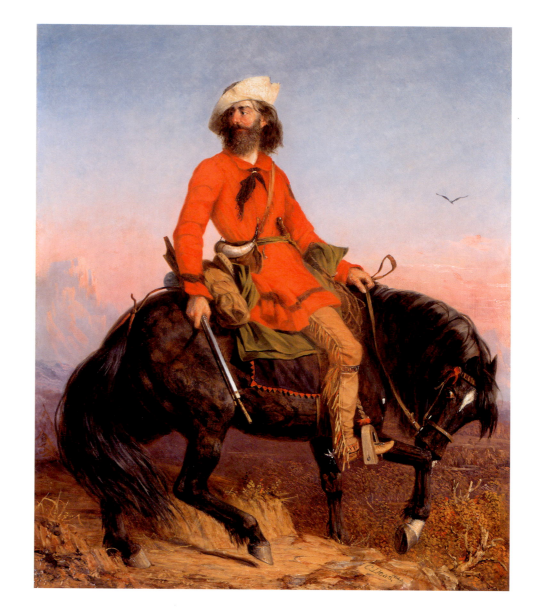

exhibitions and shop-windows, of which glaring red shirts, buckskin breeches and very coarse prairie grass are the essential ingredients."[6]

Miller certainly showed an early interest in the subject of the trappers, executing a number of simple wash sketches of camp scenes that appear to have been painted in the field or shortly there-after. These are anecdotal, sometimes humorous, images. One shows a mule from the caravan kicking wildly as a trapper rushes in to catch him (plate 2). Another depicts Lucien Fontenelle (1800–1839), a well-known trapper from the American Fur Company, being chased out of the bushes with his pants

complex aspects of Miller's representation of the trapper that need to be investigated in order to understand more fully Miller's post-Stewart project of representing the West. For Miller, the trappers' sedentary nature is crucial to establishing two important and related facets of their characterization: their sentimentality and their capacity for creative imagination.

We can see a hint of Miller's sentimental characterization of the trapper if we compare Deas' *Long Jakes* with *Portrait of Captain Joseph Reddeford Walker*. At first glance, they seem to share many of the same traits that defined the trapper genre. *Long Jakes*, arguably the progenitor of the trapper genre, encapsulates the ambitions of westward expansion by embodying both the wildness of the West and the promise of civilization. Poised on horseback on a precipice overlooking a vast plain dotted with scrub oak, *Long Jakes* suggests his role as a harbinger of Anglo-American settlement in the West. His scraggly beard, quilled leggings, and moccasins attest to his wildness.[16] Critics today, however, have pointed out that Deas' audience also saw evidence of Long Jakes' civilized (and civilizing) aspect. A contemporary critic for the *Broadway Journal* located Long Jakes' civilization in his expression and bearing:

> "Long Jake[s]" comes to us from the outer verge of our civilization; he is a Sante [*sic*] Fe trader, and with his rifle in hand, his blazing red shirt, his slouched hat, long beard and coal black steed, looks as wild and romantic as any of the characters in Froissart's pages, or Salvator Rosa's pictures. But Long Jake[s] was not always a Santa Fe trader—there are traits of former gentleness and refinement in his countenance, and he sits upon his horse as though he were fully conscious of his picturesque appearance.[17]

The implication here is that Long Jakes' internal refinement is evidenced externally by the way in which he holds himself. Lithographers have attempted to ennoble Long Jakes by cleaning up his beard and making him sit up taller in his saddle.[18]

Both Walker and Long Jakes seem adventurous, located as they are in a western setting. Walker holds his right hand over the muzzle of a gun and, tilting his head slightly to the right, looks out at the viewer. He wears the hybrid garb of the trapper—a buckskin jacket over a cloth shirt and a leather hat. A setting sun, visible in the rosy sky over his right shoulder, situates him between the geographic west and the presumably eastern viewer. Miller has included a trompe l'oeil buckskin frame surrounding the portrait (he even signs the work along the edge of the faux oval canvas), which adds to the western atmosphere, suggesting both the ruggedness of the region and the hide trade. In each painting, the presence of the trapper's equipment—gun, powder horn, and knife in Deas' and the gun and compass in Miller's—suggest both the trappers' hardiness and self-reliance and their role in opening the West to Euro-American settlement.

But on further consideration, several important differences emerge. Unlike Long Jakes, who leans back in the saddle as his horse moves across the canvas, left to right, Walker appears still. Walker

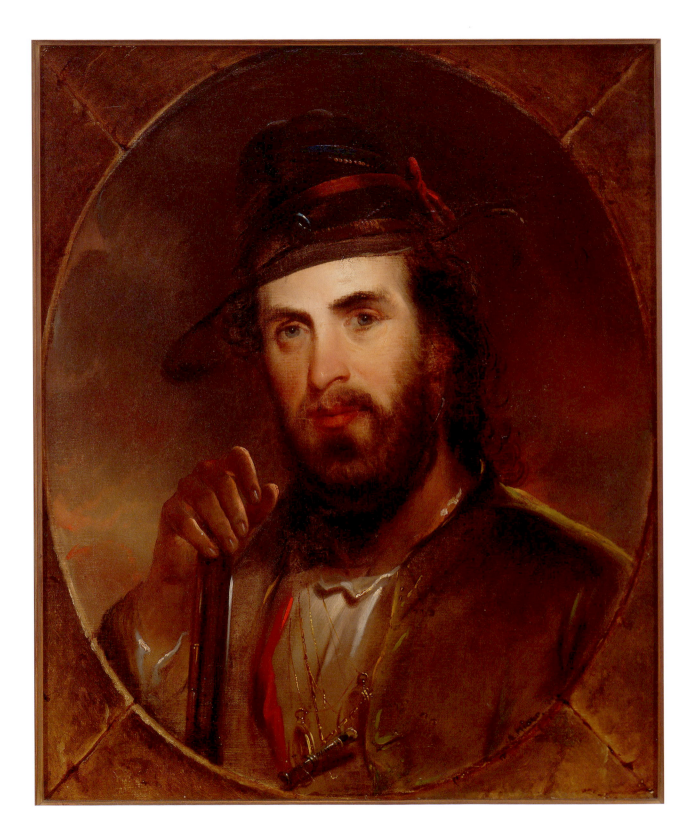

PLATE 4 A Rocky Mountain Trapper,
Bill Burrows, n.d.
Pencil, pen and ink, and wash on paper, 13 × 8⅛ inches
Joslyn Art Museum, Omaha, Nebraska

PLATE 5 Portrait of Captain Joseph Reddeford
Walker, n.d.
Oil on canvas, 24 × 20 inches
Joslyn Art Museum, Omaha, Nebraska

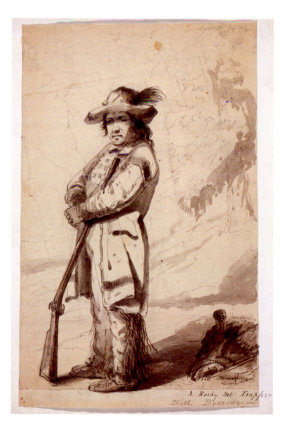

down, a bear in close pursuit (plate 3).[7] A third sketch, almost certainly done in the field, is a portrait of a trapper, Bill Burrows (plate 4), who traveled briefly with Stewart's party following the rendezvous.[8] Miller pays uncharacteristically close attention to the details of Burrows' appearance, as if to record them for future use. The trapper wears a printed calico shirt with a blanket *capot,* or coat, identifiable by the thick fabric and large dark-colored stripes at the shoulders and near the bottom seam.[9] His buckskin trousers are heavily fringed, and he wears pucker-seamed, beaded moccasins. Burrows is slightly disheveled; his coat is wrinkled and his scraggly hair spills forth from under a large-brimmed, plumed hat. Miller's sketch of Burrows is the basis for the standing trapper in the Walters watercolor *Roasting the Hump Rib* (1858–60) and in an oil-on-canvas for Stewart (ca. 1839, Westervelt Warner Collection, Tuscaloosa). The other two sketches were never reproduced.[10]

Miller's trapper scenes may not have enjoyed the popularity of Deas' images because they lacked nationalist appeal. Too often they showed the trappers relaxing and socializing rather than actively exploring, fighting Indians, or trapping. Such images consequently could be construed as being less about national expansion than about what one critic characterized as an "idyllic, exotic land that had existed primarily in the past."[11] Moreover, the same critic has argued that Miller's trappers "were widely understood to represent French or French-derived trappers of the Upper River region," rather than Anglo-Americans.[12]

Although many of Miller's paintings do portray trappers of French extraction as well as the Métis, or mixed French and Cree, hunters and guides who worked for Stewart, the artist also painted a number of prominent Anglo-American trappers who were specifically named in his titles. These include Jim Bridger (1804–1881), the first Anglo-American to reach California, and Bill Burrows.[13] One of Miller's finest oil-on-canvas works, *Portrait of Captain Joseph Reddeford Walker* (plate 5) depicts the trapper who helped establish the Santa Fe Trail and traveled to California in 1833 (see plate 6 for another of Miller's depictions of Walker). Though Walker did not publish a memoir, Washington Irving's *Adventures of Captain Bonneville* describes a number of his famous exploits.[14]

Despite its interesting subject matter, Miller appears to have had little success with *Portrait of Captain Joseph Reddeford Walker.* Its crisp outlines and confident handling suggest it was painted around the period of the earlier versions of *The Trapper's Bride* (1845–50). Its provenance suggests, however, that it remained in his studio unsold following the artist's death, and this precise subject is not repeated in Miller's oeuvre. Moreover, Miller's account book, which lists all sales between 1846 and 1870, does not mention the portrait.[15] One critic has suggested that Miller's trappers were not more popular because they were depicted as too sedentary and thus at odds with the trapper's civilizing mission. This may indeed account for the lack of success of paintings like *Portrait of Captain Joseph Reddeford Walker,* which portrays the sitter as stationary, in a traditional bust-length, three-quarters profile. The trappers' sedentary natures, however, should be understood as a much more profound feature than simply a representational miscalculation on Miller's part. Their repose points to more

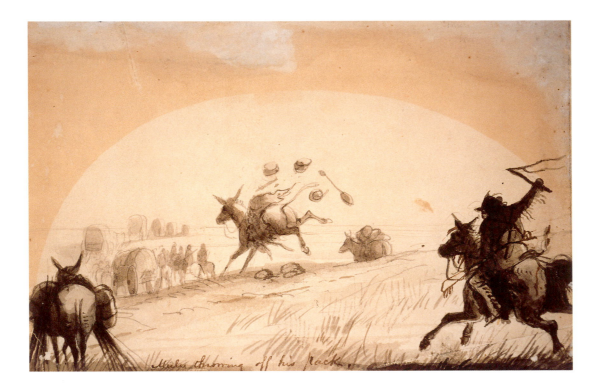

Mule throwing off his pack.

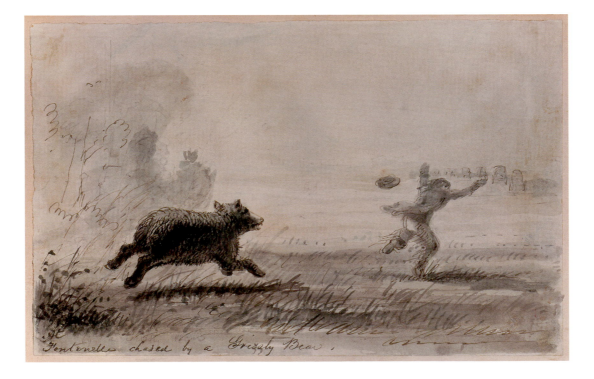

Fontenelle chased by a Grizzly Bear.

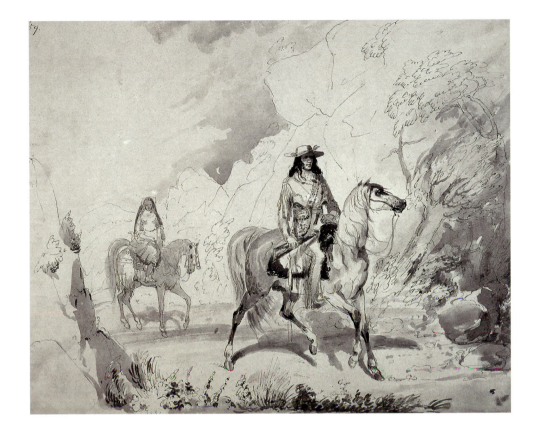

looks directly at us, creating a connection between subject and viewer lacking in Deas' work. More-over, Walker's large size relative to the opening creates the illusion that he resides closer to us, just behind the surface of the picture plane. His physical proximity may be read on the one hand as a kind of metaphor for the unconventional life of the sitter himself. Just has he breaks with eastern social conventions, so he breaches the etiquette of polite distance between one person and another. More-over, his position deviates from the conventions of portraiture, which typically place a sitter further back within the spatial plane. But his physical proximity, together with his gaze outward at the viewer, also establishes an intimacy between subject and viewer entirely lacking in *Long Jakes,* where the trap-per's cocked eyebrow suggests his attention is focused somewhere outside the canvas. Walker's life-sized scale encourages the viewer to imagine the ostensibly exotic, unconventional trapper as a kind of mirror image of him or herself; he is strange and yet familiar, far away and yet near to hand.

If Long Jakes' comportment suggests his civility, Miller went one step further in his portrayal of Walker's air to suggest his sensibility. Like Long Jakes, Walker appears to hold himself up straight, to present himself to the viewer self-consciously. His hand, gently cupped over the muzzle of his gun, literally demonstrates the gentleness of his movements, while figuratively suggesting his readiness,

as in *The Trapper's Bride,* to contain the violence his enterprise often entails. But his head is also tilted slightly to the right in a gesture of sentimentality similar to that Miller employed in *The Trapper's Bride* (see chapter 3, plate 1). His eyes, with their heavy lids and outward gaze, together with his stillness suggest dreaminess.[19]

Miller's trappers, particularly those pictured in the Walters commission, presented a vision of masculine sentimentality distinct from the prevailing ideals of masculinity. The trapper's masculine sentiment, associated as it was with the wilderness and freedom from social bonds, distinguished it from the kind of feminized sentimentalism that operated in the period as a subset of social refinement. Thus Miller's trapper imagery failed to find an audience not because the trappers did not successfully embody Manifest Destiny, but because his trappers articulated a vision of manhood that was simply too far outside the established norms for his audience to embrace.

It is important here to distinguish between the sentiment of Miller's trappers in general and the groom's more acceptable expression of sentiment in *The Trapper's Bride.* The groom's sentiment is appropriate in the context of the painting's ostensible narrative, a wedding. The trapper/groom also metaphorically restores the appropriate sentiment to the establishment of new western trade networks. But Miller's portrayal of trappers as sentimental—independent of their interactions with Indian women—faced several obstacles. First, sentimentalism, though expressed by male poets and writers, was widely seen in antebellum America as the province of women. And second, Miller, particularly in the fireside imagery to be discussed later, associated sentiment with idleness and artistry, two characteristics at odds with merchant culture.

The Walters Watercolors

As noted earlier, Miller's fullest exploration of the trapper genre can be found in an unusual commission he received in 1858 from Baltimore merchant William T. Walters for 200 watercolor sketches of western scenes accompanied by brief, explanatory notes. Unlike other of Miller's Baltimore patrons, Walters was a collector of national stature who apparently did not have the same vested interests in Miller's western work that other of the artist's patrons did. Although he, too, was a commissions merchant (specializing in whiskey), his business was principally in the South rather than the West. Consequently, Walters' decision to commission works from Miller may have been prompted by sectional strife rather than business interests. Walters, a particularly vocal supporter of the Confederacy, was so ostracized for his views among his immediate circle of friends that he emigrated to Europe for the duration of the war.[20] Although the West had been a site of contention leading up to the war, the Rocky Mountain region Miller painted lacked a clear northern or southern identity and therefore may have represented a kind of imaginary safe zone for the fractured Baltimore elite.[21] Despite divided political allegiances, Baltimore merchants were united in their ambitions for western markets.

Paintings of the West may thus have offered the promise of reconciliation among the merchant class for some of those who purchased them. Indeed, the Civil War period was Miller's most successful. In 1864 and 1865, Miller doubled his annual average for oil-on-canvas western scenes, painting twelve and thirteen oils, respectively, despite a dramatic decline in portrait commissions. Including the Walters commission, Miller sold 282 western scenes between 1858 and 1865.[22] The role Miller's western imagery played in the context of the Civil War may thus account for why his watercolors were among the few American works Walters kept when he sold off his collection in 1864 and began collecting European works.[23]

The Walters commission was different from most of Miller's other Baltimore commissions as Walters ordered the set rather than purchasing it already completed out of Miller's studio. More importantly, there is evidence to suggest that the particular subjects included in the watercolor set were chosen by Miller, not Walters. A notation in Miller's account book reads: "I commenced duplicating Indian sketches for Wm. T. Walters." Miller's use of the term "duplicating" refers to what appears to have been his common studio practice of reproducing works based on a group of stock sketches likely made in the field or immediately thereafter. Miller's patrons typically visited the artist in his studio and either bought oil-on-canvas paintings from the floor or selected watercolors from a portfolio for reproduction. Benjamin Coleman Ward, for instance, bought *The Trapper's Bride* in January 1846, after it had presumably sat for some months in Miller's studio. It appears that Miller then invited Johns Hopkins to visit and see the work prior to Ward's taking possession of it; just three days before Ward picked up the work and paid for it in full, Hopkins visited Miller's studio and ordered his own nearly exact copy.[24] For a set of forty watercolors with accompanying notes that Miller prepared for overseas patron Alexander Brown in 1867, the artist drew up a quasi contract listing the numbers and titles of the works Brown's agent had selected for inclusion in the commission.[25] But nothing in Miller's papers indicates that Walters had a hand in selecting which of the sketches Miller included in the commission for him.

A letter Miller wrote to Brantz Mayer describing the terms of the Walters commission raises the possibility that Walters left the decision up to Miller: "Mr. Walters has indeed given me an order very flattering to me & the manner in which he has done it is not its least recommendation.—In this bloated City of Baltimore, how rare are such men—I wonder if I shall reach his expectations?"[26] Walters, in fact, was known for granting artists the freedom to select their own subjects. An article in the *Cosmopolitan Art Journal* noted that Walters offered commissions "with an enlightened liberality rarely met with in America, and neither limits them to size, price or subject."[27] Just one month after Miller received his order for the watercolors, Walters commissioned works from Asher B. Durand (1796–1886) and John F. Kensett (1816–1872), allowing the artists to choose their own subjects.[28]

Walters' commission also included a request for one-page notes to accompany each image. The images and notes were bound facing one another in four plain, leather volumes.[29] By practicality and

convention, the album and text format dictate a more private viewing experience than existed for the oils.[30] The private format was mirrored by Miller's watercolor style, which readily reveals the artist's hand in its facture. Although the images are painted on fine tinted and bond papers and rendered in a high degree of finish—much of the surface is covered and areas are built up in layers of gouache and gum Arabic—we nevertheless see pencil underdrawing, rubbings or erasures, and pentimenti through thin washes of paint.

Fireside Reveries

The particular circumstances of the Walters commission, as well as its breadth, may have allowed Miller more freedom to explore subjects of personal interest, such as trappers around the campfire, in which the trapper's sentiment has its fullest evocation. Campfires appear in many of Miller's images of the trappers. The fire is sometimes the focus, as in the studio watercolor *Trappers* (plate 7), or it is a smaller part of a night landscape, as in the oil-on-canvas painting *In the Rocky Mountains* (plate 8). The campfire scenes appear most often in watercolor; the majority of them are in the Walters collection.[31]

 Camp Fire, Preparing the Evening Meal (plate 9) from the Walters collection shows six men gathered around a bright and smoky fire. The men have made camp for the night, their guns and saddles laid out on the ground behind them. The four seated (or kneeling) in the foreground are trappers. Miller identifies them as such in his accompanying note, but they are recognizable, too, by their dress: fringed buckskin pantaloons, moccasins, belted hunting shirts, and two with broad-brimmed hats. Standing behind the fire, facing outward, are two more men, one clearly Indian, possibly Pawnee with his roached hair and long queue, and the other a Métis by his resemblance to figures in other of Miller's sketches. A dark blue night surrounds the figures, punctuated by the moon glowing through a part in the clouds and a second campfire in the distance. The men are grouped closely around the fire, their bodies overlapping formally, if not physically, in an unbroken ring. While the men are prominent, it is the eponymous campfire that is formally and figuratively at the heart of the image. We do not actually see the fire itself. Rather, we see its effects as it casts its glow upward, illuminating the faces of the men and obscuring the lower half of the standing figures with its smoke. The firelight shows the men in sharp relief and makes their bodies seem still and quiet, as if held in rapt attention. In their wordless contemplation of the fire or smoke, all but the cook seem to be lost in thought.

 Just as we cannot actually see the flames, we cannot know what it is that the men are thinking as they look at the fire. Yet that they are lost in thought or imagination is implied by the formal properties of the image and by the fireside setting itself. The plumes of smoke, which curl upward and to the right of the circle, echo the curving forms of the clouds above and of the leaves of the brush at the right edge of the image. The smoke itself resembles these physical features, just as clouds are often seen to resemble something to an imaginative eye. The smoke and the light of the fire create

PLATE 7 Trappers, n.d.
Pen and ink, watercolor, and gouache on paper,
4¼ × 4½ inches
Joslyn Art Museum, Omaha, Nebraska

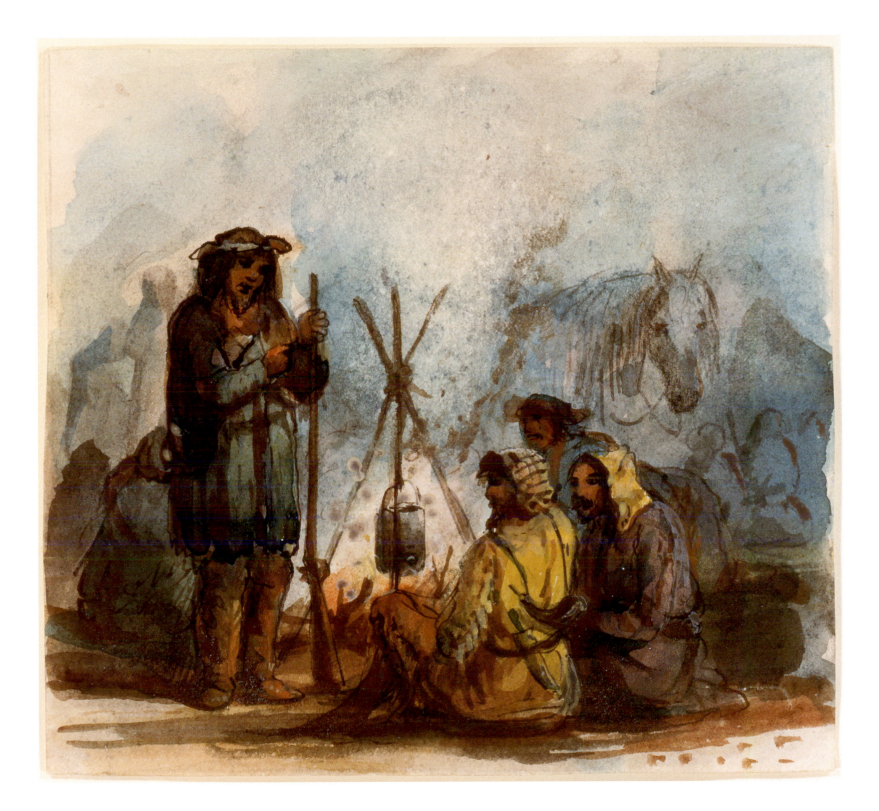

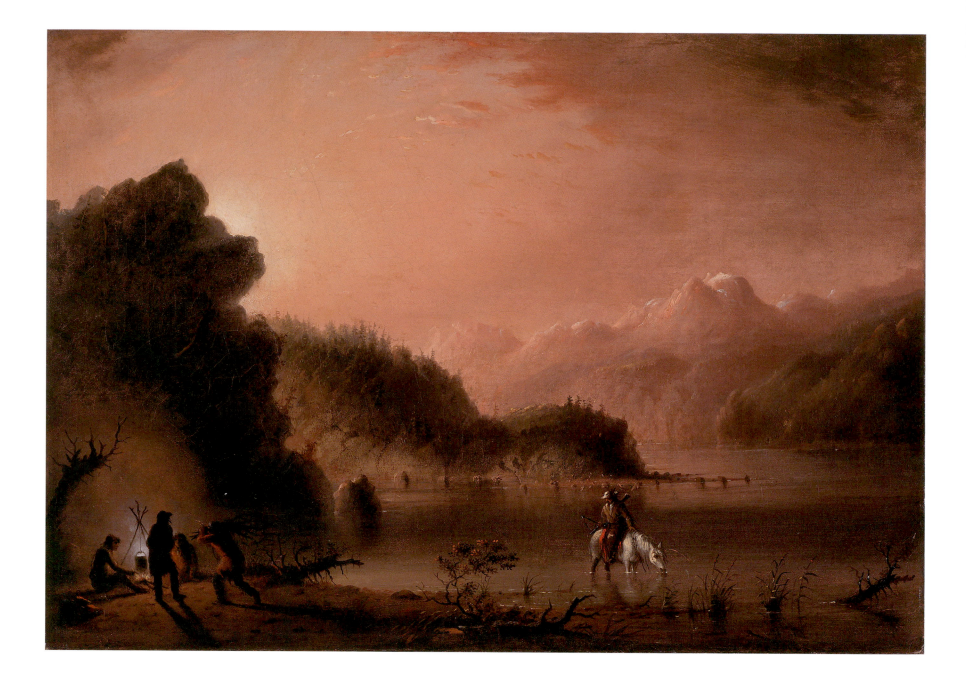

PLATE 8 In the Rocky Mountains, n.d.

Oil on canvas, 14⅜ x 20 inches

Joslyn Art Museum, Omaha, Nebraska

PLATE 9 Camp Fire, Preparing the Evening Meal, 1858–60

Watercolor, heightened with white, on paper, 11 x 9 inches

The Walters Art Museum, Baltimore, Maryland

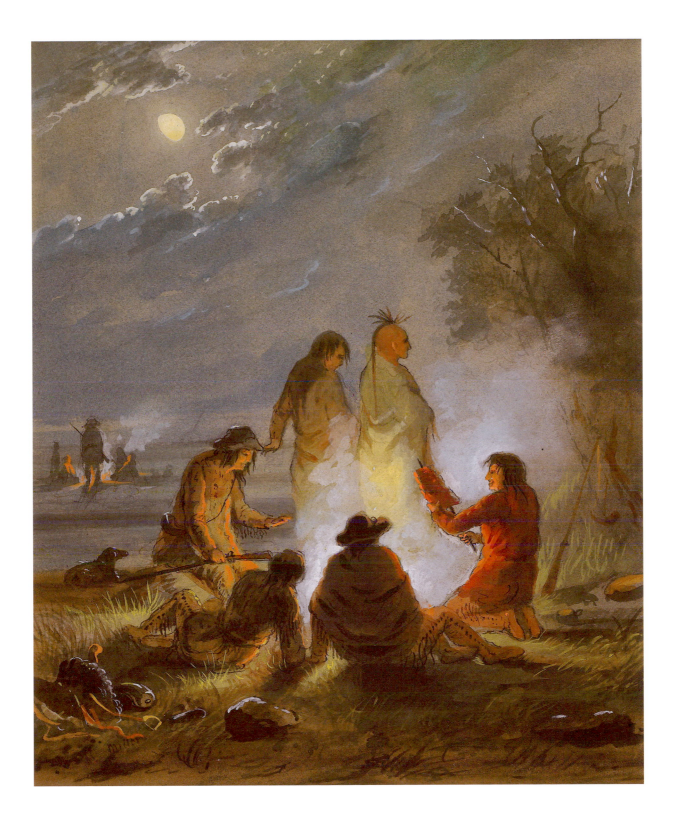

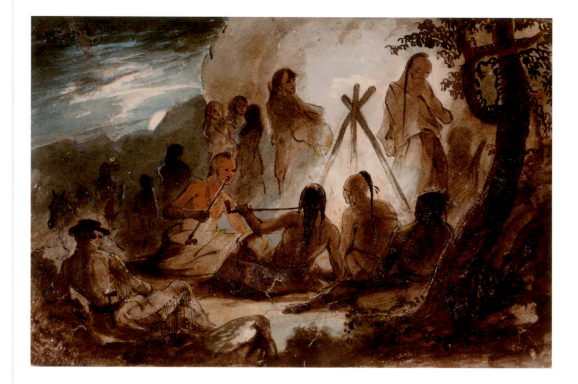

PLATE 10 Camp Fire by Moonlight,
ca. 1837–39

Pencil, pen and ink, and watercolor on paper, 6¹⁄₁₆ x 9 inches
Beinecke Rare Book and Manuscript Library, Yale University,
New Haven, Connecticut

PLATE 11 Campfire—Preparing the Evening
Meal, n.d.

Watercolor, gouache, pen and ink, and graphite on paper,
5⅛ x 4¾ inches
Gilcrease Museum, Tulsa, Oklahoma

an illuminated, almost white, area against the turned backs of the two men who face outward. This white area serves as a kind of blank space within the image where viewers may project their own imagery, just as the smoke itself inspires the ruminations of the figures pictured in the work.

The smoky area seems to have been a key component of the composition as it appears in two earlier versions, *Camp Fire by Moonlight* (plate 10), from the Stewart album, and *Campfire—Preparing the Evening Meal* (plate 11). The latter is a small, hastily executed work layered with pencil sketchings, watercolor, and gouache.[32] In each image, smoke billows across the center of the image, creating a white area directly opposite the figures pictured in the foreground. In the Gilcrease sketch, as in the one for Walters, Miller applied a thick layer of gouache to whiten the smoke above the fire, while in the Stewart sketch, he rubbed and scraped away the paint, exposing areas of blank page.[33] In each image, the curious device of the Indian and Métis men's turned backs at the far side of the circle serves the purpose of creating a flat screen where the plume of smoke takes shape.

There was certainly a social context in which contemporary viewers (or the figures seated in the painting) could have imagined themselves telling fireside tales or seeing images in the smoke of the fire. The hearth provided a conventional setting for families to gather and tell stories. Period literature contained many examples of storytelling around the hearth, and compilations of stories often capitalized on this by including "fireside" in their titles. For one, fire was at this time the only source of light.

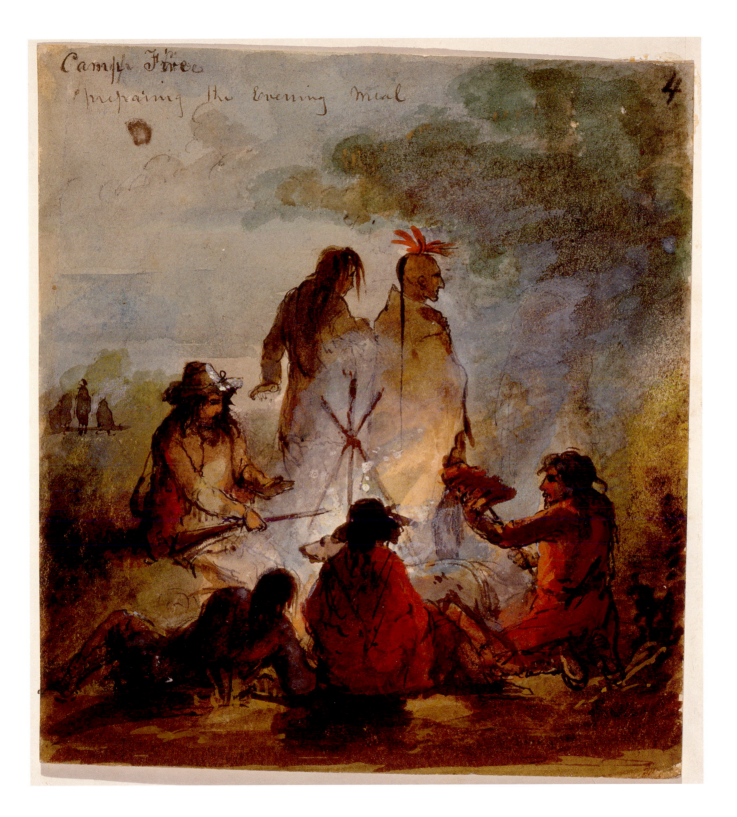

Camp Fire
Preparing the Evening Meal

4

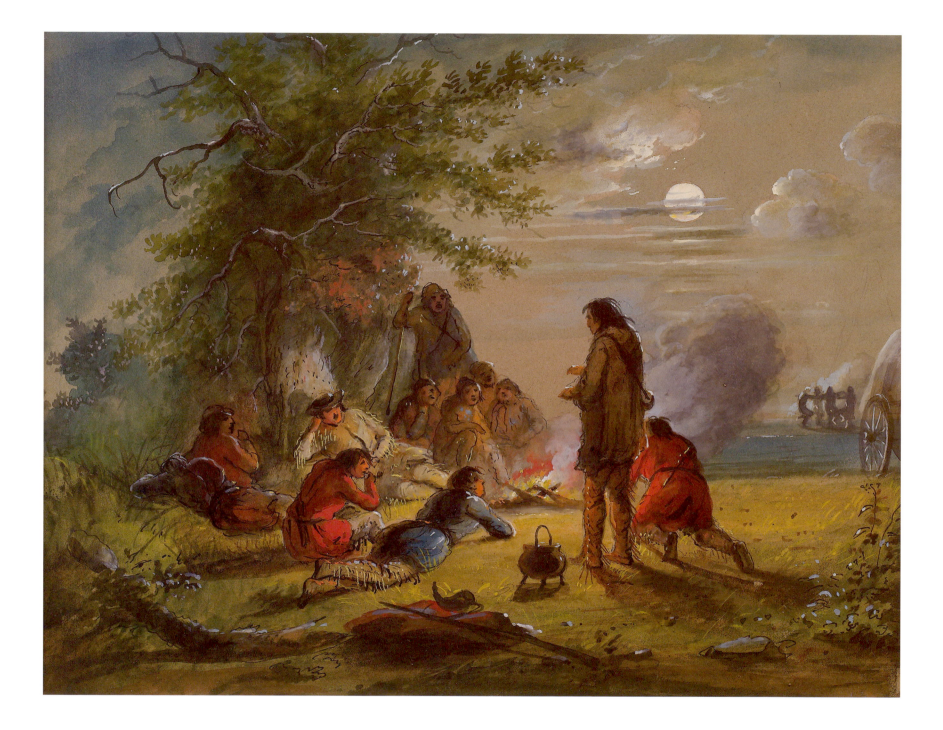

PLATE 12 Moonlight—Camp Scene, 1858-60
Watercolor on paper, 9½ × 12¼ inches
The Walters Art Museum, Baltimore, Maryland

Diaries and journals suggest that the practice was no mere literary device either, but rather a long-held folk practice.[34] Miller suggested as much elsewhere in the Walters collection in his *Moonlight—Camp Scene* (plate 12), which shows a trapper telling a story to some men seated around a campfire.

Fire may have inspired the imagination of Miller's trappers, but his image suggests a preoccupation not so much with anecdotes as with reveries. Like the trappers in *Moonlight—Camp Scene*, the figures in *Camp Fire, Preparing the Evening Meal* sit close together, but the latter is not a social image. The men do not appear to either speak or listen; they are not engaged in telling stories. Each instead seems involved in inward ruminations. Indeed, men lost in thought or reverie before a fire was a common theme in antebellum American literature. Longfellow's fireside poems, as well as numerous poems by male poets written ostensibly as meditations by the fireside, promoted the association between the fireside and emotionally laden reveries.[35] In his poem "The Fire of Driftwood" (1849), Longfellow describes sitting before a hearth with friends:

The windows, rattling in their frames,
The ocean, roaring up the beach,
The gusty blast, the bickering flames,
All mingled vaguely in our speech;

Until they made themselves a part
Of fancies floating through the brain,
The long-lost ventures of the heart that
Send no answers back again.

O flames that glowed! O hearts that yearned!
They were indeed too much akin,
The driftwood fire without that burned,
The thoughts that burned and glowed within.

The image of men ruminating before the fire would undoubtedly also have evoked one of sentimental literature's most popular works, Donald Grant Mitchell's *Reveries of a Bachelor* (1850), which sold over a million copies through its authorized publisher and went through numerous reprintings.[36] The novel presents a series of literary sketches as the musings of a lonely bachelor who sits before a fire. In the first reverie, the fire of an open hearth symbolizes different marriage scenarios. A smoky fire made of green wood causes the narrator to consider the effects of a hasty marriage to a woman who becomes unattractive and complaining as the years pass. A blazing fire stands for a happy, cheerful marriage, and ashes represent the grief of a marriage afflicted by poverty and death. In the second

PLATE 13 Father's Pride, ca. 1850
Sarony and Major
Lithograph, 12 × 8⅝ inches
Harry T. Peters "America on Stone" Lithography Collection
National Museum of American History, Behring Center,
Smithsonian Institution, Washington, D.C.

PLATE 14 Single, 1850
Kellogs and Thayer, Fulton St., N.Y.
Lithograph, 12 × 8½ inches
Harry T. Peters, "America on Stone" Lithography Collection
National Museum of American History, Behring Center,
Smithsonian Institution, Washington, D.C.

reverie, inspired by a coal fire, the narrator meditates on the nature of love and courtship, ending with an image of perfect marital happiness. The final reverie, prompted by a lit cigar, parodies the excesses of sentimental literature and its predominantly female audience with a tale of love and marriage offered to the narrator's aunt in exchange for permission to smoke a cigar in her house.

Antebellum American sentimentalism consisted of a belief in the power of emotions, particularly empathy, to correctly determine moral action. The emotionally laden flights of imagination that constituted the bachelor's reveries at once demonstrated his ability to feel things acutely and to project himself into the situation and feelings of others. Thus the bachelor ends a reverie about the imagined sufferings of his imagined family by saying, "I dashed a tear or two from my eyes;—how they came there I know not. I half ejaculated a prayer of thanks, that such desolation had not yet come nigh me; and a prayer of hope—that it might never come."[37] Though Mitchell's novel offers no particular moral guidance, its narrator relies on emotion and sympathetic identification to determine whether or not to marry. The text's format is also characteristic of sentimental writing of the period. The disparate sketches are linked to one another by what one critic has termed "mood and a thin thread of continuity."[38] And, like much sentimental literature of the period, both setting and subject matter are domestic. In fact, Mitchell foregrounded the novel's domestic themes by placing fire at its narrative center.

The sentiment of the trappers seated around the fire should not, however, be understood to be confined to the trappers' contemplativeness, or to their fireside context. As in *The Trapper's Bride,* sentimentalism could be expressed or revealed by the body. Sentimental authors often represented the traits of mental refinement—delicacy, taste, and sensibility—as biologically based.

Such traits inhered in a person and, significantly, could be manifested in bodily form. Small, dainty feet and hands, a high forehead, and graceful limbs, such as those exhibited by the boy pictured in *Father's Pride* (plate 13), were all physiognomic traits that writers associated with a sentimental nature.[39] Moreover, delicate poses, gestures, and movements were not just habitual signs, but emanations of a refined mind. Likewise, the bodies, poses, and gestures of the figures in *Camp Fire, Preparing the Evening Meal* have an elegance and refinement to them. The hands of the night guard and the Métis man beside him tilt up their slightly bent fingers, creating a delicate arch. The feet of the two foreground figures are dainty and pointed in shape, one neatly crossing beneath the other. The figure in the left foreground reclines, weight on his elbow and one hip, one leg tucked under the other in a pose likely derived from the even more mannered pose of the seated Métis man in *Camp Fire by Moonlight* from the Stewart collection. There, the figure of the seated Métis man, more than likely Antoine, has undergone a number of changes, as evidenced by the sharp scraping out and reinscribing of the contours of his head and the lightly penciled pentimento of an extended right leg below the left. The body as rendered seems not quite to belong to the two bent legs, but Miller nevertheless managed to arrive at a graceful image of a figure shown from the back, leaning on one arm, legs crossed and

PLATE 15 A Stop; Evening Bivouac, ca. 1832–33

Karl Bodmer (1809–1893)

Watercolor on paper, 17½ × 9¼ inches

Joslyn Art Museum, Omaha, Nebraska

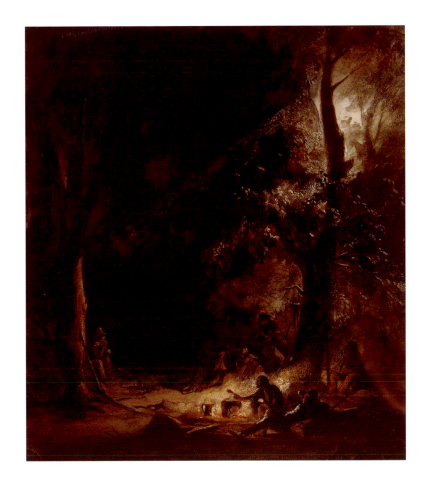

knees bent. He also made a point of carefully outlining the contours of the bottom of the man's foot, so that it rests exactly parallel to the picture plane. The result is a long, elegant line tapering down to the toe, which points from the campfire group toward the figure of Stewart, reclining at the lower left. Some of these same qualities are also readily apparent in an 1846 print of a lonely bachelor in a fireside reverie (plate 14).[40] Here, in addition to long, elegant limbs and small feet, the bachelor is presented in a graceful pose. In particular, the legs, crossed at the ankle, allow the slender contours of the body to resolve in a fine point at the tip of the toes.

If we compare the figures in *Camp Fire, Preparing the Evening Meal* (plate 9) to those in two of Karl Bodmer's camp scenes, the subtle mannering of Miller's trappers becomes more readily apparent. Bodmer's *A Stop; Evening Bivouac* (plate 15) has a compositional looseness and asymmetry matched by the individual postures of the figures. They are not grouped tightly around a bright and unseen fire but rather spread in smaller groupings at a greater distance. Gone is the sense of camaraderie in Miller's image, as well as the intimacy suggested by the trappers' close physical proximity and shared

PLATE 16 Evening Bivouac on the Missouri,
ca. 1832–33
Karl Bodmer (1809–1893)
Watercolor on paper, 9⅛ × 12⅛ inches
Joslyn Art Museum, Omaha, Nebraska

PLATE 17 Trappers, 1858–60
Watercolor and gouache on paper, 11¹⁵⁄₁₆ × 9⁷⁄₁₆ inches
The Walters Art Museum, Baltimore, Maryland

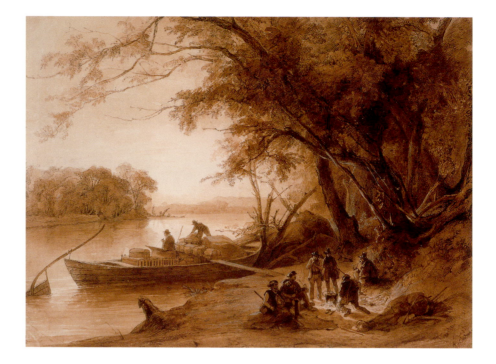

silence. Bodmer's figures themselves are rendered in sharp angles rather than flowing lines, and their poses have a stiffness as a result. The closest parallel to Miller's trappers is a figure in a hat reclining opposite the fire. He leans his head on his arm, weight to the side, but his legs, rather than crossing to create a neat pyramid, bend at jaunty angles and spread open, his feet apart, not touching. Another figure, on the opposite side of the fire, similarly bends his legs and spreads them, feet flexed, creating a broken, rather than a smooth and graceful contour. In *Evening Bivouac on the Missouri* (plate 16), again the men are broken into smaller groupings, each smoking his own pipe. Their attention, like the figures themselves, is diffused. The ungainly figure kneeling before the pot in the fire presents another strong contrast to the grace of Miller's trappers.

In using these poses, however, Miller does not mean to suggest social refinement. Quite to the contrary, the point of such images was to depict a refinement of emotions that could (or perhaps could only) be cultivated in a natural environment, beyond the reach of eastern social conventions. In the context of their natural setting, with their adoption of primitive clothing and lifestyle, these trappers' poses should be understood as natural emanations of an interior life otherwise difficult to capture in a visual medium rather than as a mark of their inculcation in the social conventions of bodily comportment. Though Miller's image from the Walters commission is by no means as pronounced in its mannerisms as either the print or the Stewart image, it does demonstrate poses which elsewhere in Miller and in popular imagery connoted interior sentiment.

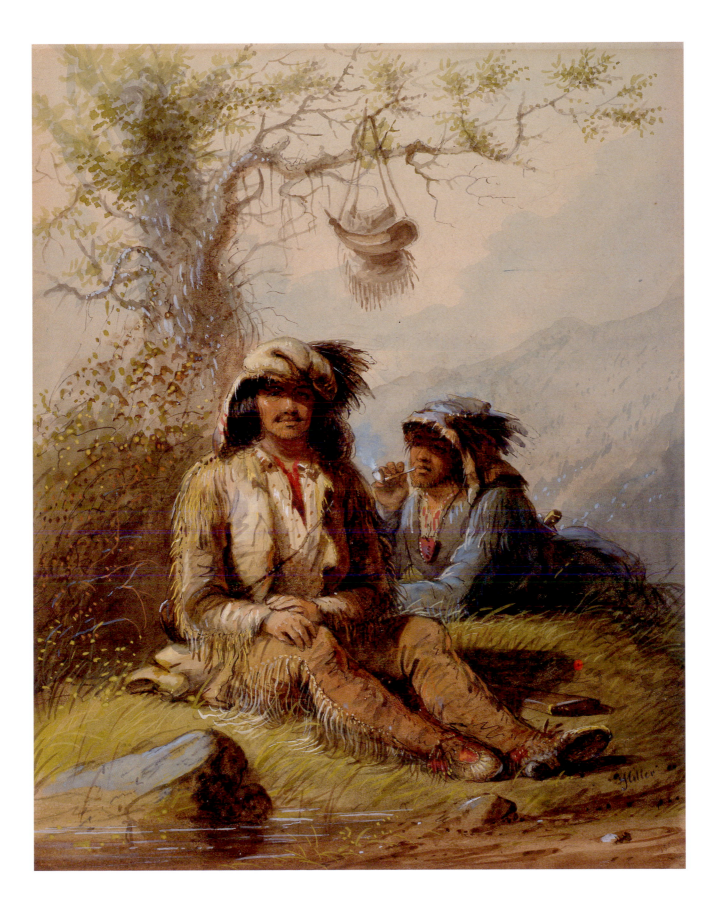

We see a similar physical articulation of natural masculine sentiment in another image from the Walters collection, *Trappers* (plate 17). Miller's accompanying note asserts that his subjects possess many of the expected traits of the trapper as popularly represented in art and literature:

> The trappers may be said to lead the vanguard in the march of civilization,—from the Canadas in the North to California in the South;—from the Mississippi East to the Pacific West; every river and mountain stream, in all probability have been at one time or another visited and inspected by them. Adventurous, hardy, and self-reliant,—always exposed to constant danger from hostile Indians, and extremes of hunger and cold,—they penetrate the wilderness in all directions in pursuit of their calling.[41]

Miller's *Trappers* are independent, unfettered by the restraints of social bonds, and happy to be so. Miller emphasizes this point in the latter half of his text, which provides an anecdote about the famous trapper Moses "Black" Harris (ca. 1800–1849).[42] For years Harris traveled back and forth across the Rockies carrying dispatches from the fur companies to the trappers. He traveled alone and by night, in order to avoid being discovered by Indians or rival traders, yet he claimed he "never knew in his life what it was to feel lonesome, or low spirited."[43] The trappers in Miller's text are also hardy, inured to the dangers of exposure or hostile Indians. And, perhaps most importantly, Miller's trappers are in the vanguard of civilization. They explore every inch of western terrain in the dogged pursuit of furs, introducing into the wilderness the seeds of their commerce.

Yet if we turn to the image itself, Miller presents us with a somewhat different vision of the trapper. Two trappers lounge in the grass by the bank of a small pool of water. The men's hair and beards are long and unkempt. They are dressed in buckskin, its hand-hewn quality emphasized by the unequal lengths of fringe that creates a rough and broken contour along their limbs. Each man also wears a loose hoodlike cap festooned with thick bunches of feathers. As with Miller's images of Stewart, their dress is rich with associations of the "primitive." The buckskin and feathers are natural materials, derived from animals rather than manufactured, and Native Americans would have worn both, albeit with more finesse. The trappers' wild features and dress are reiterated by the depiction of the wilderness that encroaches on them—the thick brush that reaches its tendril-like branches toward the seated trapper and the gnarled and sinuous branches of the tree that stretch out over their heads. The tree itself is overtaken by vines that creep upward from the brush as if they pull it down; indeed the image seems to flirt with the possibility of the men having been overtaken by the natural realm as well. This idea was, of course, reinforced by what would have been seen at the time as the strong connection to Indian life evident in most every aspect of their portrayal, from their long hair, feathers, moccasins, and buckskin garb to their ease in a natural environment. Miller, in fact, refers frequently in the Walters text to the Indian-like traits of trappers, writing, "The trappers of

the Rocky Mountains … perhaps … are more like [the native-born Indians] than any other class of civilized men."[44]

The trappers are wild. They appear almost to have taken root in the wilderness, yet they are also, in that respect, quite literally settled. But their fixed aspect would not be of consequence if it did not also suggest their establishment of community through the social bond that appears to exist between them. Though a small distance separates the two men, the foreshortening of the image places them close to one another. The juxtaposition of their two left arms makes their limbs appear nearly contiguous, as if the reclining trapper reaches across the grass to touch the right hand of the seated one. Their sense of comfort with one another is further suggested by the prone figure, lounging in the grass by his companion. Their commune with one another suggests a kind of nascent community, or even family, that they have constructed in the West. The heart-shaped *gage d'amour* that the reclining figure wears around his neck further testifies to a romantic relationship with an Indian woman.[45] Such a relationship could have symbolized either the male-female bond that was the bedrock of the family and of civilized society or, as in *The Trapper's Bride,* the initiation of trade relationships on which a western economy could be founded.

Miller's foreground trapper also demonstrates a civility that can be read in his comportment. There is a delicacy in his posture. He appears to hold himself upright, back straight. Like the subject of a formal portrait, he looks outward. His hands rest gently upon his knee, his fingers lightly bent in a gesture that suggests an analogous gentleness of spirit in the man. The physical gentleness of his posture is mirrored in the expression on the man's face. Though the loose felt hat obscures one eye, the other eye, squinting slightly at the viewer and lined with crow's feet, looks out of the picture plane warmly, as if to engage with us. His slight, welcoming smile encourages us to look back. Even more so than in *Long Jakes,* there is the sense that Miller's trapper is "fully conscious of his picturesque appearance."[46]

Fireside Nostalgia

As previously discussed, sentimental literature not only portrayed its subjects as sentimental beings, it also attempted to elicit sentiment from its readers. Miller's depiction of the vivid orange flames of the trapper's fire in the small sketch *Trappers* (plate 7) or in the more evocative *In the Rocky Mountains* (plate 8), which contrasts the warm, white pulse of the trappers' fire burning in the corner of the image to the dark, rugged cliff that extends above it, invites the viewer to feel nostalgia for the open flame. The open flame had long been an object of emotional attachment for Americans, particularly those of English descent.[47] Although the traditional English hearth and chimney were notoriously smoky and inefficient, consuming vast quantities of firewood to heat only a small area, attempts at reform with a cast-iron box stove failed to win many converts among Anglo-Americans. Examples

of superior heating technology such as the columnar tile stove used by German and Russian immigrants similarly failed to be adopted by Anglo-Americans.[48] It was not until the late 1830s that cheap cast iron and rising prices of firewood forced most Americans to make the switch to smaller enclosed parlor stoves and furnaces fueled by coal. Predictably the loss of the open flame inspired nostalgic reminiscence for it.[49]

The wood fire as a source of light could also have been a source of nostalgia for Miller's Baltimore audience. Baltimore was the first city in the United States to adopt gas lighting for private and public use. The Gas Light Company of Baltimore, founded by Rembrandt Peale (1798–1860), first supplied light to street lamps in 1817. By 1870 there were over 15,000 gas consumers in the city, including theaters, markets, government buildings, homes, and the building, Carroll Hall, which housed Miller's studio at the time he painted the Walters commission.[50] The public, however, did not uniformly embrace the technological advance of gas lighting because its illumination was too bright. In an essay on "The Philosophy of Furniture," Edgar Allan Poe (1809–1849) argued against the use of gaslight in interiors, saying: "Its harsh and unsteady light offends. No one having both brains and eyes will use it."[51] Interior design manuals, in fact, stressed the importance of choosing the appropriate lighting method, be it gas, Argand lamp, or candle for the illuminated space. The soft light of a wood fire in a hearth was deemed most appropriate to the combined public and domestic space of the parlor.[52] Andrew Jackson Downing (1815–1852) was particularly passionate about placing a hearth in the parlor, writing in *The Architecture of Country Houses* (1850): "We have a great love of the cheerful, open fireplace, with the genial expression of soul in its ruddy blaze, and the wealth of home associations that surround its time honored hearth."[53] Interestingly the Baltimore Athenaeum building, which had reenforced a hierarchy of elegance and taste within Baltimore's intellectual and mercantile elite through its use of architectural design, was lit with gas everywhere but in the top floor exhibition space of Mayer's Maryland Historical Society. There, for practical reasons, but perhaps also as a matter of taste, skylights illuminated the art galleries.[54]

The number and use of campfires in Miller's images suggest he was familiar with the different associations of light, and circumstances of his life in Baltimore reinforce that conclusion. Miller exhibited at the galleries in the Baltimore Athenaeum, and his close friendship with Mayer could have acquainted him with the particular interior design objectives of the building. Moreover, Miller's studio from 1853 to 1864 was located in Carroll Hall, just across the street from the Peale Museum, visible to the far left in plate 18. Carroll Hall was itself lit with gas, so Miller likely had access to the bright lighting in his studio as he worked on *Camp Fire, Preparing the Evening Meal* (plate 9). Significantly, Carroll Hall was known for its calculated use of both candle and gas lighting. From 1851 to 1853, the first floor housed Samuel F. B. Morse's private offices and the telegraph office, both of which were lit with gas. On the third floor it had an assembly hall that held formal balls for Baltimore's elite. Contemporary newspapers noted that the assembly rooms were lit with thousands of candles.[55]

In response to the growing illumination of cities, particularly of shop windows, artists, writers, and musicians expressed nostalgia for a simpler, dimmer, past in their work.[56] Between 1820 and 1850, historians estimate there were "more autonomous night scenes than in any other given period of western art."[57] Miller made note of the extreme brightness of lights in London shop windows during his visit in 1841: "The splendour of the stores on Regent Street at night most likely exceeds anything of the kind in the world. The plates of glass in the windows are about 10 ft. by 3 ft, and your great wonder is how the front wall is supported, for there is nothing but one uninterrupted map of glass in the front. These are filled with the most dazzling works of art and lighted up with a brilliancy almost inconceivable."[58] Miller may have felt some of the nostalgia for dimmer light. The album he completed for Stewart contained approximately ten scenes including a campfire, and the Walters watercolors contain eighteen. Thus the campfires in *Camp Fire, Preparing the Evening Meal* and other of the Walters sketches potentially served two purposes: They could elicit feelings of nostalgia from their viewers in part through their representation of the open flame, and they could signify the particular appeal of the light of a wood fire to people of sensibility or taste.

Gender and the Hearth

To a contemporary viewer, few things may seem more masculine than an image of men seated around a campfire. But historians date the emergence of this association to the late nineteenth century when the ideal of the masculinized "strenuous life" revalued many aspects of social or domestic life that had been feminized earlier in the century:

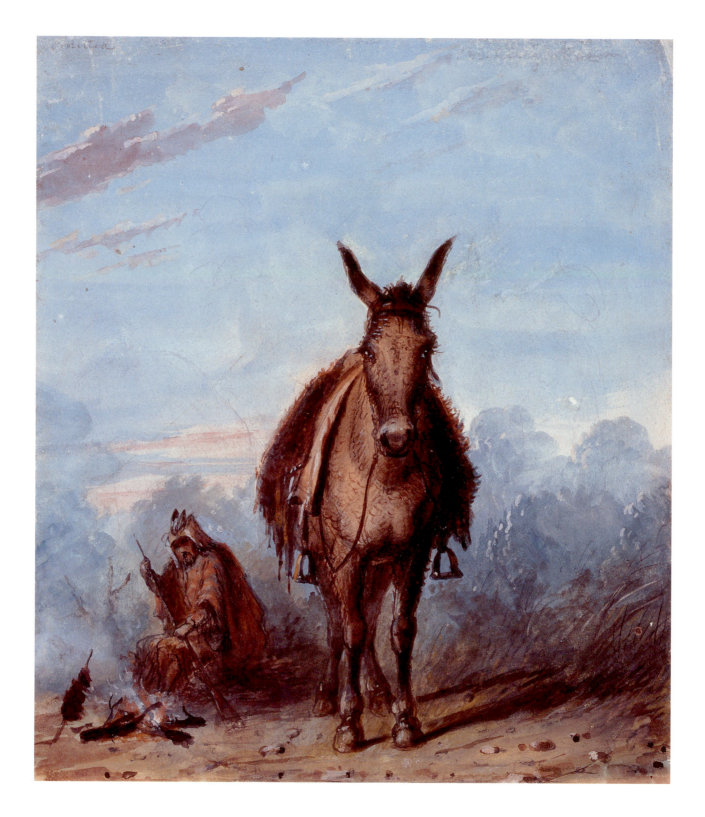

PLATE 19 A Trapper in His Solitary Camp, n.d.
Watercolor on paper, 8⅝ × 7⅜ inches
Joslyn Art Museum, Omaha, Nebraska

PLATE 20 Fireside Stories
After Enoch Wood Perry (1831–1915)
Wood engraving
From *American Painters: With Eighty-Three Examples of
Their Work Engraved on Wood* by G. W. Sheldon (New York:
D. Appleton and Company, 1879), p. 70
Museum of Fine Arts, Houston

This subtle shift in values, which began in the 1880's and continued well into the next century, manifested itself in the increase in violent sports, in the reappearance of a forceful and manly clergy, and in the glorification of outdoor life that was so dear to Theodore Roosevelt. There was also a phenomenal surge of interest in camping at this time, which, symbolically at least, pitted campfire against home fire in the minds of some.[59]

In the 1860s however, the hearth, with its open flame, was chiefly associated in popular culture with the feminine realm of the home (plate 20):

Caught up in the whirlwind of domestic and technological changes that buffeted American society during the 1800s, the family hearth gradually shed some of its more mundane attributes in order to take on a potent new symbolism. It became, in essence, the altar of a curious new religion that transformed the American house into a temple of secular virtue and elevated the wife and mother to the role of high priestess and defender of the flame.[60]

Thus Miller's campfire scenes should not automatically be understood as masculine images, but rather as images that contributed to the masculinization of the fireside.

In what seems at first an ironic juxtaposition to the poetic *Camp Fire, Preparing the Evening Meal*, Miller's accompanying commentary focuses on the cook's preparation of a rack of buffalo hump ribs. In light of the fire's shifting associations, however, his text can also be interpreted as a further attempt to challenge the feminization of the fireside:

A Trapper is here preparing that most glorious of all mountain morsels, "a hump rib" for supper.

He is spitting it with a stick, the lower end of which is stuck in the ground near the fire, inclined inwards.

The fire is often made from the *bois de Vache*, but as we had the best of all sauces, viz: most ungovernable appetites, and most impatient dispositions for this same roasting operation, the circumstances did not affect us in the least. We found hunger so troublesome that it was quite a common thing to rise again at midnight and roast more meat, if we had any.

Miller is emphatic in his association of the campfire with food preparation—not just in his note to this image, but, in almost every one of the Walters texts that mentions fires specifically. Most of the fires seen in Miller's images, in fact, have either a skewer of ribs shown roasting before them, or are surrounded by a telltale tripod, which was used to support a pot over the flames (plates 7, 19).[61] It is, of course, true that the trappers made fires to cook their dinners, but the fire served other purposes

as well. It offered light, heat, and, as the image suggests, a form of entertainment. Yet by linking the campfire to the act of cooking, Miller underscored the domesticity of this and other of his fireside settings.[62]

In *Camp Fire, Preparing the Evening Meal,* Miller suggested a number of other subtle details that emphasize the domesticity of the campfire. A little dog, long an established symbol of domesticity, lies peacefully behind the circle of figures. Dogs were, in fact, popular motifs for embroidery on the small decorative rugs placed before stoves or hearths in the mid-nineteenth century. The dog's presence appears to have been significant, as the dog is also prominently placed in the Gilcrease sketch, where he stands between one of the foreground figures and the fire. Finally, the two trappers flanking the fire represent the essential domestic comforts of food, personified by the cook roasting the ribs, and security, as personified in the armed night guard seated on the left.

But if Miller's vision of the campfire scene is domestic, it is clearly not the feminine domesticity of the Baltimore kitchen Miller left behind. The trapper's domesticity is a primitive one. There are no elaborate utensils, only the bare essentials: a cup and a frying pan, visible in the shadows to the right of the cook, and a wood skewer. And, of course, there is no cast-iron cookstove with built-in rotisserie, bread oven, and warming oven, as would increasingly have been found in eastern kitchens in this period.[63] But, perhaps most important, there are no women. Primitive domesticity is at once a sign of the trapper's self-reliance (they kill, clean, and cook all that they eat) and their ability to be domestic without women. Miller's emphasis on the trapper's ravenous appetite, so great as to render all culinary refinements unnecessary, suggests the extent to which the trapper's domestic scene renders comforts at once greater and more genuine than those of civilization.

Campfire Reveries and Artistic Creativity

To return to a discussion of the Indian and Métis figures who turn their backs to the fire: that the blank page should be formed on the back of the Indian and Métis figures is particularly significant. The Indian man's posture, stern, straight, and away from the imaginative and sentimental inspiration of the fire jibes with earlier representations in *The Trapper's Bride* of the unsentimental Indian male. This distinction is borne out in many of Miller's depictions of Indian men. In notes to *Indian Courtship* (plate 21), Miller wrote, "The North American Indian carries his wonderful stoicism into every transaction of his life,—even the tender subject of selecting a helpmate does not disturb his tranquility." The image shows the suitor standing before his intended bride and her father. He holds his body erect, his right leg and back forming a long, straight line. His head tips forward only to look down at the dowry he has brought to exchange for his bride, not at the young woman who recoils from him. His face, made noticeably unattractive by a sharp nose and chin, bears no trace of loving feelings, nor does his head tip to the side pensively, as does the trapper's in *The Trapper's Bride.* Miller

PLATE 21 Indian Courtship, 1858–60
Watercolor on paper, 8 × 10¾ inches
The Walters Art Museum, Baltimore

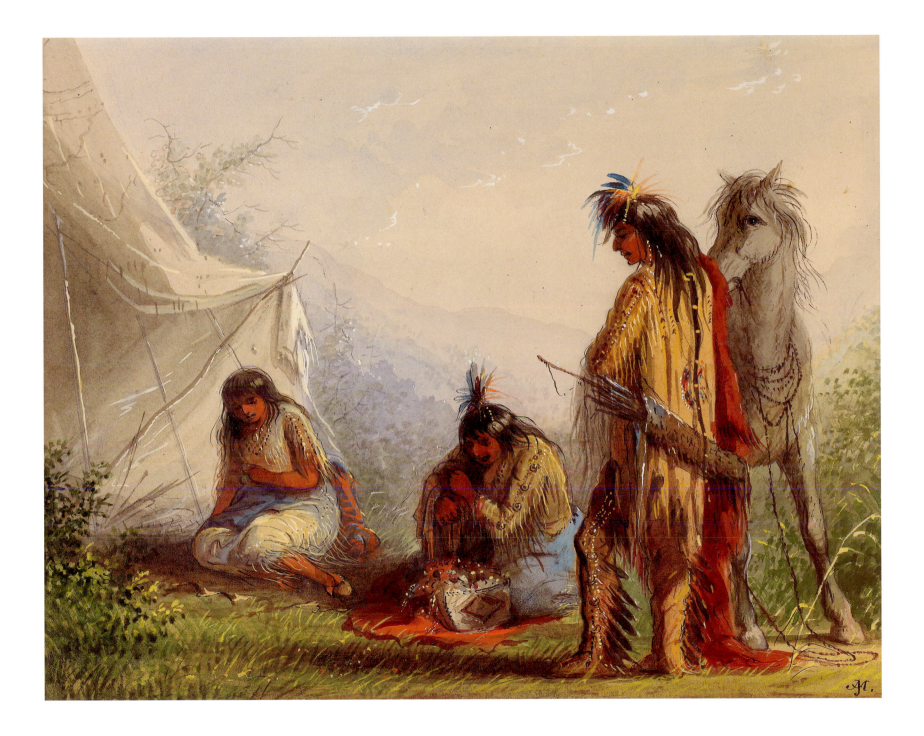

sharpens the point of the image in his text, adding an asterisk, which refers the reader to the bottom of the page. There, in smaller text, he writes, "It may as well be remarked here, once for all, that the Indian is not a sentimental creature."[64] Another image of the unsentimental Indian male is *Sioux Indian at a Grave* (plate 22). The watercolor shows an Indian man looking down at a grave with a wry expression. Miller's note describes him as sitting quietly, "trying to commune with the inmate."[65] There is some imagination and empathy implied in the contemplative presence of the man before the grave, but there are no tears, again, no chin in hand. Certainly in contrast to the kind of elaborate mourning rituals and public grief that constituted the proper, sincere emotional response for the American middle class in this period, he appears unfeeling.[66] His seated posture, legs spread around his strung bow, suggests that either in his stoicism or his absence of emotions, he lacks the refinement implied by the more graceful poses of the reflective trappers in *Camp Fire, Preparing the Evening Meal.*

Miller's representation of the Métis man in this work is somewhat more complex. The figure's delicate hand gesture is one of refinement not demonstrated by the Indian man. Yet Miller's other imagery of the Métis renders this gesture problematic. Miller's *Pierre* (plate 23), from the Walters commission shows one of Stewart's Métis engagés sitting by an embankment. (Engagés were camp employees who hunted, prepared food, tended horses, drove the wagons, and did other tasks to assist the camp; they were not trappers. In the strict hierarchies of labor that defined the fur trade, they were the lowest rung, followed by hunters, trappers, crew chiefs, fort captains, or bourgeois and company owners.)[67] Pierre sits with his head facing downward, his gaze unfocused, as if he is lost in thought. Miller's text says he was one of the caravan's most "active and successful hunters," but his posture is one not just of reverie but of melancholy. There is a slight downturn to his mouth that, together with his lowered head, suggests sadness. In the context of his general expression, his eyes, cast in the shadow of the brim of his hat, convey a dark or mysterious vision. While the trapper's reveries, directed toward the fire, imply a procreative imagination, Pierre's reverie is unfocused, or even, like his very reposed posture, enervated. Indeed, though Pierre is pictured with a donkey, as noted in chapter two, Métis men in Miller's images often ride mules—hybrids between horse and donkey that are sterile. Thus we may read the Métis and Indian men, facing away from the fire in *Camp Fire,* to represent the opposing poles of sentiment—too sentimental and unsentimental—between which falls an ideal, productive sentiment demonstrated by the trappers.[68]

Significantly, much of Miller's Walters commentary and private journal musings were directed toward outlining or defining the acceptable parameters of sentimentalism. For Miller, empathy and sympathetic identification properly applied could result in sound moral conclusions. In his journal, for instance, he remembered seeing Jewish ghettos in Rome, in which "the Jews [were] *locked up!* … in a walled city called the 'Ghetto' & within the walls of Rome…. they were required under heavy penalties to make their ingress by a certain hour (either 8 or 9 o'clock PM)." Miller regarded their treatment as "a brutal outrage—unworthy of any civilized government." His account invites a similar

PLATE *22* Sioux Indian at a Grave, 1858–60
Watercolor on paper, 10⅛ × 8³⁄₁₆ inches
The Walters Art Museum, Baltimore

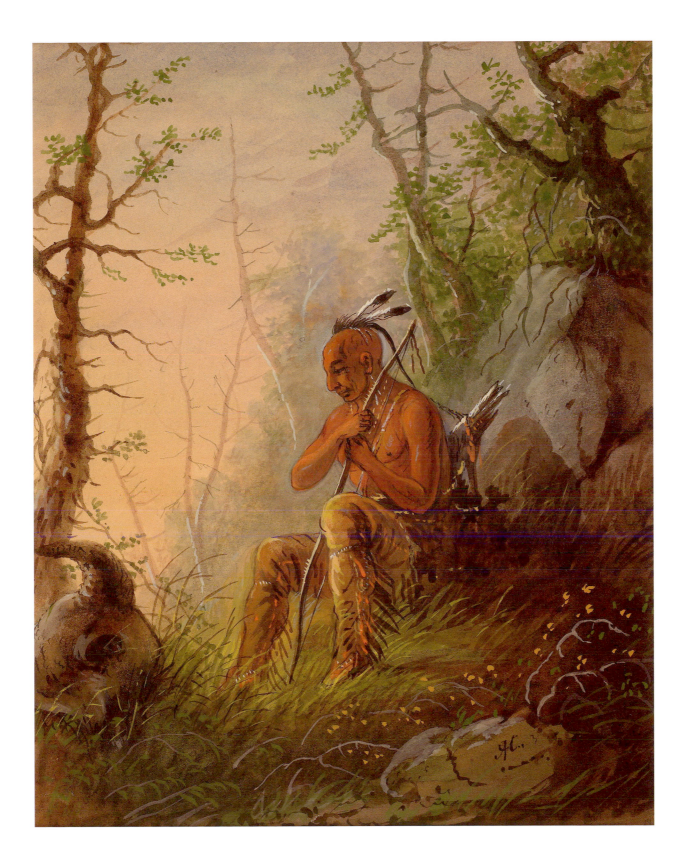

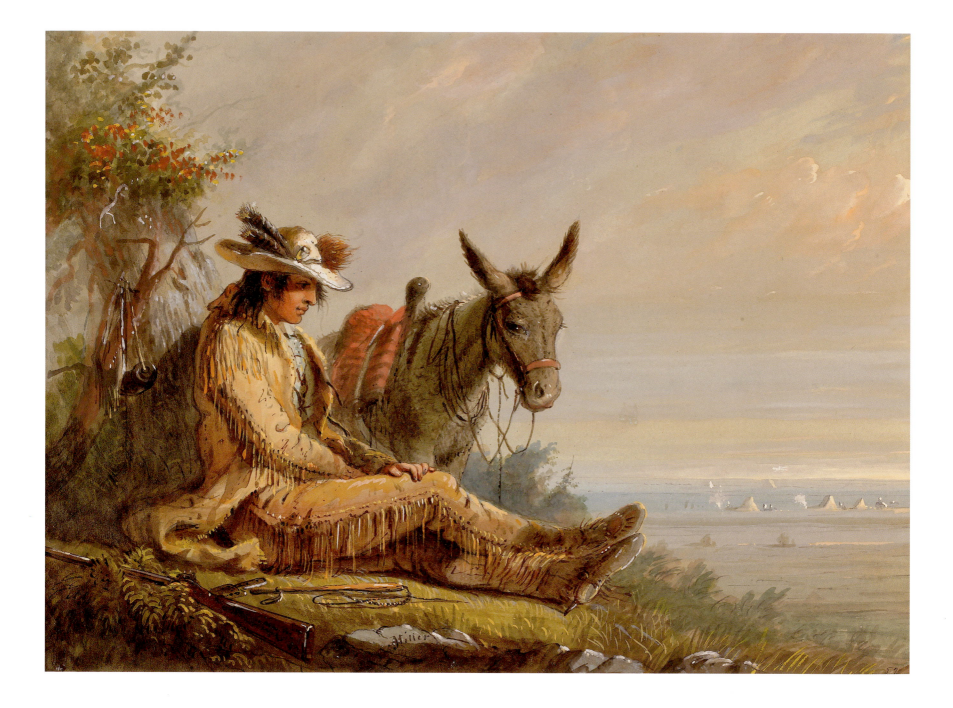

PLATE 23 Pierre, 1858–60
Watercolor on paper, 9⁵⁄₁₆ × 12³⁄₁₆ inches
The Walters Art Museum, Baltimore

reaction from his reader by providing humanizing details, such as his observation that many of them wore "long, coarse, gabardine which looked as if it had seen much service."[69]

Sympathy, however, could also be squandered on an undeserving recipient, rendering the subject foolish. In a letter to his brother from Murthly, a donkey makes another significant appearance in the context of excessive sympathy. Miller describes how a donkey that Stewart owned had kicked her mate and caused his death. She had been inconsolable since that time:

> Seeing that she was melancholy, Constantine and I used to visit her occasionally and give her flowers of dandelion, for which she seemed very grateful, and it was curious to observe that large, palpable and tangible, tears would start from her eyes and roll down her face. All this sorrow however we answered by ridicule and levity, for who in the deuce would sympathize with the crying of a donkey . . . ?[70]

Miller's commentary to the Walters sketches continues to stake out the parameters of proper sentiment.[71] Throughout his notes, he attempted to locate points of similarity that form the basis for empathy. His sympathies were properly applied to the most serious considerations of Indian life. In a note accompanying a portrait of a Nez Percé man, Miller described some of the Indian people he met as having "rare and commendable" qualities. "They are said to be religious, and honest and truthful in their intercourse with whites." They also, he claimed "are the most inveterate gamblers, playing until everything they possess has departed from them." But, he noted, "We find these inconsistencies in civilized life also, and with less excuse." Thus he not only suggested a shared humanity between Indians and whites, he also demonstrated his own ability to empathize with them on the basis of both their positive and negative traits and thereby render a moral judgment (censure and forgiveness) upon their behavior. His recognition of a shared humanity invites him to lament their presumed demise. He finished the note with some lines of poetry written, by William Cullen Bryant (1794–1878), from the perspective of an Indian.

> They waste us, aye, like the April snow,
> In the warm noon we shrink away;
> And fast they follow us as we go,
> Towards the setting day;—
> Till *they* shall fill the land and *we*
> Are driven into the western sea.[72]

The imagery of snow melting in the sun was a common cliché suggesting the naturalness and inevitability of the Indians' demise.[73] The sadness of the imagery would likely have elicited the sympathy of the reader of the Walters text, as it had presumably inspired the sympathy of Miller.

More important than the poles of sentiment that the Indian and Métis men in *Camp Fire, Preparing the Evening Meal* appear to represent, however, is their function in the image as a reference to the very creative process that brought the image into being. Miller's letter to Brantz Mayer on the eve of his departure took for granted that nature's "wild sons of the West" would provide his inspiration.[74] This is something he seems to acknowledge by positioning the Indian and Métis figures as screens for the fire's smoke. Indeed, in his journal, under the heading "On Art," Miller noted that "there is always something shadowy and vague in the very highest productions of the imagination."[75] Thus the smoke across the figures' backs forms a blank area not just for the trapper's imagination, but as an expression of the artist's own. Miller made clear that deep imaginative absorption, akin to the kind that the smoky fire inspires in the trappers, was integral to the process of making his western images. He described how, on one occasion, his reverie was broken by Stewart:

Selecting the best site & setting to work being completely absorbed, about half an hour transpired when suddenly I found my head violently forced down & held in such a manner that it was impossible to turn right or left. An impression ran immediately through my mind that this was an Indian & that I was lost. In five minutes, however, the hands were removed. It was our Commander. He said, "Let this be a warning to you or else on some fine day you will be among the missing. You must have your eyes and wits about you."[76]

The campfire setting offered Miller and his trappers a secure place in which to give their imaginations free play; the smoke across the backs of the standing figures is both the source and evidence of this.

But the smoky area across the backs of the Indian and Métis figures is linked in a second significant way with Miller's creative process. The smoky area is formed, in part, by a rubbing out of colors similar to the "dry scumbling" Miller proudly recounted mastering in oil painting. In his journal, Miller described how he sought to capture the effects of a sunset in a view of Baltimore's Laudenslager Hill, but, "I found after finishing my foreground that a great heaviness hung over the city with too much detail in the buildings, considering that they were over two miles distant." After revisiting the hilltop vantage point from which he had painted, Miller returned to the studio to experiment with a technique he had read about in an art manual. "… Mixing up on my palette portions of white, blue, Vermillion & black until I had attained what I conceived ought to be the color,—I thus took a large brush & with this mixture covered thinly all the buildings in the distance." Significantly, this appears as a digression addressed to "some young artist should he happen to read it" in an account in which he described Stewart's first visit to his studio. According to Miller, Stewart looked at the paintings

Miller had on display, and prior to leaving, told the artist he particularly liked "the management . . . & the view" of his Laudenslager Hill landscape.[77] Stewart returned a week later to offer his commission. Thus the Indian and Métis figures and the blank screen they produce are linked several times over to the very creative process which resulted in all of Miller's imagery. They at once embody the source material, the imagination, and, insofar as they are rendered by the technique that earned Miller his commission, the technical mastery of Miller's artistry.

The Indian and Métis figures are linked to Miller's creative process, as is the fire by virtue of its associations to imagination and reverie. But the trapper's quietude is also a reference to the creative process that brought the image into being. Respite from the physical activity of travel and camp life afforded Miller a time to create. As noted in chapter one, Miller used the time allotted Stewart's party for an afternoon nap to paint, and he hired trappers to do some of his camp work, presumably in part to free time for artwork.[78] But in antebellum America, the very act of writing literature was seen as leisure, rather than work, simply because it did not involve physical activity. While the "idleness" of literary production discredited it in a culture that idealized hard work, that idleness was also at the heart of literary identity.[79] Thus hard-working and enormously productive popular authors, such as Nathaniel Parker Willis, were at pains in their writing to create the impression that the act of writing was effortless.[80] A similar expectation pertained for American artists.[81] Miller's self-representation in his letters from Murthly and to other artists as one who entertained, played violin, and enjoyed long walks certainly downplayed the studio time necessary for an output as large as his. In this light, the comment made by an agent, whom Stewart had sent to check on Miller's progress once the artist had returned from the West, that the artist "seems rather lazy" leads one to wonder if he was in fact witnessing Miller's calculated posturing.[82]

If Miller's supposed idleness was central to his identity as an artist, it appears that it was something he needed to defend himself among his merchant patrons. Brantz Mayer, in his dedication address before the members of the Mercantile Library, Library Company, and Maryland Historical Society, attempted to refute the negative associations of the artist/writer as idler to his mercantile audience by emphasizing the significance of the artist's output: "Some there are, who, in their day and generation, indeed *appear* to be utterly useless,—men who *seem* to be literary idlers, and, yet, whose works tell upon the world in the course of ages." He repeatedly tries to make a case for the support of the arts on the grounds of its practical utility to the business of the merchant. "You may make money by tricks of the trade or by luck," Mayer argues, but the merchant who learns about his patrons through art or literature may more fully realize the "true dignity of commerce and the advantage to the merchant that properly derives from enlightenment."[83]

Miller's choice to imbue the trapper with certain traits, a penchant for leisure, but also for sentimental reverie and primitive domesticity, is thus not without self-interest. The masculine ideal of the self-made man excluded men like the trappers as Miller portrayed them, but it also excluded

artists like Miller himself. Artists, clergymen, and teachers were viewed at the time as effeminate because their careers involved "nurture and sentiment, an understanding of human feeling used to cultivate and ennoble the human spirit."[84] Male authors found themselves at odds with masculine norms and consequently sought to subvert middle-class standards of masculinity in their writing.[85] Henry Wadsworth Longfellow complained about the reputation of male writers in a letter to Walt Whitman:

> Americans hold the appellation of scholar and man of letters in as little repute, as did our Gothic ancestors that of Roman; associating it with about the same ideas of effeminacy and inefficiency. They think, that the learning of books is not wisdom; that study unfits a man for action; that poetry and nonsense are convertible terms; that literature begets an effeminate and craven spirit; in a word, that the dust and cobwebs of a library are a kind of armor, which will not stand long against the hard knocks of the "bone and muscle of the State," and the "huge two-fisted sway" of the stump orator.[86]

A quote from Sir Edward Bulwer-Lytton, which Miller transcribed in his journal, suggests the artist's own defensiveness about his profession: "Strange thing, art, out of an art a man may be so trivial you would mistake him for an imbecile,—at best a grown infant. Put him into his art & how high he soars above you!—How quietly he enters into a heaven of which he has become a denizen & unlocking the gates with his golden key, admits you to follow,—an humble reverent visitor."[87]

Not only was Miller's masculinity threatened by virtue of his profession, he also "failed" on another more serious count: he was a bachelor. Bachelors were accorded a kind of liminal standing within the realm of masculinity. Since marriage and children commonly marked the final passage from boyhood to manhood, bachelors were in that sense arrested in a holding pattern between the social stages.[88] Though bachelors were regarded as social misfits, Miller seems to have viewed his bachelorhood in at least one instance in positive terms as intrinsic to his work as an artist. Pasted to the inside cover of his journal was a clipping that read: "Michael Angelo the painter was asked why he did not marry. He replied: 'I have espoused my art, and it occasions me sufficient domestic cares, for my works shall be my children.' A young artist who had just married told Sir Joshua Reynolds [1723–1792] that he was preparing to pursue his studies in Italy. The great painter replied: 'Married then you are ruined as an artist.'"[89] Miller's family appears to have been quite unusual in that of the nine children who survived to adulthood, only two, or possibly three, married. None of Miller's four sisters, Harriet, Katherine, Mary, or Elizabeth, ever married.[90] His biography suggests that there may have been circumstantial or psychological explanations for his bachelorhood, but what is significant for this argument is that Miller himself presented it as a professional choice.

Miller's own masculinity may have been doubly imperiled by his personal and professional choices, but his subject matter, the trapper, was a celebrated paragon of masculinity. Histories of American masculinity devote particular attention to the frontiersman as an alternative to the prevailing ideal of the "self-made man," whose masculinity rested upon his morality, work ethic, and financial success.[91] Story writer Henry Herbert's essay on *Long Jakes* nicely illustrates the terms in which the trapper's virile manhood could be contrasted with the insipid masculinity of the businessman. Referring to the painting, he writes:

> That is the picture of a *man*. A man emphatically and peculiarly; a man, at an epoch when manhood is on the decay throughout the world; ... A man of energy, and iron will, and daring spirit, timeless, enthusiastic, ardent, adventurous, chivalric, free—a man made of the stuff that fills the mould of heroes.

Herbert continues on to draw a stark contrast between the hardiness of trappers and the "sloth, effeminacy, baseness, cowardice and dishonor" of businessmen. *Long Jakes* proves that

> there are successes of more importance to mankind than those of thriving bankers; interests of greater moment than the spinning of cotton, or the boiling of molasses—that there are such things, in a word, as truth, and honor; as patriotism and glory; and that the whole aim and intention of man's life, and the world's existence is not, as the merchants would have us to believe, mere selfishness and mammon.[92]

Miller's trappers, as he has constructed them, present a forceful challenge to the prevailing ideal of the self-made man. They are at once powerfully, physically masculine and also idle, creative, and sentimental. That the prevailing ideal that Miller challenged was also the one that would describe the merchant patrons for whom he painted is not, I think, insignificant. One historian of masculinity has argued that American men's real fear "is not fear of women but of being ashamed or humiliated in front of other men, or being dominated by stronger men."[93] If this is so, then Miller's particular formulation of the trapper can be read as a challenge to the masculinity of his patrons, to whom he was, in 1858–60, still financially beholden. Indeed, it was the very commission that Walters offered, for 200 watercolors at $12 apiece, for a total of $2,400, which provided him a base of financial security; his investments in banks and utilities picked up in the years 1860–70.[94]

Miller's articulation of the strong yet sentimental trapper served the function of carving out a positive masculine identity with which he, as an artist, could identify. He suggests as much in his portayal of himself sketching on the trail wearing the fringed buckskin garb of the trapper (plate 26). Miller's practice of replicating successful paintings like *The Trapper's Bride,* as well as his shrewd business

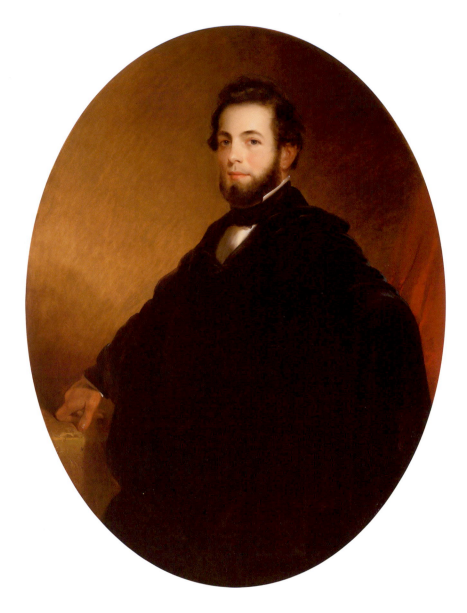

PLATE 24 Self Portrait, n.d.

Oil on board, 11 x 9 inches

Gilcrease Museum, Tulsa, Oklahoma

PLATE 25 Portrait of Decatur Howard Miller, ca. 1855

Oil on canvas (oval), 48 x 36½ inches

The Walters Art Museum, Baltimore, Maryland

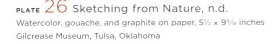

PLATE 26 Sketching from Nature, n.d.
Watercolor, gouache, and graphite on paper, 5½ × 9 9/16 inches
Gilcrease Museum, Tulsa, Oklahoma

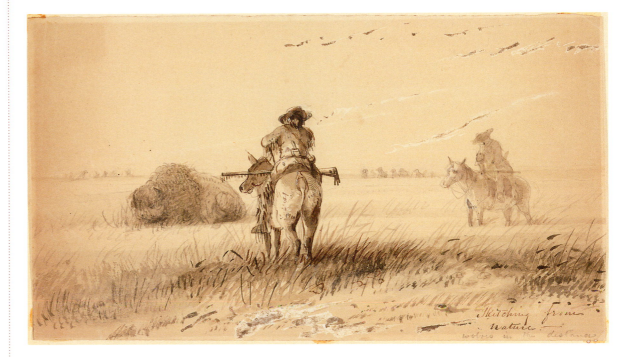

investments, helped him to succeed financially. Such sound business practices were, in the 1840s and 1850s, increasingly becoming expected of artists. Stories in popular periodicals abounded with parables of artists who learned to operate their studios as successful businesses and were glad of it, yet artists "continued to personify sensitivity and spirituality; peculiarities and extravagance remained part of their setting."[95] A comparison of Miller's late self-portrait (plate 24) and a roughly contemporary portrait of his brother Decatur Howard Miller (plate 25) suggests that Miller presented himself as an artist rather than as a member of the commercial world, despite his increasing financial success. In the self-portrait, likely done about 1855–60, Miller portrayed himself with the beard and long and tousled hair of a stereotypical artist. His jacket is open and his cravat is loosely tied.[96] Decatur, ten years Miller's junior, was on his way to becoming one of Baltimore's most successful tobacco commissions merchants. In 1840, at the age of twenty, he had entered into the business of tobacco merchant Jacob Heald, one of his father's former tavern patrons, and married Eliza Hare, the daughter of a successful producer of chewing tobacco who was in partnership with Heald. He bought a house in the affluent Mt. Vernon Place near William T. Walters in 1860. He later served as a director of several insurance, utility, and transportation companies, including the B&O Railroad, and as president of the prestigious merchant alliance, the Board of Trade.[97] In his portrait, Miller pictured Decatur standing, from the waist up. The low vantage point makes him appear to loom above. His erect posture, and hand, firmly planted on what appears to be a stone block, lend his portrait an air of power that

Miller's self-portrait does not have. Yet Miller's portrait is not without authority. He too holds himself erect. His curiously ambivalent gaze, one eye looking directly outward at the viewer, the other off into a space beyond, suggests his unique ability to, as Bulwer-Lytton's quote says, mediate between the worlds of men and art.

Sentimentalism, Romanticism, and Bohemianism

Modern critics of sentimental literature have disparaged the genre as aesthetically weak: treacly, anti-intellectual, and lacking in insight. Critics have also, fairly, condemned sentimentalism for its political failings. Sentimentalism did not "fac[e] squarely the realities of American life without losing its high ideals"; instead, it "shroud[ed] the actualities of American life in the flattering mists of sentimental optimism."[98] As discussed in the previous chapter, Miller's sentimentalism in *The Trapper's Bride* glossed over conflict between Indians and whites quite effectively. Yet the sentimental work Miller did for Walters is some of his strongest, expressing more artistic and socially radical views than those of many of his peers.

To take stock of Miller's achievement in the Walters sketches, it is illuminating to compare *Camp Fire, Preparing the Evening Meal* with another roughly contemporary but wholly antithetical image of idleness and male companionship: Richard Caton Woodville's *Waiting for the Stage* (plate 27). The two artists had much in common. Woodville was born and raised in Baltimore and may have been a student of Miller's early in his youth.[99] They almost certainly knew each other. They shared two of the same patrons: William T. Walters and Dr. Thomas Edmondson (1805–1856), and they exhibited together at the Maryland Historical Society and the Metropolitan Mechanics Institute.[100] Unlike Miller, however, Woodville took scenes of Baltimore as his subject matter. The waiting room of the Baltimore–Washington stagecoach line, along with the city's characteristic oyster houses and shop fronts, were some of his settings. Even Woodville's trademark red spittoon conjured up Baltimore's notorious and ubiquitous use of chewing tobacco. Miller was surely acquainted with the kind of spaces Woodville painted. His daily walk from his home on West Fayette Street to his studio in Carroll Hall took him past print shops, lottery sellers, oyster houses, and a billiards parlor.[101] He took the Baltimore–Washington stage when he traveled to the District and must have sat in the very waiting room that inspired Woodville.[102] Miller's paintings, of course, were very different in spirit, if not subject. Woodville's dark, menacing spaces, cluttered with objects and peopled by transients and con men, composed the Baltimore from which Miller's images offered refuge.

Woodville's *Waiting for the Stage* shows two men at a table playing cards; the coins and purse before them tell us they wager on the game. A third man, wearing dark glasses and reading *The Spy*, stands behind the table. The scene would have been readily identifiable to contemporary viewers as a cardsharp (in the top hat) and his partner (standing) cheating the bearded man at cards. Although the

PLATE *27* Waiting for the Stage, 1851
Richard Caton Woodville (1825–1855)
Oil on canvas, 15 × 18½ inches
Corcoran Gallery of Art, Washington, D.C.
Museum Purchase, Gallery Fund, William A. Clark Fund,
and through the gifts of Mr. and Mrs. Lansdell K. Christie
and Orme Wilson

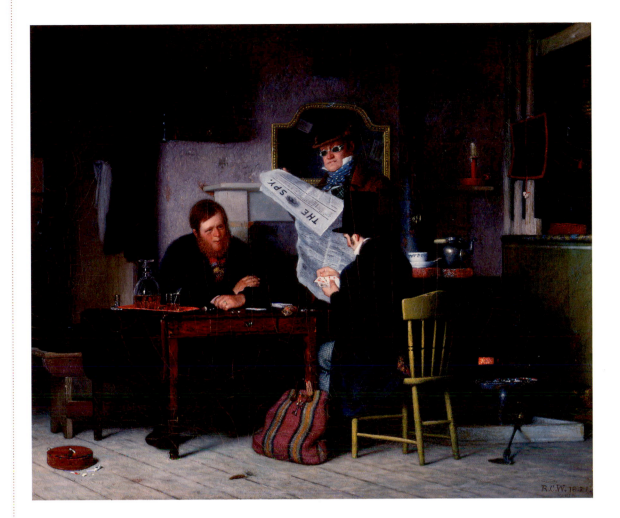

three of them keep each other company as they wait for the stagecoach to arrive, their relationship is hardly companionable. The bearded player opens his mouth as if to speak to the man seated across from him, but his hunched posture and folded arms convey a nascent wariness. We do not see the face of the cardsharp, but at some point we can presume he will look up over the shoulder of his accomplice into the mirror behind to receive his cue as to the cards his partner has spied from behind dark glasses. The overlapping figures of the cardsharp and his accomplice, together with the rhyming verticals of the stovepipe and fireplace mantel, help to divide the composition between the cheaters and the cheated. Significantly, for the purposes of comparison with Miller, it is the gray hollow of the empty hearth behind the card table that serves as a compositional divide between the players. Rather than taking a central place in the composition, the fire that warms the dark waiting room is concealed in the heavy iron frame of a modern box stove and consigned to the outer edges of the composition

with other markers of the domestic: the kettle, cup, and to the left, in a room beyond, the cot, wash-basin, and towel. Just as there is little camaraderie between the men in Woodville's painting, so there is no sentiment. The painting's narrative of deception is, of course, devoid of it. The physiology of the men, with their nondescript postures, thick, over-large hands, and heavily shod feet, lacks the delicacy that stood for refined emotion in Miller's paintings. If there is any refinement in their aspects, it is only the sham of their fancy dress.

The title of Woodville's painting makes clear that the men are passing time waiting for the stage-coach. In his essay on Woodville, Justin Wolff argues that the figures, already condemned as gamblers, are also guilty of idleness: "Rather than read the paper or engage in productive conversation, the men in the waiting room idle away the hours playing cards and deceiving one another. All their efforts are geared toward corrupt gain; they work only at pretending to be someone else."[103] In this sense, too, Woodville's painting is the antithesis of Miller's *Camp Fire, Preparing the Evening Meal.* In Woodville's painting, idleness is the proverbial devil's handmaiden, giving men the time and inclination to run amok, rather than providing the setting for creativity and imagination. It is, moreover, their desire to gain financial advantage with little work that leads them to con in the first place.

If Woodville's image is more cynical about the value of free time, it appears to be more cynical about making art as well. Wolff notes that an important subtext of *Waiting for the Stage* is surveillance and its limits. At first glance, the objects that clutter the space—the red spittoon on the floor littered with cigarette butts, the glass decanter half filled with liquid, the chalkboard with its dangling chalk, all rendered in trompe l'oeil clarity—encourage us to place confidence in the continuum of painting and seeing.[104] But, as Wolff points out, the complex composition of the painting undermines that confidence. Oblique angles make it difficult to see important elements, such as the face of the card-sharp. A back room is partially blocked by a door, and darkness obscures details in the background.[105] Woodville himself acts the part of the con man, drawing the viewer in with a false sense of security in what they see, then undermining that security compositionally and narratively.[106]

Most important, for point of comparison, is the cynicism implicit in Woodville's explicit realism. Woodville was trained in Germany to work in the detailed, highly finished style of the Düsseldorf Academy; other artists who studied there, such as Emanuel Leutze (1816–1868) and Eastman Johnson (1824–1906), shared Woodville's hard-edged, precise style of rendering objects. But Woodville's choice to study and work in such a style, and to fill his painting with objects that showcase it, could also be construed in relation to Miller as a lack of faith in the powers of imaginative art-making and in the value of painting apart from its mimetic capabilities. Although Woodville composed his images in novel ways, the overall success of the con he puts over on the viewer is dependent on his conscientious copying of the outward appearance of the color, volume, and texture of material things. Paint, in such images, is not there to be enjoyed for its stimulation of the imagination, but for its ability to delight viewers by disappearing into the deceptive surfaces of objects. Moreover, the arduous labor of

PLATE 28 Black Lion Wharf, 1859

James McNeill Whistler (1834–1903)
Etching, 5¼ × 8¾ inches
The Snite Musem of Art, University of Notre Dame,
South Bend, Indiana
Acquired with funds provided by the Humana Endowment
for American Art

the artist in rendering so many objects in so much detail stands in opposition to the idleness of the cardplayers and to the contemplative reverie that brings about Miller's image. *Camp Fire, Preparing the Evening Meal,* with forms rendered in a single brushstroke, gives the impression of hastiness rather than labor. It is the thoughts prompted by "something shadowy and vague in the very highest productions of the imagination" that matter in the work, not visual realism.[107]

Woodville was the more innovative painter in terms of his engagement with contemporary social ills and his compositional tricks, but on the topic of art-making, Miller's work seems the more daring. His insistence that art was the product of imagination and reverie was at odds with a culture that was increasingly regimented by a modern work ethic, just as his painterly watercolors were at odds with the tightly rendered, detailed style of the next generation of Düsseldorf-trained artists. To be fair, of course, *Waiting for the Stage* is in oil and *Camp Fire* in watercolor. But Miller's oils never contain the level of detail or the specificity in rendering space that Woodville's do. Perhaps more important, Miller chose to work in watercolor, a medium that lends itself to shadowy and vague forms and readily allows the viewer to have an intimate view of the artist's creative process.

On this basis, Miller's *Camp Fire, Preparing the Evening Meal* could be described as a romantic image. Its painterly brushwork is characteristic of the romantic movement, as is its exotic subject matter. Miller's rejection of the modern work ethic in favor of idleness and creativity also represents a key feature of the romantic outlook. Viewed in such a framework, *Camp Fire,* painted thirty years after the heyday of romanticism, is stylistically outdated. But the opposite may also be true; Miller's outlook could be described as bohemian, and *Camp Fire,* in certain respects, as avant-garde. One intellectual historian has argued that romanticism evolved into bohemianism in Paris in the 1830s. According to the theory, romantic artists' embrace of irrationality and spirituality in their artwork, as well as their unconventional lifestyles, made it easy for representatives of bourgeois society to ridicule and marginalize them. Romantic values did not die with the movement, however, but evolved into a more practical form of social critique, namely bohemianism. Like romantics, bohemians rejected the values of bourgeois society, but they positioned themselves differently in relation to the mainstream. Instead of being outsiders, bohemians engaged with modern society, particularly in the marketplace, at the same time that they were critical of it. As such, they functioned as spokesmen for those things that ran counter to modern society: creativity, imagination, individualism.[108]

On this point, it is profitable to compare Miller's *Camp Fire, Preparing the Evening Meal* to James McNeill Whistler's early etching *Black Lion Wharf* (plate 28). Whistler, quintessentially bohemian in his outlook, chose as his subject matter the squalid, dangerous wharfs that were alien to middle- and upper-class London society. In the etching, a slouching, bearded figure leans against a rail, his back to a harbor filled with small skiffs and lined by a row of dilapidated but beautifully rendered buildings. The figure, likely a stand-in for Whistler, looks at something outside the viewing frame. His casual posture suggests relaxation, even idleness. His head, however, is alert, his brow furrowed as if to

suggest that his mind is actively engaged in studying something on the wharf—perhaps another row of buildings like the one portrayed in the background. The figure's concentration in the foreground of the image, together with Whistler's careful study of the background, alludes to the creative process that brought about the image. Whistler's image also demonstrates how an artist of refined sensibilities, attuned to beauty, can find the picturesque, even in the squalor of a dilapidated wharf.[109] As one Whistler historian concludes, "Whistler's successful appropriation of the picturesque idiom gave him license to negotiate looking at the most dangerous part of London without giving offense to his own middle-class sensibilities and to those of his potential patrons."[110] Thus Whistler acted the part of the spokesman, introducing the bourgeois to beauty outside the range of conventional subject matter.

If we take the foreground figures in Miller's *Camp Fire* to be stand-ins for the artist, as Whistler's wharf dweller is in *Black Lion Wharf,* we see that Miller, too, records the creative reverie that brought his image into being. Miller also breaks with convention in his emphasis on the value of idleness and sentimental manhood. Whistler's invitation to his viewers to see the beauty in a squalid section of London they would never dare visit, and Miller's invitation to his viewers to appreciate the refined sensibilities of ruminative trappers with whom they would never socialize, sets each artist apart from the mores of their public. Miller was not alienated from the Baltimore elite in the way that a romantic artist might be. He did not behave outrageously, reject elite society, or paint the kind of dark, disturbing imagery that would offend them. Rather, like Whistler, Miller functioned as a spokesman whose promotion of idlers over busy men set him apart from his merchant patrons even as his images packaged cultural exoticism for their consumption. Miller's work never expressed the radical vision that Whistler would later achieve in his *Nocturnes.* However, Miller's polite eschewal of the conventional work ethic, as well as his interest in art-making as a subject, suggests that late in his career he was moving toward a modern sensibility rather than looking back to a romantic one.

Previous chapters interpreted Miller's work within the context of his local audience and patronage. The close quarters he shared with Stewart, coupled with his lifelong connections to the Baltimore merchant community, familiarized him with his patrons' interests. Moreover, his studio practice—a mixture of careful record keeping, quasi manufacturing of stock images, and face-to-face interactions with a tight-knit community of patrons—mirrored the mixture of traditional and modern business practices his merchant-patrons employed. Just as nationalist ideologies do not dictate Miller's art-making, neither do his patrons' interests. As his watercolors for Walters suggest, Miller's paintings could address concerns outside of, even antithetical to, those of his patrons. By identifying with aspects of the trappers' freedom from conventional working life, Miller articulated a vision of the trapper as sentimental, virile, *and* creative. By drawing on his own experience as western traveler, artist, and businessman, Miller circumvented the hackneyed image of the trapper codified by Deas and promoted as an icon of westward expansion by the American Art-Union. In so doing, he fashioned a unique portrayal of the trapper. That he did so within the apparently safe parameters of the open commission Walters offered speaks both to his creativity and his pragmatism.

Notes

1. See, for instance DeVoto, *Across the Wide Missouri*, ix; John Mack Faragher, et al., *Out of Many: A History of the American People*, 3rd ed. (Upper Saddle River, N.J.: Prentice Hall, 2007), 390; and William H. Goetzmann, *Exploration and Empire: The Explorer and the Scientist in the Winning of the American West* (New York: W. W. Norton & Co., 1978), 208–10.

2. The remaining images depicted either landscapes or scenes of Stewart and his party. Approximately 100 images focus on the trapper out of a total of 916 western scenes, as compared to 437 total images of Indians. This count includes both distinct images and subsequent versions of the originals. If illustrations were available to me, I have counted landscapes in which trappers appear as subjects.

3. Miller, Account Book; Cowdrey, *National Academy of Design Exhibition Record, 1826–1860;* Rutledge, *Cumulative Record of Exhibition Catalogues.*

4. Henry R. Wagner and Charles L. Camp, *The Plains and the Rockies: A Critical Bibliography of Exploration, Adventure, and Travel in the American West, 1800–1865,* 4th ed. (San Francisco: J. Howell Books, 1982).

5. Elizabeth Johns, *American Genre Painting: The Politics of Everyday Life* (New Haven: Yale University Press, 1991), 60–99; Carol Clark, "Charles Deas," in *American Frontier Life: Early Western Paintings and Prints,* ed. Alan Axelrod (New York: Cross River Press, 1987), 51–78.

6. *Literary World,* 1 May 1852, 316, as quoted in Johns, *American Genre Painting,* 80.

7. Alan C. Trottman, "Lucien Fontenelle," in *The Mountain Men and the Fur Trade of the Far West,* ed. Leroy Hafen, 10 vols., (Glendale, Calif.: Arthur H. Clark Co., 1965–), 4: 81–99.

8. *A Rocky Mountain Trapper, Bill Burrows* (plate 4) is sketched on a sheet of paper that is relatively large in size, but appears worn and creased, as if damaged by travel. The simple media, pencil and a light wash, suggest a work done in the field, as does Burrows' informal pose and direct address of the viewer. The loose handling of the trees behind Burrows and the saddle at his feet are also indicative of Miller's early style.

9. James Austin Hanson and Kathryn J. Wilson, *The Mountain Man's Sketch Book,* vol. 2, 1976 (Crawford, Neb: Fur Press, 1980), 10–11.

10. Tyler, *Artist on the Oregon Trail,* cat. nos. 54, 120A, 120B, 280, 283.

11. Johns, *American Genre Painting,* 222.

12. Ibid.

13. Cornelius M. Ismert, "James Bridger," in Hafen, *Mountain Men,* 7: 85–104. Tyler, *Artist on the Oregon Trail,* cat. no. 269. In his notes, Miller identifies the trapper in plate 6 as Joseph R. Walker, Miller in Ross, *West of Alfred Jacob Miller,* xxxiv.

14. Irving, *Adventures of Captain Bonneville,* 44. See also Ardis M. Walker, "Joseph R. Walker," in Hafen, *Mountain Men,* 5:361–80. Walker's middle name, Rutherford, was often transcribed incorrectly as Reddeford, a mistake Miller made in his portrait title.

15. Miller, Account Book. The catalogue raisonné indicates that the painting came from Mae Reed Porter's collection. Porter purchased many of her paintings from Miller's Baltimore descendants.

16. Henry Herbert, "Long Jakes, the Prairie Man," *New York Illustrated Magazine of Literature and the Arts,* 1 January 1846, 2.

17. "The Art Union Pictures," *Broadway Journal* 1, no. 1, 4 January 1845; I am here indebted to Elizabeth Johns and Carol Clark's discussion of the critical literature on Deas' painting.

18. Johns, *American Genre Painting,* 69–70.

19. *Portrait of Walker* bears the faint inscription "Fra Diavolo" on the tubular accoutrement around the sitter's neck (spyglass or whistle). Fra Diavolo was the nickname for Michele Pezza (1771–1806), a famous Italian brigand. Miller, a fan of the theater and opera, may have known the legend through a popular French opera *Fra Diavolo, ou L'hôtellerie de Terracine* (1830) by Daniel Auber (1782–1871). Fra Diavolo was known for the violence of the atrocities he committed against his enemies, and Walker had a contemporary reputation for violence against Indian peoples. Since Walker's reputed brutality seems at odds with the tenor of the portrait, it may be that the inscription was a later attempt by Miller either to romanticize his reputation or to sensationalize it in order to capture his audience's imagination. Goetzmann, *Exploration and Empire,* 151–53. Miller indirectly refers to Walker's violent history in his note to a watercolor of Walker, *Bourgeois Walker and His Squaw,* in the Walters collection. The note describes how a group of Indians tricked Walker into eating a stew made up of the bodies of his fallen men as revenge for past mistreatment. Miller in Ross, *West of Alfred Jacob Miller,* pl. 78.

20. William R. Johnston, *William and Henry Walters, The Reticent Collectors* (Baltimore: Johns Hopkins University Press in association with Walters Art Gallery, 1999), 22–23.

21. Patricia Hills makes this argument about American Art-Union patronage of western art during and after the Civil War, "American Art-Union," in Hemingway and Vaughan, *Art in Bourgeois Society,* 316.

22. Miller, Account Book.

23. Johnston, *Reticent Collectors,* 39. Before the Civil War, Walters principally collected American work. Following the war he sold off his American collection and began acquiring contemporary European works. Miller's *Buffalo Hunt* was among the works sold, but the album of watercolors remained in Walters'

collection. See Miller's Account Book and photocopy of *Property of a Collector, Resident of Baltimore [Now in Europe] Long Distinguished for His Taste and Liberality,* Henry H. Leeds and Company, New York, 12, 13 February 1864, Walters Art Museum Library. I thank Bill Johnston for calling my attention to the catalogue.

24. Apart from the two watercolor versions, the Ward and Hopkins *Trapper's Bride*s are the most similar compositionally and share almost exactly the same dimensions. Miller's account book always includes two entries. One records the date upon which the patron either commissioned the work or offered to purchase it. The second recorded the date and means of payment. The timing of the payment (weeks or as much as a year later) may indicate whether the work was already on hand in the studio or had yet to be painted. The difference in date between the signature on the painting and its sale offers evidence that Miller made works on speculation. If, for instance, the De Ford *Trapper's Bride* is the same as was painted in 1852, then it took Miller four years to sell it. This is perhaps why it was his last oil-on-canvas version of the work.

25. Alfred Jacob Miller's scrapbooks, Decatur H. and L. Vernon Miller Collection, Baltimore.

26. A. J. M. to Brantz Mayer, Baltimore, 10 October 1858, Maryland Historical Society. MS 581.3. Among Miller's papers is a list by title of 191 sketches that roughly correspond to the Walters images that may be his own record of the images he chose for inclusion.

27. "Domestic Art Gossip," *Cosmopolitan Art Journal* 3, 1858–59: 88, as quoted in Johnston, *The Reticent Collectors,* 21.

28. Johnston, *The Reticent Collectors,* 21, 13–14.

29. The original albums are in the Walters Art Museum. On the inside of the first page of each volume is the number of sketches included in each: forty-seven in volume one; fifty-three in volume two; and fifty each in volumes three and four.

30. Most of the images were roughly 12 × 9 inches, large enough for one to two people at most to view at time.

31. When it does appear in oil, it generally appears in the format of a larger landscape. *Trappers Around a Campfire in the Wind River Mountains,* based on the Burrows sketch, was made for Stewart. *Roasting the Hump Rib,* sold to commissions merchant Heinrich Oelrichs in 1850, was likely another version of the scene, also painted for Stewart.

32. Joan Troccoli has stated that this image is characteristic of work in the field, and I would certainly not rule out its being a field sketch. The style of rendering of the trappers, the brittle line, the small size, and the condition of the paper all suggest field work. Troccoli, *Watercolors of the American West,* 49.

33. Miller uses this technique to render smoke in several of his early images of the campfire. See, for instance, *Trappers Encampment on the Big Sandy River* (cat. no. 286), *Crossing the River by Moonlight—Making Camp* (cat. no. 72), and *Trappers* (plate 7, cat. no. 278).

34. Margaret Hindle Hazen and Robert M. Hazen, *Keepers of the Flame: The Role of Fire in American Culture, 1775–1925* (Princeton: Princeton University Press, 1992), 61–63. William C. Sharpe, "What's Out There: Frederic Remington's Art of Darkness," in Nancy K. Anderson, *Frederic Remington: The Color of Night* (Princeton: Princeton University Press, 2003), 21.

35. Hazen and Hazen, *Keepers of the Flame,* 231; Vincent Bertolini, "Fireside Chastity: The Erotics of Sentimental Bachelorhood in the 1850s" in Chapman and Hendler, *Sentimental Men,* 19; Kirsten Silva Gruesz, "Feeling for the Fireside: Longfellow, Lynch, and the Topography of Poetic Power," in Chapman and Hendler, 51–53; Leonard M. Trawick, "Whittier's *Snowbound:* A Poem About the Imagination," *Essays in Literature* 1 (Spring 1974): 46–53; James H. Justus, "The Fireside Poets: Hearthside Values and the Language of Care," in A. Robert Lee, ed., *Nineteenth-Century American Poetry* (New York: Barnes and Noble, 1985), 146–65; Kate Roberts, "Fireside Tales to Fireside Chats: The Domestic Hearth," in Jessica H. Foy and Karal Ann Marling, eds., *The Arts and the American Home, 1890–1930* (Knoxville: University of Tennessee Press, 1994).

36. James D. Hart, *The Popular Book: A History of America's Literary Taste* (New York: Oxford University Press, 1950), 98.

37. Ik Marvel [Donald Grant Mitchell], *Reveries of a Bachelor* (Boston, 1850, Rpt. Philadelphia: Henry Altemus, 1896), 49.

38. Hart, *Popular Book,* 98; David W. Pancost, "Donald Grant Mitchell's *Reveries of a Bachelor* and Herman Melville's 'I and My Chimney,'" *American Transcendental Quarterly* 42, Spring 1979, 129–36.

39. Bushman, 293–98.

40. See Hazen and Hazen's discussion of the image in *Keepers of the Flame,* 216ff.

41. Miller in Ross, *The West of Alfred Jacob Miller,* pl. 29.

42. "Moses Harris," in Hafen, *Mountain Men,* 4:103–17.

43. Miller in Ross, *The West of Alfred Jacob Miller,* pl. 29.

44. Ibid., pl. 156.

45. Of another image, Miller wrote, "On his breast [he wears] a pipe holder, usually a *gage d'amour* in the shape of a heart, worked in porcupine quills by some dusky charmer." Ross, *The West of Alfred Jacob Miller,* pl. 1.

46. "The Art Union Pictures," *Broadway Journal* 1, no. 1 (January 1845): 4.

47. Hazen and Hazen, *Keepers of the Flame,* 217.

48. John E. Crowley, *The Invention of Comfort: Sensibilities & Design in Early Modern Britain & Early America* (Baltimore: Johns Hopkins University Press, 2001), 171–74; Cynthia G. Falk, "Symbols of Assimilation or Status? The Meanings of Eighteenth-Century Houses in Coventry Township, Chester County, Pennsylvania," *Winterthur Portfolio* 33, 2/3. I thank Joe Torre for bringing these sources to my attention.

49. Tammis Kane Groft, *Cast with Style: Nineteenth Century Cast-Iron Stoves from the Albany Area* (Albany: Albany Institute of History and Art, 1984), 18–19; Katherine Anne-Marie Roberts, "Hearth and Soul: The Fireplace in American Culture," Ph.D. diss., University of Minnesota, 1990, 18–23, 25–27; Gruesz, "Feeling for the Fireside," 51; Hazen and Hazen, *Keepers of the Flame,* 59, 215–35.

50. David P. Erlick, "The Peales and Gas Lights in Baltimore," *Maryland Historical Magazine,* 80, no. 1 (Spring 1985): 9–18; Scharf, *History of Baltimore City and County,* 1: 500–501; Passano Files, Maryland Historical Society.

51. Edgar Allan Poe, "Philosophy of Furniture," *Burton's Gentleman's Magazine,* May 1840, as reprinted in *The Works of Edgar Allan Poe,* ed. Hervy Allen (New York: Walter J. Black, 1927), 920. Part of this quote appears in Andreas Blühm and Louise Lippincott, *Light! The Industrial Age 1750–1900: Art & Science & Technology & Society* (New York: Thames & Hudson, 2001), 35.

52. Blühm and Lippincott, *Industrial Age,* 136; Roberts, "Hearth and Soul," 27, 31.

53. Andrew Jackson Downing, *The Architecture of Country Houses,* 397, as quoted in Roberts, "Hearth and Soul," 31.

54. Hazen and Hazen note that an open hearth was associated with upper-class homes since lower- and some middle-class families could not afford them, *Keepers of the Flame,* 223; Groft writes, "It should be noted that the wealthy rarely installed stoves in the parlors, but used fire places instead," *Cast with Style,* 19; Blühm and Lippincott argue that natural light (versus Argand or gaslight) "acquired a moral identity—pure, healthy, truthful, as well as a physical one," *Industrial Age,* 19.

55. Gaslight first began to appear in American studios in the 1840s. On Carroll Hall, 201–203 East Baltimore Street, see Passano Files, Maryland Historical Society; Laura Rice, *Maryland History in Prints, 1743–1900* (Baltimore: Maryland Historical Society, 2002), pl. 169.

56. Sharpe, "What's Out There," 23; Blühm and Lippincott, *Industrial Age,* 25.

57. Blühm and Lippincott, *Industrial Age,* 25.

58. A. J. M. to D. H. M., Mount Hotel, Grosvenor Square, London, 22 November 1841, Porter Papers.

59. Hazen and Hazen, *Keepers of the Flame,* 223. Roberts refers to the domesticity of the hearth as the "cult of the fireplace," "Hearth and Soul," 18–47, esp. 23.

60. Hazen and Hazen, *Keepers of the Flame,* 59; Roberts, "Hearth and Soul," 20–23.

61. Miller in Ross, *The West of Alfred Jacob Miller,* pls. 4, 21, 34, 36, 52, 115, 129, 142, 163, 177, and 197 mentions fire in association with cooking. Only plates 94 and 156 mention fire without

reference to food preparation. In addition, plates 12, 22, 24, 50, 60, 77, 94, 161, 169, and 174 also show fire used for cooking, while plates 110, 126, 135, 139, 146, 152, 156, 159, 162, 177, and 196 show fire without.

62. It also provided yet another source of nostalgia for eastern viewers, who were seeing the kitchen hearth replaced by cookstoves at the same time the parlor hearth was being replaced by furnaces and box stoves. Ellen M. Plante, *The American Kitchen, 1700–The Present: From Hearth to Highrise* (New York: Facts on File, 1995), 47–70.

63. Priscilla J. Brewer, "We Have Got a Very Good Cooking Stove: Advertising, Design and Consumer Response to the Cookstove, 1815–1880," *Winterthur Portfolio* 25, no. 1 (1990): 35–54.

64. Miller in Ross, *The West of Alfred Jacob Miller,* pl. 168.

65. Ibid., pl. 191.

66. Halttunen, *Confidence Men and Painted Women,* esp. chapter 5.

67. Swagerty, "View from the Bottom Up," 23.

68. Kenneth Haltman, personal communication.

69. Miller, Journal, 23–24.

70. A. J. M. to D. H. M., Murthly Castle, 2 October 1841, Porter Papers. Interestingly, this passage immediately follows a mention of the progress of *The Trapper's Bride.* The event that occasioned Miller's mention of the donkey was her having given birth the night previous. He concludes his passage by saying that "now she has something to lavish her affections on, it is to be hoped that she will become more composed and resigned."

71. One of the sentimental authors that Miller most often quotes in his notes is Oliver Goldsmith, who Barbara M. Benedict argues attempted to refine and reform understandings of sensibility by pointing out its excesses in *The Vicar of Wakefield. Framing Feeling: Sentiment and Style in English Prose Fiction, 1745–1800* (New York: AMS Press, 1994).

72. William Cullen Bryant, "An Indian at the Burying Place of His Fathers" (1824) as quoted in Miller in Ross, *The West of Alfred Jacob Miller,* pl. 33.

73. Brian W. Dippie, *The Vanishing American: White Attitudes and U.S. Indian Policy* (Middletown, Conn.: Wesleyan University Press, 1982), 13.

74. See 18–19. Alfred J. Miller to Brantz Mayer, Esq., Saint Louis, 23 April 1837, Brantz Mayer Papers, reprinted in Warner, *Fort Laramie,* 146.

75. Miller, Journal, 122.

76. Miller as quoted in DeVoto, *Across the Wide Missouri,* 314.

77. Miller, Journal, 54–59.

78. Miller in Ross, *The West of Alfred Jacob Miller,* pl 139; Miller, Journal, 45.

79. William Charvat, *The Profession of Authorship in America, 1800–1870: The Papers of William Charvat,* ed. Matthew J.

Bruccoli (Columbus: Ohio State University Press, 1968), 5–24, 49–67.

80. Sandra Tomc, "An Idle Industry: Nathaniel Parker Willis and the Workings of Literary Leisure," *American Quarterly* 49, no. 4 (1997): 780–805.

81. Neil Harris, *The Artist in American Society: The Formative Years, 1790–1860* (New York: George Braziller, 1966), 218–53; artists were increasingly expected to join the marketplace, but not to such an extent that they lost their "otherworldly" spiritual qualities.

82. On Miller's time at Murthly, see for instance, A. J. M. to Brantz Mayer, Murthly Castle, 18 October 1840; Mayer was himself a prime example of the literary idler that Tomc and Charvat discuss. Jerry E. Patterson, "Brantz Mayer, Man of Letters," *Maryland Historical Magazine* 52, no. 4 (December 1957), 275–89; Mayer was also very close friends with Nathaniel Parker Willis, who gave him professional advice, "Francis Blackwell Mayer," 228. Miller was also acquainted with Willis, with whom he traveled briefly in Italy. In his journal, Miller makes a point of defending Willis' reputation. Miller, Journal, 14–21. On Crawford, see John Crawford to W. D. S., New Orleans, 11 October 1838, Sublette Papers, Missouri Historical Society.

83. Mayer, "Commerce, Literature and Art," 15–16, 23.

84. E. Anthony Rotundo, *American Manhood: Transformations in Masculinity from the Revolution to the Modern Era* (New York: Basic Books, 1993), 170.

85. David Leverenz, *Manhood and the American Renaissance.* (Ithaca, N.Y.: Cornell University Press, 1989), 16–17.

86. Gruesz, "Feeling for the Fireside," 48.

87. Miller, Journal, 122. Miller refers to him as Edward Lytton Bulwer, but he surely means British politician, poet, and novelist Baron Edward Bulwer-Lytton (1803–1873).

88. Bertolini, "Fireside Chastity," 21.

89. Miller, Journal, inside front cover, Walters Art Museum.

90. Census records for 1840–70 place all four sisters (Harriet Amelia, 1811–1905, Mary Ann, 1813–1896, Katherine Stevens, 1814–1873, and Elizabeth Eleanor, 1815–1899) in his home. I have found no record of their marriages in records of Baltimore marriages 1840–60. I have not been able to identify with certainty George Washington Miller (b. 18 November 1816), whom no one in the family seems to have had contact with, but obituaries for Columbus A. Miller (1818–1883) and Theodore Quincy Adams Miller (1825–1900) indicate that Columbus was a bachelor and Theodore married once. "Death of Mr. C. A. Miller," *Baltimore Sun,* 24 May 1883, and "Theodore Miller," *Baltimore Sun,* 1 August 1900.

91. Johns, *American Genre Painting,* 77–78. Clark, "Charles Deas," in Axelrod, *American Frontier Life,* 60–64. See also Zanger,

"Frontiersman in Popular Fiction," in McDermott, *Frontier Re-examined,* 141–53; Leverenz, *Manhood and the American Renaissance,* 217–26.

92. Herbert, "Long Jakes," 169.

93. David Leverenz, "Manhood, Humiliation and Public Life," *Southwest Review* 71 (Fall 1986), 451, as quoted in Michael S. Kimmel, *Manhood in America: A Cultural History* (New York: Free Press, 1995), 8.

94. Miller, Will, Maryland Historical Society.

95. Harris, *Artist in American Society,* 250.

96. Ibid., 218–53.

97. Decatur lived at 700 Cathedral Street. Biographical information on Decatur Howard Miller can be found in the Dielman Hayward Files, Maryland Historical Society; "Death of Mr. Decatur H. Miller," *Baltimore Sun,* 1 January 1891; D. H. Miller Scrapbook, Decatur H. and L. Vernon Miller Collection, Baltimore, Maryland.

98. Brown, *Sentimental Novel,* 360, 370, as quoted in Chapman and Hendler, *Sentimental Men,* 4.

99. Justin Wolff, *Richard Caton Woodville: American Painter, Artful Dodger* (Princeton: Princeton University Press, 2002), 38.

100. *Catalogue of Paintings, Engravings, &c. at the Picture Gallery of the Maryland Historical Society. First Annual Exhibition; Catalog of the First Annual Metropolitan Mechanics Institute Exhibition,* 1853.

101. For a list of the buildings on the 200 block of Baltimore Street, see Passano Files, Maryland Historical Society.

102. Among Miller's miscellaneous papers is a brief account of a trip he took on the stage. Decatur H. and L. Vernon Miller Collection, Baltimore. According to Wolff, Woodville's *Card Players* (1846) likely portrayed the waiting room of the Baltimore–Washington stagecoach line, *Richard Caton Woodville,* 68.

103. Wolff, 142.

104. Bryan J. Wolf, "History as Ideology, or, "What You Don't See Can't Hurt You, Mr. Bingham," in Burnham and Geise, *Redefining American History Painting,* 259–60.

105. Wolff, *Richard Caton Woodville,* 137–38.

106. Ibid., 141.

107. This discussion of antebellum art and labor relies on Emily Dana Shapiro's essay on the subject at the turn of the century, "J. D. Chalfant's Clock Maker: The Image of the Artisan in the Mechanized Age," *American Art* 19, no. 3 (Fall 2005), 53–54.

108. Mary Gluck, "Theorizing the Cultural Roots of the Bohemian Artist," *Modernism/modernity* 7, no. 3 (September 2000): 351–78.

109. This discussion of Whistler's wharf scenes relies on Kathleen Pyne, "Whistler and the Politics of the Urban Picturesque," *American Art* 8, nos. 3/4 (Summer/Autumn 1994), 61–77.

110. Pyne, 61.

If I could but show the picture that hangs on memory's wall of Mr. Miller in his quiet home, on a secluded grass-grown city street in Baltimore, with his violin near him, and his paintings on the easels, and his very handsome, bright face and charming manner, and hear him talk of his wild Indian life and its adventures, and then of his love for his native city and that now hackneyed subject "the beauty of its women," I would have shown a picture of old Baltimore as interesting as he ever painted.

—Emil Kett, 1874[1]

CONCLUSION "A PICTURE OF OLD BALTIMORE"

MILLER PAINTED *A Reconnoitre* (plate 1) in the spring of 1867 as part of a set of forty-one watercolor sketches with accompanying notes for Alexander Hargreaves Brown (1844–1922), an heir to the venerable Baltimore firm of Alexander Brown and Sons. At first glance the scene of an American Indian man riding out onto a precipice appears to be an example of a common type of western genre. "Last of the Race" images, such as John Mix Stanley's work *Last of Their Race* (1857, Buffalo Bill Historical Center), show American Indians who have literally been driven to the shores of the Pacific Ocean by Indian Removal and waves of white settlement.[2] In the context of Miller and his Baltimore patrons, however, the painting takes on more specific meaning, as a metaphor for the knowledge of the painter himself and the knowledge—specifically credit information—that his patron traded in. Perhaps because it comes so long after his initial journey west, this painting, and the commission of which it was a part, is almost never discussed in the literature on Miller. But in its theme of knowledge through experience, and in its careful blend of the interests of artist and patron, *A Reconnoitre* arguably marks the culmination of Miller's career as a painter of the West in Baltimore.

According to notes Miller wrote to accompany *A Reconnoitre*, "The scene represented in the sketch is a Crow Indian riding to the point of a bluff to examine the prairie, and he forms an extremely picturesque subject, full of wild grace and beauty. From these elevations their eyes sweep the horizon, and from long practice they discern an object much sooner than an inexperienced person could do; they observe in which direction game is to be had, the approach of an enemy, or of a caravan of 'pale faces,' and make their preparations accordingly."[3] In an earlier version of the image, Miller seemed less concerned with the idea of knowledge gained than with the picturesque image of horse and rider. *Reconnoitering* (plate 2), is a broadly brushed watercolor drawing from the Stewart album showing an Indian man on horseback looking out onto the landscape from a rocky promontory. The lack of

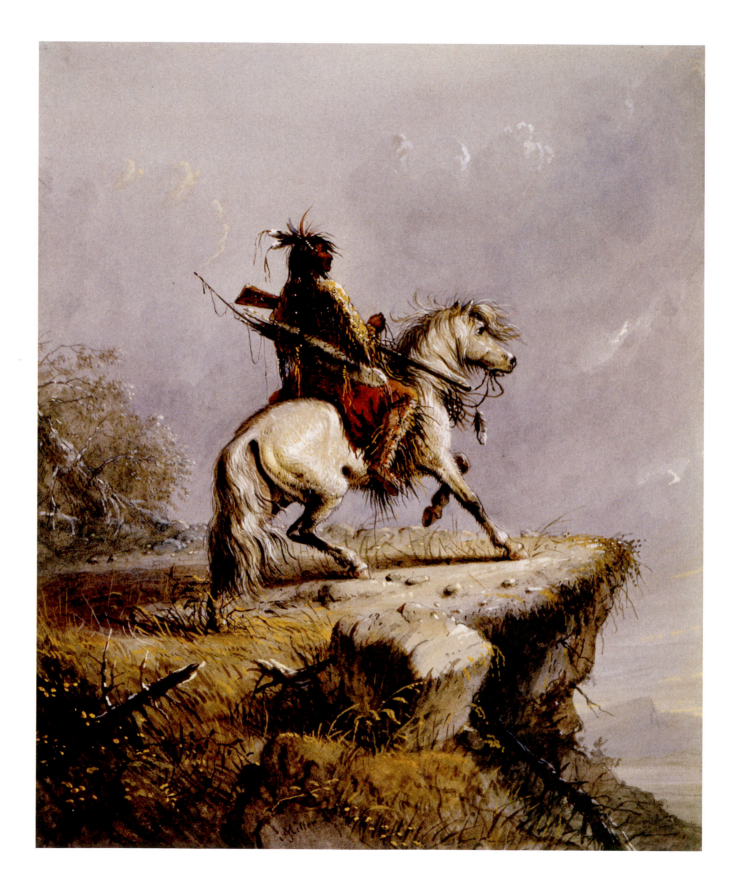

PLATE 1 A Reconnoitre [Reconnoiter], 1867

Watercolor, gouache, and pen and ink over pencil on paper,
11½ × 9³⁄₁₆ inches
Library and Archives Canada, Ottawa

PLATE 2 Reconnoitering, c. 1837

Watercolor with touches of white on paper, 6¼ × 5³⁄₁₆ inches
The James E. Sowell Collection, Texas Tech University, Lubbock

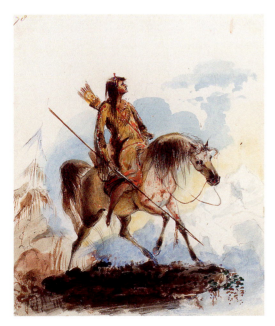

a clearly defined landscape in the distance, however, makes the exact location of horse and rider difficult to discern and shifts the emphasis from the act of reconnoitering to formal elements, such as the refined anatomy of the centrally placed horse and the visual rhyme of the rider's sharp, slender lance with the horse's delicate, curving reins. In the Brown version, Miller has reversed the orientation of horse and rider, turning them away from the picture plane toward a truncated landscape in the distance. Although the new orientation focuses the narrative more clearly on the rider's surveillance, the horse and rider in the Brown version (plate 1) lack the boldness of their counterparts in *Reconnoitering.* In the Brown version, the horse appears to be drawing back from the edge of the precipice with a worried look. In response, his rider leans back in his saddle rather than holding himself in an erect posture as he does in the Stewart image. Moreover, in the Brown version, the rider's large size relative to his horse humbles him while his bent, protruding bow and slack bow-string mitigate any threat such weapons might pose. Nevertheless, his relaxed posture gives him a solidity, like the stone that rests just below him amid sharply jutting dead trees and restive grass. Although the viewer sees little of the landscape before the rider, the rider himself is well positioned to appraise its full span. At the same time, he seems less precariously placed in the landscape than the rider in the Stewart sketch. There is ground visible beneath the ledge, so that horse and rider appear to stand over a gentler, less precipitous slope.

Knowledge about the West is an identifiable theme that runs throughout the set of forty-one watercolors of which *A Reconnoitre* is a part. In the case of the Brown commission, there is direct evidence that the images included were specifically selected from Miller's portfolios of sketches for Alexander Hargreaves Brown by William H. Graham (1823–1885), the manager of the Baltimore branch of Alexander Brown and Sons. Among Miller's papers is a copy of a contract for the commission. On two sheets of blue lined paper, Miller carefully recorded the scenes selected by title and by the number presumably inscribed in the corner of the studio sketch. To these sheets, he affixed a small card written in Graham's hand that read: "Mr. Miller will please make forty of his Indian water sketches as per selection for $1,000." "Ordered by Mr. William H. Graham, March 26, 1867."[4] Graham selected few of the kind of personal or sentimental images that predominated in the Stewart and Walters commissions. He did not, for instance, request a *Trapper's Bride* or an *Attack by Crows.* Rather, activities, such as hunting and warfare predominate. Stereotypes notwithstanding, the focus of the collection may best be characterized as quasi-ethnographic for its emphasis on Native American social practices, skills, and handicrafts, and for its attention to details of clothing and accoutrements.

Ma-wo-ma ("Little Chief"; plate 3) for instance, shows a bust-length figure of Ma-Wo-Ma in profile. His dress is rendered in a level of detail uncharacteristic for Miller. His hair bow ornament reveals fringe, red-and-white patterning, and even an indication of individual beads or porcupine quill stitches. The same may be said for intricate designs on his buckskin shirt and the five earrings he wears. In comparison, Miller's rendering of the same subject in the Walters watercolors lacks the

same level of detail. The feathers in the hair bow are not clearly differentiated from one another in color and texture, nor do we see the same attention to the patterning of his hunting shirt. In keeping with the shift in emphasis in the rendering, Miller appends to Ma-Wo-Ma's portrait a *Facsimile of a Drawing Made by Ma-wo-ma* (plate 4). The inclusion of a copy of Ma-Wo-Ma's drawing gives the collection the aura of scientific illustration and harkens back to the work of Karl Bodmer, whose illustrations for Prince Maximilian of Wied's academic treatise on the American Indians included a facsimile of a painting by Mandan leader Mato Tope.

The quasi-ethnographic flavor of some of the Brown sketches is uncharacteristic for Miller, but their promise of knowledge held and imparted is compatible in spirit with the business model of Alexander Brown and Sons. Founded in Baltimore in 1800, it originally operated as a mercantile firm dealing in southern tobacco and cotton, but shortly thereafter began providing commercial services to merchants. By the late 1830s, the firm had risen to prominence as America's largest foreign-exchange dealer and international banking and credit firm with offices in Baltimore, New York, Philadelphia, and Liverpool. Although bank loans and currency exchange were its chief business operations, after the 1850s, the company's focus was increasingly directed toward the sale of credit information. Alexander Brown and Sons rated American companies and backed their loans to British merchants and creditors.[5] In a letter to Miller expressing his pleasure with the sketches, which were "all that I could wish," Brown noted that they "will be extremely valuable to me, especially in this country, as there are nothing like them here."[6] Their uniqueness aside, Miller's sketches could also have had value as evidence of Brown's ties to and familiarity with America. American Indians were long associated in American and British culture with authentic or indigenous Americanness, so paintings of American Indians displayed either in the company offices, or in the home of one of its directors, could thus attest to the company's American origins and to its knowledge of America as a whole.[7]

Although the Brown sketches were sent to Brown in Liverpool, the commission may have represented an important gesture in the Baltimore business community. The company served both British suppliers and Baltimore merchants who required letters of credit in order to obtain goods for sale to inland domestic markets. Until 1867, when Graham became a partner in the firm, he worked on commission receiving a percentage of every letter of credit he sold. The particularities of banking in Baltimore often demanded credit and loan practices that were against policy set by New York, forcing Graham to lobby frequently on behalf of his Baltimore clients. Thus his success as a broker has been attributed to his diplomacy in dealing with the New York and Baltimore ends of the business.[8]

Many of the images that Graham selected were also included in the Walters collection, and there was overlap with other Baltimore merchant collections as well. Miller's *A Reconnoitre,* for instance, was particularly popular with patrons. His account book lists five other versions of this scene sold to Baltimore collectors, including Dr. Thomas Edmondson and provisions dealer Samuel Early.[9] Graham had extensive business dealings with many of Baltimore's mercantile elite. He served on

boards of financial institutions and charities throughout the city with several of Miller's patrons.[10] It was thus likely he was already familiar with many of the images in Miller's portfolio, having seen them in local exhibitions or in the homes of colleagues. Choosing images present in other Baltimore merchant collections may have been another way for Graham to declare Alexander Brown and Sons' allegiance to the Baltimore mercantile elite.

In fact, there is evidence to suggest that purchasing any western painting by Miller was already a statement of allegiance to the merchant elite. As discussed earlier in relation to *The Trapper's Bride,* the 1850s saw an increasingly successful manufacturing class begin to challenge the economic and political hegemony of Baltimore's merchants. Historians have argued that in an attempt to contain the power of the manufacturers, and to assert their unique, exclusive status, merchants created a regulatory institution called the Board of Trade, which expressly excluded manufacturers from its membership. Among other powers, the Board of Trade assumed the right to adjudicate contract disputes between themselves and manufacturers. Three of Miller's most active western patrons, Patrick Henry Sullivan, Alexander Reiman (1814–1888), and Johns Hopkins, were officers of the Board and many more were likely members.[11] Significantly, hanging in the meeting room of the Board of Trade was Miller's monumental painting *Bombardment of Fort McHenry, September 13–14, 1814* (see introduction, plate 8). As noted earlier, the work depicts the battle of Fort McHenry, a signal battle in the war of 1812 and one that held great significance for the city of Baltimore's merchant elite.[12] In the years leading up to the battle, the British had left Baltimore harbor unguarded, enabling Baltimore merchants to gain a monopoly on America's international trade by capturing British vessels and commandeering their valuable cargoes. In 1814 the British retaliated by attacking the city, but an all-volunteer militia made up of Baltimoreans along with a fleet of merchant ships succeeded in staving them off. The War of 1812 made the first generation of Baltimore merchants rich and influential, but it was the battle of Fort McHenry that made them patriots. The sight of the flag still flying over the fort was the inspiration for Francis Scott Key's *Star Spangled Banner* (1814), and even today, histories of Baltimore refer to the date of the battle as Baltimore's Fourth of July. Miller painted the work with the guidance of his father, a veteran of the battle. Thus the painting had powerful symbolism not only as a record of the merchant elite's patriotic origins, but for Miller himself, linking the artist decisively to the city and class that supported and enriched him.

The Brown commission was the last of Miller's major commissions. He had given up his studio three years earlier, and in 1872, at the age of sixty-two, he would formally retire.[13] It is fitting, then, that the mature artist expressed the theme of knowledge gained through experience in *A Reconnoitre*'s facture as well as its narrative. The painted surface contains copiously brushed foliage details set off by relatively unworked areas of the stone, the horse's flank, and the sky and landscape below. Critics have disparaged Miller's late watercolors as busy, for their high level of finish and layers of opaque paint, perhaps because their seeming laboriousness highlights their temporal and conceptual distance from

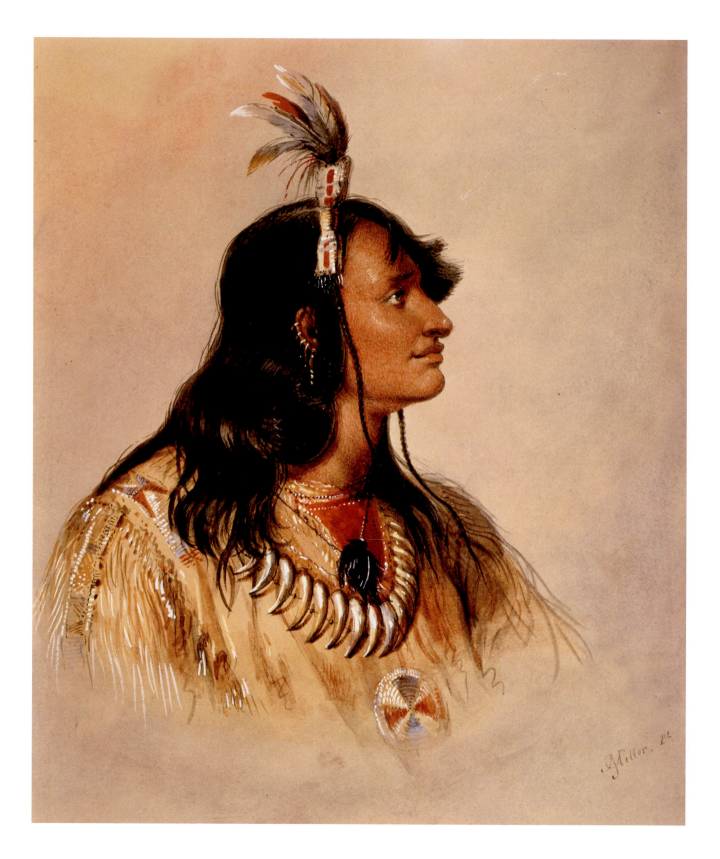

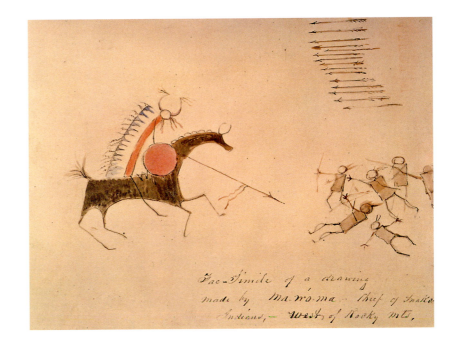

the loosely brushed trail sketches. In *A Reconnoitre,* however, the brushstrokes play an important, expressive role, establishing a juxtaposition between active areas of the composition that seem to recoil from the cliffside, such as the horse's mane and the grass, and areas of relatively undifferentiated pigment at the center of the image that hold the figure in place. Miller's brushwork, although copious, does not equivocate. Form and space in his composition are fully realized, and the draftsmanship evident in the foreground rock and cliffside is fine. Rather, it creates a detailed, richly textured surface that demonstrates the effects of his long practice at his craft.

At one level, *A Reconnoitre's* rider is a noble, romantic stand-in for the clerks and managers of the House of Brown, poised over the financial precipice of extended credit, with the knowledge to guide clients toward a vast horizon of profitable business alliances. But Miller's lone rider is also like the artist himself, a repository of information about the West. Viewed from the perspective of biography, rather than patronage, the relationship between text and image is less straightforward. The term *reconnoiter* means to survey or explore, but another, older meaning of the term was to remember, recollect, or recognize. Insofar as Miller's survey of the West occurred thirty years in the past, *A Reconnoitre* is his remembrance. In this context, Miller's copious brushwork is akin to verbal embellishments on a story told and retold from memory. But his subtle evocation of gray clouds, rendered in some areas in opaque pigment and placed immediately in the rider's sight line, casts some doubt on the reliability of the rider's reconnaissance, and perhaps on the artist's recollections as well. Miller's use in the text of the phrase "long practice" is also significant. Long practice, he says, improves the rider's observations.

Understood in relation to Miller's career, however, long practice (as well as faulty memory) is also reasonable justification for retirement. With this meaning in view, ominous imagery, such as the precipice and the wary horse, is a harbinger not of the end of the American Indian, per se, but of the end of Miller's career.

On the face of it, shifting Miller's paintings from the West to the more prosaic settings of Baltimore and Scotland would seem to strip them of much of their romance and interest. But it is only by seeing how their meanings were translated to a new context that we can appreciate the full measure of Miller's abilities as an artist. Miller created images with many layers of meaning out of seemingly simple western genre scenes, imbuing them with intangible qualities such as mood, sensibility, and reverie. He found a way to give visual form to the contradictory terms of sentimental masculinity and used that vision of masculinity to allegorize his creativity in terms that were at odds with prevailing ideas of work. In so doing, he produced images of the West that were more innovative and compelling than those of many of his peers working in the West or the East.

A friend and former student penned a tribute to Miller just a month after the artist's death. In it, the author imagined Miller in his home, surrounded by his paintings of the West, and described the mental image as a picture of "old Baltimore." Although his eulogy was written over one hundred years ago, there has perhaps been nothing since that sums up so aptly the varying facets of Miller's life and career. The author does not celebrate Miller solely for providing us with images of the American West. Rather, he presents Miller's western work as one of many tales told by the artist from his studio, firmly rooted in his native city. Knowing that Miller's paintings do not offer straightforward "windows on the West" should in no way diminish our interest in them. Miller's rare professional acumen, his skill in identifying, codifying, challenging, and representing his audience's interests, no less than his ability to create images of great subtlety and complexity, make him worthy of study independent of his western subject matter. Narrowing the scope of his art from the open spaces of the West to the crowded streets of mercantile Baltimore should in no way lessen either its importance or its appeal. For neglecting a picture of the artist at his easel in his quiet Baltimore home would indeed mean missing a picture as interesting as anything he ever painted.

Notes

1. Kett's text is included in Early, *Alfred J. Miller, Artist,* n.p., which is, in turn, primarily a reprint of an article in *Baltimore Bulletin,* July 1874.

2. See, for instance, William H. Truettner, "Ideology and Image: Justifying Westward Expansion," *The West as America,* 44.

3. Miller in Michael Bell, *Braves and Buffalo: Plains Indian Life in 1837* (Toronto: University of Toronto Press, 1973), 68.

4. The contract for the commission appears among the loose papers enclosed in one of Alfred Jacob Miller's scrapbooks, Decatur H. and L. Vernon Miller Collection, Baltimore. Although Alexander Brown requested forty, Miller appended a forty-first image, *Facsimile of a Drawing Made by Ma-wo-ma* (plate 4).

5. Edwin J. Perkins, "William Graham: Branch Manager and Foreign-Exchange Dealer in Baltimore in the 1850s," *Maryland Historical Magazine* 87, no. 1 (Spring 1992): 10–11.

6. Alexander Hargreaves Brown to A.J.M., Richmond Hill, Liverpool, England, 1 October 1867, Decatur H. and L. Vernon Miller Collection, Baltimore.

7. Deloria, *Playing Indian,* 10–37.

8. Perkins, "William Graham," 11, 16, 21.

9. Tyler, *Artist on the Oregon Trail,* cat. nos. 395C, 395D. Thomas Edmondson (1798–1858) was the son of a prosperous merchant who studied medicine at the University of Maryland but never practiced. He collected paintings by American artists only, including Thomas Doughty, Thomas Newell, and Richard Caton Woodville. Baltimore Museum of Art, *A Century of Baltimore Collecting, 1840–1940* (Baltimore Museum of Art, 1941), 13.

10. *Matchett's Baltimore Directory,* 1847, 1848.

11. Brugger, *Maryland: A Middle Temperament,* 180; Scharf, *History of Baltimore City and County,* 1:437–40.

12. *Baltimore Bulletin,* 1874, J. Hall Pleasant's paintings files, Maryland Historical Society, Baltimore.

13. One of the reasons Miller gave for his retirement was severe rheumatoid arthritis, which he had struggled with at least since his return from the Rocky Mountains. Presumably he completed the Brown commission between bouts of the ailment. Kate Breckenridge to A.J.M., Baltimore, 30 January 1872, Decatur H. and L. Vernon Miller Collection, Baltimore.

BIBLIOGRAPHY

Manuscripts

Catlin, George. Papers. Bureau of Ethnology, Smithsonian Institution, Washington, D.C. (Archives of American Art, Roll 2136, Frames 513–15).

DeVoto, Bernard. Papers. Macgill James File. Stanford University Library, Palo Alto, Calif.

Diehlman-Heyward Biographical Files. Maryland Historical Society, Baltimore, Md.

Dreer Collection. Historical Society of Pennsylvania, Philadelphia (Archives of American Art, reel P20, frame 522).

Duveen, Albert. Collection. Archives of American Art, Washington, D.C.

Library Company of Baltimore, 1795–1855, MS 80, Special Collections, Maryland Historical Society, Baltimore, Md.

Mayer, Frank B. Papers. Library, Metropolitan Museum of Art, New York. (Copies in Johnston files, Walters Art Museum).

Mayer, Brantz. Papers. MS 581.3, Special Collections, Maryland Historical Society, Baltimore, Md.

Miller, Alfred Jacob. Account Book. Library, Walters Art Museum, Baltimore, Md.

———. Captions for Paintings. Library, Walters Art Museum, Baltimore, Md.

———. Estate Papers. Maryland Historical Society, Baltimore, Md.

———. Files. Gilcrease Institute of American History and Art, Tulsa, Okla.

———. Files. Buffalo Bill Historical Center, Cody, Wyo.

———. Journal. Walters Art Museum, Baltimore, Md.

———. "Rough Draughts for Notes to Indian Sketches." Manuscript. Library, Thomas Gilcrease Institute of History and Art, Tulsa, Okla.

———. Scrapbooks, Sketchbook, Letters. Decatur H. and L. Vernon Miller Collection, Baltimore, Md.

———. Vertical File. Library, National Museum of American Art, Smithsonian Institution, Washington, D.C.

Murthly Muniments. G.D. 121. Scottish Record Office, H.M. General Register House, Edinburgh.

Passano Files. Maryland Historical Society, Baltimore, Md.

Pleasants File. Curatorial Division, Museum of the Maryland Historical Society, Baltimore, Md.

Porter, Mae Reed and Clyde H. Papers. American Heritage Center, University of Wyoming, Laramie.

Records of the Oelrichs and Lurman Company, Gustavus W. Lurman Papers and Genealogy, 1833–1945, MS 541, Special Collections, Maryland Historical Society, Baltimore, Md.

Ross, Marvin C., ed. "Artists' Letters to Alfred Jacob Miller." Typescript. Library, Walters Art Museum, Baltimore, Md.

Sublette, William. Papers. Missouri Historical Society, St. Louis, Mo.

Way, Arthur J. Scrapbook. J. Hall Pleasants Papers, Special Collections, MS 194, Box 13, Maryland Historical Society, Baltimore, Md.

Webb, J. Watson. Papers. Manuscripts and Archives, Yale University Library, New Haven, Conn.

Books, Articles, Theses, Dissertations

Aderman, Ralph M., ed. *Critical Essays on Washington Irving.* Boston: G. K. Hall & Co., 1990.

Albers, Patricia, and Beatrice Medicine, eds. *The Hidden Half: Studies of Plains Indian Women.* Lanham, Md.: University Press of America, 1983.

Alexander, David. *Affecting Moments: Prints of English Literature Made in the Age of Romantic Sensibility, 1775–1800.* York, U.K.: University of York, 1993.

Allen, Hervey, ed. *The Works of Edgar Allan Poe.* New York: Walter J. Black, 1927.

"American Art Union, Conclusion of Sale," *New York Daily Times,* 18 December 1852.

Anderson, Benedict. *Imagined Communities: Reflections on the Origin and Spread of Nationalism.* New York: Verso, 1999.

Anderson, Nancy K. *Frederic Remington: The Color of Night.* Princeton, N.J.: Princeton University Press, 2003.

Anderson, Rev. William James. "Sir William Drummond-Steuart [*sic*] and the Chapel of St. Anthony the Eremite, Murthly." *Innes Review* 15, no. 2 (1964): 151–70. Glasgow: Scottish Catholic Historical Association.

Arps, Walter E., Jr., ed. *Maryland Mortalities, 1876–1915 from the (Baltimore) Sun Almanac.* Westminster, Md.: Heritage Books, 2004.

"The Art Union Pictures." *Broadway Journal* 1, no. 1 (4 January 1845).

Axelrod, Alan, ed. *American Frontier Life: Early Western Paintings and Prints.* New York: Cross River Press, 1987.

Ayres, William, ed. *Picturing History: American Painting 1770–1930.* New York: Rizzoli International Publications, 1993.

Baker, Thomas N. *Sentiment & Celebrity: Nathaniel Parker Willis and the Trials of Literary Fame.* New York: Oxford University Press, 1999.

The Baltimore Directory, for 1845. Baltimore: John Murphy, 1845.

Baltimore Museum of Art. *A Century of Baltimore Collecting, 1840–1940.* Baltimore: Baltimore Museum of Art, 1941.

———. *Two Hundred and Fifty Years of Painting in Maryland.* Baltimore: Baltimore Museum of Art, 1945.

Barnes, Elizabeth. *States of Sympathy: Seduction and Democracy in the American Novel.* New York: Columbia University Press, 1997.

Bell, Michael. *Braves and Buffalo: Plains Indian Life in 1837.* Toronto: University of Toronto Press, 1973.

Benedict, Barbara M. *Framing Feeling: Sentiment and Style in English Prose Fiction, 1745–1800.* New York: AMS Press, 1994.

———. *The Vicar of Wakefield. Framing Feeling: Sentiment and Style in English Prose Fiction, 1745–1800.* New York: AMS Press, 1994.

Berger, Martin A. *Man Made: Thomas Eakins and the Construction of Gilded Age Manhood.* Berkeley: University of California Press, 2000.

Bieder, Robert E. *Science Encounters the Indian, 1820–1880.* Norman: University of Oklahoma Press, 1986.

Billig, Michael. *Banal Nationalism.* London: SAGE Publications, 1995.

The Biographical Cyclopedia of Representative Men of Maryland and District of Columbia. Baltimore: National Biographical Publishing Co., 1879.

Blühm, Andreas, and Louise Lippincott. *Light! The Industrial Age 1750–1900: Art & Science, Technology & Society.* New York: Thames & Hudson, 2001.

Blumin, Stuart M. *The Emergence of the Middle Class: Social Experience in the American City, 1760–1900.* Cambridge: Cambridge University Press, 1989.

Blunt, Rev. John Henry. *The Annotated Book of Common Prayer: Being an Historical, Ritual, and Theological Commentary on the Devotional System of the Church of England.* London: Rivingtons, 1866.

Bonner, Thomas D. *The Life and Adventures of James P. Beckwourth.* Lincoln: University of Nebraska Press, 1972.

Branch, E. Douglas. *The Sentimental Years, 1836–1860.* New York: D. Appleton-Century Company, 1934.

Brewer, Priscilla J. "'We Have Got a Very Good Cooking Stove': Advertising, Design and Consumer Response to the Cookstove, 1815–1880." *Winterthur Portfolio* 25, no. 1 (1990): 35–54. Winterthur, Del.: The Henry Francis du Pont Winterthur Museum.

Bridgewater, William, and Seymour Kurtz, eds. *The Columbia Encyclopedia,* 3rd ed. New York: Columbia University Press, 1963.

Brilliant, Richard. *Portraiture.* Cambridge, Mass.: Harvard University Press, 1991.

Brown, David L. "Three Years in the Rocky Mountains." *Cincinnati Daily Morning Atlas, 1840.* New York: Edward Eberstadt & Sons, 1950.

Brown, Herbert Ross. *The Sentimental Novel in America, 1789–1860.* Durham, N.C.: Duke University Press, 1940.

Brown, Jennifer S. H. *Strangers in Blood: Fur Trade Company Families in Indian Country.* Vancouver: University of British Columbia Press, 1980.

Brown, Jennifer S. H., W. J. Eccles, and Donald P. Heldman, eds. *The Fur Trade Revisited: Selected Papers of the Sixth North American Fur Trade Conference, Mackinac Island, Michigan. 1991.* East Lansing: Michigan State University Press, 1994.

Brown, John Crosby. *A Hundred Years of Merchant Banking: A History of Brown Brothers and Company, Brown, Shipley & Company and the Allied Firms.* New York: privately printed, 1909.

Browne, Gary Lawson. *Baltimore in the Nation, 1789–1861.* Chapel Hill: University of North Carolina Press, 1980.

Brugger, Robert J. *Maryland: A Middle Temperament, 1634–1980.* Baltimore: Johns Hopkins University Press, 1988.

———. *The Maryland Club: A History of Food and Friendship in Baltimore, 1857–1997.* Baltimore: Maryland Club, 1998.

Brunet, Pierre. *Descriptive Catalogue of a Collection of Water-Colour Drawings by Alfred Jacob Miller (1810–1874) in the Public Archives of Canada.* Ottawa: Edmond Cloutier, 1951.

Bryson, Gladys. *Man and Society: The Scottish Inquiry of the Eighteenth Century.* Princeton, N.J.: Princeton University Press, 1945.

Bryson, Norman, Michael Ann Holly, and Keith Moxey, eds. *Visual Culture: Images and Interpretations.* Hanover, N.H.: University Press of New England, 1994.

Burnham, Patricia M., and Lucretia Hoover Giese, eds. *Redefining American History Painting.* Cambridge: Cambridge University Press, 1995.

Bush, M. L. *The English Aristocracy: A Comparative Synthesis.* Manchester, U.K.: Manchester University Press, 1984.

Bushman, Richard L. *The Refinement of America: Persons, Houses, Cities.* New York: Alfred A. Knopf, 1992.

Buzard, James. "Translation and Tourism: Scott's *Waverley* and the Rendering of Culture." *Yale Journal of Criticism* 8, no. 2 (1995): 31–60.

Calloway, Colin G. *New Worlds for All: Indians, Europeans, and the Remaking of Early America.* Baltimore: Johns Hopkins University Press, 1997.

———. "Neither White Nor Red: White Renegades on the American Indian Frontier." *The Western Historical Quarterly* 17, no. 1 (January 1986): 43–66. Logan, Utah: Western History Association.

Camfield, Gregg. "The Moral Aesthetics of Sentimentality: A Missing Key to *Uncle Tom's Cabin.*" *Nineteenth-Century Literature* 43, no. 3 (December 1988). Los Angeles: University of California Press.

Campbell, Colin. *The Romantic Ethic and the Spirit of Modern Consumerism.* New York: Basil Blackwell, 1987.

Cannadine, David. *Aspects of Aristocracy: Grandeur and Decline in Modern Britain.* New Haven, Conn.: Yale University Press, 1994.

———. *The Decline and Fall of the British Aristocracy.* New Haven, Conn.: Yale University Press, 1990.

Carnes, Mark C., and Clyde Griffen, eds. *Meanings for Manhood: Constructions of Masculinity in Victorian America.* Chicago: University of Chicago Press, 1990.

Carter, Harvey Lewis, and Marcia Carpenter Spencer. "Stereotypes of the Mountain Man." *Western Historical Quarterly* 6, no. 1 (1975): 17–32. Logan, Utah: Western History Association.

The Catholic Encyclopedia: A General Work of Reference for Art, Biography, Education, History, Law, Literature, Philosophy, the Sciences, Religion, and the Church. New York: Gilmary Society, 1936.

Catalog of the First Annual Metropolitan Mechanics Institute Exhibition. Washington, D.C., 1953.

Catalogue of Paintings, Engravings, &c. at the Picture Gallery of the Maryland Historical Society. First Annual Exhibition, 1848. Baltimore: John D. Toy, 1848.

Catalogue of Paintings, Engravings, &c. &c. at the Picture Gallery of the Maryland Historical Society. Second Annual Exhibition, 1849. Baltimore: John D. Toy, 1849.

Catalogue of Paintings, Engravings, &c. &c. at the Picture Gallery of the Maryland Historical Society. Third Annual Exhibition, 1850. Baltimore: John D. Toy, 1850.

Catalogue of Paintings, Engravings, &c. &c. at the Picture Gallery of the Maryland Historical Society. Fourth Annual Exhibition, 1853. Baltimore: John D. Toy, 1853.

Catalogue of Paintings, Engravings, &c. &c. at the Picture Gallery of the Artists' Association, and of the Maryland Historical Society. Baltimore: John D. Toy, 1856.

Catalogue of Paintings, Engravings, &c. &c. at the Picture Gallery of the Maryland Historical Society. Sixth Annual Exhibition, 1858. Baltimore: John D. Toy, 1858.

Catalogue of Pictures and Other Works of Art: the Property of the American Art-Union: to Be Sold at Auction by David Austen, Jr., at the Gallery, 497 Broadway, on Wednesday, the 15th, Thursday 16th, and Friday 17th, December, 1852… New York: The American Art-Union, 1852.

Catalogue of the English Prose Fiction, Including Translation and Juvenile Fiction, in the Mercantile Library Association, of Baltimore, to October 1874. Baltimore: J. W. Woods, 1874.

Catlin, George. *Letters and Notes on the Manners, Customs, and Condition of the North American Indians.* 2 vols. London: George Catlin, 1844.

Chapman, Mary, and Glenn Hendler. *Sentimental Men: Masculinity and the Politics of Affect in American Culture.* Berkeley: University of California Press, 1999.

Charvat, William. *The Profession of Authorship in America, 1800–1870: The Papers of William Charvat.* Edited by Matthew J. Bruccoli. Columbus: Ohio State University Press, 1968.

Chittenden, Hiram Martin. *The American Fur Trade of the Far West.* 2 vols. New York: Francis P. Harper, 1902.

Clifford, James. *The Predicament of Culture: Twentieth-Century Ethnography, Literature, and Art.* Cambridge, Mass.: Harvard University Press, 1988.

Clifton, James A., ed. *Being and Becoming Indian: Biographical Studies of North American Frontiers.* Chicago: Dorsey Press, 1989.

Cohn, Marjorie B. *Wash and Gouache: A Study of the Development of the Materials of Watercolor.* Boston: The Center for Conservation and Technical Studies, Fogg Art Museum, 1977.

Colbert, Charles. *A Measure of Perfection: Phrenology and the Fine Arts in America.* Chapel Hill: University of North Carolina Press, 1997.

Colley, Linda. *Britons: Forging the Nation 1707–1837.* New Haven, Conn.: Yale University Press, 1992.

Conn, George H. *The Arabian Horse in America.* New York: A. S. Barnes and Company, 1957, 1972.

The Contents of Knockdow: Toward, Dunoon, Argyll: to Be Sold by Auction within Our Glasgow Sale-rooms on Tuesday 3 July, Wednesday 4 July and Thursday 5 July 1990. Glasgow, Phillips of Scotland, 1990.

Cooke, Gretchen M. "On the Trail of Alfred Jacob Miller." *Maryland Historical Magazine* 97, no. 3 (Fall 2002). Baltimore: Maryland Historical Society.

Cott, Nancy F. *Public Vows: A History of Marriage and the Nation.* Cambridge, Mass.: Harvard University Press, 2000.

Cottom, Robert I., Jr. and Mary Ellen Hayward. *Maryland in the Civil War: A House Divided.* Baltimore: Maryland Historical Society, 1994.

Cowdrey, Mary Bartlett. *American Academy of Fine Arts and American Art-Union, 1816–1852.* New York: New-York Historical Society, 1953.

———. *National Academy of Design Exhibition Record, 1826–1860.* 2 vols. New York: New-York Historical Society, 1943.

Crowley, John E. *The Invention of Comfort: Sensibilities & Design in Early Modern Britain & Early America.* Baltimore: Johns Hopkins University Press, 2001.

Custis, George Washington Parke. "Pocahontas, or the Settlers of Virginia." 1830, in *Representative American Plays from 1767 to the Present Day,* 7th ed. Edited by Arthur Hobson Quinn. New York: Appleton Century Crafts, 1953.

Cunningham, Alexander. *The History of Great Britain: From the Revolution in 1688, to the Accession of George the First.* London: Thomas Hollingbery, 1787.

Davis, Jana. "Sir Walter Scott's *The Heart of Midlothian* and Scottish Common-Sense Morality." *Mosaic* 21, no. 4 (Fall 1988): 55–63. Winnipeg: University of Manitoba.

Davidson, Cathy N., and Jessamyn Hatcher, eds. *No More Separate Spheres!* Durham, N.C.: Duke University Press, 2002.

Deloria, Philip J. *Playing Indian.* New Haven, Conn.: Yale University Press, 1998.

DeVoto, Bernard. *Across the Wide Missouri.* Boston: Houghton Mifflin, 1947.

Dippie, Brian W. *The Vanishing American: White Attitudes and U.S. Indian Policy.* Middletown, Conn.: Wesleyan University Press, 1982.

———. *Catlin and His Contemporaries: The Politics of Patronage.* Lincoln: University of Nebraska Press, 1990.

Dockstader, Frederick J. *Indian Art in America: The Arts and Crafts of the North American Indian.* New York: Promontory Press, 1974.

Duff, David, ed. *Victoria in the Highlands.* London: Frederick Muller, 1968.

Early, Maud G. *Alfred J. Miller, Artist.* Baltimore: privately published, 1894.

Edwards, Lee M. *Domestic Bliss: Family Life in American Painting, 1840–1910.* Yonkers, N.Y.: The Hudson River Museum, 1986.

Ellis, Markman. *The Politics of Sensibility: Race, Gender and Commerce in the Sentimental Novel.* Cambridge: Cambridge University Press, 1996.

Elsner, John, and Roger Cardinal, eds. *The Cultures of Collecting.* London: Reaktion Books, 1994.

Encyclopedia Britannica. Chicago: William Benton Publishers, 1973.

Ens, Gerhard J. *Homeland to Hinterland: The Changing Worlds of the Red River Métis in the Nineteenth Century.* Toronto: University of Toronto Press, 1996.

Erlick, David P. "The Peales and Gas Lights in Baltimore." *Maryland Historical Magazine* 80, no. 1 (Spring 1985): 9–18. Baltimore: Maryland Historical Society.

Ewers, John C. "Deadlier than the Male." *American Heritage* 16, no. 4 (June 1965): 10–13.

———. *Indian Life on the Upper Missouri.* Norman: University of Oklahoma Press, 1968.

———. "Mothers of the Mixed Bloods: The Marginal Women in the History of the Upper Missouri." In *Probing the American West: Papers from the Santa Fe Conference,* edited by K. Ross Toole, et al., 62–70. Santa Fe: Museum of New Mexico Press, 1962.

———. *Plains Indian Painting: A Description of an Aboriginal American Art.* Stanford, Calif.: Stanford University Press, 1939.

Falk, Cynthia G. "Symbols of Assimilation or Status? The Meanings of Eighteenth-Century Houses in Coventry Township, Chester County, Pennsylvania," *Winterthur Portfolio* 33, no. 2/3 (1998). Winterthur, Del.: The Henry Francis du Pont Winterthur Museum.

Fane, Diana, Ira Jacknis, and Lise M. Breen. *Objects of Myth and Memory: American Indian Art at the Brooklyn Museum.* Brooklyn: Brooklyn Museum, 1991.

Faragher, John Mack, et al. *Out of Many: A History of the American People.* Upper Saddle River, N.J.: Prentice Hall, 2007.

Faxon, Frederick W. *Literary Annuals and Gift Books: A Bibliography, 1823–1903.* Pinner, Middlesex, U.K.: Private Libraries Association, 1973.

Feest, Christian F. *Native Arts of North America.* New York: Oxford University Press, 1980.

Ferguson, Adam. *An Essay on the History of Civil Society 1767.* Edited by Duncan Forbes. Edinburgh: Edinburgh University Press, 1966.

Ferris, W. A. *Life in the Rocky Mountains: A Diary of Wanderings on the Sources of the Rivers Missouri, Columbia, and Colorado from February, 1830, to November, 1835.* Edited by Paul C. Phillips. Denver, Colo.: The Old West Publishing Company, 1940.

Field, Matthew C. *Prairie and Mountain Sketches.* Edited by Kate L. Gregg and John Francis McDermott. Norman: University of Oklahoma Press, 1957.

Fisher, Philip. *Hard Facts: Setting and Form in the American Novel.* New York: Oxford University Press, 1987.

Fiske, Jo-Anne, Susan Sleeper-Smith, and William Wicken, eds. *New Faces of the Fur Trade: Selected Papers of the Seventh North American Fur Trade Conference, Halifax, Nova Scotia, 1995.* East Lansing: Michigan State University Press, 1998.

Fleming, E. McClung. "The American Image as Indian Princess, 1765–1783." *Winterthur Portfolio* 2 (1965): 65–81. Winterthur, Del.: The Henry Francis du Pont Winterthur Museum.

Forbes, Duncan. "The Rationalism of Sir Walter Scott." *The Cambridge Journal* 7, no. 1 (October 1953): 20–35. Cambridge: Bowes & Bowes.

Foster, Sally M. *Picts, Gaels and Scots: Early Historic Scotland.* London: B. T. Batsford, 2004.

Foy, Jessica H., and Karal Ann Marling, eds. *The Arts and the American Home, 1890–1930.* Knoxville: University of Tennessee Press, 1994.

Fraser, William. *The Red Book of Grandtully.* 2 vols. Edinburgh: privately published, 1868.

Funk, Rebecca, and the First Unitarian Church of Baltimore. *A Heritage to Hold in Fee, 1817–1917.* Baltimore: Garamond Press, 1962.

Garrod, H. W., ed. *The Poetical Works of John Keats,* 2nd ed. Oxford: Clarendon Press, 1958.

Garside, Peter D. "Scott and the 'Philosophical' Historians." *Journal of the History of Ideas* 36, no. 3 (July–September 1975): 497–512. Ephrata, Penn.: Journal of the History of Ideas.

Gash, Norman. *Aristocracy and People, Britain 1815–1865.* Cambridge, Mass.: Harvard University Press, 1979.

Gaudio, Michael. *Engraving the Savage: The New World and the Techniques of Civilization.* Minneapolis: University of Minnesota Press, 2008.

Gerdts, William H. *The Art of Henry Inman.* Washington, D.C.: National Portrait Gallery, Smithsonian Institution, 1987.

Geyer, Charles A. *Notes on the Vegetation and General Character of the Missouri and Oregon Territories, Made During a Botanical Journey from the State of Missouri, Across the South-pass of the Rocky Mountains, to the Pacific, During the Years 1843 and 1844.* Privately published, 1846.

Giraud, Marcel. *The Métis in the Canadian West.* 2 vols. Translated by George Woodcock. Edmonton: University of Alberta Press, 1986.

Glanz, Dawn. *How the West Was Drawn: American Art and the Settling of the Frontier.* Ann Arbor: UMI Research Press, 1982.

Gluck, Mary. "Theorizing the Cultural Roots of the Bohemian Artist," *Modernism/modernity* 7, no. 3 (September 2000): 351–78.

Goetzmann, William H. *Exploration and Empire: The Explorer and the Scientist in the Winning of the American West.* New York: W. W. Norton & Co., 1978.

———. "The Mountain Man as Jacksonian Man." *American Quarterly* 15, no. 3 (Fall 1963): 402–15. Philadelphia: University of Pennsylvania.

Goetzmann, William H., and William N. Goetzmann. *The West of the Imagination.* New York: W. W. Norton & Co., 1986.

Gombrich, E. H. *Art and Illusion: A Study in the Psychology of Pictorial Representation.* Princeton, N.J.: Princeton University Press, 1969.

Goodbody, Bridget Luette. "George Catlin's Indian Gallery: Art, Science, and Power in the Nineteenth Century." Ph.D. diss., Columbia University, Ann Arbor: UMI, 1996.

Gowans, Fred R. *Rocky Mountain Rendezvous: A History of the Fur Trade Rendezvous, 1825–1840.* Provo, Utah: Brigham Young University Press, 1975.

Graham, Patrick. *Sketches of Perthshire.* Edinburgh: J. Ballantyne and Co. for P. Hill, 1812.

Gray, William H. "The Unpublished Journal of William H. Gray, from December, 1836, to October, 1837." *Whitman College Quarterly* 16, no. 2 (June 1913): 1–79.

Green, Rayna. "The Pocahontas Perplex: The Image of Indian Women in American Culture." *Massachusetts Review* 16, no. 4 (Autumn 1975): 698–714.

Greenblatt, Stephen. *Marvelous Possessions: the Wonder of the New World.* Chicago: University of Chicago Press, 1991.

Groft, Tammis Kane. *Cast with Style: Nineteenth Century Cast-Iron Stoves from the Albany Area.* Albany, N.Y.: Albany Institute of History and Art, 1984.

Grossberg, Michael. *Governing the Hearth: Law and the Family in Nineteenth-Century America.* Chapel Hill: The University of North Carolina Press, 1985.

Guttsman, W. L., ed. *The English Ruling Class.* London: Weidenfeld and Nicolson, 1969.

———. *The British Political Elite.* New York: Basic Books, 1963.

Hafen, Leroy R., ed. *The Mountain Men and the Fur Trade of the Far West.* 10 vols. Glendale, Calif.: Arthur H. Clark Company, 1965–.

Hagensick, A. Clarke. "Revolution or Reform in 1836: Maryland's Preface to the Dorr Rebellion." *Maryland Historical Magazine* 57, no. 4 (December 1962): 346ff. Baltimore: Maryland Historical Society.

Haltman, Kenneth. *Looking Close and Seeing Far: Samuel Seymour, Titian Ramsey Peale, and the Art of the Long Expedition, 1818–1823* (University Park, Penn.: Penn State University Press, 2008).

———. "Private Impression and Public Views: Titian Ramsay Peale's Sketchbooks from the Long Expedition, 1819–1820." *Yale University Art Gallery Bulletin* (Spring 1989): 39–54. New Haven, Conn.: Yale University Art Gallery.

Halttunen, Karen. *Confidence Men and Painted Women: A Study of Middle-Class Culture in America, 1830–1870.* New Haven, Conn.: Yale University Press, 1982.

Hamlin, William M. "Imagined Apotheosis: Drake, Harriot, and Raleigh in the Americas." *Journal of the History of Ideas* 57, no. 3 (July 1996): 405–28. Baltimore: Johns Hopkins University Press.

Hanham, H. J. *Scottish Nationalism.* Cambridge, Mass.: Harvard University Press, 1969.

Hanson, James Austin, and Kathryn J. Wilson. *The Mountain Man's Sketch Book.* Crawford, Neb.: Fur Press, 1980.

Haraway, Donna. "Teddy Bear Patriarchy: Taxidermy in the Garden of Eden, New York City, 1908–1936." *Social Text* (Winter 1984): 20–63. New York: Social Text.

Harriot, Thomas. *A Briefe and True Report of the New Found Land of Virginia, with Engravings by John White. Published by Theodor de Bry. Frankfurt-am-Main, 1590.* Facsimile with an introduction by Paul Hulton. New York: Dover Publications, 1972.

Harris, Neil. *The Artist in American Society: The Formative Years, 1790–1860.* New York: George Braziller, 1966.

Hart, James D. *The Popular Book: A History of America's Literary Taste.* New York: Oxford University Press, 1950.

Harvie, Christopher. *Scotland and Nationalism: Scottish Society and Politics 1707–1994.* New York: Routledge, 1994.

Hassrick, Peter H. *Frederic Remington: A Catalogue Raisonné of Paintings, Watercolors and Drawings.* Cody, Wyo.: Buffalo Bill Historical Center, 1996.

Hassrick, Peter H., and Patricia Trenton. *The Rocky Mountains: A Vision for Artists in the Nineteenth Century.* Norman: University of Oklahoma Press, 1983.

Hazen, Margaret Hindle, and Robert M. Hazen. *Keepers of the Flame: The Role of Fire in American Culture, 1775–1925.* Princeton, N.J.: Princeton University Press, 1992.

Hemingway, Andrew, and William Vaughan, eds. *Art in Bourgeois Society, 1790–1850.* Cambridge: Cambridge University Press, 1998.

Hendler, Glenn. *Public Sentiments: Structures of Feeling in Nineteenth-Century American Literature.* Chapel Hill: University of North Carolina Press, 2001.

Herbert, Henry. "Long Jakes, the Prairie Man." *New York Illustrated Magazine of Literature and the Arts* (1 January 1846).

Hill, Tom, and Richard W. Hill, Sr., eds., *Creation's Journey: Native American Identity and Belief.* Washington, D.C.: Smithsonian Institution Press, 1994.

Hobsbawm, Eric, and Terrence Ranger, eds. *The Invention of Tradition.* Cambridge: Cambridge University Press, 1983.

Hollander, Anne. *Sex and Suits.* New York: Alfred A. Knopf, 1994.

Horsman, Reginald. *Race and Manifest Destiny: The Origins of American Racial Anglo-Saxonism.* Cambridge, Mass.: Harvard University Press, 1981.

Howard, June. "What Is Sentimentality?" *American Literary History* 11, no. 1 (Spring 1999): 63–81. New York: Oxford University Press.

Hulme, Peter. *Colonial Encounters: Europe and the Native Caribbean, 1492–1797.* New York: Methuen & Co., 1986.

Hulton, Paul. *America, 1585: The Complete Drawings of John White.* Chapel Hill: University of North Carolina Press, 1984.

Hunt, David C., et al. *Karl Bodmer's America.* Lincoln: University of Nebraska Press, 1984.

Hunter, James. "Angus Macdonald: A Scottish Highlander Among Indian Peoples." *Montana: The Magazine of Western History* 47, no. 4 (Winter 1997): 2–17. Helena: Montana Historical Society.

Hutchinson, Elizabeth. "Modern Native American Art: Angel DeCora's Transcultural Aesthetics." *Art Bulletin* 83, no. 4 (December 2001): 740–56. New York: College Art Association.

———. "When the 'Sioux Chief's Party Calls': Käsebier's Indian Portraits and the Gendering of the Artist's Studio." *American Art* 16, no. 2 (Summer 2002). Washington, D.C.: Smithsonian American Art Museum.

Hutchison, I. G. C. *A Political History of Scotland, 1832–1924: Parties, Elections and Issues.* Edinburgh: John Donald Publishers, 1986.

Irving, Washington. *Astoria or Anecdotes of an Enterprise Beyond the Rocky Mountains.* Edited by William. H. Goetzmann. New York: J. B. Lippincott Company, 1961.

———. *The Adventures of Captain Bonneville U.S.A. in the Rocky Mountains and the Far West.* Edited by Edgeley W. Todd. Norman: University of Oklahoma Press, 1961.

———. *A Tour on the Prairies.* London: John Murray, 1835.

Janetta, Armando E. "'Travels Through Forbidden Geography': Métis Trappers and Traders Louis Goulet and Ted Trindell." *Ariel* 25, no. 2 (April 1994): 59–74. Calgary: University of Calgary.

Johns, Elizabeth. *American Genre Painting: The Politics of Everyday Life.* New Haven, Conn.: Yale University Press, 1991.

Johnson, Allen, ed. *Dictionary of American Biography.* New York: Charles Scribner's Sons, 1964.

Johnson, Pegram, III. "The *American Turf Register and Sporting Magazine:* 'A Quaint and Curious Volume of Forgotten Lore.'" *Maryland Historical Magazine* 89, no. 1 (Spring 1994): 5–9. Baltimore: Maryland Historical Society.

Johnston, William R. "Alfred Jacob Miller—Would-Be Illustrator." *The Walters Art Gallery Bulletin* 30, no. 3 (December 1977). Baltimore: Walters Art Gallery.

———. *William and Henry Walters, The Reticent Collectors.* Baltimore: Johns Hopkins University Press in association with Walters Art Gallery, 1999.

Jones, Eugene H. *Native Americans as Shown on the Stage, 1753–1916.* Metuchen, N.J.: Scarecrow Press, 1988.

Judd, Carol M., and Arthur J. Ray, eds. *Old Trails and New Directions: Papers of the Third North American Fur Trade Conference.* Toronto: University of Toronto Press, 1980.

Kaplan, Fred. *Sacred Tears: Sentimentality in Victorian Literature.* Princeton, N.J.: Princeton University Press, 1987.

Karp, Ivan, and Steven D. Lavine, eds. *Exhibiting Cultures: The Poetics and Politics of Museum Display.* Washington, D.C.: Smithsonian Institution Press, 1991.

Kasson, Joy S. *Marble Queens and Captives: Women in Nineteenth-Century American Sculpture.* New Haven, Conn.: Yale University Press, 1990.

Katz, Francis Ross. "The Imitative Vocation: Painters, Draughtsmen, Teachers and the Possibilities for Visual Expression in Early Nineteenth-Century Baltimore, 1800–1830." Ph.D. diss., Columbia University, 1986.

Katz, Wendy Jean. *Regionalism and Reform: Art and Class Formation in Antebellum Cincinnati.* Columbus: Ohio State University Press, 2002.

Kelsey, Robin. "Viewing the Archive: Timothy O'Sullivan's Photographs for the Wheeler Survey, 1871–1874." *Art Bulletin* 85, no. 4 (December 2003). New York: College Art Association.

Kendrick, T. D. *British Antiquity.* London: Methuen & Co. Ltd., 1950.

Kiernan, V. G. *The Duel in European History: Honour and the Reign of Aristocracy.* Oxford: Oxford University Press, 1986.

Kimmel, Michael S. *Manhood in America: A Cultural History.* New York: Free Press, 1995.

Kupperman, Karen Ordahl, ed. *America in European Consciousness, 1493–1750.* Chapel Hill: University of North Carolina Press, 1995.

Lamar, Howard R., ed. *The Reader's Encyclopedia of the American West.* New York: Thomas Y. Crowell Company, 1977.

Lee, A. Robert, ed., *Nineteenth-Century American Poetry.* New York: Barnes and Noble, 1985.

Lee, Anthony W. *Picturing Chinatown: Art and Orientalism in San Francisco.* Berkeley: University of California Press, 2001.

Lehuu, Isabelle. *Carnival on the Page: Popular Print Media in Antebellum America.* Chapel Hill: University of North Carolina Press, 2000.

Leonard, Zenas. *Narrative of the Adventures of Zenas Leonard.* Ann Arbor, Mich.: University Microfilms, 1966.

Leverenz, David. *Manhood and the American Renaissance.* Ithaca, N.Y.: Cornell University Press, 1989.

———. "The Last Real Man in America: From Natty Bumppo to Batman." *American Literary History* 3, no. 4 (1991). New York: Oxford University Press.

Liebersohn, Harry. *Aristocratic Encounters: European Travelers and North American Indians.* Cambridge: Cambridge University Press, 1998.

———. "Discovering Indigenous Nobility: Toqueville, Chamisso, and Romantic Travel Writing," *The American Historical Review* 99 (June 1994): 760.

Longfellow, Henry Wadsworth. *The Complete Poetical Works of Henry Wadsworth Longfellow, Cambridge Edition.* Edited by Horace E. Scudder. Cambridge, Mass.: Riverside Press, 1908.

Lovejoy, David S. "American Painting in Early Nineteenth-Century Gift Books." *American Quarterly* 7, no. 4 (Winter 1955): 345–61. Philadelphia: Committee on American Civilization of the University of Pennsylvania.

Lott, Eric. *Love and Theft: Blackface Minstrelsy and the American Working Class.* New York: Oxford University Press, 1993.

Lubin, David M. *Picturing a Nation: Art and Social Change in Nineteenth-Century America.* New Haven, Conn.: Yale University Press, 1994.

Lucas, George A. *The Diary of George A. Lucas: An American Art Agent in Paris, 1857–1909.* Princeton, N.J.: Princeton University Press, 1979.

Macaulay, Thomas Babington. *The History of England from the Accession of James II.* 5 vols. Chicago: Belford, Clarke & Co., 1884.

Mangan, J. A., and James Walvin, eds. *Manliness and Morality: Middle-Class Masculinity in Britain and America, 1800–1940.* Manchester: Manchester University Press, 1987.

Martin, Ann Smart, and J. Ritchie Garrison, eds. *American Material Culture: The Shape of the Field.* Winterthur, Del.: Henry Francis du Pont Winterthur Museum, 1997.

Martin, Terence. *The Instructed Vision: Scottish Common Sense Philosophy and the Origins of American Fiction.* Bloomington: Indiana University Press, 1961.

Martyn, Charles. *The William Ward Genealogy: the History of the Descendants of William Ward of Sudbury, Mass., 1638–1925.* New York: Artemas Ward, 1925.

Matchett's Baltimore Directory. Baltimore: R. J. Matchett, 1847–1848.

Mauss, Marcel. *The Gift: The Form and Reason for Exchange in Archaic Societies.* London: Routledge, 1990.

Mayer, Brantz. *Commerce, Literature and Art. Mr. Brantz Mayer's Discourse at the Dedication of the Athenaeum, Baltimore, October 23, 1848.* Baltimore: John Murphy, 1848.

McCahill, Michael W. "The Scottish Peerage and the House of Lords in the Late Eighteenth Century." *The Scottish Historical Review* LI, no. 2:152 (October 1972). Aberdeen: The Aberdeen University Press Ltd.

———. "Peerage Creations and the Changing Character of the British Nobility, 1750–1830." *The English Historical Review* 96, no. 379 (April 1981). Harlow, Essex: Longman Group Limited.

McCall, Laura. "'The Reign of Brute Force is Now Over': A Content Analysis of *Godey's Lady's Book*, 1830–1860." *Journal of the Early Republic* 9, no. 12 (Summer 1989): 217–36. Indianapolis: Society for Historians of the Early American Republic.

McDermott, John Francis, ed. *The Frontier Re-examined.* Urbana: University of Illinois Press, 1967.

McLaughlin, Castle. *Arts of Diplomacy: Lewis and Clark's Indian Collection.* Seattle: University of Washington Press, 2003.

McLerran, Jennifer. "Trappers' Brides and Country Wives: Native American Women in the Paintings of Alfred Jacob Miller." *American Indian Culture and Research Journal* 18, no. 2 (1994): 1–41. Los Angeles: American Indian Studies Center.

Mechling, Jay. "The Magic of the Boy Scout Campfire." *Journal of American Folklore* 93, no. 367 (January–March 1980): 35–56. Washington, D.C.: American Folklore Society.

Medicine Crow, Joseph. *From the Heart of the Crow Country: The Crow Indians' Own Stories.* Lincoln: University of Nebraska Press, 2000.

Merritt, John I. *Baronets and Buffalo: The British Sportsman in the American West, 1833–1881.* Missoula, Mont.: Mountain Press Publishing Co., 1985.

Mielke, Laura L. "'native to the question': William Apess, Black Hawk, and the Sentimental Context of Early Native American Autobiography." *American Indian Quarterly* 26, no. 2 (March 2002): 246–70. Lincoln: University of Nebraska Press.

———. "Encountering the Indian in the Age of Sentiment, 1824–1868," Ph.D. diss., University of North Carolina, Chapel Hill. Ann Arbor: UMI, 2003.

Miller, Lillian B. *Patrons and Patriotism: The Encouragement of the Fine Arts in the United States, 1790–1860.* Chicago: University of Chicago Press, 1966.

Mitchell, Donald G. [pseud. Ik Marvel]. *The Reveries of a Bachelor.* Philadelphia: Henry Altemus Company, 1896.

Mitchell, W. J. T. *Iconology: Image, Text, Ideology.* Chicago: University of Chicago Press, 1986.

Muensterberger, Werner. *Collecting: An Unruly Passion.* Princeton, N.J.: Princeton University Press, 1994.

Murphy, Peter T. "Fool's Gold: The Highland Treasures of MacPherson's Ossian." *ELH* 53, no. 3 (1986): 567–92. Baltimore: Johns Hopkins University Press.

Neale, John Preston. *Jones' View of the Seats, Mansions, Castles, etc. of Noblemen and Gentlemen in England, Wales, Scotland and Ireland, and other Picturesque Scenery Accompanied with Historical Descriptions of the Mansions, Lists of Pictures, Statues, &c. and Genealogical Sketches of the Families and Their Possessors; Forming Part of the General Series of Jones' Great Britain Illustrated.* London: Jones & Co., 1831.

Nelson, Dana D. *National Manhood: Capitalist Citizenship and the Imagined Fraternity of White Men.* Durham, N.C.: Duke University Press, 1998.

Nemerov, Alexander. *Frederic Remington & Turn-of-the-Century America.* New Haven, Conn.: Yale University Press, 1995.

———. *The Body of Raphaelle Peale: Still Life and Selfhood, 1812–1824.* Berkeley: University of California Press, 2001.

The New England Historical & Genealogical Register and Antiquarian Journal. Boston: S. G. Drake, 1859, 1862.

Nochlin, Linda. "The Imaginary Orient." *Art in America* 71, no. 5 (May 1983): 118–31, 187–91. New York: Whitney Communications Corporation.

Nylander, Jane C. *Our Own Snug Fireside: Images of the New England Home, 1760–1860.* New York: Alfred A. Knopf, 1993.

O'Neill, Francis P. *Index of Obituaries and Marriages in the [Baltimore] Sun, 1866–1870.* 2 vols. Westminster, Md.: Family Line Publications, 1996. 1871–5/1861–5.

Orel, Harold, Henry L. Snyder, and Marilyn Stokstad, eds. *The Scottish World: History and Culture of Scotland.* New York: Harry N. Abrams, 1981.

Page, Jean Jepson. "Notes on the Contributions of Francis Blackwell Mayer and His Family to the Cultural History of Maryland." *Maryland Historical Magazine* 76, no. 3 (September 1981): 217–39. Baltimore: Maryland Historical Society.

Palmeri, Frank. "The Capacity of Narrative: Scott and Macaulay on Scottish Highlanders." *Clio* 22, no. 1 (1992): 37–52. Fort Wayne, Ind.: Purdue University.

Pancost, David W. "Donald Grant Mitchell's *Reveries of a Bachelor* and Herman Melville's 'I and My Chimney.'" *American Transcendental Quarterly* 42 (Spring 1979): 129–36. Kingston: University of Rhode Island.

Parke-Bernet Galleries. *A Series of Watercolour Drawings by Alfred Jacob Miller of Baltimore: Artist to Captain Stewart's Expedition to the Rockies in 1837.* 6 May 1966. (Sale 2436). New York: Parke-Bernet Galleries.

Patterson, Jerry E. "Brantz Mayer, Man of Letters." *Maryland Historical Magazine* 52, no. 4 (December 1957): 275–89. Baltimore: Maryland Historical Society.

Pattie, James O. *The Personal Narrative of James O. Pattie, of Kentucky.* Edited by Timothy Flint. Cincinnati: John H. Wood, 1831.

Pearce, Roy Harvey. *Savagism and Civilization: A Study of the Indian and the American Mind.* Baltimore: Johns Hopkins University Press, 1965.

Pearce, Susan M. *On Collecting: An Investigation into Collecting in the European Tradition.* New York: Routledge, 1995.

Perkins, Edwin J. *Financing Anglo-American Trade: The House of Brown, 1800–1880.* Cambridge, Mass.: Harvard University Press, 1975.

———. "William Graham: Branch Manager and Foreign-Exchange Dealer in Baltimore in the 1850s," *Maryland Historical Magazine* 87, no. 1 (Spring 1992). Baltimore: Maryland Historical Society.

Perkins, Robert F., Jr., and William J. Glavin III, eds. *The Boston Athenaeum Art Exhibition Index, 1827–1874.* Boston: Library of the Boston Athenaeum, 1980.

Peterson, Jacqueline, and Jennifer S. H. Brown, eds. *The New Peoples: Being and Becoming Métis in North America.* Lincoln: University of Nebraska Press, 1985.

Phillips, Ruth B. *Trading Identities: The Souvenir in Native North American Art from the Northeast, 1700–1900.* Seattle: University of Washington Press, 1998.

Phillipson, N. T., and Rosalind Mitchison, eds. *Scotland in the Age of Improvement.* Edinburgh: Edinburgh University Press, 1970.

Pine, L. G. *The Genealogist's Encyclopedia.* New York: Weybright and Talley, 1969.

Pittock, Murray G. H. *The Invention of Scotland: The Stuart Myth and the Scottish Identity, 1638 to the Present.* London: Routledge, 1991.

Plante, Ellen M. *The American Kitchen, 1700 to the Present: From Hearth to Highrise.* New York: Facts on File, 1995.

Porter, Denis. *Haunted Journeys: Desire and Transgression in European Travel Writing.* Princeton, N.J.: Princeton University Press, 1991.

Porter, Mae Reed, and Odessa Davenport. *Scotsman in Buckskin: Sir William Drummond Stewart and the Rocky Mountain Fur Trade.* New York: Hastings House, 1963.

Pratt, Mary Louise. *Imperial Eyes: Travel Writing and Transculturation.* New York: Routledge, 1992.

Prebble, John. *The Highland Clearances.* Harmondsworth, U.K.: Penguin Books, 1969.

Price, Kenneth H. *To Walt Whitman, America.* Chapel Hill: University of North Carolina Press, 2004.

Property of a Collector, Resident of Baltimore [Now in Europe], Long Distinguished for his Taste and Liberality. New York: Henry H. Leeds and Company, 12, 13 February 1864.

Prown, Jules David. "Mind in Matter: An Introduction to Material Culture Theory and Method." *Winterthur Portfolio* 17, no. 1 (1982): 1–19. Winterthur, Del.: Henry Francis du Pont Winterthur Museum.

Pyne, Kathleen. "Whistler and the Politics of the Urban Picturesque," *American Art* 8, nos. 3/4 (Summer/Autumn 1994).

Prown, Jules David, et al. *Discovered Lands, Invented Pasts: Transforming Visions of the American West.* New Haven, Conn.: Yale University Press, 1992.

Quinn, Arthur Hobson, ed. *Representative American Plays from 1767 to the Present Day.* 7th ed. New York: Appleton-Century-Crofts, 1953.

Quinn, David Beers. *The Elizabethans and the Irish.* Ithaca, N.Y.: Cornell University Press, 1966.

Ramsay, John, of Ochtertyre. *Scotland and Scotsmen in the Eighteenth Century.* Edited by Alexander Allardyce. 2 vols. Edinburgh: William Blackwood and Sons, 1888.

Rasmussen, William M. S., and Robert S. Tilton. *Pocahontas—Her Life & Legend.* Richmond: Virginia Historical Society, 1994.

Ray, Arthur J. *Indians in the Fur Trade: Their Role as Trappers, Hunters, and Middlemen in the Lands Southwest of Hudson Bay, 1660–1870.* Toronto: University of Toronto Press, 1974.

———. "Reflections on Fur Trade Social History and Métis History in Canada." *American Indian Culture and Research Journal* 6, no. 2 (1982): 91–107.

Record of the First Exhibition of the Metropolitan Mechanic's Institute, Held in Washington, February, 1853. Washington, D.C.: Metropolitan Mechanic's Institute, 1853.

Reed, Sue Welsh, and Carol Troyen. *Awash in Color: Homer, Sargent, and the Great American Watercolor.* Boston: Little, Brown and Company, 1993.

Reynolds, Sir Joshua. *Discourses.* Edited by Pat Rogers. London: Penguin Books, 1992.

Rice, Laura. *Maryland History in Prints, 1743–1900.* Baltimore: Maryland Historical Society, 2002.

Roberts, Katherine Anne-Marie. "Hearth and Soul: The Fireplace in American Culture," Ph.D. diss., University of Minnesota, 1990.

Robertson, William. *The History of Scotland, During the Reigns of Queen Mary and King James VI. Until His Accession to the Crown of England; with a Review of the Scottish History Previous to that Period: And an Appendix Containing Original Papers.* 2 vols. Albany, N.Y.: E. and E. Hosford, 1822.

Rosaldo, Renato. "Imperialist Nostalgia." *Representations* 26 (1989): 107–22. Berkeley: University of California Press.

Ross, Marvin C., ed. *The West of Alfred Jacob Miller.* Norman: University of Oklahoma Press, 1968.

Rothman, Ellen K. *Hands and Hearts: A History of Courtship in America.* New York: Basic Books, 1984.

Rotundo, E. Anthony. *American Manhood: Transformations in Masculinity from the Revolution to the Modern Era.* New York: Basic Books, 1993.

Russell, Osborne. *Journal of a Trapper.* Edited by Aubrey L. Haines. Portland, Ore.: Champoeg Press, 1955.

Rutledge, Anna Wells. "Early Art Exhibitions of the Maryland Historical Society." *Maryland Historical Magazine* 42, no. 2 (June 1947): 124–36. Baltimore: Maryland Historical Society.

———. "Robert Gilmor, Jr.: Baltimore Collector." *Journal of the Walters Art Gallery* 12 (1949): 19–39. Baltimore: Walters Art Gallery.

———. *Cumulative Record of Exhibition Catalogues: The Pennsylvania Academy of the Fine Arts, 1807–1870.* Philadelphia: American Philosophical Society, 1955.

Ruxton, George Frederick. *Adventures in Mexico and the Rocky Mountains.* London: John Murray, 1847.

———. *Life in the Far West.* Edited by Leroy R. Hafen. Norman: University of Oklahoma, 1951.

Said, Edward W. *Orientalism.* New York: Pantheon Books, 1978.

"Sale of Antique Furniture and Tapestry from Murthly Castle." *The Scotsman* 17 (June 1871): 2, c. 1.

Samuels, Shirley, ed. *The Culture of Sentiment: Race, Gender, and Sentimentality in Nineteenth-Century America.* New York: Oxford University Press, 1992.

Scharf, J. Thomas. *History of Baltimore City and County from the Earliest Period to the Present Day: Including Biographical Sketches of Their Representative Men.* 2 vols. Philadelphia: Louis H. Everts, 1881.

Scheckel, Susan. *The Insistence of the Indian: Race and Nationalism in Nineteenth-Century American Culture.* Princeton, N.J.: Princeton University Press, 1998.

Schlissel, Lillian, Vicki L. Ruiz, and Janice Monk, eds. *Western Women: Their Land, Their Lives.* Albuquerque: University of New Mexico Press, 1988.

Schneider, Mary Jane. "Plains Indian Clothing: Stylistic Persistence and Change." *Bulletin of the Oklahoma Anthropological Society* 17 (November 1968): 1–55.

Schoelwer, Susan Prendergast. "Painted Ladies, Virgin Lands: Women in the Myth and Image of the American Frontier, 1830–1860." Ph.D. diss., Yale University. Ann Arbor, Mich.: UMI, 1994.

Scurlock, William H., ed. *The Book of Buckskinning.* Texarkana, Tex.: Rebel Publishing, 1981.

———. *The Book of Buckskinning VII.* Texarkana, Tex.: Scurlock Publishing, 1995.

Shapiro, Emily Dana. "J. D. Chalfant's Clock Maker: The Image of the Artisan in the Mechanized Age." *American Art* 19, no. 3 (Fall 2005).

Shapiro, Margery. *A Short History of the Martin Gillet Tea Co.* Baltimore, Md.: Maryland Historical Society, May 1938 [pamphlet].

Sheehan, Bernard W. *Seeds of Extinction: Jeffersonian Philanthropy and the American Indian.* New York: W. W. Norton & Co., 1973.

Sheets, Kevin B. "Saving History: The Maryland Historical Society and Its Founders." *Maryland Historical Magazine* 89, no. 2 (1994): 133–55. Baltimore: Maryland Historical Society.

Sherman, Stuart C. "The Library Company of Baltimore, 1795–1854." *The Maryland Historical Magazine* 39, no. 1 (1944): 6–24. Baltimore: Maryland Historical Society.

Shirley, John W., ed. *Thomas Harriot: Renaissance Scientist.* Oxford: Clarendon Press, 1974.

Sigmon, Mark Alan. "Heretics of Race: an Exploration of Indian-White Relationships in the Trans-Mississippi West 1820–1850." Ph.D. diss., University of California, Berkeley, 1995.

Slotkin, Richard. *The Fatal Environment: the Myth of the Frontier in the Age of Industrialization, 1800–1890.* New York: Atheneum, 1985.

Smith, Henry Nash. *Virgin Land: The American West as Symbol and Myth.* Cambridge, Mass.: Harvard University Press, 1978.

Smith, W. Wayne. "Jacksonian Democracy on the Chesapeake: The Political Institutions." *Maryland Historical Magazine* 62, no. 4 (December 1967): 381–93. Baltimore: Maryland Historical Society.

Smits, David D. "'Squaw Men,' 'Half-Breeds,' and Amalgamators: Late Nineteenth-Century Anglo-American Attitudes Toward Indian-White Race-Mixing." *American Indian Culture and Research Journal* 15, no. 3 (1991): 29–61. Los Angeles: American Indian Studies Center.

———. "'We Are Not to Grow Wild': Seventeenth-Century New England's Repudiation of Anglo-Indian Intermarriage." *American Indian Culture and Research Journal* 11, no. 4 (1987): 1–32. Los Angeles: American Indian Research Center.

Smout, T. C. *A Century of the Scottish People, 1830–1950.* New Haven, Conn.: Yale University Press, 1986.

———. *A History of the Scottish People, 1560–1830.* New York: Charles Scribner's Sons, 1969.

Spivak, Gayatri Chakravorty. "Can the Subaltern Speak?" *Marxism and the Interpretation of Culture.* Edited by Cary Nelson and Lawrence Grossberg. Urbana: University of Illinois Press, 1988.

Spring, David, ed. *European Landed Elites in the Nineteenth Century.* Baltimore: Johns Hopkins University Press, 1977.

Springer, James Warren. "An Ethnohistoric Study of the Smoking Complex in Eastern North America." *Ethnohistory* 28, no. 3 (1981): 217–35. Wichita Falls, Tex.: American Society for Ethnohistory.

Stafford, Barbara Maria. *Voyage into Substance: Art, Science, Nature, and the Illustrated Travel Account, 1760–1840.* Cambridge, Mass.: MIT Press, 1984.

Sterne, Julia A. *The Plight of Feeling: Sympathy and Dissent in the Early American Novel.* Chicago: University of Chicago Press, 1997.

Stewart, Susan. *On Longing: Narratives of the Miniature, the Gigantic, the Souvenir, the Collection.* Baltimore: Johns Hopkins University Press, 1984.

[Stewart, Sir William Drummond]. *Altowan; or, Incidents of Life and Adventure in the Rocky Mountains by an Amateur Traveler.* Edited by J. Watson Webb. 2 vols. New York: Harper & Bros., 1846.

———. *Edward Warren.* 2 vols. London: G. Walker, 1854.

Stocking, George W., Jr., ed. *Objects and Others: Essays on Museums and Material Culture.* Madison: University of Wisconsin Press, 1985.

———. *Victorian Anthropology.* New York: Free Press, 1987.

Stone, John Augustus. "Metamora, Or the Last of the Wampanoags: An Indian Tragedy in Five Acts as Played by Edwin Forrest." *Favorite American Plays of the Nineteenth Century.* Edited by Barrett H. Clark. Princeton, N.J.: Princeton University Press, 1943: 2–34.

Sunder, John E. *The Fur Trade on the Upper Missouri, 1840–1865.* Norman: University of Oklahoma Press, 1965.

Sutro, Ottilie. "The Wednesday Club: A Brief Sketch from Authentic Sources." *Maryland Historical Magazine* 38, no. 1 (March 1943): 60–68. Baltimore: Maryland Historical Society.

Swagerty, William R. "A View from the Bottom Up: the Work Force of the American Fur Company on the Upper Missouri in the 1830s." *Montana: The Magazine of Western History* 43, no. 1 (1993): 18–33. Helena: Montana Historical Society.

———. "Marriage and Settlement Patterns of Rocky Mountain Trappers and Traders." *Western Historical Quarterly* 11, no. 2 (1980): 159–80. Logan, Utah: Western History Association.

Tawil, Ezra F. "Domestic Frontier Romance, or, How the Sentimental Heroine Became White." *Novel: A Forum on Fiction* 32, no. 1 (Fall 1998): 99–124.

Thom, Helen Hopkins. *Johns Hopkins: A Silhouette.* Baltimore: Johns Hopkins Press, 1929.

Thompson, F. M. L. *English Landed Society in the Nineteenth Century.* London: Routledge & Kegan Paul, 1963.

Thompson, Ralph. *American Literary Annuals & Gift Books, 1825–1865.* New York: Archon Books, 1967.

Thoresen, Timothy H. H., ed. *Toward a Science of Man: Essays in the History of Anthropology.* The Hague: Mouton Publishers, 1975.

Thrift, Linda Ann. "The Maryland Academy of the Fine Arts and the Promotion of the Arts in Baltimore, 1838–1839." Master's thesis, University of Maryland, 1996.

Todd, Edgeley W. "Indian Pictures and Two Whitman Poems." *The Huntington Library Quarterly* 19, no. 1 (November 1955): 1–11. San Marino, Calif.: Henry E. Huntington Library and Art Gallery.

Todd, Janet. *Sensibility: An Introduction.* London: Methuen & Co., Ltd., 1986.

Tomc, Sandra. "An Idle Industry: Nathaniel Parker Willis and the Workings of Literary Leisure." *American Quarterly* 49, no. 4 (1997): 780–805. Baltimore: Johns Hopkins University Press, 1997.

Tompkins, Jane. *Sensational Designs: The Cultural Work of American Fiction, 1790–1860.* New York: Oxford University Press, 1985.

Trawick, Leonard M. "Whittier's 'Snowbound': A Poem about the Imagination." *Essays in Literature* 1 (Spring 1974), 46–53.

Troccoli, Joan Carpenter. *Painters and the American West: The Anschutz Collection.* New Haven, Conn.: Yale University Press, 2000.

———. *Alfred Jacob Miller: Watercolors of the American West.* Tulsa, Okla.: Thomas Gilcrease Museum Association, 1990.

Truettner, William H. *The Natural Man Observed: A Study of Catlin's Indian Gallery.* Washington, D.C.: Smithsonian Institution Press, 1979.

———, ed. *The West as America: Reinterpreting Images of the Frontier, 1820–1920.* Washington, D.C.: Smithsonian Institution Press, 1991.

Truettner, William H., and Alan Wallach, eds. *Thomas Cole: Landscape into History.* New Haven, Conn.: Yale University Press, 1994.

Tyler, Ron, ed. *Alfred Jacob Miller, Artist as Explorer: First Views of the American Frontier.* Santa Fe, N.Mex.: Gerald Peters Gallery, 1999.

———, ed. *Alfred Jacob Miller: Artist on the Oregon Trail.* Catalogue raisonné by Karen Dewees Reynolds and William R. Johnston. Fort Worth, Tex.: Amon Carter Museum, 1982.

———, ed. *Prints of the American West: Papers Presented at the Ninth Annual North American Print Conference.* Fort Worth, Tex.: Amon Carter Museum, 1983.

Upton, Dell, and John Michael Vlach. *Common Places: Readings in American Vernacular Architecture.* Athens: University of Georgia Press, 1986.

Van Kirk, Sylvia. *Many Tender Ties: Women in Fur-Trade Society, 1670–1870.* Norman: University of Oklahoma Press, 1980.

Vibert, Elizabeth. "Real Men Hunt Buffalo: Masculinity, Race and Class in British Fur Traders' Narratives." *Gender & History* 8, no. 1 (April 1996): 4–21. Oxford: Blackwell Publishers.

———. *Trader's Tales: Narratives of Cultural Encounters in the Columbia Plateau, 1807–1846.* Norman: University of Oklahoma Press, 1997.

Viola, Herman J. *Diplomats in Buckskins: A History of Indian Delegations in Washington City.* Washington, D.C.: Smithsonian Institution Press, 1981.

———. *The Indian Legacy of Charles Bird King.* Washington, D.C.: Smithsonian Institution Press and Doubleday & Co., 1976.

Wagner, Henry Raup, Charles Lewis Camp, and Robert H. Becker. *The Plains & The Rockies: A Critical Bibliography of Exploration, Adventure, and Travel in the American West, 1800–1865.* San Francisco: J. Howell Books, 1982.

Walker, James R. *Lakota Society.* Edited by Raymond J. Demallie. Lincoln: University of Nebraska Press, 1982.

Wallach, Alan. "'This is the Reward of Patronizing the Arts': A Letter from Robert Gilmor, Jr. to Jonathan Meredith, April 2, 1844." *American Art Journal* 21, no. 4 (1989): 76–77.

———. *Exhibiting Contradiction: Essays on the Art Museum in the United States.* Amherst: University of Massachusetts Press, 1998.

Walsh, Linda. "The Expressive Face: Manifestations of Sensibility in Eighteenth Century French Art." *Art History* 19, no. 4 (December 1996). Oxford: Association of Art Historians.

Walters Art Gallery. *The Taste of Maryland: Art Collecting in Maryland, 1800–1934.* Baltimore: Walters Art Gallery, 1984.

Ward, Gerald W.R., ed. *The American Illustrated Book in the Nineteenth Century.* Winterthur, Del.: Henry Francis du Pont Winterthur Museum, 1987.

Warner, Robert Combs. *The Fort Laramie of Alfred Jacob Miller: A Catalogue of All the Known Illustrations of the First Fort Laramie.* Laramie: University of Wyoming, 1979.

Watters, Robinson C. "Audubon and His Baltimore Patrons." *Maryland Historical Magazine* 34 (June 1939): 138–43. Baltimore: Maryland Historical Society.

Welsh, Alexander. *The Hero of the Waverley Novels.* New York: Atheneum, 1968.

Weston, Latrobe. "Art and Artists in Baltimore." *Maryland Historical Magazine* 33, no. 3 (September 1938): 212–27. Baltimore: Maryland Historical Society.

White, Hayden V. *Tropics of Discourse: Essays in Cultural Criticism.* Baltimore: Johns Hopkins University Press, 1978.

White, Richard. *The Middle Ground: Indians, Empires, and Republics in the Great Lakes Region, 1650–1815.* Cambridge: Cambridge University Press, 1991.

———. *The Roots of Dependency: Subsistence, Environment, and Social Change Among the Choctaws, Pawnees, and Navajos.* Lincoln: University of Nebraska Press, 1983.

Who Was Who in America: Historical Volume, 1607–1896. Chicago: A. N. Marquise Co., 1967.

Williamson, Arthur H. "Scots, Indians and Empire: The Scottish Politics of Civilization 1519–1609." *Past and Present: A Journal of Historical Studies* 150 (February 1996): 46–83. Oxford: Oxford University Press.

Wolf, Bryan Jay. *Romantic Re-Vision: Culture and Consciousness in Nineteenth-Century American Painting and Literature.* Chicago: University of Chicago Press, 1982.

Wolff, Justin. *Richard Caton Woodville: American Painter, Artful Dodger.* Princeton, N.J.: Princeton University Press, 2002.

Womack, Peter. *Improvement and Romance: Constructing the Myth of the Highlands.* London: Macmillan Press, 1989.

Wood, P. B. "The Natural History of Man in the Scottish Enlightenment." *History of Science* 28, no. 79 (March 1990): 89–123.

Wood's Baltimore Directory. Baltimore: John W. Woods, 1856–1857, 1860–1861, 1865–1866.

Wright, Mary C. "Economic Development and Native American Women in the Early Nineteenth Century." *American Quarterly* 33, no. 5 (1981): 525–36. Philadelphia: American Studies Association.

Yellow Bird, Michael. "What We Want to Be Called: Indigenous Peoples' Perspectives on Racial and Ethnic Identity Labels." *American Indian Quarterly* 23, no. 2 (Spring 1999): 1–21. Lincoln: University of Nebraska Press.

Young, Vernon. "The Emergence of American Painting." *Art International,* 20 September 1974. Lugano, Switzerland: James Fitzsimmons.

Youngson, A. J. *After the Forty-Five: The Economic Impact on the Scottish Highlands.* Edinburgh: Edinburgh University Press, 1973.

Zalesch, Saul E. "What the Four Million Bought: Cheap Oil Paintings of the 1880s." *American Quarterly* 48, no. 1 (March 1996): 77–109. Baltimore: American Studies Association.

INDEX

This publication was made possible in part by a grant from the National Endowment for the Arts. It was produced in conjunction with the Anne Burnett Tandy Distinguished Lectures on American Art at the Amon Carter Museum and published to coincide with the exhibition *Sentimental Journey: The Art of Alfred Jacob Miller.*

Amon Carter Museum
Fort Worth, Texas
September 20, 2008–January 11, 2009

Joslyn Art Museum
Omaha, Nebraska
February 7–May 10, 2009

© 2008 Amon Carter Museum. All rights reserved. First edition.

The Amon Carter Museum was established through the generosity of Amon G. Carter (1879–1955) to house his collection of paintings and sculpture by Frederic Remington and Charles M. Russell; to collect, preserve, and exhibit the finest examples of American art; and to serve an educational role through exhibitions, publications, and programs devoted to the study of American art.

Amon Carter Museum
3501 Camp Bowie Boulevard
Fort Worth, Texas 76107
www.cartermuseum.org

Distributed by the University of Oklahoma Press
www.oupress.com

Library of Congress Cataloging-in-Publication Data

Strong, Lisa Maria
 Sentimental journey: the art of Alfred Jacob Miller / by Lisa Strong.—1st ed.
 p. cm.
 Includes bibliographical references and index.
 ISBN 978-0-88360-105-1 (alk. paper)
 1. Miller, Alfred Jacob, 1810–1874—Criticism and interpretation. 2. West (U.S.)—In art. I. Amon Carter Museum of Western Art. II. Title.
 N6537.M54S76 2008
 759.13—dc22 2008008514

FOR THE AMON CARTER MUSEUM

Mary Jane Crook
Editor and Proofreader

Jonathan Frembling
Archivist and Reference Services Manager

Will Gillham
Director of Publications

Miriam Hermann, Elizabeth Le Coney
Publications Assistants

Steven Watson
Manager of Photographic Services

Page 2: *Pierre,* 1858–60 (detail). Chapter 4, plate 23

Pages 4–5: *Indians Tantalizing a Wounded Buffalo,* 1837 (detail). Chapter 2, plate 4

Page 6: *Sketching from Nature,* n.d. Chapter 4, plate 26

Page 38: *An Attack by Crows on the Whites on the Big Horn River East of the Rocky Mountains [Crows Trying to Provoke the Whites to an Act of Hostility],* 1841 (detail). Chapter 1, plate 9

Page 84: *Breakfast at Sunrise,* 1858–60 (detail). Chapter 2, plate 9

Page 120: *Bartering for a Bride (The Trapper's Bride),* 1845 (detail). Chapter 3, plate 1

Page 162: *Sioux Indian at a Grave,* 1858–60 (detail). Chapter 4, Plate 22

Designed by Jeff Wincapaw

Proofread by Jenifer Kooiman and Marie Weiler

Indexed by Lys Ann Weiss

Typeset by Maggie Lee

Color management by iocolor, Seattle

Produced by Marquand Books, Inc., Seattle
 www.marquand.com

Printed and bound by CS Graphics Pte., Ltd., Singapore